✔ KU-707-547

THE OXFORD ILLUSTRATED HISTORY OF
MEDIEVAL ENGLAND

Aberdeenshire

3143089

THE OXFORD ILLUSTRATED HISTORY OF
MEDIEVAL ENGLAND

Edited by
NIGEL SAUL

OXFORD
UNIVERSITY PRESS

OXFORD

UNIVERSITY PRESS

Great Clarendon Street, Oxford OX2 6DP

Oxford University Press is a department of the University of Oxford.
It furthers the University's objective of excellence in research, scholarship,
and education by publishing worldwide in

Oxford New York

Athens Auckland Bangkok Bogotá Buenos Aires Calcutta
Cape Town Chennai Dar es Salaam Delhi Florence Hong Kong Istanbul
Karachi Kuala Lumpur Madrid Melbourne Mexico City Mumbai
Nairobi Paris São Paulo Shanghai Singapore Taipei Tokyo Toronto Warsaw

with associated companies in Berlin Ibadan

Oxford is a registered trade mark of Oxford University Press
in the UK and in certain other countries

Published in the United States
by Oxford University Press Inc., New York

© Oxford University Press 1997

The moral rights of the author have been asserted
Database right Oxford University Press (maker)

First published 1997
First issued as an Oxford University Press paperback 2000

All rights reserved. No part of this publication may be reproduced,
stored in a retrieval system, or transmitted, in any form or by any means,
without the prior permission in writing of Oxford University Press,
or as expressly permitted by law, or under terms agreed with the appropriate
reprographics rights organization. Enquiries concerning reproduction
outside the scope of the above should be sent to the Rights Department,
Oxford University Press, at the address above

You must not circulate this book in any other binding or cover
and you must impose this same condition on any acquirer

British Library Cataloguing in Publication Data

Data available

Library of Congress Cataloging in Publication Data

Data available

ISBN 978-0-19-289324-6

7 9 10 8

Printed in Great Britain by
Ashford Colour Press Ltd
Gosport, Hants.

ABERDEENSHIRE LIBRARIES	
3143089	
Bertrams	09/07/2014
942.03	£17.99

Editor's Preface

IN recent years historians of medieval England have become more aware of the 'British' dimension to their subject. Studies of political history have increasingly taken a British rather than a purely English context, while in the social and cultural fields scholars such as R. R. Davies and J. Gillingham have illuminated the role of interaction between English and Celt in shaping popular identities. In the light of this thinking, a book that focuses exclusively on England requires justification. In essence, two main reasons can be offered, the first practical and the second intellectual. The first is simply that it is easier to assemble a team of writers on England than on the British Isles as a whole. In an age of increasing specialization of knowledge there are no more than a handful of scholars with the necessary range and expertise to write authoritatively on both English and non-English history. One has to settle for one or the other. The second—the intellectual point—is that the middle ages, and, in particular, the later middle ages, were a key period in the formation and the sharpening of English national identity. It has long been a commonplace that England was highly precocious in establishing a centralized system of royal government. But it is also worth noting that it was exceptional in the early coalescence of its ethnic and political borders. Thus, although a history of medieval England may appear narrower than desirable, it none the less has a coherence that a history of the medieval British Isles might lack.

The organization of this book is both thematic and chronological. The book opens with an introductory chapter which sketches the formation of English political identity and the nature and degree of England's contacts with the wider world. Next, a series of chronological chapters examines English political history between roughly 500 and the end of the fifteenth century. There then follow discussions of popular piety and Church life, and of the social and economic history of the period. In conclusion, there are chapters on English achievements in the visual arts, and in language and literature.

A number of debts have been incurred in the preparation of this book. The first is to Anne Gelling of Oxford University Press, under whose watchful eye the book has progressed from conception to completion. The second is to Sandra Assersohn for her work in seeking out suitable illustrations. A third debt is to the contributors themselves. Not only have they collaborated superbly as a team; more than that, they have delivered their work on, or very close to, the required date. The editor is grateful to them all.

NIGEL SAUL

Contents

List of Colour Plates

List of Maps and Family Trees

List of Contributors

NICOLA COLDSTREAM, Centre for Medieval Studies,
University of Reading

CHRISTOPHER DYER, University of Birmingham

GEORGE GARNETT, St Hugh's College, Oxford

CHRIS GIVEN-WILSON, University of St Andrews

HENRIETTA LEYSER, St Peter's College, Oxford

JANET L. NELSON, King's College, London

DEREK PEARSALL, Harvard University

NIGEL SAUL, Royal Holloway and Bedford New College,
University of London

1 Medieval England
Identity, Politics, and Society
~~ Nigel Saul ~~~~~~~~~~~~

Bede and the 'Birth' of England

Not uncommonly nations have their origins in an idea long before they have an existence in reality. This was the case with present-day France and Germany in the middle ages. And so it was with England. The earliest extant evidence of a sense of Englishness comes from the Anglo-Saxon period. In the 720s or 730s, after the establishment in the former Britannia of the mosaic of Germanic kingdoms, St Boniface dwelled on the apparent characteristics of the 'English'. These, he considered, were sodomy, adultery, and drunkenness. Around the same time the Northumbrian Eddius, in his life of Wilfrid, said that the saint had been spared execution at Lyons when he was found to be 'of the English nation from Britain' ('de Anglorum gente ex Britannia'). In a *Life of Gregory* written at Whitby in the late seventh or early eighth century, an anonymous writer said that Pope Gregory would lead the English people ('gentem Anglorum') before the Almighty on the Day of Judgement.

That a sense of Englishness should have been cur-

rent as early as the eighth century is perhaps a little surprising. The people whom we know as the Anglo-Saxons were not only disunited; they were of diverse geographical origin. Bede in one of his most famous passages categorized them as comprising three peoples—the Angles, from present-day Schleswig, the Saxons from Saxony, and the Jutes from Jutland. These peoples settled in England piecemeal and established separate kingdoms. There were no administrative or institutional ties holding them together. Bede mentions that there were rulers who exercised *imperium*—a kind of overlordship of the kingdoms; but this jurisdiction had little objective reality and existed largely in the eye of the beholder. Early medieval England, it might be observed, was a geographical expression. So how did the sense of 'Englishness' come about?

The suggestion has been made that its originator (however unintentionally) may have been Pope Gregory the Great. Bede, following the Whitby *Life*, tells a well-known story of Pope Gregory seeing some English slaves in a market at Rome and commenting that they were 'non Angli sed angeli'. Quite possibly Gregory's quip may have become widely known. It can hardly be coincidental that before Gregory's time the Germanic invaders of Britain were generally known as Saxons but afterwards almost universally as 'Angli'—English. There are signs that the influence of Christ Church, Canterbury, may have been instrumental in disseminating a notion of Englishness. Canterbury wanted to draw all the English and Saxon people into its obedience and was accordingly keen to promote a notion of their unity. Bede drew much of the material for his history from Canterbury, and Nothelm, one of his informants, subsequently became archbishop. Bede's unconscious acceptance of Canterbury's ideas is implicit in the title that he gave to his work: an *Ecclesiastical History of the English People*; and further recognition of his assumptions is found in his discussion of the *bretwaldas*, where he speaks of these men's *imperium*—their authority over the whole island. Bede's *Ecclesiastical History* enjoyed enormous contemporary acclaim. Very likely its wide circulation helped to ensure that his—and Canterbury's—ideas gained widespread recognition.

How deep did this idea of 'Englishness' go in the eighth and ninth centuries? England was still politically fragmented and loyalties were still personal and local. It is true that from the seventh century there was a tendency to the creation of larger political units, such as the kingdom of Northumbria in the mid-seventh century and that of Mercia in the eighth; but as yet there was no sign of the creation of a kingdom of all the English. The turning-point came in the late ninth and early tenth centuries, when in the wake of the Viking invasions there was a redrawing of the territorial map. Around the 860s the Vikings, who had hitherto conducted intermittent raiding, stepped up their attacks and the kingdoms of eastern and northern England fell before their assaults. After 871 the Vikings turned their attacks against Wessex, and within a few years they were penetrating deep into the kingdom. In 878, however, Alfred defeated them at Edington and Guthrum, their leader, sub-

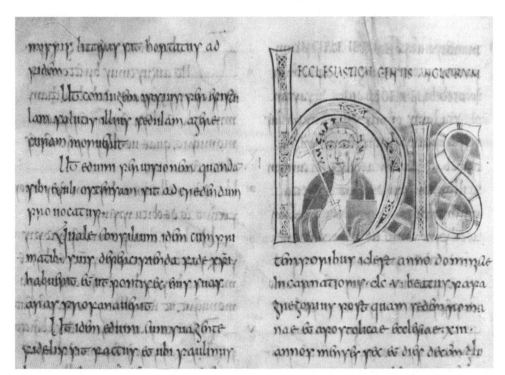

BEDE'S ECCLESIASTICAL HISTORY was the single most influential work by an English writer in the early middle ages. The Leningrad manuscript, shown here, was written at Bede's own monastery of Monkwearmouth/Jarrow, within a dozen years of his death. The illustrated figure has been identified as Pope Gregory the Great.

mitted. In the following decade Alfred took to the offensive. By the 880s or earlier he had recaptured London and at his death in 899 he was consolidating his position in the midlands. His son Edward the Elder carried on his father's work, establishing himself firmly in Mercia and completing a chain of forts. In the 930s Alfred's grandson Athelstan extended his dominion to the north. There are grounds for considering Athelstan the first ruler of all England. Like his two predecessors Athelstan aimed to promote a common identity among his people. Significantly he did not reconstitute the kingdoms that he and they had 'freed'; he absorbed them into a greater Wessex. It was by this process of absorption and expansion that Wessex eventually became England.

The aspirations of Alfred and his successors are reflected in their cultivation of an 'English' self-image. From towards the end of the 880s Alfred styled himself 'rex Anglorum (et) Saxonum'. In the prologue to the treaty with Guthrum he spoke of his advisers as 'councillors of all the English race'. In his preface to the translation of Pope Gregory's *Cura Pastoralis* he repeatedly refers to 'Englishkind' and the 'English' (*Angelcynn* and *Englisc*). But all the while this emphasis on Englishness was

coupled with continued recognition of the Wessex roots of the monarchy: the *Anglo-Saxon Chronicle*, which was compiled under his influence, is a hymn of praise to his forebears' achievements. Alfred was never less than an old-fashioned dynast. But it was clear to him that if he was to fashion a united front against the Vikings he needed to stimulate a broadly national or 'English' feeling. He did this by fostering in his subjects a belief in themselves as a chosen race. Bede, whose work he had ordered to be translated, was his source of inspiration here. Bede had told the story of the conversion of the English to Christianity in the 600s. A couple of centuries later, when the Vikings were raiding and plundering, that Christian inheritance was in jeopardy. The reason for this, in Alfred's view, was that the English, like the people of Israel, had sinned; and the torments which they were suffering were their punishment. The people of Israel had saved themselves by repenting; and the English should do likewise. God had singled them out for this supreme test, and it was possible for them to regain his favour by passing it. This was a message that Alfred put across in his own writings and by commissioning a translation of Bede. And it was reiterated in his law code. Included as a preface to the customs of the West Saxons, the Mercians, and the people of Kent were lengthy extracts of the law given by God to Moses. Obedience to God's law as interpreted by the 'king of the English' was to be the condition of the survival of all 'Englishmen' in future.

Alfred's lofty conceptions did not win automatic or immediate acceptance. In midland and eastern England there was widespread suspicion of West Saxon aggrandisement. Alfred had to be diplomatic in his dealings with members of the former Mercian royal house. Not all of his contemporaries were inclined to see the Vikings as invaders or aggressors. To many, even in Wessex, the Viking wars were more a clash of competing lordships than a battle for survival. The formation of national consciousness, like the formation of the nation-state, was a slow and uneven process. But in the tenth century it appears to have undergone a marked acceleration. The struggles with the Vikings, and in the north with the Scots, had obviously encouraged co-operation between people and promoted the formation of a common outlook. The ambitions and remarkable successes of the West Saxon rulers from Alfred also promoted a sense of pride in being English. There was an imperial touch to these rulers' vision. In some Worcester charters of the period they were styled 'emperor' (*imperator*), indicating their lordship over the British peoples. By the beginning of the eleventh century a measure of uniformity was being brought to English government. In Cnut's law code of the 1020s, drafted by Archbishop Wulfstan of York, Danish idiosyncrasies received scant recognition and Mercian ones almost none. A generation earlier, the *Regularis Concordia*, the blueprint for

THE CRUCIFIXION from the Litlington Missal, Westminster Abbey. The missal was commissioned by Nicholas Litlington, abbot of Westminster, in 1383. Italian influence is evident in the central miniature, but the interlace decoration of the borders is evidence of more traditional taste.

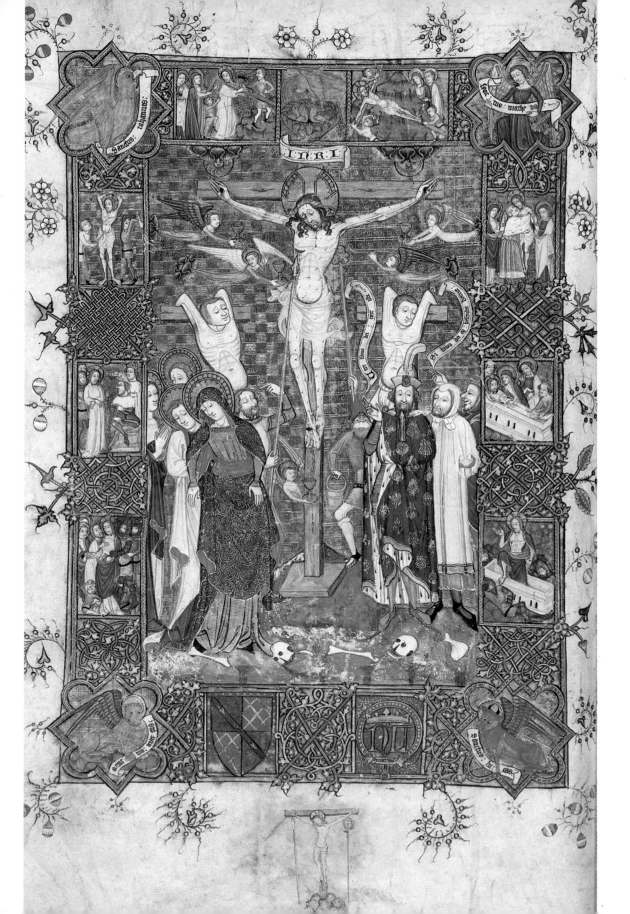

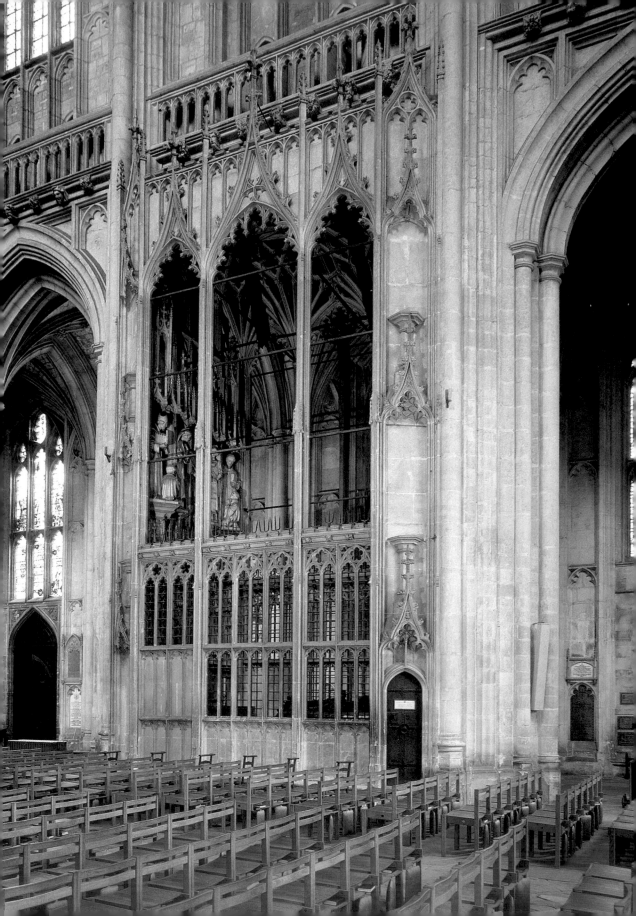

the reform of the English Church, was said to be the rule for 'the monks and priests of the English nation' ('Anglicae nationis monachorum sanctimonialiumque'): the Rule applied to the whole realm. The separate English kingdoms had gone, and the kingdom of England had been born.

'English' and 'Aliens'

Progress towards the creation of a unified English, or Anglo-Scandinavian, society was broken by a series of crises in the eleventh century. In 1016 the line of Wessex kings was interrupted by the succession of Cnut of Denmark; while in 1066 the last English king, Harold of Wessex, was killed at Hastings, and the highly distinctive state that he ruled extinguished. As a result of these two major upsets, England was drawn, for periods of varying length, into a composite 'empire' or confederation. England was ruled by a 'foreigner': a king whose patrimony was abroad.

The early eleventh-century rule of the kings of Denmark was to be no more than a transient phenomenon; it lasted barely two generations. Even in Cnut's lifetime the signs of disintegration were evident. Around 1034 Norway had become independent under Magnus, the son of King (St) Olaf. After Cnut's death in 1035 the process gathered pace. England and Denmark became separated, with Harold, Cnut's son by Ælfgifu, succeeding to England, and Harthacnut, his other son, to Denmark. On Harold's death the two were reunited under his brother, but on his death they broke apart again, this time for good. For the final twenty years before the Conquest the country was again under the rule of the house of Wessex.

The Norman Conquest, when it came, had an altogether different impact from its predecessor. Not only were its effects far greater; they were also more long-lasting. There was an obvious reason for this. England and Normandy were much closer to each other than England and Denmark: the king-duke could govern them as a single unit by journeying backwards and forwards across the Channel. But there was a second reason for the permanence of the Conquest. The Norman takeover in 1066 was more comprehensive in character than its predecessor. In the years around 1070 the Conqueror, faced with continuing native resistance, had gradually expropriated the Old English aristocracy and re-granted their lands to his own men. As a result, an entirely new aristocracy came into being which was endowed with lands on both sides of the Channel. More than anything else, it was the existence of this cross-Channel aristocracy which held the two dominions together. In the intervals

MANY OF THOSE 'provided' to bishoprics in the fourteenth century were ambitious careerists. One of the most successful was William of Wykeham. Wykeham was essentially an administrator; after serving Edward III as clerk of the works at Windsor, he rose to be successively keeper of the privy seal and chancellor, and in 1367 he was rewarded with the see of Winchester. The size and splendour of his chapel in the cathedral attest his worldly success.

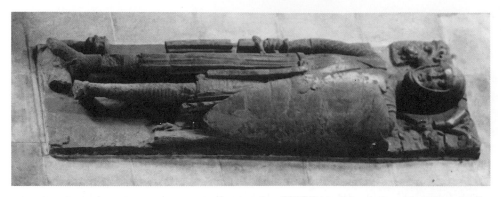

A STUDY IN KNIGHT ERRANTRY: the tomb of William Marshal, earl of Pembroke (d. 1219) in the Temple church, London. William Marshal was born in England, spent his youth in Normandy, and in old age became 'rector', or regent, of England under Henry III. Like many twelfth-century magnates he moved freely on both sides of the Channel.

between 1087 and 1135, when the Conqueror's dominions were divided between his competing sons, it was the aristocracy that brought them together again—for it was essential for them to avoid the problems of a divided allegiance. England and Normandy were additionally drawn closer by the Normanization of the Church and the establishment in England of dependent cells of mother houses in Normandy. The suggestion has been made that the English were reduced to something like colonial status by the Normans. It is open to question whether this was precisely the case, but certainly a number of aspects of a colonial society were present.

In the short term at least, the arrival of the Normans led to an assault on the traditional cultural values of the English. The English language was downgraded, and French became the language of polite society and Latin, over a longer period, the language of government. It seems that in some cathedrals or abbeys the new Norman prelates challenged the sanctity of the more obscure early English saints: at Canterbury, for example, Lanfranc had some English saints deleted from the cathedral calendar. But it has recently been shown that as early as the 1080s attitudes had begun to change. A process of assimilation began. An early indication of this is the growing respect shown to the pre-Conquest English cults. At Christ Church, Canterbury, Lanfranc reinstated the English saints and his successor Anselm actively encouraged their cults. At Crowland Abbot Geoffrey fostered a local cult of the executed English Earl Waltheof. At Canterbury, Durham, and St Augustine's Canterbury the relics of English saints were translated with due honour into the new Anglo-Norman churches. It was accepted by now that these saints had the power to protect churches and ward off plunderers. Simultaneously, it appears, English and Normans together were developing a new line in hagiography. The lives of the Old English saints were written or rewritten to meet the demands of the new age. The Flemish monk Goscelin of St Bertin, who had come to England before the Con-

quest, produced lives of Edith for the nuns of Wilton and Wulfhilde of Barking for the bishop of London. At Worcester the Englishman Coleman wrote a life of his bishop, the saintly Wulfstan, shortly after his death. At Christ Church, Canterbury, two Englishmen, Eadmer and Osbern, kept their house's long hagiographical tradition alive. A sign of the changing times was that these lives were increasingly written in Latin. The clear implication of this is that they had a Norman readership as well as an English.

The process of the merging of cultures was greatly aided by the growing interest that the Normans took in the country's past. Whether because they were insecure or as part of the process of settling down the Normans quickly appropriated the English past to their own. Many of the leading chroniclers of the period—Orderic Vitalis, for example—were conscious that there were both English and Norman sides to their inheritance. Geoffrey Gaimar, a Norman who composed a history for the wife of a minor Lincolnshire lord in the 1130s, treated English pre-Conquest history as if it were part of the Norman heritage. Significantly, a number of leading English writers reciprocated by showing an interest in the Norman inheritance. The admittedly cosmopolitan Ailred of Rievaulx prefaced an account of the battle of the Standard (1138) with a rhetorical speech by Walter Espec on the valiant deeds of the Normans in places as far afield as Sicily and Calabria. By the twelfth century one or two writers were even showing an interest in British history. Henry of Huntingdon introduced his readers to the career of King Arthur, describing his battles with enthusiasm, while his contemporary Geoffrey of Monmouth conjured up a whole exotic world of British myth. Geoffrey's main object was to entertain and amuse. But in the course of so doing he satisfied many of the yearnings of the new Anglo-Norman élite. He unfolded before them the romantic past for which they longed, and he provided their rulers with a genealogy even more glorious and fantastic than that of the French kings.

By the middle of the twelfth century it is evident that a homogeneous nation was once again being forged. The nobility and their tenantry may have been divided by language, as they were to be for another two centuries; but there was a growing willingness to identify with England on the part of people of all backgrounds. As so often in history, this sense of nationhood was defined, in its early stages at least, negatively. The English saw themselves as different from other peoples. Towards their neighbours in the Celtic lands to the west the English affected a definite superiority. John of Salisbury, writing in the 1150s, said that the Welsh were 'rude and untamed; they live like beasts and although they nominally profess Christ, they deny him in their life and ways'. Gerald de Barri was equally scathing in his comments about the Irish. 'They are so barbarous that they cannot be said to have any culture … They are a wild people, living like beasts, who have not progressed at all from the primitive habits of pastoral farming.' This attitude of superiority was probably rooted in a belief that the English economy was more advanced. By the middle of

the twelfth century the level of economic development achieved in England was far in excess of that in the Celtic lands. The English lived better than the Celts; they ate better and they grew better crops. They were conscious of belonging to a wealthier and more civilized world. The fact that they spoke French lent weight to this perception because French was becoming the lingua franca of a cosmopolitan European-wide community. Only in relation to the subjects of the king of France did the English feel a certain inferiority. English visitors to France often commented on the happiness of the people and the evident accord between them and their king. As John of Salisbury wrote: 'After crossing the sea I seemed to feel the breath of a gentler breeze [than in England]; I admired with joy the wealth and abundance on all sides, and a people quiet and contented.' John was not in any way humbled by France. He had earlier written proudly: 'The French fear our king and hate him equally.' But he recognized the magnitude of French achievements. This was a time when the Parisian schools were flourishing and when the great cathedrals were being built. In the France of the Capetians he felt himself in a land of civilization.

In John of Salisbury's time national identities in Europe were only vague and in process of formation. Political boundaries generally did not coincide with boundaries between peoples, and loyalties were as much to lords as to territories. The process of giving a sharper definitional edge to identity proceeded at different speeds in different kingdoms and states. In England's case, the process was greatly assisted by the ending of the cross-Channel connection at the beginning of John's reign. With the recovery of Normandy by the French in 1204, England was severed from her closest mainland partner. Her political society became self-contained, and the Anglo-Norman nobility, already Anglicized, became, in effect, an English nobility. The effects of the change can be seen in the shifting language of political debate. No longer did the baronage and knightly class speak, as they once had, in semi-feudal terms of 'liberties' and inheritances. Rather they spoke of nations and communities. In 1258 in their petition to Henry III they demanded that castles should be entrusted to 'faithful men, natives of the kingdom of England'; and in an associated document they demanded that ladies should not be married to men 'who are not of the nation of the kingdom of England'. A major factor in the outbreak of the crisis of 1258 was opposition to the foreign-born favourites at Henry III's court. To a degree this opposition had its roots in the growth of English national feeling. But there is also a sense in which it cloaked a factional struggle between those who enjoyed the king's favour and those who did not. The king's favourites, principally his Lusignan half-brothers, were 'aliens' in the sense that they came from France; thus attacking them for their alienness could be a useful way of engineering their removal. It is doubtful if there are any grounds for taking all the complaining about 'aliens' at this time at face value. William de Valence, one of the Lusignans, had a largely English retinue. But it is none the less significant that political debate should have been couched in

terms of 'alienness'. The old distinctions of ethnicity had gone; new ones were taking their place.

England and the Wider World

The presence of foreign-born favourites at Henry III's court affords a reminder that at no time in the middle ages was England cut off from the wider world. England, though physically separate from the mainland, was very much in touch with it. English influence is evident in all the main cultural movements of the middle ages—the Carolingian Renaissance, the crusades, the twelfth-century monastic reform movement, and so on; while at the same time European influence is evident in various aspects of English creative life, notably polite literature, courtly culture, and the visual arts.

The extent of England's involvement with Europe is apparent early on. Well before 600 there were close ties between the southeast of England and Francia. Trading links between the two territories are attested by the presence of Frankish goods in cemeteries in eastern Kent and by the discovery in Kentish hoards of Merovingian gold coins from as far afield as Bordeaux. Formal political ties between England and Francia appear to have been initiated by Æthelbert of Kent's marriage in the 560s to Bertha, daughter of the Merovingian Charibert. From the 590s, in the wake of Augustine's evangelizing mission and Æthelbert's conversion, ties between England and the Continent multiplied. English (or British) missionaries contributed to the work of spreading Christianity on the Continent. Already in the 590s a British monk, Columbanus, had travelled to Francia and founded a monastery at Luxeuil. In the 690s a Northumbrian, Willibrord, established a bishopric among the Frisians (in the present-day Netherlands), while early in the 700s his younger con-

TREASURES from the Sutton Hoo ship burial of the 630s: Merovingian coins from Gaul (*above*) and the Anastasius silver dish of Byzantine origin (*c.*490–*c.*520) (*below*). The treasures buried with the nameless ruler at Sutton Hoo bear witness to the range and variety of England's ties with other lands.

temporary, Boniface, continuing his predecessor's work, preached in Germany and founded the abbey of Fulda. The religious and diplomatic links forged by these missionaries sometimes followed in the wake of trading ties. It is evident that by the early middle ages English or British traders were travelling in almost every part of Europe. A vivid idea of the range of goods that they exchanged can be gained from the Sutton Hoo ship burial of the 630s. Among the goods buried with the deceased ruler were Roman plate, Merovingian gold coins, silver spoons and a silver dish from Byzantium. The British Isles, although physically on the fringes of Europe, were locked into trading routes or gift-exchange systems that covered the whole continent.

After the Norman Conquest England's ties with the wider world underwent reorientation. Contact with Norway and Denmark, with which relations had earlier been close, diminished, while on the other hand much closer links were forged with the European mainland and, in particular, the French-speaking world. Up to a point this reorientation was a direct result of the Conquest, which drew England into governmental union with her southern neighbour. But it was also a product of more general movements sweeping across Europe. As the popes from Gregory VII became steadily stronger and established themselves as the centre of a close-knit spiritual empire, so more and more people were drawn to Rome to do business with them and to seek their favour. The establishment on the Continent of 'schools'—in other words, proto-universities—also drew people southwards from England. The scholar Robert Pullen, for example, lectured at Paris, while Thomas of Marlborough, later abbot of Evesham, had studied at Bologna. The Norman Conquest and its legacy should not be seen in isolation from these broader changes: very likely the Conquest only speeded up a process that had already been set in motion. It is arguable that its greatest impact lay in broadening the horizons of aristocrats and laymen. English-born knights were now employed in the non-English parts of the Angevin 'empire'. Robert of Thornham, for example, was employed by Henry II as seneschal of Anjou and later of Aquitaine. A number of laymen in the service of the monarchy exploited opportunities created by the many marriage alliances that Henry II contracted. After Henry's daughter Joan was given in marriage to William of Sicily, Robert of Selby became head of the Sicilian chancery and Richard Palmer bishop of Syracuse. Other Englishmen worked in Spain and further afield still.

The breakup of the Angevin 'empire' made relatively little difference to the network of ties and interests that held England and Continental Europe together. The king of England was still ruler of Aquitaine in south-western France, and from 1259 he was recognized as a peer of France. Successive English rulers were linked to the ruling houses of Europe by a series of ties of friendship and blood. Henry III married into the comital house of Provence, while Edward I was allied by marriage to Castile and, after 1299, to France. A decade later Edward II married into the royal house of France, and Edward III into the comital house of Hainault. As a result of

these ties a number of families of foreign origin were attracted to the service of the English monarchy. Members of the Lusignan family, related to Henry III in the half-blood, were active in England from the 1240s to the 1320s, while in the fourteenth century the Savoyard knight Odo de Grandson and his nephew John, bishop of Exeter, played an active role in politics under the first and third Edwards. Underpinning these political ties were the cultural links that held the ruling élites of Europe together. Kings and nobility generally subscribed to the same outlook and tastes, read the same literature, and observed the same courtesies. The ethic of chivalry, which they all unconsciously accepted, allowed them to make similar or identical assumptions in their dealings with one another. The pervasiveness of the ethic of chivalry made for a powerful horizontal solidarity between the European élites at a time when the growth of the vertical solidarities of nationhood was pulling in the other direction.

The *Chronicles* of the Hainaulter Jean Froissart (*c.*1335–1410) show clearly that the gentry and nobility were drawn together by chivalry until well into the late middle ages. However, at the end of the thirteenth century, when a series of bitter wars in northern Europe broke out, a shift in attitudes is discernible. Traditional horizontal solidarities were increasingly undermined and perceptions of ethnicity sharpened. In the shaping of English self-identity two wars were of particular importance—

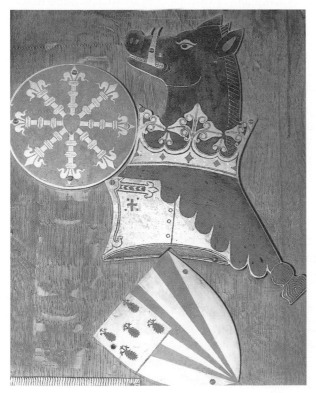

THE STALL PLATE of Ralph, Lord Basset of Drayton K.G., in St George's Chapel, Windsor. Windsor was the headquarters and spiritual home of the Order of the Garter. Lord Basset's stall plate, of the late fourteenth century, is the oldest surviving in the chapel.

those with Scotland and France. The Scottish war, the result of Edward I's bid to establish hegemony over his northern neighbour, began in the 1290s and lasted for nearly half a century; the long struggle with France, known as the Hundred Years War, began when the Scottish war was dying down and lasted, on and off, for over a century. In the case of each of these struggles the length and intensity of the fighting stimulated the growth of national self-consciousness. The kings of England deliberately exploited such self-consciousness to win popular support for their cause. Edward I in letters patent accused the French of seeking to extirpate the English tongue, while Henry V encouraged in his subjects a belief in themselves as a chosen people. At the same time as national consciousness was being fostered, an assault was mounted on the horizontal bonding of chivalry by the establishment of national orders of chivalry. Edward III's Order of the Garter, founded around 1348, provided an influential model for the others by requiring of its members exclusive allegiance to the sovereign. Similar obligations were laid on members of other orders founded later in this period—the Order of the Star in France, the Order of the Golden Fleece in Burgundy, and so on. As a result of the establishment of these Orders the horizontal solidarities of chivalry were increasingly overlaid by the vertical ones of royal and national allegiance.

By the mid- to late fifteenth century the nexus of ties, cultural and familial, that had bound the English nobility to their peers in Europe appears to have been weakening. At the same time the monarchy itself was becoming less cosmopolitan. Fewer marriage alliances than before were contracted with foreign houses. In the 200 years to 1420 every English ruler had taken a foreign wife; in the ninety or so years after that only one did, the hapless Henry VI. Increasingly kings looked for their brides to the native nobility. There were good domestic reasons for so doing: the Yorkist and Tudor dynasties had their origins in the nobility and needed to consolidate their ties with that group. All the same, the trend was symptomatic of narrowing horizons. The English monarchy was retreating from its once dominant, if not pre-eminent, position in Europe. Periodically after 1450 kings attempted to stage a comeback: Edward IV followed in the footsteps of Henry V in 1475, when he took an army to France. But the days of redrawing the map of Europe were over. By the sixteenth century the contests that mattered were not between Plantagenet and Valois, but between Habsburg and Valois.

The Church in England

The one institution that transcended national barriers and brought together people of all races was, of course, the Church. The Church was a universal body in the sense that it embraced all the faithful. Its membership was coextensive with society. The fundamental rites of passage in life—baptism, marriage, and absolution at death—were all ones that were defined and regulated by the Church.

The unity of the Church found expression in the primacy and leadership of the pope—the vicar of Christ and lineal successor of St Peter. By the thirteenth century papal influence was felt in every corner of Europe. Popes were intervening in the internal affairs of states, taxing ecclesiastical wealth, sponsoring the dispatch of crusaders, and summoning General Councils. The papacy had come a long way from the time, three centuries before, when it was little more than the object of the competing ambitions of the senatorial families of Rome. The reasons for the rise of papal power were several. One of the most important was the successful outcome to the struggle with the empire at the end of the eleventh century which led, in the longer term, to a decline in the emperors' authority. A second reason was the growth in the twelfth century of the crusading movement, which had its origins in a papal initiative and which stimulated the levying of papal taxation. A third was the development of canon law and the growth of appellate procedures which brought suitors and litigants to Rome and placed the pope at the head of an elaborate judicial system. As a result of these various processes, the papacy was able to pull the provincial Churches more closely together and to assert its own claim to direct the affairs of a united Christendom.

Papal aspirations to supremacy found expression in the thirteenth century in the growth of the practice of 'providing', or directly appointing, to benefices. 'Provision' had its origins in the papal ambition of reforming and opening up the dynasticized cathedral chapters, particularly those of Germany. But by the thirteenth century the pope's need to find rewards for the growing number of bureaucrats in his service had led to a wide extension of the practice. By the decree *Licet ecclesiarum* in 1265 the benefices of all clergy who died at the papal curia were reserved for papal provision. In the 1320s John XXII's bull *Ex debito* extended this general reservation to the benefices of all clerics who died within two days' journey of Rome, as well as to all cardinals and all bishops consecrated in Rome. As a result of these initiatives there was a rapid expansion in the practice of provision. Whereas Clement V (1305–14) had provided, on average, to eight English livings a year, John XXII provided to around forty; and thirty years later Clement VI was providing to some sixty prebends and forty-two parish livings. Clement is reckoned, overall, to have provided to more than 1,600 English benefices in the decade of his pontificate.

The practice of providing to benefices gave vivid outward expression to the doctrine of the papal plenitude of power. But, highly effective as it was as an instrument of patronage, it undermined respect for the papacy and embroiled it in faction and dispute. Patrons from the king and the nobility downwards found their wishes overridden or ignored, while clerks who had been presented by the normal channels were liable to find themselves dispossessed. In England, probably more than anywhere in Europe, provisions gave rise to anger and controversy. In the fourteenth century the parliamentary commons were vociferous in denouncing the practice. Their first complaint was made in the Carlisle parliament of 1307, when a petition

was submitted against provisions and the export of English money abroad. In 1309 the magnates sent a letter of protest to Clement V. In April 1343 the commons and the temporal lords together protested about the provision of aliens to benefices. In the parliaments of 1344, 1346, and 1347 further petitions were submitted against the practice. Edward III turned this torrent of complaint to his advantage by using it to wring concessions from the pope. In 1351 he gave his approval to a statute—the Statute of Provisors—which authorized him, in the event of a provision which threatened rights of patronage, to intervene as patron paramount and make the appointment as though the benefice were still vacant. The pope was furious at the passing of the statute and was keen to secure its repeal. In practice, however, he showed a willingness to compromise. In the middle and late fourteenth century each side offered concessions to the other. The king recognized the pope's right to provide to benefices and sees, while the pope, for his part, acquiesced in providing the king's nominee. The outcome of the informal understanding was more favourable to the king than to the pope. While the formal structure of papal centralization was preserved, in reality there was a rapid increase in royal influence on the composition of the episcopal bench. In the period before the rise of provisions the choice of a bishop or abbot had normally rested with the chapter, and it was common for these bodies to choose one of their own number or at least someone known to them. But once the process of selection was taken over by the king, the way was open to the appointment of more political figures—of curialists, civil servants, and scions of the aristocracy. Rarely now were scholars or religious chosen as bishops. As a result, by the 1360s Edward III had gained an episcopate shaped largely in his image and amenable to his wishes. It is small wonder that in the late middle ages there were no longer clashes between Church and Crown like those that had occurred between Henry II and Becket, and John and Innocent III.

The establishment of a royal ascendancy over the Church was equally evident in other areas of ecclesiastical life. In the early to mid-fourteenth century there was a rapid increase in the Crown's own exercise of ecclesiastical patronage. In the thirty-five years of Edward I's reign just over 900 appointments to benefices had been made by the Crown. In the twenty years of Edward II's the figure had risen to 1,400; and in the first twenty-five years of Edward III's reign there were over 3,000. In consequence of this, there was a large and growing number of clergy who looked to the Crown rather than to the pope for leadership. At the same time, the Crown was active in limiting the threat to its interests from the prosecution of appeals to Rome. In 1353 royal approval was given to the Statute of Praemunire which decreed that anyone appealing to a court outside the realm on matters pertaining to the king's courts was to answer for his or her contempt before his judges; and should he or she fail to do so then he was to face outlawry and forfeiture of his goods. Like the Statute of Provisors, the statute was never properly enforced; its twin functions were to reinforce the legislation on provisions and to strengthen the king's hand in bargaining

with the pope. Royal influence was equally evident in the measures taken by Edward III and his successors to elicit support for the war effort in France. Mandates to say prayers for the success of English arms were issued at regular intervals in the fourteenth and fifteenth centuries—in 1342, for example, for an expedition to Brittany, in 1355 for the Poitiers campaign, in 1380 for Buckingham's *chevauchée*, in 1420 for the conquest of Normandy, and so on. Increasingly, it seems, in the late middle ages the institutions of the Church were manipulated to serve the interests of the Crown. Nominally the English Church remained part of the one universal Catholic Church. But by Edward III's reign at the latest it was becoming an 'Ecclesia Anglicana', a national Church over which the king established a powerful ascendancy. In the sixteenth century Henry VIII, in his measures to establish the royal supremacy, was simply following where his medieval predecessors had led.

The drift to centralization in the upper levels of the Church nevertheless contrasted with the deeply ingrained tendency to localism in ordinary religious expression. People did not usually think of 'the Church' in the abstract; they tended rather to think in terms of 'church*es*'—cathedral churches, abbey churches, and, increasingly, parish churches. Churches commanded people's affection. They were the focal point of communities, and commonly they aroused feelings of communal pride. In the early 1300s, when the nave of York Minster was rebuilt, contributions to the cost poured in from members of the northern nobility, whose support was commemorated by the placing of coats-of-arms in the spandrels of the arcade. At a humbler level, when the nave and chancel of Long Melford church (Suffolk) were rebuilt from the 1480s, the names of those who contributed to the fabric fund were inscribed in the stonework of the clerestory. The number and scale of rebuilding projects, particularly at parish level, in the later middle ages bear witness to the importance of these structures in the local communities. They gave expression to people's self-identity and to their sense of place in the world.

The localism of medieval religion was powerfully reinforced by the cult of the saints. The secret of the saints' popularity in everyday piety was that they made the practice of religion accessible to people. The saints were patrons, protectors, mediators: people with whom ordinary folk could identify. Commonly they were perceived as a living presence. It was widely believed that they inhabited the places where their relics were preserved. St Cuthbert was considered a living presence at Durham, St Ætheldreda at Ely, and so on. The epitaph on the tomb of St Martin of Tours had said: 'Here lies Martin the bishop, of holy memory, whose soul is in the hand of God; but he is fully here, present and made plain in miracles of every kind.' Most saints in the middle ages had a localized following, but a few had a regional appeal. St Cuthbert was adopted as the regional saint of the north of England. In 1346, when the English went into battle with the Scots at Neville's Cross, they did so under St Cuthbert's banner, and the victory that followed was attributed to the saint's anger with the aggressors. Increasingly in the late middle ages saints were

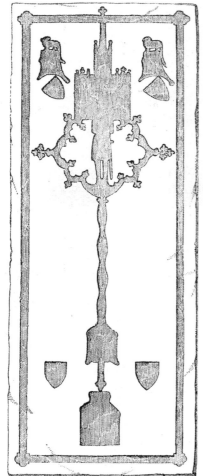

adopted as patrons by nations. By as early as the twelfth century the French had elevated St Denis to this status. Within the next two centuries by a more halting process St George was given a similar position in England. When the English met the French at Agincourt, they did so to cries of 'St George for England'.

Commonly the power of the saints was communicated through the working of miracles. Miracle-working capacity was seen as evidence of the saint's possession of divine favour. Reports of miraculous happenings made particular shrines centres of popular pilgrimage. Much the most celebrated shrines in the middle ages lay far beyond England's shores. Pre-eminent among them were Rome and Jerusalem, but Santiago, the alleged burial place of St James, and Cologne, with its shrine of

MANY OF THE FAITHFUL sought commemoration by a brass or monument. This indent of the lost brass to Sir John de la Rivière, at Tormarton, Gloucestershire, hints at the knight's piety: above him rises a model of the church in which he founded a chantry. In later years Sir John went on pilgrimage to Jerusalem and, on returning, he joined the London Dominicans. No reference to these initiatives is made on the brass. Very likely Sir John commissioned the brass in mid-career: on stylistic grounds it can be dated to the time of his wife's death c.1350.

PILGRIMS collected souvenir badges from the shrines that they visited. Shown here are (left) the scallop shell of St James, from Santiago de Compostella; (centre) the key of St Peter, from Rome; (right) St Michael triumphing over the dragon, Mont Saint-Michel.

THE BOOTS OF A PILGRIM, Worcester Cathedral, *c.*1500. The pilgrim's grave was found under the south-east pier of the tower in 1986. Unusually, the pilgrim, whose identity is unknown, was buried fully clothed.

the Three Kings, were also popular. The most celebrated English pilgrimage centre was the shrine of St Thomas at Canterbury. At the time of the Translation of the relics in 1220 offerings exceeded £1,000 per annum. Most other English shrines were, by comparison, objects of lesser interest. The most heavily visited in the thirteenth century were those of the early English saints, notably St Æthel-dreda at Ely, St Chad at Lichfield, and St John at Beverley; the burial places of all three attracted significant followings as English self-consciousness grew stronger. Cults seldom, however, flourished for long. Like other aspects of Church life, they passed in and out of fashion. Even St Thomas's cult at Canterbury faded in the fifteenth century: annual offerings made at the shrine slumped to less than £100. On the eve of the Reformation the most popular places in England to visit were probably the hitherto obscure shrines of Our Lady at Walsingham and the Holy Rood at Bromholm.

By the fifteenth century, however, the faithful were no longer going on pilgrimage in the numbers that they had. A variety of factors help to account for this. One was a gradual shift in devotional patterns. In the early and central middle ages devotion had for the most part been focused on relics, whereas in the late middle ages it was focused on images. All over England minor cults grew up around such images. Images were seen as aids to prayer and devotion, but they did not inspire pilgrimages. A second reason for the change was that people were collecting their own relics. By the fourteenth century it was relatively easy to lay one's hands on a few. Sir John Fastolf put together a collection that included a relic of the true Cross, an arm of St George, and a finger of St John the Baptist. A kinsman of his, William Haute, had pieces of bone of St Nicholas and St Bartholomew and 'the stone on which the Archangel Gabriel descended when he saluted the Virgin'. The formation of these relic collections is a phenomenon which neatly encapsulates many of the main themes in the history of late medieval piety. On the one hand, it demonstrates that the cult of the saints had lost none of its potency. But, on the other, it points to a tendency to abandon the more traditional modes of religious expression. For the better-off, so it seems, by this period pilgrimage no longer mattered. The Fastolfs of this world had all that they wanted in their own homes—not only relics, but bibles, psalters, books of hours, and smaller works of devotion as well; and, being literate,

they could read them for themselves. Religion, Colin Richmond has suggested, was becoming 'privatized'. The word 'privatized' is one from which many historians of the period have shied away. But certainly attitudes were emerging that were to undermine the old order and pave the way for the changes ushered in by the Reformation.

An English Culture?

The pattern of religious devotion provided the framework within which much of the literature and art of the period was produced. Art (or, at least, visual art) in the middle ages was essentially religious art. Patrons commissioned works in the cause of piety, while those who executed them saw themselves as offering an insight into the kingdom to come. True art was inseparable from personal religion; it was a product of the one holistic Christian vision.

But the local influences that made for diversity of religious expression also made for diversity of artistic production. There were variations in styles of painting and illumination between one part of Europe and another, and regional or national taste was reflected in the layout and design of churches. Artistically, Europe was little more than a geographical expression. So how far, if at all, is it possible to identify a distinctive English culture or a distinctive English style? Are there any characteristics that are observable through the whole period?

Throughout the middle ages English art, in whatever form, was enriched with the arrival of influences from abroad. Such influences were felt as early as the fifth to the seventh centuries, when the first Germanic settlers arrived in these islands. These settlers brought with them a taste for animal forms and patterns of intertwined creatures which merged with the native Celtic tradition to produce the so-called Insular style. A notable characteristic of this style was a love of interlace and geometric or animal ornament, which was displayed at its most brilliant in jewellery designs. With the coming of the Roman missionaries at the end of the sixth century a new wave of influence was felt. The arrival from the Mediterranean of classically derived representational forms encouraged artists to develop a grander, more naturalistic style. The finest example of the new art is the portrait of St Matthew in the Lindisfarne Gospels. The saint is shown with his feet on a stool, penning his gospel, watched by an assistant who pulls back a curtain to observe him. The whole is a masterly attempt at representational art.

Already in these first two or three centuries of the Saxon period it is possible to identify a handful of characteristics that were to distinguish English art and architecture for the rest of the middle ages. Perhaps the most noticeable of these is a preoccupation with linearity. As Margaret Rickert once wrote, both Anglo-Saxon and Celtic art were from inception and by their very nature wholly linear, and whatever Mediterranean forms—whether figure or foliage—went into the Insular mill came

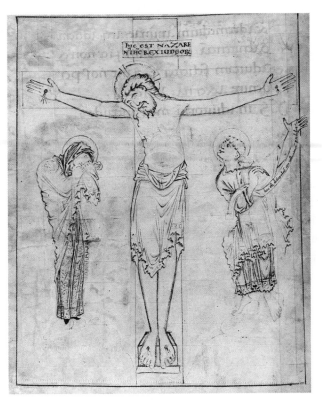

THE CRUCIFIXION from the Ramsey Abbey Psalter. The Psalter was executed in the late tenth century, probably for Oswald, spiritual founder of the abbey. This drawing of the Crucifixion is a fine example of the tinted outline style of the artists of the south-east of England.

out as linear pattern. The taste for linearity was to be a recurring feature of English artistic styles over the centuries. It is evident in the crucifixion in the Ramsey Abbey Psalter—a masterpiece of the tinted outline style of the eleventh-century Winchester artists—and in a Canterbury psalter of *c*.1000 in the British Library. After the Conquest it re-emerged in the extraordinary passion in architecture for linear arcading on the façades of buildings. This is grandly illustrated on the west fronts of Castle Acre priory and Lincoln cathedral, each of which is covered with row upon row of such arcading. A second characteristic of English art is the love of interlacing. Interlace decoration is an early Celtic motif displayed at its purest on the 'carpet' pages of the Lindisfarne Gospels. In the twelfth century it was employed in such de luxe works as the Lothian Bible, and in the fourteenth it made triumphant re-appearances in the St Omer Psalter and the Litlington Missal. Though occasionally submerged, the love of interlace was never lost sight of.

The reception and reinterpretation of influences from abroad was a theme in English artistic and architectural history throughout the central and later middle ages. The greatest influence in England in the tenth and early eleventh centuries was probably that of the Carolingian world. In manuscript painting the grander, more decorative style fashioned at the Carolingian court gradually caught on in England. The mandorlas and acanthus-leaf borders, which were the hallmarks of the south-

ern English 'Winchester' style, were essentially of Carolingian origin. In ecclesiastical architecture there was a growing taste for the Carolingian pattern of transeptal plans, towers at the west or centre, and altars at both eastern and western ends. The ambitious eleventh-century churches of Winchester and Sherborne both owed a great deal to Carolingian and, later, to Ottonian styles.

In the later eleventh and twelfth centuries the dominant influence was, of course, that of the Normans. A decade before the Conquest Norman models had been favoured by Edward the Confessor in the rebuilding of Westminster abbey. In the fifty or so years to the 1120s every major church in England was rebuilt in the new style. Romanesque, as it developed in England, was a style of eclectic origin. There were features such as the giant-order pillars at Tewkesbury and Gloucester suggestive of Burgundian or north Italian influence, while decorative details such as the patterning of shafts and plinths point to continuing English influence. But the basic design source was, of course, Normandy itself. At the ducal abbey of Jumièges, near Rouen, in the 1030s a design was evolved which provided the model for Duke William's and Matilda's abbeys at Caen and which was carried thence to England. In its English setting the main characteristics of the style were double bays with alternate columnar and compound piers, boldly defined galleries, and clerestories and aisles with groin vaulting. The churches built by the Normans at Durham, Rochester, Waltham, and Ely all broadly conformed to this design. The overall effect was magnificent. Powerful articulation combined with qualities of massiveness and vigour to produce interiors of rare solemnity. Norman architecture had many of the characteristics of the architecture of imperialism. It is hard not to feel, when looking at these buildings, that the settlers wanted to make their mark on the country that they had conquered.

Yet within half a century English churches were already looking very different from their Norman precursors—and, indeed, from those built after the Conquest in Normandy. For one thing, they were becoming longer. Jumièges had had a nave of eight bays and the Abbaye-aux-Dames at Caen one of nine. St Albans and Ely, however, had naves of thirteen bays and Winchester and Norwich ones of fourteen. The tendency to greater length may have owed something to such factors as imperialist pride and the need to accommodate processions, but it also owed something to the English liking for horizontal vistas. This liking was to reach its climax in the following century, when the eastern arms of the greater churches were extended. At Ely a choir of four bays was lengthened to become one of ten, while at Winchester one of five was transformed into an elaborate complex of nine. In Normandy and the Île de France church plans never extended in this way. They remained compact and

SAINT-THIBAULT, Cote d'Or, France, c.1290–1320: interior of the choir looking east. The extended mullions anticipate the similar patterning favoured in early Perpendicular in England.

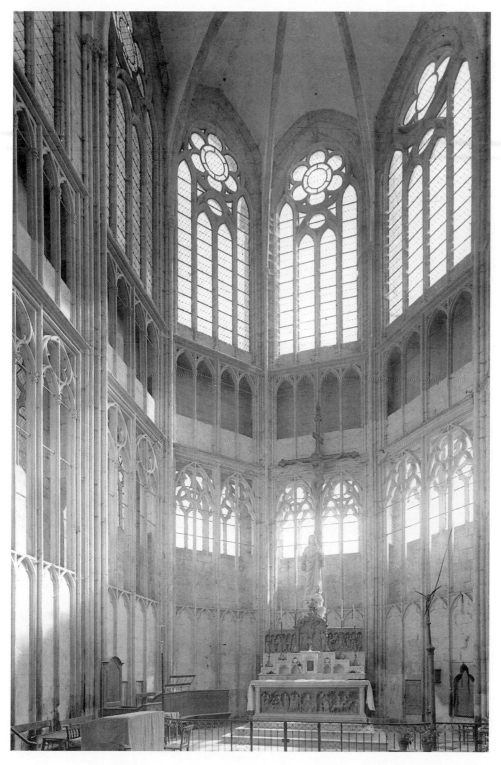

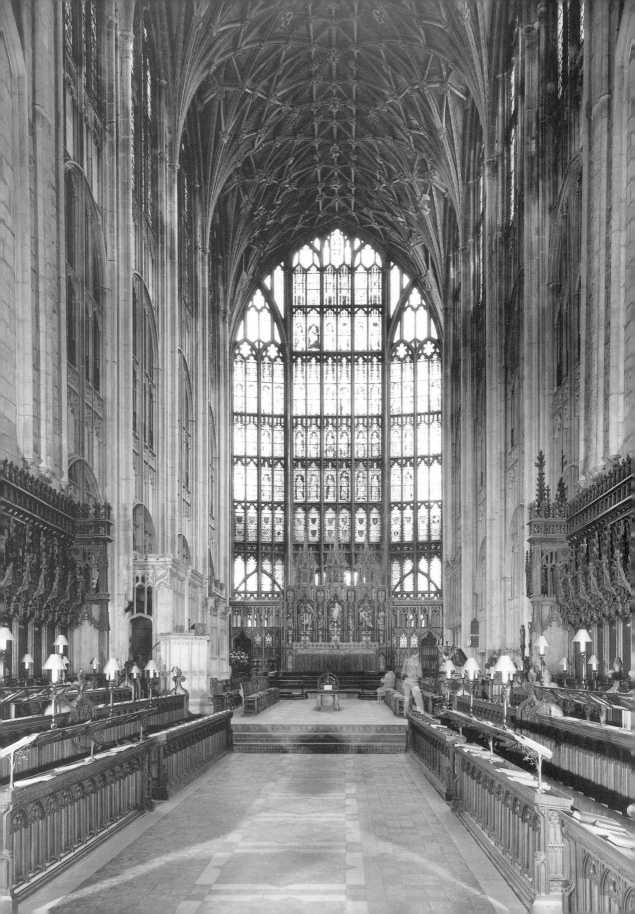

integrated; smaller units were drawn into greater. The emphasis was never on length; it was on verticality.

At the same time as opting for horizontalism, English masons indulged their traditional taste for surface texture. Before 1066 in Normandy the walls of churches, both inside and out, had mostly been plain. In England, later, they became steadily more elaborate. Blind arcading was introduced into the aisles of Peterborough, Durham, and Ely. Tier upon tier of arcading and geometrical designs was laid on the tower of Norwich. Geometrical patterning was given to the cylindrical piers of Durham. A century after the Conquest, when the Romanesque style gradually evolved into Gothic, the English scarcely changed their techniques. Largely disregarding the structural possibilities afforded by Gothic—the opportunity to build higher and lighter structures—they concentrated exclusively on the decorative possibilities. In cathedrals like Wells and Lincoln, rebuilt from the 1180s and 1190s respectively, arch mouldings were elaborated, vaulting ribs multiplied, and surface ornament enriched. The native English masons had observed and studied the new style, reinterpreted it, and made it their own.

Towards the end of the middle ages the insular character of English art and architecture became still more pronounced. 'Perpendicular', the final phase of Gothic in England, is now thought to have originated in part in a tendency in French *rayonnant* to continue the mullions down through the storeys. But very quickly Perpendicular assumed the character of what earlier historians called 'England's distinctive national style'. There was no exact parallel to it on the Continent. French Gothic in its final phase became steadily more florid and showy; it has aptly been named the 'flamboyant' style. English Perpendicular was, by contrast, more restrained. Curviness was eschewed and tracery simplified; rectilinearity became the norm. As a building like St George's chapel in Windsor castle shows, the near-universal form of surface patterning was the grid.

The tendency to insularity is probably more evident in architecture than in the other arts. In manuscript illumination the working of foreign influence can be observed until well into the late middle ages. In the early fourteenth-century St Omer Psalter and Gorleston Psalter crucifixion, for example, Italian influence is evident in such characteristics as the delicate scale, the sculptural modelling, and the illusionistic textural effects. In the 1370s and 1380s the Italian approach to figure painting is also evident in a beautifully executed group of manuscripts associated with the de Bohun family. In the following century the influence of French, Netherlandish, and German artists can be detected in such works as the Bedford Psalter

THE TRIUMPH OF PERPENDICULAR in England: the interior of the Gloucester choir. The similarity to the design at Saint-Thibault is obvious. The abbey (now the cathedral) choir was rebuilt from the mid-1340s by masons familiar with the up-to-date styles of Westminster.

and Hours, and the illuminated *Metrical Life of St Edmund*. By the time of the English retreat from France, however, cross-Channel fertilization had weakened and English illuminators were cutting a lonely and often uninspired furrow. The influence of Low Countries artists is evident in the wall paintings in Eton College chapel (*c*.1480). But it took the arrival of Hans Holbein the younger from Germany in the 1520s to breathe significant new life into English painting as a whole.

It is likely that England's most distinctive achievement in the late middle ages is to be found in the field of literature. By the middle of the fourteenth century the English vernacular had gained a new respectability as a medium for literary expression. Writers using the vernacular were displaying a new confidence and maturity. A characteristic of the period is the use of a version of the Old English alliterative mode (the mode in which the rhyme was formed by the repetition of the initial letter or letters). The most celebrated writer of alliterative verse is William Langland, whose *Vision of Piers the Ploughman* is one of the finest poems of the age. Langland, a midlander by birth, spent the bulk of his working life in London, but most of the other alliterative poems appear to have been written in or around the north-west midlands. The highly polished *Sir Gawain and the Green Knight* may have been written by someone with court connections. By the time that the alliterative revival was drawing to a close, a new type of vernacular literature was coming into existence. This was the polite literature of romances and *fabliaux* written for an audience that previously had read mainly in French. Chaucer, John Gower, and Sir John Clanvow were the leading figures in this area. Chaucer, a king's esquire, was a giant among his contemporaries and appears to have been recognized as such. His range was remarkable, and he knew more of the French and Italian corpus than any Englishman before him. His achievement bears witness to his own innate genius and to his powers of perception. But it also conveniently highlights the eclecticism of English art. Like others before and after him, he was familiar with the principal currents of thought on the Continent. However, he adapted and reinterpreted almost everything that he used. What Pevsner termed 'the Englishness of English art' is a quality as evident in the work of Chaucer and his contemporaries as it is in that of Shakespeare and his.

2 Anglo-Saxon England
c.500–1066

∾∾ Janet L. Nelson ∾∾∾∾∾∾∾∾

Telling Anglo-Saxon History

History has often taken shape with the telling of tales. Early medieval historians used oral material, but then structured their written narratives around models taken from the Bible. Bede wrote ecclesiastical history presupposing the existence of an 'English people': a new chosen people, who naturally had to move into their promised land, and were quite different from the aboriginal inhabitants. The crucial part of Bede's story was the subsequent conversion of his *Angli* to Christianity, though as we shall see, that triumphant outcome was not the end of Bede's story. Bede relied for his account of the English 'arrival' almost exclusively on one written source, Gildas's *The Ruin of Britain*. Gildas's master-narrative was prophetic rather than strictly historical, and his 'chosen people' were the Britons—his own people. Their leaders, the 'kings and priests', had abandoned their calling, violated God's commands, and so deserved divine punishment at the hands of pagan invaders whom Gildas

called 'Saxons'. Gildas must have hoped to inspire a reformation, and a return to God's ways; but his story did not reach so far.

More recent historians too have had their guiding narratives for writing of the Anglo-Saxon period. In the seventeenth century, the central theme was the freedom of a class, the yeomen of England, subjected to the Norman yoke in 1066, but sticking triumphantly to their common law and re-emerging to challenge absolutist foreign (Scottish) kings. In the nineteenth century, the favoured narrative was a nation's story. It was told in masterly fashion by Bishop Stubbs. Its heroes were the English (regardless of class), who differed distinctively from both Romans and Celts, but shared with the Germans a propensity to develop democracy and civilization. Stubbs wrote in the heyday of Empire and before twentieth-century wars had made Germanness suspect. Many twentieth-century historians nevertheless retold a form of Stubbs's story. Sir Frank Stenton did so in *Anglo-Saxon England*, first published in 1943, the second volume of the Oxford History of England and still the standard work. The earlier Anglo-Saxon period fitted Stenton's bill quite easily, with settlement, conversion, the freedom of the *ceorl* (pronounced 'churl'), and cultural identity providing strong themes. The Viking invasions of the ninth century took their place as a trial, a testing, whence brave little Wessex emerged to unify England in the tenth century. The latter part of the story fitted less well. Significantly, Stenton dealt with the period from *c.*950 under the heading 'decline'.

Modern narrators have often been specialists in the Old English (OE) language, interested in the history of a culture. Language and literature are seen as central to English uniqueness. In this story, the later Anglo-Saxon period becomes very important, because most OE literature belongs to it. Ælfric and Wulfstan have inspired whole scholarly industries. On the other hand, poetry, though extant only in late Anglo-Saxon manuscripts, can be seen as timeless: it does not matter whether *Beowulf* was composed in the eighth century or the tenth. The Anglo-Saxons can become timeless too. The disruptiveness of the Norman Conquest dissolves in cultural continuity, as the conquerors are taken captive. The emergence of Middle English allows the narrative to progress, in stately fashion, via Chaucer and *Gawain and the Green Knight*, to the age of Spenser and Shakespeare.

A second kind of narrative, often linked with the first, but enjoying a remarkable vogue in the late twentieth century, is more specifically historians' own. It is the story of a state: the theme is the growing power of kings and the strengthening of central government which, by a special English virtue, worked hand in hand with local government. The working-out of this theme takes the Conquest comfortably on board, with Domesday Book an essentially Anglo-Saxon achievement. The story sweeps majestically on to Henry II and Edward I and the sovereignty of the king-in-Parliament, easily incorporating the subaltern zones of Wales and Ireland (not themselves states) and, less easily, Scotland, which grew more statelike by imitating England. The British state can thus emerge ready for a wider empire.

This chapter does not tell a story quite like those just described. It goes with the grain of evidence that appears often as a sequence of images rather than events. The formation of an English kingdom, and an English identity, during the Anglo-Saxon period may emerge from the images, but the focus is often fuzzy. Anglo-Saxon cultural glories sometimes shine brightly, yet Continental borrowings, contacts, and resemblances loom large, shading Anglo-Saxon distinctiveness. The local power of the aristocracy is seen as coexisting often uneasily with, and not chiefly integrated into, royal government. Surviving regional identities, and the view from the provinces, sometimes block out the 'centre', that is, the heartlands of West Saxon royal power. The Church is part of the picture, firmly located in social and political history. The political is seen as the necessary context for the institutional, as well as vice versa. The visual metaphor is deliberate. What follows is episodic and impressionistic. An *illustrated* history can work the images hard.

Settlement

At the start, the fifth and sixth centuries provide an object-lesson in what can be done *without* written material for an events-based narrative. Gildas, the only contemporary 'source', wrote invective not history. His series of vivid Old Testament passages, evocations of bloodthirsty kings and evil-living priests, throws only oblique light on the military and political end of Roman Britain. Gildas took for granted the world known otherwise from late Roman historians, in which Britons were liable to attack by Picts from the north and Scots (that is, Irish) from the west. We can untangle some kind of British plea to Rome for help, and Rome's refusal, leaving the Britons on their own. Saxons, it transpires, were also part of the picture, potential mercenaries, and this too we know from Roman sources. The Britons asked some Saxons for help, Gildas said, and they arrived in three ships in 'eastern parts', but there was soon trouble over pay. These Saxons revolted and allied with the 'former enemies', the Picts. The Britons, divided among themselves, lost ground. Cities and fields were devastated. Then, under a man of Roman stock called Ambrosius, the Britons rallied and defeated the Saxons. Finally, apparently co-inciding with Gildas's own lifetime, came a period of peace and moral decline. Civil war began again. Gildas wrote in prophetic gloom: the way was open for further Anglo-Saxon expansion, and the Britons would soon be confined to the Celtic fringe.

Gildas's chronology was virtually non-existent. The *Life* of Bishop Germain of Auxerre (*c.*460) who came to Britain to stamp out Pelagian heresy in 428, says he found Saxons and Picts allied. If Gildas wrote, not in the 540s as believed until recently, but *c.*470 (and the earlier date would make Gildas's excellent Latin more explicable, in terms of both author and intended audience), then the sequence of events culminating in the Saxon revolt could more plausibly be back-dated to the

420s. Dates did not interest Gildas anyway. They did interest Bede, as he struggled in the 720s to construct a fifth/sixth-century prelude to his story of the English Church. Bede took Gildas to imply a dating of 'the coming of the Saxons' to *c.*450; but Bede had no other or more reliable source against which to check this. The *Anglo-Saxon Chronicle* used to be considered an independent witness: no longer. It is a ninth-century concoction, and will be dealt with later. Its account of the Saxons' 'arrival' pads out Bede with the mythical character of Port, eponymously derived from Portsmouth. Nothing inspires faith in alleged 'traditions' and lost sources there.

Roman Britain ended, militarily and politically, early in the fifth century, when Continental writers confirm Gildas's impression of a withdrawal of Roman armies. Where did Gildas's wicked kings continue their Roman-style rule over territory? The memorial stone of one 'proud tyrant' still stands in Dyfed, South Wales. These kingdoms seem already located far to the west. An ending of the infrastructure of Romanity further east and south might be inferred from Gildas's 'cities and fields destroyed'. Archaeologists offer evidence of change in everyday life. No more coins were minted in fifth-century Britain; no more wheel-thrown pottery was manufactured; no more Latin inscriptions were put up except, it seems, in South Wales, nor stone or brick buildings erected. Anglo-Saxons would eventually call the chunks of Roman masonry littering the landscape *enta weorc*, 'the work of giants'. Even before *c.*450, and increasingly in the second half of the fifth century, cemetery evidence shows that many residents of Kent, the Thames valley, and Hampshire were dressing in the same style as 'barbarians' on the Continent, and practised similarly un-Roman burial customs. Archaeology, to that extent, bears out Gildas on Saxon immigrants; but no reading of Gildas would have led archaeologists to predict such heavy immigration in the Thames valley or Hampshire.

Archaeologists' evidence comes in the form of slices of time. Archaeologists disagree quite as much as historians do about assembling the slices into a story. The migration is a case in point. Bede wrote, and he did not take this from Gildas, that the immigrants were 'Angles, Saxons and Jutes' from north Germany. The archaeology of sites in north Germany does not conflict with this; but there is plenty of 'Jutish' material in northern Gaul as well. What route(s) the migrants followed; whether they moved in stages, via Frisia and Gaul; how many came *after* the apocryphal three shiploads; what the tempo of movement was and over how long a period: all these questions continue to be debated. A change in sea-level, flooding coastal land in Frisia, may have been what drove the migrants westwards. Was Bede right in surmising that they were drawn, positively, by 'the fertility of the island [of Britain]'? Burials of swords in graves indicate that the immigrants were warriors. Warlords and retinues needed the yields of a fertile land. Who worked it? Recent calculations based on the size of excavated boats indicate that several hundred thousand people could have crossed to England between the mid-fifth and the mid-sixth

centuries. Were they *all* warriors? Place-names like Hastings or Roding are thought to derive from personal names (Heasta, Roda) and their *-ingas*, their people. It is often assumed that the core-groups were kin. That might say nothing about ethnicity, however. Physical anthropological investigation of bones in a Hampshire cemetery dating to the fifth century (similar findings have yet to emerge elsewhere) has indicated two distinct populations: relatively tall men and smaller women. Intermarriage between British women and Anglo-Saxon men is a tempting inference. It seems the likeliest explanation for the bearing of the Celtic name 'Ceawlin' by a sixth-century West Saxon king, the second on Bede's list of 'rulers with *imperium* (commanding power)'. Intermarriage is frequently documented on the Continent between 'barbarians', and between 'barbarians' and Romans, at ruler-level. The hypothesis of extensive Anglo-Saxon intermarriage with Celtic women is another matter; but it would help answer the question of what happened to the Celts, without excluding the possibility of widespread Celtic enslavement. The Anglo-Saxon word for 'slave' is *weal*—'Briton'. Given current estimates of the population *c*.400 at 4–5 million, it seems highly unlikely that Celts could have been erased from the landscape by genocide or wholescale expulsion. Why would relatively small numbers of fifth-century incomers have created a blank slate when they could have maintained a substantial workforce on the land? Anglo-Saxon social dominance could have imposed linguistic change in the long run, leaving Old English, with virtually no Celtic loanwords, the universal language except in Wales and the south-west by the ninth century.

Archaeologists have also argued over settlement sites. It used to be thought that both rural villa sites and towns were abruptly abandoned early in the fifth century if not earlier. A more nuanced picture is now suggested. Many villas remained occupied well into the fifth century, with signs of violent destruction thereafter quite rare. Continuities of estate organization are compatible with relocation of the central residence. The tempo of such relocation would have been faster in Kent, with immigrants travelling rapidly inland along Roman roads in the fifth century, and slower in the west midlands, where the migrant flow was lighter and later. As for urban sites, the dark earth layer which excavators so often encounter overlying Roman occupation levels, for instance at London and Southwark, and previously interpreted as indicating site-abandonment and reversion to soil cover, is now being *re*-interpreted as the product of settlement, but with houses of wattle or timber rather than brick or stone. Recent work at Lincoln has raised the possibility that the Roman city and its Christian cult sites persisted in some form through the fifth and sixth centuries, and one hypothesis is that immigrant warlords established themselves in the old fortified centre to dominate the surrounding area.

Kentish cemeteries of the sixth century, excavated for instance at Sarre in the late 1970s and at Dover in 1994, contained some women's graves exceptionally richly furnished, their occupants buried with evidence of distinctive jewellery and clothing

aged Æthelbert to flatter by imitation. Frankish kings, if anyone, ruled with *imperium* in the sixth-century West.

Recent accounts of Anglo-Saxon political change in the fifth and sixth centuries have postulated very small territorial lordships, for instance, the Rodings area in western Essex which covers *c*.50 sq km, competing for land and manpower, with the less successful gradually being incorporated in larger, more stable, and more internally differentiated blocs. This model of state-formation is plausible. A document known as the Tribal Hidage, possibly of seventh-century origin but more likely eighth-century in its present form, seems to preserve the names of formerly independent, quite small population groups, such as 'the Hitchin-people', or 'the Chiltern-people', who had become tribute-payers within larger kingdoms. The subject-peoples would have acknowledged an overlord's 'power of command' (whatever they called it) that was based on his commanding, literally, a large number of warriors, but also commanding personnel (the same warriors?) to take tax. Modern historians can start to talk about 'administration'. Seventh-century royal laws mention 'ealdormen', in Latin *duces*, 'commanders' or 'regional magnates', whom kings purport to use as their agents in maintaining local order. Archaeology strengthens confidence in this reconstruction. There is increasing differentiation between richer 'princely' graves and less rich ones. Weapon-deposits become hallmarks of the few: an élite. Other grave-goods show dominant styles that could, as in the case of the Kentish women, reflect overlordship.

The best evidence comes from the ship-burial of Sutton Hoo, near Woodbridge (Suffolk), first excavated in 1939, and re-excavated in the late 1980s. The assemblage of grave-goods in Mound 1 is of exceptional splendour and indicates an extraordinary range of Continental contacts: with Scandinavia (where ship-burials are well attested), with the Mediterranean world, but above all with the Franks. The thirty-nine coins found in the dead man's purse are all Frankish, each from a different mint. They date the burial to *c*.630; and this quite un-random collection could represent a diplomatic gift, maybe a symbol of Frankish overlordship, for Bede supplies evidence for lively contacts between East Anglian and Frankish royalty at this period. Sutton Hoo Mound 1 surely is a king's grave, perhaps that of Raedwald king of East Anglia, Bede's fourth ruler with *imperium*. The 'whetstone' with the carved human heads top and bottom, and surmounted by a stag, looks like a piece of regalia. A near parallel is 'the sceptre (*baculus*) with the likeness of a man carved at its head' handed over in 787 by the Bavarian ruler when he acknowledged conquest of his *patria* by the Franks. Other contents of the Sutton Hoo grave suggest a warrior, appropriately, since effective kingship necessarily included war-leadership in early Anglo-Saxon England: the finely wrought and fearsome helmet and the large ornamented shield; the huge buckle once attached to a mighty sword-belt. And there are the tokens of great wealth, some of it old: the silver-gilt dish made in Byzantium in the early sixth century; the silver spoons inscribed 'Paul' and 'Saul', formerly inter-

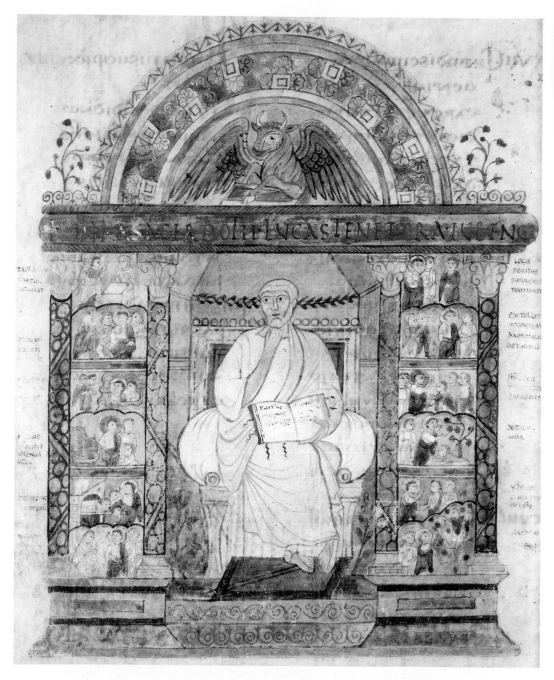

LUKE EVANGELIST PAGE, St Augustine Gospels. This sixth-century Italian gospel book was almost certainly brought by St Augustine to Canterbury, where it remained for nearly a thousand years. The portrait of Luke, legs elegantly crossed, surmounted by his bull-symbol and flanked by scenes from Christ's life, is typical of late Antique models that powerfully influenced later Anglo-Saxon manuscript illumination.

preted by archaeologists as a baptismal gift, but more likely East Anglian royal heir-looms once looted from a fourth-century Roman silver-hoard. The recent re-excavation revealed not just one mound, but several, all constructed in the seventh century, including at least one woman's grave, and, at the eastern periphery of the site, other burials of persons in bizarre postures, apparently executed, perhaps even sacrificed. The great ship-burial, then, looks like a pagan burial, perhaps defiantly so at a time when other Anglo-Saxon kings had opted for Christianity. If Mound 1's occupant *was* pagan, this had not prevented him becoming powerful and rich, nor having close contacts with the Christian Continent. But it may be that we should retain Bede's memorable image of the eclectic Raedwald with his sanctuary of pagan and Christian altars: perhaps those who organized Raedwald's burial wished to convey a more uncompromising message—but if so, it had no future.

Christianization

Of course it is impossible to ignore (or escape) Bede's perspective. For Bede, the arrival of missionaries sent by Pope Gregory, and led by the Italian monk Augus-tine, was a sign of unequivocal progress: God's grace bestowed on the Anglo-Saxons. The Gospels that Augustine brought with him survive: they embody not only Christ's power, not only the power of the book, but the authority of the culture of the ancient Mediterranean. Later Anglo-Saxon missionaries imagined illiterate warriors quailing before the written Word that came to them from Rome. It was Augustine and his colleagues, certainly, who enabled Æthelbert to 'establish for his people, after the example of the Romans, judicial decrees which written in the Eng-lish language are preserved to this day', in other words, put spoken Old English into written form for the first time. Unsurprisingly, the first clause of Æthelbert's Code set down compensations for damage to the property of God and the Church. Nor was Bede wholly misleading: Christianity made a huge difference. But it did so slowly, disjointedly, and in ways that the *Ecclesiastical History* does not always lead us to expect. Augustine's locating of his see at Canterbury was not what Gregory had planned when he looked in the old records at Rome and found London listed as the capital of *Britannia*. Whatever Augustine encountered at London, it was not the secure base he needed: he found that at 'the king's city' in Æthelbert's Kentish king-dom. In its very origin, the Church of the English compromised—necessarily—with the secular power that was. Bede does not quite admit this.

Bede's achievement is staggering: he wrote history that we can recognize, a story with a theme, a coherent sequence of events, and with AD dates! And he did this in his monastery at Monkwearmouth/Jarrow, assembling his source-material from helpful correspondents, notably in Canterbury (hence his full information on Kent). For Bede, the conversion, one by one, and after some backsliding, of all the various kings and their peoples by the later seventh century, and the creation of a Church

through the preaching of wonder-working saint-bishops, the prayers of devout monks, and the service of zealous priests, were manifestations of God's power. To witness such a manifestation, we should look at another burial: that of Cuthbert, one of Bede's best-loved saints and a fellow Northumbrian. Cuthbert had made his name as a monk-priest, a preacher: his monastery, or 'minster', of Melrose (now, but not then, located near a political border) took responsibility for pastoral care in that part of Northumbria. Bede says that he would spend up to a month away on preaching-tours among local farming people, pitting his Christian power against their amulets. Later Cuthbert moved to Lindisfarne. What now seems a remote spot was then politically important, a bishopric as well as a minster located near the royal fortress of Bamburgh and much visited by Northumbrian kings. Cuthbert was 'elected' bishop in the king's presence. Though he spent most of his time as a hermit on the island of Farne, Cuthbert was buried in the church of Lindisfarne in 687. There were several subsequent moves, finally to Durham. Yet, amazingly, Cuthbert's oak coffin and some of its original contents survive. Cuthbert's body was wrapped in Byzantine silk, as befitted a great man in this period. Round his neck, he wore a magnificent pectoral cross of cloisonné work (reminiscent of the Kentish woman's brooch, and the Sutton Hoo king's buckle). Cuthbert's professional tools were buried with him: a portable altar, an ivory liturgical comb (used in ordinations), and a Gospel-book small enough for a pocket, bound in leather in a style derived from the Mediterranean. All this helps us to understand why the Northumbrian Church triumphed as the Kentish one did, by attaching itself to points of power, locally and far afield. It was an integral part of Latin Christendom, in constant contact with the papacy and with Frankish churchmen, but also with Ireland and Iona, another numinous isle. Bede, however focused his vision, was not insular. He wanted to provide an antidote to political divisions between Anglo-Saxon kingdoms and an affirmation of the identity of the *Angli* as Gregory's, and God's, new chosen people. Bede's vision was of one English Church.

The Church in the World

It is just after his account of Cuthbert's wonderful life that Bede's story falters: for in his own lifetime Bede saw (as Gildas saw in his) ecclesiastical corruption. That diagnosis, of the Church perverted by the forces of the world, split into innumerable local churches, incapable of fulfilling its mission, Bede offered not in the *Ecclesiastical History* but in a letter to Archbishop Egbert of York. Behind the archbishop's pastoral problems, dioceses too large to cope with and an insufficiency of priests, lay shortage of the fundamental resource, landed estates. For Bede, there were only two worthwhile functions for such estates: they could endow the diocesan church, or the king could use them to reward fighting-men who defended the *patria*. What Bede saw, or imagined, beyond the walls of Jarrow, were 'monasteries in name only', com-

munities of married clergy in the residences of aristocrats who had 'usurped' estates under false pretences 'to gratify their own desires'. They had done this by getting royal charters entitling them to pass on these establishments to their own heirs. Bede's complaint hits the nub of Christianization: charters had been introduced into Anglo-Saxon England to enable kings and aristocrats to endow churches 'forever' by denying the residual claims of kin; but now in the eighth century, the charter itself had become the means whereby aristocrats appropriated what by rights should have gone to the Church.

Perhaps it is curious that Bede, born almost certainly of aristocratic parents and offered for their souls' sake as a child to the Church, should see things in this way. Other contemporaries clearly did not share his view. Cuthbert's community kept a Book—they called it 'The Book of Life'—in which were the names of all the benefactors for whom they prayed. Such liturgical commemoration, under Cuthbert's potent patronage, was believed to ease the difficult passage of the soul to heaven. On Durham's lengthy list were not only monks and clergy but many secular potentates, aristocrats, *duces*, as well as kings. Royal and aristocratic women too were commemorated; and they also played a major part, as abbesses and nuns, in such commemoration. Excavations in the 1980s on the site of the convent of Barking in Essex revealed two characteristic types of object: first, fragments of gold thread, for the inmates were clearly women of rank who continued to display their status in fine

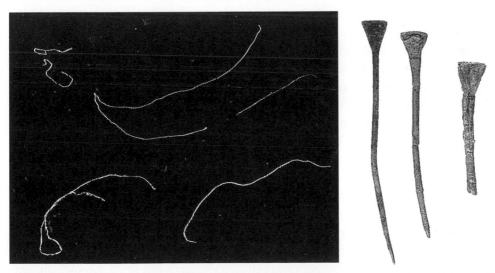

BEDE describes the foundation of the convent of Barking by an aristocratic bishop of London *c*.675. The bishop's sister became abbess. A treatise on virginity written for the community specifically warned against 'costly headbands'. These recent finds by archaeologists evokes the nuns' noble lifestyle: were their veils held by headbands of gold thread? The iron styli, used to inscribe drafts on wax tablets, evoke nuns' characteristic contribution to eighth-century Christian culture, the copying of manuscripts.

clothes and adornment; and second, styli, writing instruments, for Barking's founders and patrons wanted commemoration and that meant the keeping of name-lists and the recording of prayers. Where Bede, and to some extent his hero Cuthbert too, kept a clear distance between consecrated and profane things, contemporaries were busy bonding them. The medium was gift-exchange, land in return for commemoration, or, more precisely, what a French historian recently called 'a pious gastric alchemy' that transmuted monastic feasting into prayer. Through royal and aristocratic patronage, churches became very rich, none more so than Canterbury. Studies working back from Domesday Book have shown that the lion's share of the cathedral church's 1066 endowment was already held by it in 800. The first two Christian centuries, by and large, were thus crucial in creating a distribution of resources that persisted in some respects until the Reformation. The distribution was a three-way one. Perhaps the greatest of Bede's misleading impressions in the *Ecclesiastical History* is virtually to ignore the aristocracy, as if bishops and kings could somehow operate elsewhere than in an aristocratic world. Thanks to Bede's *Ecclesiastical History*, we know the names of many seventh- and early eighth-century kings; thanks to Bede's *Letter to Egbert*, we understand one form of aristocratic church patronage. Yet we learn little from the *Ecclesiastical History* of the aristocrats of this period unless they became bishops or saints; and from the *Letter to Egbert*, we gain an impression of an aristocracy undermining the Church instead of, as they did, sustaining and moulding it. To understand 'the age of Bede' we have at some point to set Bede aside.

Once we straddle the oral and the written, and embrace the visual too, we realize that the ecclesiastical and the secular were not two separate cultures in the seventh and eighth centuries but a single one. The Ruthwell Cross stands in another part of what was once Northumbria (now south-west Scotland). It too tells a story: the story of Christ's life and death. The iconography (especially the depiction of Mary Magdalene), and the vine-scroll ornament, show the influence of models in the Mediterranean world. The monument, though now damaged, was made in the form of a cross. It literally stands as a whole for the Cross of the crucifixion. The lines inscribed in runes (a form of early northern European alphabetic script) around its sides come from a poem called *The Dream of the Rood* (i.e. Cross) which survives otherwise, and complete, only in a tenth-century manuscript from southern England. In the poem, the Cross speaks to Christ, recalling its moment of supreme suffering and glory 'when I bore You'. To grasp the function of the Ruthwell Cross, it needs to be imagined no longer inside the little church but in its original site outdoors. And consider this passage from the story (written by the nun Hygeburc) of the early eighth-century Anglo-Saxon missionary St Willibald:

At the age of three, [Willibald] was suddenly attacked by a severe illness ... when his parents, in great anxiety of mind, were still uncertain about the fate of their son, they took him and

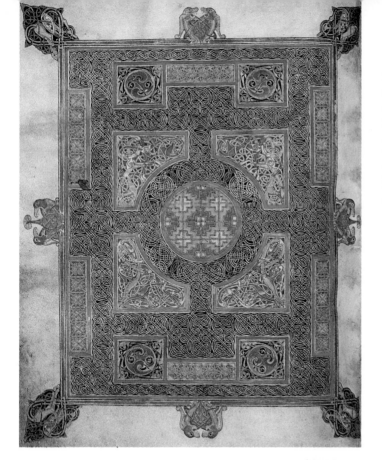

INTERLACE DECORATION is shown here at its most elaborate on a 'carpet' page from the Lindisfarne Gospels, *c*.700. Resemblances between the decoration and contemporary metalwork point to metalwork as a possible source of the artists' inspiration.

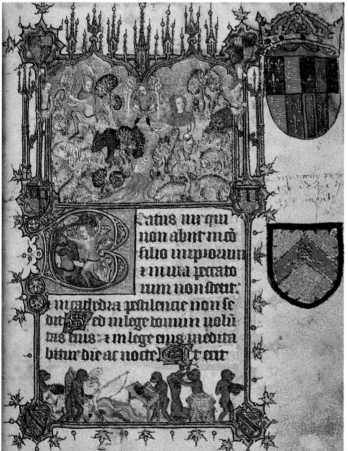

THE BOHUN PSALTER is a fine example of English illumination *c*.1370–90. Italian influence is evident in the texturing, but the traditional English taste for drolleries is found in the border decoration.

offered him up before the Holy Cross of our Lord and Saviour. And this they did, not in the church but at the foot of the Cross, for on the estates of the nobles and good men of the Saxon race it is a custom to have a cross, which is dedicated to our Lord and held in great reverence, erected on some prominent spot for the convenience of those who wish to pray daily before it. There before the cross they laid [the child]. And in their prayers they made a solemn promise that in return for the health of their child they would at once have him tonsured … and would dedicate him to the service of Christ … Their favour was granted by the Lord, and the former health of the child was restored.

The Ruthwell Cross stands as a memorial not only to a type of aristocratic piety but also to a type of pastoral care; its imagery locates it firmly within the 'official' style and theology of Christendom; the poetic fragment evokes a distinctively northern European religious theme of the Cross as Tree, the pre-Christian image here completely embraced by the Christian one, while the poem's later survival hundreds of miles further south suggests both a unity and a continuity in the religious traditions of Anglo-Saxon England. Could the original patrons of the Cross have read its runes? If those lines had been read out to them, could they have 'finished' the poem themselves by heart? As usual, we have more questions than answers—but sufficient of both to suggest otherwise unsuspected dimensions in early Anglo-Saxon Christianity.

THE RUTHWELL CROSS, Dumfriesshire, Scotland (*right*). Originally 17 feet high, and standing outdoors near a church built for Northumbrian aristocratic patrons, this eighth-century sculptured cross shows techniques and vinescroll ornament imported from the Mediterranean world, with Christian themes, notably Mary Magdalene's washing of Christ's feet in the central facing panel, treated in distinctively Anglo-Saxon style. Lines from the Old English poem *The Dream of the Rood*, inscribed in runes, image Christ's Crucifixion as his 'raising on high'.

WHETSTONE AND STAG from Sutton Hoo (*facing, below left*). The 'whetstone' resembles in general size and shape the staff of office borne by Roman consuls and depicted on consular portraits. There is nothing Roman, however, about the carved heads, which seem to evoke the ancestral roots of the bearer's authority, nor about the stag, symbol of power in the northern world. This object shows no signs of ever having been used as a whetstone. Was it a badge of office, or the dead man's personal emblem?

OBJECTS FOUND in the tomb of St Cuthbert (*facing*). Cuthbert (d. 687) was buried at Lindisfarne, but in 875 his coffin was exhumed and carried away by the monks to escape Viking raiders. Eventually it was reinterred at Durham in 995. The grave was opened in 1827. The oak lid of the innermost of three coffins was inscribed with an image of Christ surrounded by the Evangelist symbols. Inside were Cuthbert's remains, wrapped in Byzantine silk. On his chest was a jewelled cross, 6 cm across, beside him a rectangular travelling-altar of oak, inscribed 'in honour of St Peter', and encased in silver sheet.

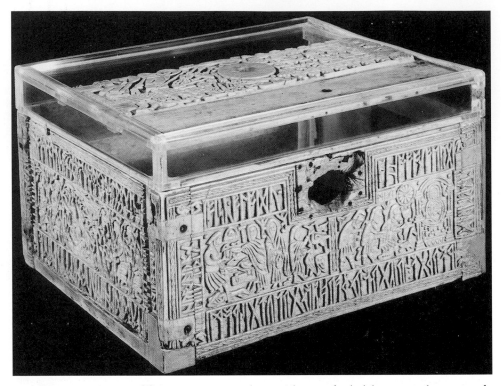

THE FRANKS CASKET. This 23 × 13 × 19 cm box, with carved whalebone panels, was made in Northumbria in the first half of the eighth century. The depiction on the back, of the destruction of Jerusalem by Titus, is 'answered' on one side by the image of Romulus and Remus, founders of Rome. The front, pictured here, shows on the viewer's left the Anglo-Saxon legend of Weland the Smith, complete with anvil, and on the right the Adoration of the Magi. The main runic inscription is a riddle, with the answer: 'whale's bone'.

The Franks Casket now in the British Museum, whose modern name recalls a nineteenth-century collector Sir Augustus Franks, coincidentally has a Frankish provenance: that is, it was apparently preserved from medieval times at Brioude in the southern part of the Frankish kingdom. It got there (according to a recent plausible suggestion) by the gift of an Anglo-Saxon scholar to the shrine of St Julien at Brioude. This object is certainly a piece of Anglo-Saxon workmanship dating from the early eighth century. Its whalebone plaques must have been originally fixed on to wood. Relics may have been put in it. Runic inscriptions caption the images. The iconography again shows plenty of Mediterranean influence: there are Romulus and Remus suckled by the she-wolf, for instance. There is the archetypically Christian scene of the Coming of the Magi. But there are also distinctively northern European themes, such as the legendary figure of Weland the Smith referred to in an Old English literary work of the ninth century. This object embodies a mixture of

influences: a successful blend of pre-Christian and Christian imagery. It is distinctively Anglo-Saxon.

New Claims and New Connections

With the eighth century we move into a period when written documentation becomes very much more plentiful, and must now be incorporated in our visualization of Anglo-Saxon culture. Royal government and specifically Mercian government looms larger. This may well be the period to which the Tribal Hidage belongs. A strikingly large number of the surviving royal charters of the 730s through to the 860s are from Mercia. This is partly through accident: the church of Worcester was a major beneficiary of royal generosity and its archive has survived. But there was a substantial shift of power in Mercia's favour. Two exceptionally long reigns, of Aethelbald (716–55), then Offa (756–96), gave Mercia stability. The kingdom of Northumbria, by contrast, suffered an exceptional number of succession disputes, and could no longer compete south of the Humber as it had done in the seventh century. The church of York, perhaps because of the economic weaknesses diagnosed by Bede, failed to act as a consolidating force. Elsewhere, smaller and weaker kingdoms fell under the overlordship of Mercia, a kingdom relatively large and situated in the richest agricultural zone of lowland England. But the wealth of Anglo-Saxon kingdoms in the eighth century did not only come from the land. This was the age of emporia, ports of seasonal international trade, open sites located on coasts and estuaries, fuelled by the demands of royal courts and élites for prestigious goods that were the stuff of gift-giving: high-grade pottery, amber, walrus-ivory, quern-stones, wine, jewellery, quality textiles. Commerce was symptomatic too of increasing contacts within the Latin West and beyond it. Anglo-Saxon pilgrims, women as well as men, thronged the roads to Rome. (Every Italian town had its Anglo-Saxon whore in consequence, it was unkindly alleged.) Willibald travelled as far as Jerusalem. Anglo-Saxon missionaries, most famously St Boniface (d. 754) revered still nowadays as the 'apostle of Germany', were drawn to the courts of the new powers on the Continent: the leading men of the Franks, Alamans, and Bavarians saw political as well as religious advantages in welcoming them. These Anglo-Saxon voluntary exiles crossed the sea to convert the Frisians, the Thuringians, the Saxons: 'even they say "we are of one blood and bone"', Boniface reported, implying some social memory of shared origin, encouraged no doubt by linguistic similarity. These multiple contacts, religious and cultural as well as economic, were part and parcel of the same opening-out of Anglo-Saxon England towards the Continent.

Land-locked Mercia became directly involved in these transactions through expansion south-eastwards to take over the once-East Saxon *metropolis* (so Bede had called it) of London. Archaeologists are now confident that they have located 'Lundenwic', the eighth-century emporium, around the modern Aldwych (the 'old

wic', or port). The charter of King Æthelbald for the bishop of Rochester remits tolls on one ship, 'whether one of his own or of any other man, tolls hitherto belonging to me by royal right in the port of London'. The charter is one of a group, and it carries a ninth-century king's confirmation. If it looks like a workaday document, that is precisely its significance. Tolls on trade were becoming a significant part of royal revenue, hence their remission for this favoured magnate was a valuable concession. Toll-collecting of course presupposes royal agents (probably now men with some expertise, and wearing other hats than helmets) at trading-places, and a protective capacity to make tolls worth paying. There are interesting implications from the Rochester side too: the bishop had his own ships trading into London, but used other merchantmen as well. We can imagine that the bishop and his household ate off Frankish pottery, his church was adorned with Continental plate, and the mills on his estates used Rhineland quern-stones.

King Offa's imported quern-stones do not have to be imagined: archaeologists have found them on the site of a royal watermill at Tamworth, Staffs. Offa too was interested in London: he minted coins there and controlled the coinage strictly. Each coin was a little advertisement for royal authority; and all excavated coins in Mercia datable to Offa's reign are *his* coins, because it seems that foreign merchants, on entry, had to convert what money they brought with them into Mercian coin (this is certainly how the system worked in the tenth century). Excavated coins of Offa's period found at the emporium of Hamwih (Saxon Southampton) are Mercian too, confirming what documentary evidence shows, that Wessex was under Offa's overlordship. Coinage was important to Offa: the medium of commercial contacts—cloaks were exported from England to the Carolingian court—and of his largesse to Rome.

COINS were potent symbolic as well as economic objects. From the eighth century onwards, Anglo-Saxon kings publicized their regimes in coin-imagery derived from Roman models. *Offa Rex* (i) is depicted in imperial guise. His silver pennies matched in weight and fineness those of contemporary Frankish rulers. Offa's wife Cynethryth is the only Anglo-Saxon queen to have coins issued in her name. The obverse (ii) names her: the reverse, shown here, has her stylized queenly image, with the name of the moneyer Æoba.

THIS PENNY of King Æthelbert of East Anglia (iv), beheaded on Offa's orders in 794, depicts the she-wolf suckling Romulus and Remus (iii). A contemporary East Anglian genealogy included Caesar among Æthelbert's ancestors. The penny was found near Rome, perhaps part of a 'tribute' sent to the pope.

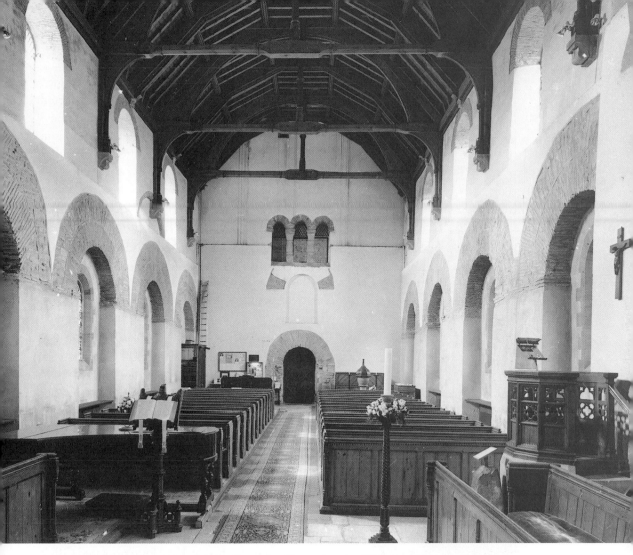

THE EARLIEST SURVIVING Anglo-Saxon basilican church, All Saints' Brixworth (North-amptonshire), belongs to the period of Offa. A series of side-chambers or chapels, accessible through wide arches, originally flanked the 40-metre-long nave. The apse was surrounded by a ring-like crypt. This imposing building seems influenced by Carolingian models.

When Charlemagne increased the weight of the Frankish penny, Offa followed suit. Offa even had the audacity to propose a marriage between his son and Charlemagne's daughter; that was going too far and Charlemagne declared an embargo on cross-Channel trade: itself an indication of that trade's value. Offa used *his* daughters in the traditional way: their marriages to the kings of East Anglia, Wessex, and Northumbria signalled not only alliance but something like overlordship, since certainly two and perhaps all three bridegrooms needed Mercian support against rivals in their own kingdoms. Kent was ruled at this time by several kings at once. Offa took the offensive, defeated resistance, and annexed it. He also wanted control of

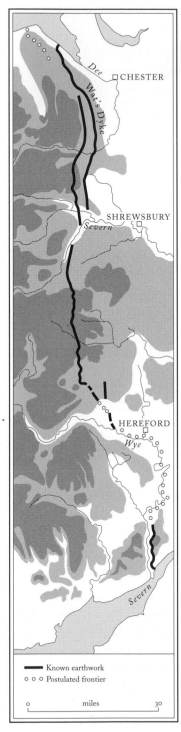

Known earthwork
○ ○ ○ Postulated frontier

0 miles 30

OFFA'S DYKE

Canterbury, the most important site in the Anglo-Saxon Church. When the archbishop, supported by the Kentishmen, was uncooperative, Offa persuaded the pope to authorize a new metropolitan see in the heart of Mercia at Lichfield. This affair coincided with the anticipatory succession of Offa's son Ecgfrith, consecrated (this is the first mention of an Anglo-Saxon royal consecration) as co-ruler and heir in 787. The minting of coins at Canterbury in the name of Offa's wife Cynethryth, a queenly issue unique for the Anglo-Saxon period, may have been linked with Ecgfrith's consecration. Both the fact that Offa shed 'much blood' to secure his son's succession, and the way in which he staged it, are characteristic. Offa saw the link between smooth succession arrangements that avoided division, and political stability. He had also learned from Charlemagne the importance of mobilizing the Church in royal ritual and display. The church at Brixworth, Northants, reminiscent of contemporary Carolingian buildings, could well have been a theatre for the presentation of Mercian kingship to the kingdom's élite.

The great earthwork known as Offa's Dyke runs virtually along the whole Mercian–Welsh border. Much excavation has not succeeded in dating any part of it; some parts may have long predated Offa's reign. Nevertheless, three generations or so after his death, a Welshman associated it with 'the tyrannous Offa'. Social memory may have been right. Perhaps the Dyke was built with Welsh slave-labour. Certainly Offa repeatedly attacked the Welsh, and the Dyke could have been used offensively as well as defensively, according to need. Its monumental scale seems appropriate for this most ambitious of early Anglo-Saxon kings. It too was a piece of royal display. Nevertheless only a rather literal, and wishful, reading of Frankish diplomatic language has allowed modern English historians to claim that Offa was Charlemagne's equal. Although destabilizing potential client-

regimes and exiling opponents were Offa's stock-in-trade, he could not compete in Charlemagne's league. Charlemagne harboured the exiles, and bided his time. In Wessex and in Northumbria (though not in Kent), the exiles returned to rule with Frankish help. At the Frankish court in the early ninth century, both those kingdoms, and probably Mercia too, were seen as client-states of a restored Christian-Roman empire that stretched from Benevento to the Baltic. It was not Offa's fault that his son outlived him by just twenty weeks. But it was of the nature of the early Anglo-Saxon situation that no one kingdom was likely to retain hegemony for long. As Bede noted, young aristocrats would abandon their *patria* and seek service with another lord provided the rewards were great enough.

The Age of the Vikings

After Offa's death, the high-point of Mercian power seems to have passed. Yet the speed and extent of Mercia's decline before the 860s have often been exaggerated. Wessex hogs the limelight in the *Anglo-Saxon Chronicle*. The earliest manuscript, very probably written at Winchester in the 890s, is suggestive of the work's origins. The annals are written in Old English. They are prefaced by a regnal list naming all the West Saxon kings from Cerdic, 'who landed at Cerdicshore in 494 with five ships', down to Alfred, and a two-part genealogy, tracing Cerdic back to Woden, and Alfred back to Cerdic. At the entry for 855 there is another genealogy, from Æthelwulf, Alfred's father, back to Adam. The entry for 829 declares that 'Egbert [of Wessex, Alfred's grandfather] conquered the kingdom of the Mercians and everything south of the Humber; and he was the eighth king who was called "Bretwalda"'—meaning 'Britain-ruler'. The annal goes on to reproduce, in OE translation, Bede's list of 'rulers with *imperium*'. There is a strong case for seeing the *Anglo-Saxon Chronicle* as dynastic history and linking its production with the court of Alfred. What arguably clinches the case is the entry for 853, marked in this manuscript with two large marginal crosses added in the tenth century: 'King Æthelwulf sent his son Alfred to Rome. The lord Leo was then pope in Rome, and he consecrated him king.' Since Alfred was aged 4 at the time, and had three elder brothers living, and since other evidence shows that Æthelwulf planned to, and did, divide his realm between his two elder sons, this entry cannot mean that Alfred was consecrated as Æthelwulf's successor—which is what the reader is led to infer. The obvious explanation is that this statement was inserted at Alfred's instigation, or connivance, to enhance his prestige.

Egbert and his son extended the West Saxon kingdom considerably. Originally it consisted of four shires: Wiltshire, Hampshire, Somerset, and Dorset. Sussex, Surrey, and Kent, which had been Mercian satellites in the eighth century, were brought within the West Saxon orbit by Egbert though they retained distinct identities. Essex too was under Egbert's rule. There was campaigning in the south-west

against the old Celtic kingdom of Dumnonia, with West Saxon settlement in Devon. The Cornishmen, according to the *Anglo-Saxon Chronicle*, allied with 'Danes' in 838 to fight against the West Saxons, but 'Egbert put them to flight'. In the 840s, Berkshire was under West Saxon, no longer Mercian, rule. Wessex had become what is sometimes called 'Greater Wessex', in part at Mercia's expense. Mercia remained, though, a large and wealthy midland kingdom, still in control of the Thames valley and London; and from the early 850s it was Wessex's ally: the 853 *Chronicle* entry also records the marriage of Æthelwulf's daughter to the Mercian king.

What caused Mercia's abrupt eclipse, and the eclipse of every other Anglo-Saxon kingdom, save Wessex, was an external factor that few apparently foresaw (despite some sporadic earlier raids): the Vikings. Though originally from Scandinavia, and sometimes labelled 'Danes' by the *Chronicle* author(s), many if not most of these attackers came immediately from the Carolingian Empire, where a number of distinct fleets, each with its own chief, had been operating since the 840s. Civil war among the Franks had lured ambitious warlords from Denmark to seek easy money. It took the Franks some twenty years to organize effective resistance; and meanwhile there were several raids on the coasts of Kent and Wessex by Danes crossing from Francia. In autumn 865, as the Franks were getting their defences in place (though the *Chronicle* is silent on that), 'a great heathen *here* (army)' came into England (says the *Chronicle*), 'and took up winter quarters in East Anglia; and there they were supplied with horses, and the East Angles made peace with them'. This *here* went to Northumbria in 866, defeated the Northumbrians, and took York. In 867 they moved south into Mercia and the Mercians 'made peace' without a battle. In 869 they went into East Anglia, killed King Edmund in battle, and 'conquered all the land'. In 871 they began raiding in Wessex. This was the year of Alfred's accession.

How did the Vikings achieve such rapid success? In 865, a 'civil war' impeded Northumbrian resistance (the *here* killed both contestants). Elsewhere kings' first idea was 'to make peace', that is, pay the attackers off, a well-tried Carolingian tactic that had often worked well with relatively small Viking groups. But *micel here*, 'the great army', incorporating many such groups to make a co-ordinated force, was something else. These were enemies numbering thousands rather than hundreds. Their years in the Carolingian empire had given them immense experience in warfare on land and on water. They were adroit at finding, and building, fortifications; in defending them; and then raiding the countryside from them. They were adept negotiators for 'peace'. They found some aristocrats, and potential 'kings', willing to collaborate with them. Some of the 'army' leaders, at least, hit on the idea of settlement; and the density of Scandinavian place-names in eastern and northern English shows immigrant lords in control of extensive territories and, less certainly, immigrant cultivators on the land. This was, again, a different story from that of Scandinavians in ninth-century Francia.

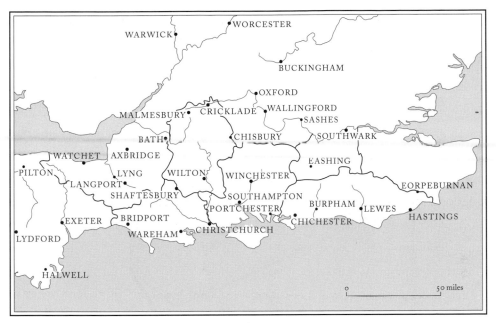

ALFRED'S *BURHS*

In military terms Alfred had one advantage in 871: the Vikings had conquered so much so rapidly that they needed time to consolidate. Wessex faced small groups rather than the *here* as a whole. Still, Alfred could win battles when necessary; and his victory at Edington, Wiltshire, in 878 was necessary. Ealdorman Wulfhere of Wiltshire had thrown in his lot with the Vikings. Had Alfred failed to defend that shire, further defections would surely have followed. As it was, he dismissed the ealdorman who had 'betrayed him and his *patria*', and deprived him of his lands. Then Alfred had some luck: Carolingian dynastic problems (short reigns and minorities) and civil wars drew 'the great army' (Frankish writers used the same term, but in Latin) across the Channel. In the 880s, Alfred had a breathing-space.

Alfred used this breathing-space in two important and related ways. First, he organized a network of fortifications, called *burhs* in OE, right across Wessex, sometimes reusing old ones, as at Winchester, Hampshire, where old Roman walls were still partly standing, sometimes constructing from scratch, as at Wallingford, Berkshire, where ramparts were raised on ploughed soil. Those two were the largest of the *burhs*, each with ramparts 3,300 yards in length. Others were a lot smaller. But there is evidence of building to a common internal plan, with a cross-shape of streets meeting in a central space. Later many *burhs* became markets, and mints were located in them. It is tempting to suppose that Alfred planned them that way. His own view was that 'wealth and wisdom' went together. Defensively, the West Saxon *burhs* were never put to the test, not even when Viking forces returned to England after defeat in Francia, in 891. But *burhs* garrisoned with thegns, fighting-men,

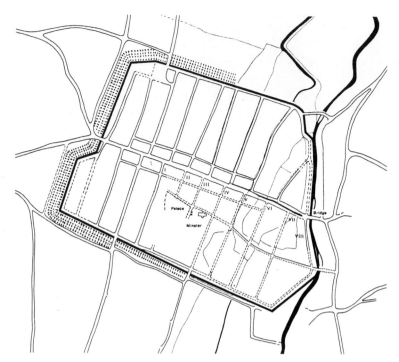

AN OLD ROMAN CITY, Winchester was re-used by Alfred as a *burh*. Excavations have confirmed the wall-length of 3,300 yards indicated in an Alfredian document, the Burghal Hidage. The Roman street-pattern, skewed by the large royal south-east quarter with minster and palace, was further changed by the addition of intra-mural streets for defensive purposes, and, parallel to the main east-west artery, of back-streets for which a commercial function has been suggested.

could become spearheads of counter-offensives. The *Chronicle* describes one such campaign in 893, when 'the thegns in the fortifications' co-operated with ealdormen to pursue and defeat the Vikings at Buttington on the river Severn.

Secondly, and even more extraordinary, Alfred mounted an ideological counter-attack. This has left several visible memorials. One is the sword dating from this period excavated at Abingdon, with an ornamented hilt apparently showing tiny Evangelist symbols. The sword itself might then be seen as a symbol of a new kind of Christian warfare, waged against pagans. Another object more certainly connected with Alfred is the Jewel found at his stronghold of Athelney in Somerset, and inscribed 'Alfred had me made'. Two other smaller but structurally similar objects, one of them discovered after a cliff-slide in Dorset in 1990, suggest a concerted plan. These may be parts, the most valuable parts, of three of the *æstels*, book-pointers, which Alfred ordered to be sent to each of his bishops to accompany a copy of Gregory the Great's *Pastoral Care* in an OE translation prepared at the king's court. Each *æstel* (Alfred was particular) was to be worth 50 mancuses, that is, 1,500 silver pen-

nies. Alfred's bishops were among his 'best thegns', men who served him. They in turn warmed to a treasure-giver. Alfred wanted to harness the bishops' pastoral and teaching functions to his own purposes. Alfred had had translated a group of Latin books which he thought 'necessary for all men to know', books that purveyed a social message, of obedience, of service, above all of loyalty to a God-appointed king. The *Chronicle* too was, in its way, a 'necessary' book. So was Bede's *Ecclesiastical History* in OE translation. Literary historians salute Alfred as the first proselytizer for the English language. Political historians admire the deliberate yet sensitive way that Alfred set about winning and keeping the hearts and minds of men and women who mattered. We can know this king's character and aims because he left writings of his own. He was eclectic: his scholar-helpers came from Saxony, Francia, Mercia, Wales. And he learned much from the Carolingians' example. Charlemagne too had pursued wisdom. Yet Alfred's synthesis, the translating of Christian Latin works into OE, and the explicit, attractive combining of wealth and wisdom, were distinctively his own.

Alfred was a consummate politician. Like Offa, the West Saxon kings had had difficulty in controlling Kent. Alfred dealt with this problem within his overall programme. Viking attacks had driven the religious communities (they were probably the sort Bede would have disapproved of) from the minsters of Kent. Formerly, the archbishop of Canterbury had been the lord of those minsters, with access to their wealth. Now Alfred simply replaced the archbishop in that capacity. He seems to have hung on to the minster lands to augment the West Saxon royal estates. His further aims can be inferred from his similar policy at the minster of Abingdon, where he granted out the community's lands to reward the *patria*'s warriors (Bede would have half-approved of that).

Alfred exploited, indeed completed, the Vikings' weakening of the Mercian kingdom. After 879, not long after Edington, there

FOUND AT ABINGDON, Berkshire, an ancient Mercian minster appropriated by Alfred of Wessex, this sword-hilt adorned with silver and niello inlay is stylistically similar to objects produced for West Saxon kings. One side, shown here, depicts a man and (perhaps) an eagle. These have been interpreted as the symbols of the Evangelists John and Matthew and John, corresponding hypothetically to symbols of Mark and Luke on the now-lost reverse side. Such imagery on a sword would fit the Christian militancy promoted at Alfred's court in the 890s.

ceased to be a Mercian king. Instead, and in south-western Mercia only, there was an ealdorman, Æthelred, who 'had authority by Alfred's leave'. Ealdorman Æthelred married Alfred's daughter Æthelflæd, and the pair thereafter extended Alfred's burghal policy to Worcester and beyond. The probable date of the marriage was 886, the year when, according to the *Chronicle*, 'all Englishkind bowed to Alfred at London'. 'Englishkind' included the Angles, that is, the Mercians, along with the Saxons. London was an evocative location to choose for such a unifying ritual. Alfred did not reconquer England from the Vikings. He ruled only in Greater Wessex. But he had overlordship of part of Mercia, and a vision of something larger still. It was a vision that did not exclude Scandinavians. In fact one version of Alfred's own genealogy included Scandinavians. It is significant, too, that few of the ethnic labels in the standard modern translation of the *Chronicle* are present in the original. There *here* confronts *fyrd*, that is, men levied by Alfred and the ealdormen. Ethnic consciousness was considerably less important, it seems, than the pagan/Christian divide. But that divide was not too hard to bridge: Vikings could be converted.

The Making of a Kingdom

The tenth century is most easily characterized as a period of conquest and unification. Alfred may have made both possible, but he made neither inevitable. The West Saxons had to fight, intermittently, over two generations, to conquer the rest of England, and the process of unifying was never finished. But it was not just a matter of fighting. Athelstan (924–39), on campaign in Northumbria, visited Chester-le-Street, temporary home of the community of Cuthbert. Later stories of lavish gifts of treasure are now thought implausible, and we should probably discard, regretfully, the image of Athelstan opening Cuthbert's tomb to place his gift-list beside the saint's head. Yet Athelstan did visit. He gave to Cuthbert's shrine, perhaps in 934 *en route* to campaign against the Scots, a copy of another of Bede's works, his *Life of Cuthbert*. The frontispiece of this early tenth-century manuscript depicts Athelstan crowned in Ottonian style, in the act of presenting the book to the saint. As well as acquiring spiritual benefits for himself (he was a famous relic-collector) the king thus made a spectacular gesture of conciliation towards the great Northumbrian saint. It was gesture towards Scandinavians too, whose antecedents in the late ninth century had already acknowledged Cuthbert's power. Athelstan had six *duces*, 'earls' (equivalents of Anglo-Saxon ealdormen), with Scandinavian names in his retinue in 934. The conversion of Scandinavians in Northumbria was near-complete by then. It had proceeded at remarkable speed: so fast, indeed, that there is practically no archaeological or artefactual evidence for Scandinavian paganism in England. The cult of Cuthbert symbolized a region's identity, and a focus of integration, under new lordship as under old.

The series of tenth-century law-codes can be read as evidence for growing royal

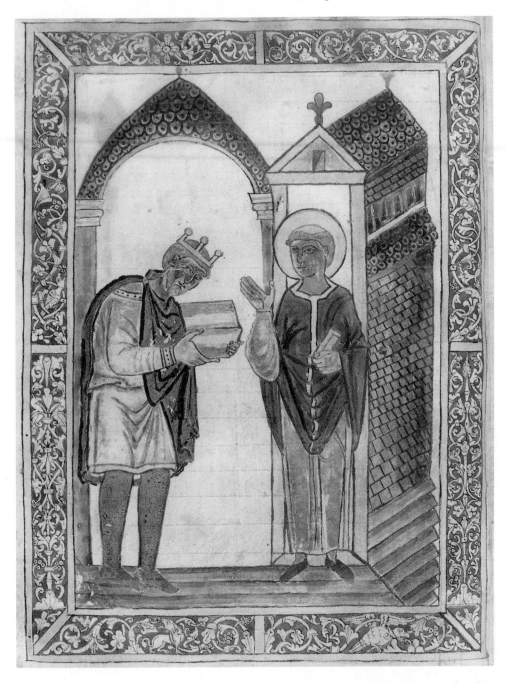

THIS MANUSCRIPT of Bede's prose and verse versions of St Cuthbert's *Life* is prefaced by a frontispiece showing King Athelstan offering the book to the saint. The iconography reflects Athelstan's close relations with the East Frankish court. Probably made in Wessex shortly after Athelstan's victories in Northumbria and visit to Cuthbert's shrine in 934, the manuscript belongs with Athelstan's political campaign to win support in the north.

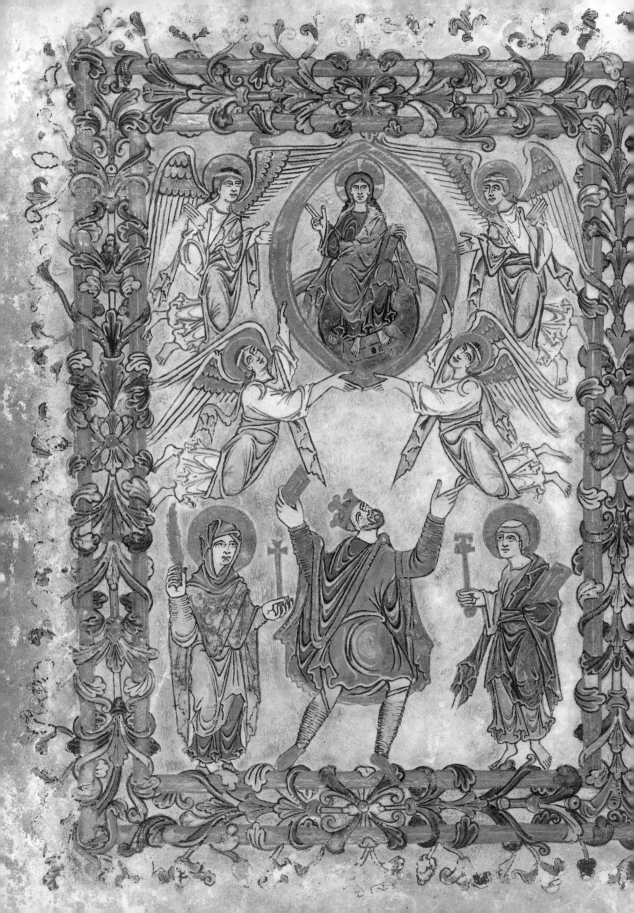

power. All but two of the Anglo-Saxon kings after Alfred have left some record of legislation. The 'local government at the king's command' which historians have identified as characteristic of post-Conquest England seems already in place. Courts and the conduct of judges are sternly regulated; and in Edgar's Fourth Code one earl and two ealdormen, all named, are ordered to enforce 'the maintenance of peace'. In the burhs, reeves (royal officers) were instructed to supervise trading and the minting of coins. This is reminiscent of Frankish capitularies, copies of which were certainly in England by this date. Tenth-century Anglo-Saxon kings continued a practice of large-scale legislation which had ceased in the Carolingian successor-states. But legislation and administration are different things. For evidence that the laws were implemented, historians have looked to charter-records of disputes settled, and crimes punished, by kings or their agents. Yet the same tenth century that saw the growth of royal government also saw the growing power of aristocrats, in towns as well as in the countryside. 'West Saxon conquest' meant that scions of West Saxon families, not least of the royal family, had been implanted as lords in Mercia and East Anglia from the early tenth century on. In mid-century Athelstan, nicknamed 'Half-King', was ealdorman of East Anglia and the leading magnate in eastern England. Ælfhere, ealdorman of Mercia, dominated the west midlands. These magnates wielded regional power to serve the interests of themselves and their kin, as well as to serve the king. The fact that all tenth-century kings' brides were from ealdormanic families is symptomatic of those families' power, and at the same time suggests what channels of influence regional magnates could work through. Nearly all recorded legal disputes involved people of this class. What their political interests were can usually only be surmised. One curious case involved the forfeiting of land to the king by a widow who was found guilty of witchcraft and drowned. The ultimate recipient of the land was Bishop Æthelwold of Winchester, known from other sources as an ecclesiastical empire-builder who with royal support ruthlessly acquired for his monastery of Ely any property to which he believed it had a claim.

The tenth-century monastic reform itself presents a similar mesh of interlocking royal, aristocratic, and episcopal interests. The frontispiece to Edgar's 'charter' for New Minster Winchester, in fact a lengthy document setting out rules for the monastic life, shows how the king wished to be portrayed and remembered in that community: he gives to Christ, who in return confers his grace on the king. The espousing of reformed Benedictine monasticism in place of the old minsters of mar-

KING EDGAR presents his charter to Christ. In this frontispiece to the lengthy document whereby Edgar refounded the New Minster, Winchester, in 966, the king is depicted between the Virgin and St John. The image, an early product of the 'Winchester School' of manuscript illumination, reflects the enthusiastic royalism of Bishop Æthelwold of Winchester, doyen of tenth-century monastic reform. Winchester was now a kind of West Saxon 'capital'.

ried clergy (Bede had already pitted these models against each other) set Edgar squarely in the forefront of contemporary piety, as practised, for instance, by the tenth-century counts of Flanders, cousins of Anglo-Saxon kings (Alfred had married a daughter to a Flemish count in the 890s) and in frequent touch with England. Patronage of reformed houses brought obvious benefits in terms of prayer for ruler and territory, since prayer was believed indispensable for success. Patronage also allied Edgar with bishops who were powerful regional figures in their own rights. This was especially so at Winchester, now emerging as an effective capital under the joint auspices of Edgar and Bishop Æthelwold (the marginal crosses at 853 in the Winchester manuscript of the *Chronicle* may be in his hand). The New Minster's design made possible lavish stagings of royal ritual. The reformed monastery of Bath was another favoured setting: in 973 Edgar and his queen were consecrated there in a kind of imperial rite, that is, to rulership over several peoples. The aura of reforming sanctity was desired. Perhaps Bath was also chosen because of its imposing Roman remains: or were they (as a poet imagined) 'the work of giants'—*enta weorc*?

When Edgar died in 975, a writer in the East Anglian reformed monastery of Ramsey described frenzied attacks on reformed monks in Mercia. Some historians have identified an 'anti-monastic reaction'. Closer scrutiny suggests an outbreak of factional rivalry between the East Anglian and Mercian ealdormanic families. The Mercian 'persecutor', Ælfhere, was kindly remembered at the Mercian monastery of Evesham, which he had patronized. Everyone was in favour of reform in theory; but local applications became vehicles for pre-existing local power-struggles in a world where the title of ealdorman might not always have been hereditary but social power nearly always was. In the end there was much compromise, much diversity, and some reform.

Everyone was also in favour of justice. No group of persons was in more need of justice than widows. Of some forty-four Anglo-Saxon wills, mostly from the tenth and eleventh centuries, eleven are those of women, most of them probably widows. The will of Æthelgifu is an example dating from *c*.980. It came to light in an outhouse in the 1960s. Its closely packed form mirrors its content. Æthelgifu was a noblewoman with estates in Hertfordshire and Bedfordshire, operating at shire level rather than the regional level of magnates. She began her will by 'declaring' it to the king and queen, offering them gifts in return for their securing of her wishes. Actually Æthelgifu was declaring her will in the shire-court, strictly a court of two shires, in the presence of no fewer than 2,000 men. They too, all 2,000 of them, were witnesses to the will. Among other bequests to kin, of flocks of sheep, of free and slave peasants, as well as land and a house in London, Æthelgifu left property to the church of St Albans, which later preserved the will. She also left a psalter to 'the women who will say psalms for my soul'. Æthelgifu's hopes and fears emerge from the dry document: hopes to live out her days as a chaste widow in her own properly

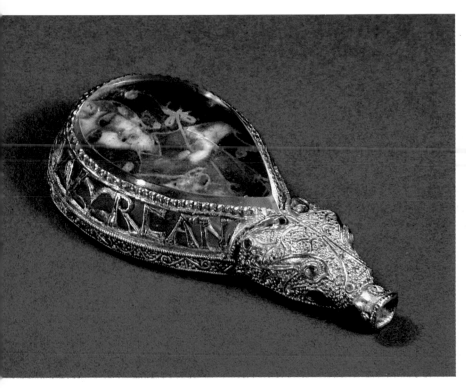

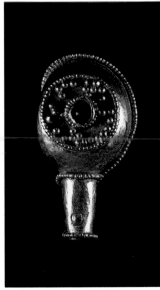

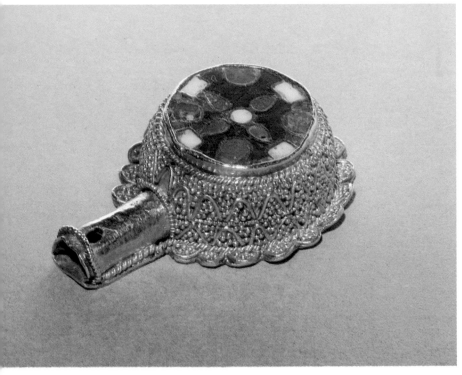

ALFRED JEWEL,
Minster Lovell jewel,
Bowleaze cove mount
(*anti-clockwise from top
left*). Stylistically, these
objects belong together.
Each consists of a deco-
rated head, and a socket
into which a wood or
ivory rod or pointer was
originally fitted. The
largest and most ornate
is the 6.2 cm long
Alfred Jewel, an enam-
elled plaque held in a
golden frame beneath a
polished rock-crystal.
These objects have been
identified with the
æstels, each worth 50
mancuses, which
accompanied the copies
of Gregory the Great's
Pastoral Care which
Alfred sent 'lovingly
and friendlily' to his
bishops. The high value
could suggest that each
æstel contained a relic.

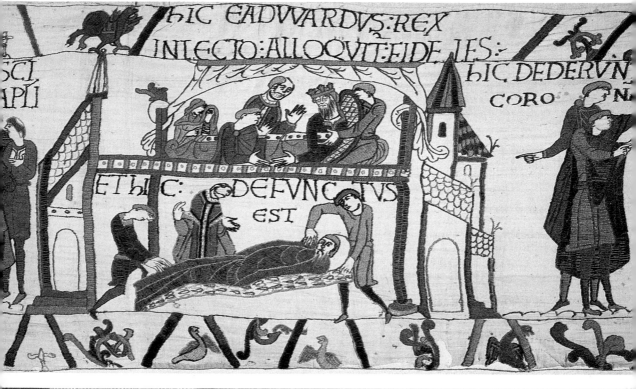

HIC EADWARDUS REX
IN LECTO ALLOQUIT FIDELES HIC DEDERUN
CORO N
SCI
APLI
ET HIC DEFUNCTUS
EST

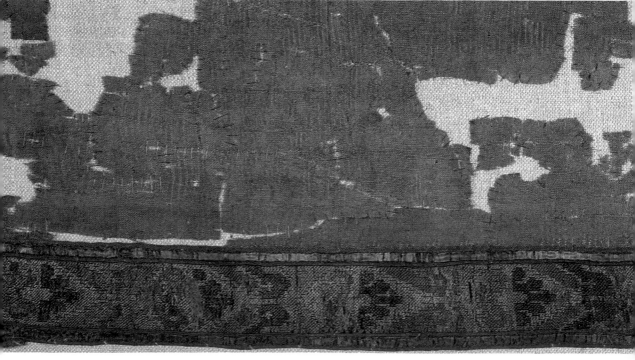

resourced house-convent with a few women-servants and perhaps kinswomen; fears that she might be prevented from doing so by kinsmen and others keen to lay hands on her property. The king's power was acknowledged; but Æthelgifu also mobilized a great weight of local opinion. Religious motivation jostled with a hard-headed

BAYEUX TAPESTRY (*facing, above*): the death of King Edward. On the right, in the top panel the dying Edward is depicted symbolically handing his kingdom over to Harold by the gesture of touching fingers, while Queen Edith grieves at the foot of the death-bed. In the lower panel, Edward's corpse is wrapped in its shroud. To the left, in reverse comic-strip fashion, the king's body is shown being carried to newly consecrated Westminster Abbey for burial.

THIS BROCADE FRAGMENT (*facing, below*), of silk thread imported from the Mediterranean, and with a pattern derived from a Western-Central Asian design, was woven in England probably in the late eighth century. It was used to edge a cream silk bishop's dalmatic (ecclesiastical vestment), also made in England, which was put into St Cuthbert's tomb sometime after *c*.800, perhaps by Athelstan in 934.

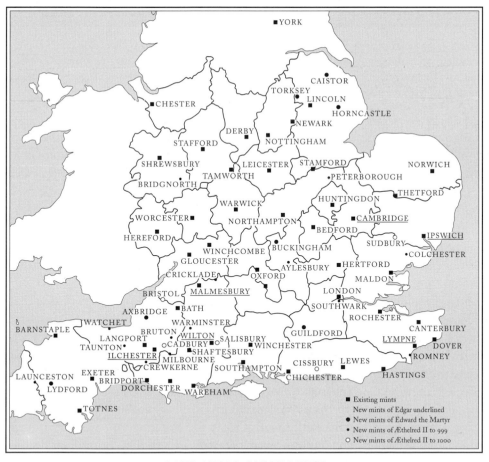

LATE ANGLO-SAXON MINTS

IN ÆTHELRED II'S REIGN, Viking attacks, led by the Danish kings, were on a much larger scale than earlier, and armies were far better co-ordinated and better equipped. London was a major target. This hoard of Viking spear-heads and axe-heads, together with an anchor, was found at London Bridge.

recognition of competing interests and the location of real power in the shire community of thegnly landowners, as well as at court. The late Anglo-Saxon squirearchy left their mark on the landscape too. One thegnly residence that has been excavated is Goltho Manor, Lincolnshire. It was fortified by a ditch and palisade: a little *burh*. Perhaps Æthelgifu's house looked something like that. The king's 'maintenance of peace' did not stop people from building for self-defence.

The strongest evidence for royal government at work and working effectively has been seen in the late Anglo-Saxon coinage. All coin was issued in the king's name, and no foreign coin was allowed to circulate. By the reign of Æthelred (978–1016) some sixty mints were operating. South of the Humber few people were further than fifteen miles from a mint. In Æthelred's reign the issuing of coin was decentralized in this way because at regular intervals of seven to ten years all the currency was called in, and reminted in a new issue. People were forced to comply because the old coins were now demonetized, no longer acceptable. Each time the recoinage was effected, the king, and his moneyers (whose names were also on the coins), took a cut. Æthelred's moneyers, it seems, were not just royal agents but were, especially in the north, controlled by the ealdormen. It was a form of kingdom-wide taxation in which king and aristocracy to some extent shared. Æthelred had particular need to operate this system successfully: his reign saw the renewal of Scandinavian attacks,

now on a far larger scale than in the ninth century because now organized by a powerful and united Danish state, and led by the Danish king Swein, then his son Cnut. The Danes were also very well equipped. The tactic that Æthelred frequently adopted, as several ninth-century rulers had, was the payment of large sums of money to Vikings on condition that they depart, at least temporarily. On this basis, Æthelred's regime held out from 992 until 1016. Close reading of the evidence for how the taxation was collected has revealed how intrusive were local politics: in the midlands, for instance, Eadric Streona ('Grabber') used his job as tax-collector to settle scores and reward political friends. Late Anglo-Saxon coinage tells an equivocal story: it proves administrative sophistication, but it also tells of the play of politics, and of regional diversity, with perpetual trade-offs between central and provincial interests.

By 1016 very large quantities of silver had been raised, handed over, and shipped out of the country. Clearly late Anglo-Saxon England was wealthy, as in the eighth century, because of its indigenous resources, with wool-production probably of growing importance (there must have been a market for the fleeces of Æthelgifu's numerous sheep), and because of involvement in increasingly lively imports and

WHARF AT BILLINGSGATE. Æthelred II's imposition of tolls on traders from northern France, Flanders, and Germany shows the commercial use of the bank of the Thames within the London restored by Alfred. Excavations in the 1980s at Billingsgate confirmed that, from the later tenth century, boats could use timber wharves with access, via the breached Roman wall, to the heart of the city. Late Anglo-Saxon England was highly urbanized for its time, with perhaps 10 per cent of people living in towns.

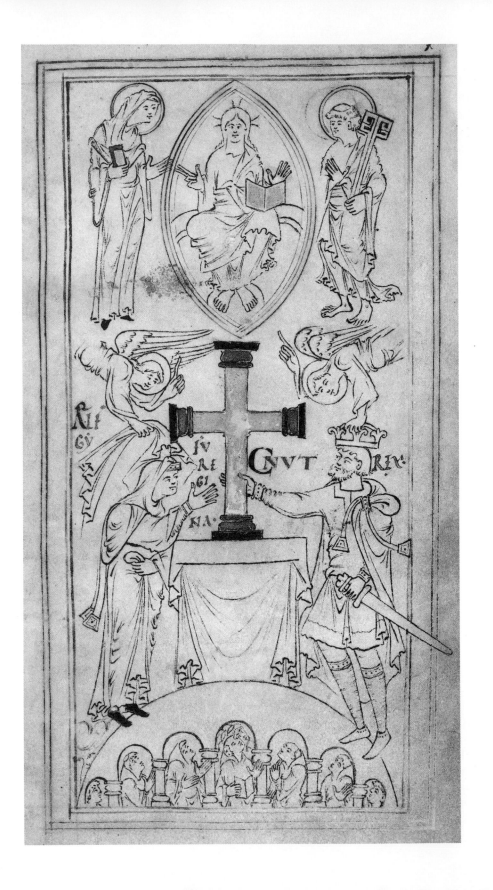

exports. The construction of successive wharves at Billingsgate, securely tree-ring-dated by archaeologists to Æthelred's reign onwards, confirms written evidence for Continental traders in London. The unstoppable rise in London's fortunes started now; and it continued, along with increasing commercial transactions generally, right through the eleventh century. England's wealth was widely appreciated abroad.

Æthelred, after centuries of denigration, has been rehabilitated in recent historiography. Precisely targeted violence can be considered administrative action. In 1014, Æthelred took revenge on the men of Lindsey who had agreed to 'ravage' with Cnut: 'Æthelred came to Lindsey and it was ravaged and burnt and all the men who could be got at were killed.' What this episode, like the reign generally, also suggests is that enthusiastic celebration of England's tenth-century unity is premature. Under pressure, the kingdom tended to fall apart again into its component parts, Northumbrians, then Mercians accepting Danish lordship, while Wessex maintained resistance. In 1017, after Æthelred's death, his son Edmund agreed with Cnut to divide England along the ancient Mercia–Wessex boundary.

Conquests

Anglo-Saxon England was conquered twice in the eleventh century, not only in 1066 but already in 1017 as well, when Edmund's death enabled Cnut to succeed. Cnut's conquest should not be taken to prove the 'decline' of the late Anglo-Saxon state. That state had never operated in higher gear. And, paradoxically, conquest did make it more unified. The relative unimportance of ethnic distinctions and the very great importance of Continental contacts became clearer than ever in the eleventh century. One woman's career epitomizes these traits: Emma, daughter of Duke Richard of Normandy, married Æthelred in 1002 (the *Chronicle*, exceptionally, mentions this royal marriage). In 1017 the *Chronicle* says that Cnut 'ordered Æthelred's widow, Richard's daughter, to be fetched as his wife'. The image of this pair presenting their cross to New Minster, Winchester, can be contrasted with the late tenth-century one of Edgar offering his charter: Emma's prominence is striking. Her status as queen, and also her Danish-Norman descent, allowed the representation of her second marriage as a 'transfer of the kingdom' to a Danish conqueror who would rule English and Danes. In England, Cnut worked with the Anglo-Saxon aristocracy, and his patronage of Winchester was an adroitly conciliatory gesture.

CNUT AND ÆLFGYFU/EMMA present a cross to the New Minster, Winchester. Cnut's consolidation of his conquest depended on his winning over of the English. His marriage to Æthelred's widow, here captioned in the Register of the New Minster by her English name Ælfgyfu, shows her political importance and her new husband's political sense. His endowment of the New Minster was a calculated appeal to Anglo-Saxon royal traditions.

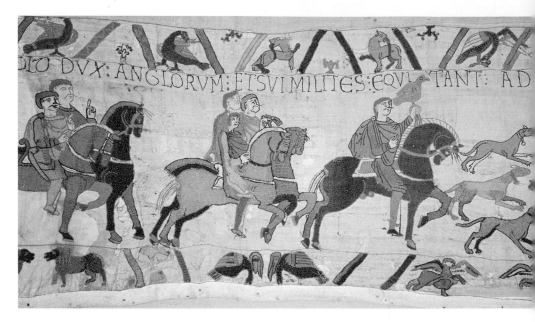

Certainly there were changes of form: ealdormen now were called earls. But late twentieth-century historians tend to see in Cnut's regime the substantial power of the late Anglo-Saxon state, not its decline.

Meanwhile Edward, Emma's son by Æthelred, had gone into exile in Normandy, where he stayed, boy and man, for over twenty-five years. When, thanks to further dynastic accidents, he did become king of England in 1042, he surrounded himself with Normans, and seriously considered Duke William as a potential heir.

SEALED WRIT of Edward the Confessor. Addressed to 'Bishop Leofwine [of Lichfield], Earl Edwin [of Mercia], and all my thegns in Staffordshire', this royal writ states that the king has granted the estate of Perton to Westminster Abbey. The local notables are to ensure that the king's will is observed.

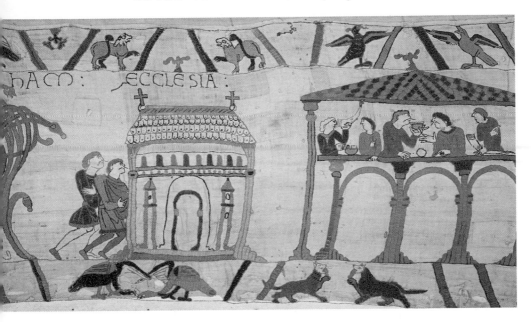

THE BAYEUX TAPESTRY. Commissioned by William the Conqueror's half-brother, Bishop Odo of Bayeux, this massive piece of embroidery, made not long after 1066, is almost certainly the work of English women, but tells the story of the Conquest seen through Norman eyes. These scenes depict Earl Harold, with hawk and hounds, riding with his warrior retinue to his estate at Bosham, Sussex, and then feasting there in an impressive hall.

Edward's regime nevertheless was as English as Cnut's had been. The extensive use of the written word was a characteristic of Carolingian government no longer much in evidence in Normandy but very much alive and well in Edward the Confessor's England. Edward's writ to the notables of Staffordshire may look unassuming; none the less, this was a piece of administrative machinery, crisply conveying central instructions to the key personnel of the shire. The men who ran the shires were, as ever, magnates with their own territorial power, pursuing their families interests. Wessex itself had become the territory of an ealdorman, Earl Godwin, one of Cnut's Anglo-Saxon supporters. Godwin had five ambitious sons, and one no less ambitious daughter, Edith, whom King Edward married at the very start of his reign: both 'sides' at that wedding-feast must have felt happy with the match. Domesday Book, which was made in 1086 but recorded who owned what lands 'on the day King Edward was alive and dead', 5 January 1066, shows that over the kingdom as a whole King Edward's lands were more, and more valuable, than anyone else's. Yet the lands of Godwin's sons together were even more extensive and more valuable than the king's. Edith's own holdings were vast: but should modern historians rate them on Edward's 'side', or the Godwinsons'? In fact, 'the Godwinsons' did not present a united front, for two of the brothers were fierce rivals. All of them, and Edith too,

depended on the king to maintain their rank and status. The king, though, could not rule without the support of at least some of them. Harold Godwinson emerged the leading magnate of Edward's last years. And on the day, 6 January 1066, that saw Edward's death and burial in his new-built abbey-church at Westminster, Harold was consecrated king in the very same church.

It is to those years that the most memorable, and best-known, images of the entire Anglo-Saxon period relate. The Bayeux Tapestry (really an embroidery) was probably made in the 1070s not far from St Augustine's monastery at Canterbury, whose illustrated books seem to have provided some of the iconographic models, and probably by a team of Englishwomen, for embroidery was then English-women's speciality *par excellence*. Although produced for a Norman patron, the Conqueror's brother Bishop Odo of Bayeux, the Tapestry was a characteristic product of Anglo-Saxon culture. Here Harold rides out with his *milites*, his warrior-following, and here he dines with them in his hall at Bosham in Sussex. Harold too was a product of Anglo-Saxon culture; yet he could travel to Normandy and find so much there that was familiar. The personal display, the noble life, the religious practices, the weapons and horses, of Harold and his men, are not depicted as significantly different (their hair-styles differ) from those of William and his. In conquering England, William quite literally took Harold's place. Yet Hastings was fought between men who in fundamental respects shared a culture: the aristocratic culture of Latin Christendom. Beside that huge commonality, linguistic difference or distinctive haircuts were of relatively small account. That explains why Harold could feel at home in Normandy; more important, it explains why William, though he spoke French not English, could realistically hope to be accepted as king of England, and why his *Franci*, in time, would come to think of England as a second home.

3 Conquered England
1066–1215

∿∿ George Garnett ∿∿∿∿∿∿

'The more loudly just law was talked about, the more unlawful things were done.' Thus wrote the Anglo-Saxon chronicler in a pungent obituary of William the Conqueror. He had perceived a central truth about the regime imposed upon England by the Norman Conquest: that the elaborate attempts made to establish the justice of Duke William of Normandy's claim to succeed Edward the Confessor, and therefore to present him as a traditional English king, were in their legal scrupulosity testimony to precisely the opposite. The Normans protested too much. It can be argued that there is a conclusion to be drawn here. The sheer detail in which the Norman claims were expounded, and the ways in which their assumptions and terms of reference underlie much of the new regime's documentation, reveal the extent to which a new society was shaped by them. They provide what today would be called that society's legal framework. Like many totalitarian regimes in the twentieth century, the Normans seem to have realized that control of the past was a prerequisite for mastery of the present, and

THE STILLNESS of the parish church of Saint-Pierre de Thaon, near Caen, could be described only in poetry. It is arguably the most atmospheric church in Normandy surviving from the time of the Conqueror and his sons. The tower has been dated no later than 1080, and the choir had been built by about 1100. The richly decorated stonework of the nave is modelled on that of the choir, but dates from perhaps 1120–30. The only change since has been the disappearance of the side aisles, and the filling-in of the arcade arches, during the eighteenth century.

set about propagating an official version of history. By decrypting that version, and demonstrating its influence on the nature of the new regime, it is possible to see how England was transformed by the Norman Conquest.

Duke William's Claim

William the Conqueror claimed to be the legitimate, designated, direct heir and successor of the childless Edward the Confessor. Historians have by and large accepted all or most of this claim, but there is not a shred of pre-Conquest English

(or for that matter Norman) corroboration for it. It appears to rest wholly on sources written in Normandy after the Conquest; the authors were William of Jumièges, who completed his *Deeds of the Dukes of the Normans* in about 1070, and William of Poitiers, who probably finished his biography of William the Conqueror in 1077. The claim and the Conquest eventually mounted to enforce it are the principal concern of William of Poitiers; they seem to be almost an afterthought and a diversion for William of Jumièges. But despite the difference in the level of detail, both record a story which is virtually identical in its essentials. Edward the Confessor had chosen William as his successor in 1051, years before his death. He had done so largely out of gratitude for the succour afforded to him in Normandy, when he and other surviving members of the English royal family had been forced to flee into exile by the Danish King Cnut, following the first eleventh-century conquest of England. After the restoration of the traditional line, he was repaying old favours by making the Norman duke, who was not of that line, his successor. He had ensured that the English nobility pledged their faith to the duke in the duke's absence, and then sent a messenger to Normandy to inform him of the decision. That messenger, Robert of Jumièges, the new archbishop of Canterbury, has been categorized as a member of a Norman fifth column, introduced into England by the Normannophile Edward, and resisted by the Eurosceptic Earl Godwin of Wessex and his sons. Nevertheless, Godwin and the other earls (with the unexplained exception of Harold, then earl of East Anglia) formally consented to the arrangements for William's eventual succession.

If Earl Harold had not bound himself, by pledging his faith, at the time of the original designation, the Norman sources devote much attention to the circumstances in which he was alleged to have done so during a visit to the Continent in 1064 or 1065, by which time he had succeeded his father as earl of Wessex. According to the Normans, he had been sent by King Edward to reconfirm the designation made over a decade previously. Harold had become William's vassal, and had, amongst other things, undertaken to assist the duke's accession after Edward's death. In the event, this was precisely what he did not do. Instead, he accepted what he claimed was Edward's death-bed designation of himself as successor to the throne, thereby perjuring himself. There is nothing in the Norman sources which directly questions what the English sources record: that Edward had in some fashion nominated Harold as king after him. With the exception of Robert of Jumièges's trip to the Continent, which the English sources explain solely in terms of the new metropolitan's obligatory visit to Rome, failing to mention either Normandy or the succession, this is the first point at which there is any common ground at all between the two sets of sources. This is strange, given the wealth of detail which both lavish on the reign of Edward the Confessor. Historians might have paused for reflection. But instead they have attempted to combine the two accounts, discrepant to Edward's death on 5 January 1066, into a single, coherent story. This is a formidable

challenge, because they are not different accounts of the same events, and they appear to be incompatible.

The English sources, for instance, record the return from exile in Hungary, in 1057, of the son and grandson of Edward's half-brother, King Edmund Ironside. Edmund Ironside had been the last English king prior to the completion of the Danish conquest of England in 1018. His son and grandson were the last remaining male members of the West Saxon royal house which had ruled Wessex and later England, since the seventh century. As such, they were termed 'aethelings'. With the exception of the Danish conqueror Cnut and his sons, no one had become a king of Wessex or England who had not been so styled. The *Anglo-Saxon Chronicle* records that Edmund Ironside's son died in mysterious circumstances immediately on his return to England, but his grandson Edgar survived at Edward's court. The Norman sources recognize Edgar aetheling's existence, but say nothing about how he came to be in England. This is not particularly surprising, for the return of the aethelings, if it was arranged by the king, fits ill with his alleged previous orchestration of a Norman succession. It is therefore passed over in silence by the Norman sources. Conversely neither the designation of William nor Harold's Continental trip is mentioned in any contemporary or near-contemporary English source. They first appear in English narratives in the work of twelfth-century chroniclers like William of Malmesbury, who attempted to combine the two traditions into one coherent story, and succeeded only in confusing himself. In despair, he eventually attributed Harold's visit to the Continent not to the king's instigation, but to a fishing trip which had gone wrong.

In the absence of more reliable evidence about the reign of Edward the Confessor, attempts to reconcile the two stories can be made only by weighting one piece of evidence over another for no compelling reason, or inventing facts for which there is no evidence whatsoever—a case in point being the assertion that Harold must have arranged for the return of the aethelings, because the king wanted Duke William to succeed. A different approach is to acknowledge that the sources are not giving partisan accounts of a single truth, but are mounting discrete, probably incompatible arguments. To a degree, this may be true of the *Anglo-Saxon Chronicle*; but the surviving manuscripts are in most cases clearly based on accounts written during Edward's reign. They lack the teleological drive which the Conquest lends to the Norman sources. The Norman sources view Edward's reign and, in so far as they consider it at all, earlier English history entirely in terms of the justice of Duke William's claim. They are legal briefs. This is particularly striking in the case of William of Poitiers, whose book is shot through with legal terminology. But how convincing was the case that the Normans presented? Did Duke William's claim make sense in terms of English tradition?

It did not, even allowing for the turmoil in early eleventh-century England. There is very little evidence for anything akin to designation in Anglo-Saxon England, and

none for the king being able to bequeath the kingdom, like a chattel or piece of land, to someone who was not of the royal line. Although the Norman sources, and later the Conqueror himself, made much of the fact that his paternal grandfather's sister, Emma, was Edward the Confessor's mother, he was not descended in the male line of the house of Cerdic, and was therefore not eligible for the title of aetheling. This in turn meant that, in terms of English tradition, he could not be an eligible candidate for the throne. Moreover, there is no English evidence for succession to the throne being secured by nobles individually pledging their faith to the chosen successor, long before the king's death, whether in the successor's absence or in his presence. So why do the Norman sources base William's claim on a designation of this type, confirmed in this way?

A plausible answer is supplied by William of Jumièges's *Deeds*. It consists of a series of biographies of dukes, from Rollo onwards. Towards the end of each duke's life the arrangements made for succession to the duchy are described. In each case the ruling duke, feeling mortality pressing upon him, is said to have summoned an assembly of the magnates of the duchy. They ask him which of his sons he wants to succeed him. He selects one, who in practice seems always to have been the eldest. Then the magnates individually pledge their faith to the chosen successor, in order that each of them should be bound to him prior to his father's death, meaning that anyone who contested the designation later would be guilty of perfidy. Thus is solved the puzzle of why the Confessor's alleged designation of Duke William conformed with no recoverable English tradition. What the Norman sources describe is a ducal designation ceremony, retrospectively imposed upon England in 1051. This does not prove that no such thing ever happened, but it does make it seem highly unlikely. And this putative solution emerges from examining whether the Norman claim makes sense as an argument, rather than trying to squeeze it into some sort of congruity with the *Anglo-Saxon Chronicle*'s accounts of the Confessor's reign.

Of course this does not mean that Harold, Edward's immediate successor, had any better claim. His sister was Edward's wife, but he was no more entitled to be called aetheling than Duke William was. He therefore lacked any legitimacy, in traditional English terms. Moreover, his claim to have been designated by the dying Edward is at odds with what we know of the practice of royal succession in pre-Conquest England, even if, for the sake of argument, it be accepted that a king had the power to choose a successor who was not of the royal line. That something was rotten in the kingdom of England under Edward the Confessor is indicated by the treatment of Edgar aetheling. He did not attest Edward's charters, and he did not control any of the estates which in the tenth century were specifically reserved for the maintenance of aethelings. Historians have generally not taken his claim seriously (although William of Malmesbury, in one of his self-contradictory discussions of the matter, recorded that Edward the Confessor had recommended Edgar,

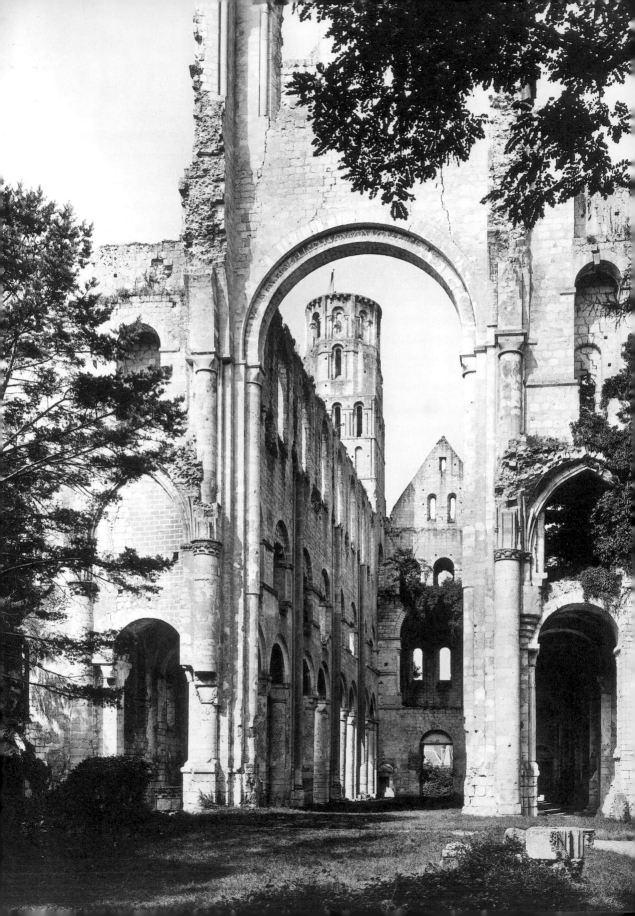

THE ABBEY OF JUMIÈGES lies on the north bank of the Seine, downstream from Rouen. Destroyed by Vikings in the ninth century, it was restored by the early Norman dukes. The foundations of the abbey church of Notre-Dame were laid in 1040 in the time of Robert Champart, later bishop of London (1044-51) and briefly archbishop of Canterbury (1051-2), before having to flee back to Jumièges. There he may have been William of Jumièges's principal source on English history. The church was dedicated on 1 July 1067, in the presence of the new king of England. The illustrations show the abbey before and after the French Revolution, when it was dissolved. The engraving of 1678 (*above*) gives a view from the west; the photograph is taken from the choir, looking up the nave.

'who was closest to the kingdom on account of his birth', as his successor). He was fourteen at the time of the Conquest, by which age aethelings in the past had regularly attested charters, and had possibly enjoyed the revenues of their reserved estates. Several tenth-century kings had acceded as adolescents, and once Harold was dead the English elected Edgar as king. The concentration of land in the hands of Godwin's sons, particularly Harold, so that their resources far outweighed those of the king, meant that Edward had by the end of his reign been reduced to the status of a *roi fainéant*. In these circumstances it is perhaps not surprising that his only legitimate successor could be marginalized.

Yet Harold must have felt insecure about his newly royal status. Revealingly, the Godwinist manuscript (E) of the *Anglo-Saxon Chronicle* labours the point that

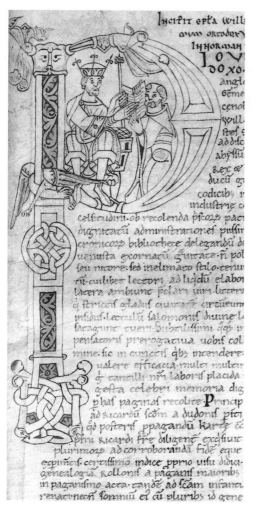

ORDERIC VITALIS' APPRENTICESHIP as a historian consisted in rewriting and continuing William of Jumièges's *Deeds of the Dukes of the Normans*, a task he had completed by 1113. This manuscript contains his autograph copy, in which William of Jumièges's dedicatory letter to William the Conqueror opens with an illuminated initial, depicting the author presenting his book to the king.

Harold had been designated, elected, and anointed as king. Not only does the *Chronicle* not say of any other king that he had been designated, it very rarely mentions both election and anointing. In Harold's case the conjoining of the two ceremonies in the *Chronicle* accurately reflects reality, for Harold was both elected and anointed on the day after Edward the Confessor's death. To be crowned and anointed immediately after the death of the last king was, so far as we can tell, unprecedented in England; consecration was clearly a more pressing matter for Harold than it had ever been for a member of the line of Cerdic. A neglected post-Conquest English source, the *Miracles of St Edmund*, by Herman, archdeacon of Bury St Edmunds, describes how, 'with adroit use of force', Harold usurped the kingdom, sacrilegiously telescoping the mass of Edward's funeral day with that for his own coronation. This account might be written off as infected by Norman character assassinations of Harold, were it not for the fact that in no other respect does it echo the official Norman version of history, and that Edward the Confessor's doctor was Baldwin, abbot of Bury St Edmunds. Baldwin is more likely than anyone to have been one of those unidentified figures depicted on the Bayeux Tapestry as attending the king's death-bed. Herman's is therefore the closest we are likely to get to an eyewitness account of Harold's coronation, and its tone could not contrast more sharply with that of the E manuscript of the *Anglo-Saxon Chronicle*. It indicates that Harold's claim was probably no less embroidered than the attempt, in the Bayeux Tapestry, at a visual representation of many of the elements in William's claim. Harold's claim lacks the richness of detail and precise legal reasoning of William's, partly because, unlike William, he did not present it at the papal curia to secure papal backing, and partly because he was swept away by the Conquest.

The Influence of the Claim

The character of the Norman regime was foreshadowed in those details and that precise legal reasoning. William's claim, presenting Edward's designation of William as a bequest, treated the kingdom as if it were a piece of land or a chattel, left in a will. In other words, it was William's. The whole kingdom was his, for he was heir to it. Whatever land anyone held in the kingdom was therefore held either directly or intermediately of the king. Whereas royal lordship in Anglo-Saxon England was complex and did not necessarily involve a tenurial relationship, with the Conquest personal and tenurial lordship became one.

This may be demonstrated from every folio of that remarkable tenurial record, Domesday Book, drawn up in 1086, the year before William's death. With very few exceptions, it recorded who held every inch of land in the kingdom. It was divided in the first place into Anglo-Saxon shires, but within each shire the land was divided into *terra regis* (land of the king)—that is to say, what he and his agents exploited directly on his behalf—and the lands held of him by individuals, whether bishops and abbots or lay barons. Those barons, whether ecclesiastical or lay, held their lands as a function of a personal relationship with the king. They were, in other words, tenants-in-chief, holding precariously, in the legal sense of the word. This was quite different from an Anglo-Saxon thegn, who had a legally defined status, and did not necessarily hold anything of the king; there were no tenants-in-chief in Anglo-Saxon England. After the Conquest each baron's relationship with the king, and therefore whatever claim he had to the land he held of the king, was created by the king's acceptance of his homage. This was true not just of lay barons, but of those bishops and abbots who held ecclesiastical baronies, or tenancies-in-chief, too. Eadmer, an English historian writing at Canterbury in the very early twelfth century, decried the fact that from the time of the Conquest—and not before—no one could become a bishop or abbot 'without first becoming the king's man [*homo*, hence *homagium*]'.

With the exception of the liturgy, homage became the most solemn ceremony in post-Conquest England, with practical, terrestrial, tenurial implications which liturgical ceremonies could never have, for it involved the grant of land as well as a reciprocal, personal pledging of the faith into which both parties had been baptized. It took the form of the aspiring 'man' (or vassal) kneeling in the posture of a suppliant before the lord, placing his hands within the lord's, and swearing an oath of fidelity. By accepting homage, the lord granted his new vassal—or 'seised' him with—the land, and undertook to protect him in his tenure so long as the vassal performed whatever services had been specified. It is clear that King William did this not only with those co-conquerors whom he rewarded with large estates in England, but even with those few major Anglo-Saxon landholders who managed to survive the Conquest as tenants-in-chief, like Æthelwig, abbot of Evesham, or

Wulfstan, bishop of Worcester, both of whom seem to have acted as quislings for the new regime. For one of William's innovations was the imposition of a system of military service quotas, over and above existing Anglo-Saxon military service obligations, on tenants-in-chief. The chance survival of a copy of a writ from the king to Æthelwig shows that Æthelwig owed the quota by 1073 at the latest. The obligation must have been imposed on him, and by inference probably on all other tenants-in-chief, very soon after the Conquest. It seems likely that it was imposed at the point when Æthelwig became a tenant-in-chief; when he first did homage for the estates of the abbey. In other words, knight service quotas were a function of the imposition of a new tenurial dependence on the king as the lord of all land within the kingdom.

The quotas were imposed only on tenants-in-chief, and were not assessed on a territorial basis. They were personal deals. It was up to the individual tenant-in-chief how he fulfilled his obligation. In the very early stages of the Conquest, he might not yet have control of all the land he had been given; the king might make a grant to him, as it were, partly in prospect. In such circumstances it made sense to render military service with armed retainers. But very soon, with the king's rapid subjugation of the country, this ceased to be the case everywhere except on the marches. Monastic chronicles describe how bishops and abbots rapidly came to the conclusion that it was less undesirable to create their own tenants owing military service to them, rather than relying on hordes of unruly stipendiary knights. This was by no means the only motive for subinfeudation—many surviving Anglo-Saxons who were not simply dispossessed found themselves reduced to the status of subtenants—but it was an important one. Crucially, the king's relationship with each of his tenants-in-chief provided the model for their lordship over their subtenants. Within each shire the first layer or two of subtenants is recorded in Domesday Book within each tenancy-in-chief, although the stratification was not as rigid as this description might suggest. In the earliest surviving document (1085) recording the creation of a subtenancy (more accurately two subtenancies, one held in return for military service), the bishop of Hereford made Roger de Lacy, a substantial tenant-in-chief, his subtenant. It became quite common for barons to hold small parcels of land of other barons. And the circumstances in which the fruits of the Domesday survey were presented to the king at an assembly held at Salisbury demonstrate that the familiar metaphor of a feudal pyramid is quite inappropriate, indeed misleading. For the *Anglo-Saxon Chronicle* records that 'all landholding men who were of any account over all England, whosesoever men they were' did homage to him. The chronicler does not use any Anglo-Saxon term which might be translated as 'subtenant', and perhaps betrays a lingering English understanding of lordship, in which personal and tenurial bonds were not necessarily congruent; but when 'Florence' of Worcester translated the *Chronicle* into Latin in the early twelfth century he interpreted this passage as referring to knightly subtenants (*milites*) of

barons. And rightly so, for the oath of Salisbury was the point at which post-Conquest subtenancy was defined. Henceforth it was not just the barons who were personally bound to the king: the subtenants—at least those 'who were of any account'—were too. Their homage re-emphasized that whatever they held of their lords was ultimately held of the king. It forged a direct bond between subtenants and king which was to have far-reaching consequences for English history during this period.

Both Domesday Book and the ceremonial associated with its completion, as far as the Conqueror was concerned, therefore represented an attempt to draw a final line under the almost total revolution in both the personnel and the character of aristocratic landholding which had followed the Conquest. It has rightly been characterized as a sort of vast charter, embodying the post-Conquest settlement. But most historians have treated it as what it purports to be, an objective record of fact. Yet, as should already be clear from the role that it attributes to the king as the source of all tenure, its fundamental presuppositions follow from the nature of William's claim. It is therefore unsurprising that those presuppositions, based on the official interpretation of history, can be shown to be no less tendentious than those of William of Jumièges or William of Poitiers.

William of Jumièges and William of Poitiers both recognized that Harold had been king, though a perjured one, who had been judged by God in trial by battle at Hastings. But William of Poitiers laid the ground for considering that Harold had never been a king at all: for the usurper had allegedly been consecrated by the usurping archbishop of Canterbury, Stigand. (In fact, precisely because Stigand's status was dubious, Harold had been consecrated by Ealdred, archbishop of York, as the Conqueror was.) According to William of Poitiers, Stigand's consecration of Harold was therefore invalid; and because the Normans, unlike the Anglo-Saxons, considered that consecration made someone king, it would be easy to conclude that, strictly speaking, Harold had never been a king. The conclusion was not arrived at immediately. But in order to prevent the process of redistributing the lands of dead or dispossessed Englishmen from degenerating into anarchic land-grabbing, some fixed base line had to be found by reference to which might be defined the rights in land being granted by the king. If what seems to have been a wealth of Anglo-Saxon documentation were to be utilized in the administration of the process, then it would have to be fixed prior to the Conquest. In view of William's claim, that base line selected itself: Edward the Confessor's reign, or more precisely the day of his death. All rights were defined in relation to what was deemed to have been the situation at that last legitimate point. In the numerous land pleas to which the process of redistribution gave rise, this and evidence of the king's grant were the two determining facts.

In this way is resolved the apparent paradox between reverence for Englishmen's testimony about what had obtained in the 'time of King Edward' and the simulta-

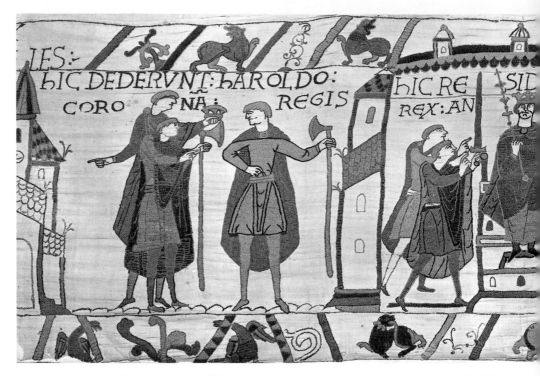

neous systematic dispossession of those very Englishmen, many of whom had held estates on the crucial date: at the celebrated trial held on Penenden Heath the English bishop on whose testimony the case turned had recently been deposed by the king with such improper dispatch that even the papacy, that wholehearted backer of the Conquest, had jibbed. The logical conclusion is apparent in Domesday Book: with the exception of two slips in proof-reading, Harold is not treated as a king, even a perjured one; his reign had never happened; it was written out of history. When he was mentioned—almost always in derogatory terms—the title of earl was frequently attributed to him, even in those very few instances where Domesday could not avoid referring to an event which can be shown to have happened during Harold's reign. Domesday Book might refer in passing on a few occasions to King William's arrival in England, but, read as history, it would not give the impression that there had been a Conquest at all. King William had succeeded King Edward directly. It was as simple (and tendentious) as that. And thereby William's claim established the legal framework underlying every entry in Domesday.

Each and everyone's rights in the land which they held by grant from the king were defined by reference to what were established by English testimony to have been the rights of those who had held the lands on the day 'when King Edward was alive and dead'. From the ruthlessly simple Norman tenurial viewpoint, there was rich scope for misunderstanding the complex, overlapping rights of tenure, lordship, and jurisdiction which had existed in Anglo-Saxon England, all of which

THE BAYEUX TAPESTRY shows Archbishop Stigand officiating at Harold's coronation, at what appears to be the moment of acclamation. It thereby agrees with the story told by William of Poitiers. But 'Florence' of Worcester states that both Harold and William the Conqueror were anointed by Ealdred, archbishop of York, because Stigand's dubious standing made it impossible for him to consecrate a king. For the same reason many new bishops and abbots had avoided being consecrated by Stigand.

Normans might categorize by the verb 'held'. Such misunderstandings account for many of the land pleas with which the Conqueror's reign is littered. Everyone's rights were defined according to those of their Edwardian *antecessor* (predecessor) or, more commonly, *antecessores*. This tended to be stated explicitly only when there was some dispute, but the rights of *antecessores* underpin every invocation of 'the time of King Edward' in almost every entry in Domesday Book. The model was the king, the death of whose *antecessor* defined every other *antecessor*. This framework fails to state explicitly that all tenure depended on the king, but the assumption underpins it. For the framework defines all rights by reference to the legitimacy of the occupant of the throne. It therefore retrospectively imposed on Anglo-Saxon England a tenurial dependency which was quite foreign to Anglo-Saxon England. In other words, the attempts to establish continuity with the English past, to present William as the legitimate, designated, direct successor of Edward, prove how catastrophic had been the break with that past. As manifest in Domesday Book, they also point to what might be considered the fundamental flaw in the society created by the Conquest.

The Conquest had been a joint enterprise. The point is articulated most memorably *c.*1180 by the chronicler of Battle Abbey, founded by the Conqueror in expiation for the sin involved in the Conquest, its high altar allegedly placed on the very spot where Harold had fallen. The abbey was, so the barons told King Henry II, 'a symbol of your triumph and ours', for 'by the conquest at Battle we were all

enfeoffed.' But the joint nature of the enterprise had already been implicitly expressed a century before in Domesday, in the way in which the king's right provided a template for every other tenant's right. Yet embodied in that shared definition of tenurial right was an assumption of absolute tenurial dependence on the king, embodied in the very layout of the Book. Thus was created a tension between king and barons which, exacerbated by many other factors, was to be the central theme in English history between the Norman Conquest and Magna Carta.

Causes of Baronial Resentment

Those co-conquerors who became barons in England, mostly but not exclusively Norman, brought over in their heads a series of assumptions about what good custom was. In Normandy and elsewhere in France, for instance, they were used to heirs inheriting estates from their fathers (or other ancestors). Rulers, whether dukes, counts, or the king, by and large played little or no part at all in the process. In this respect there were similarities between French custom and that of Anglo-Saxon England. The contrast presented by post-Conquest England could not have been more violent. There a baron was created and seised by the king in a single act. His tenure was a function of his personal relationship with his lord king. When that relationship ceased due to the baron's death, so did the tenure. The land reverted—the technical term is escheated—to the king, from whom it had come in the first place. The king resumed the direct control over it which he had temporarily renounced in return for services. Although in Domesday Book the baron's rights to constituent parts of his estate might be defined in terms of *antecessores* from whom, by legal fiction, he might be said to have inherited, he had no right to that estate independent of the king, and therefore his heir or heirs had no right either. He might have thought, in his Norman way, that he had an heir, but that heir could only secure the lands from the king by persuading the king to renew the personal, tenurial relationship with him, by receiving his homage. For the most part, successive kings were more than happy to accede to such persuasion, provided the price was right. Thus was created the feudal incident known as relief, paid to the king—or more often pledged, because the sums were so huge—as a sort of bribe. Barons' heirs might resent the size of the bribes, but they were always prepared to pay because spoils of the Conquest in England by and large vastly exceeded the value of any estate in Normandy. Relief became one of the most important benefits accruing to the king from the manner in which post-Conquest dependency sliced through Norman hereditary conventions.

Domesday Book provides corroborative witness to the ruthlessness of royal exploitation of the baronage. Despite the importance to the king of subtenants, recognized in the oath of Salisbury, the focus of the Book is on tenants-in-chief, both ecclesiastical and lay. It has been demonstrated that its layout, beginning each shire

with a numbered directory of tenants-in-chief, with their lands and resources recorded as discrete units within the shire, must have been devised to facilitate the calculation of a baron's wealth within the shire. If a baron died, it would be a matter of moments to establish precisely where and what he had held of the king. Then writs could be fired off to the relevant sheriffs, making them accountable for the lands which had fallen into the king's hands. The king's financial records, known as pipe rolls, the first surviving one dating from 1130, show that this is how escheats were administered. And this was true in the case of ecclesiastical barons too: when a bishop or abbot died, the lands of his church reverted to the king. This practice of royal custody during ecclesiastical vacancy was the principal object of Eadmer's denunciations. He stated, rightly, that it was a Norman innovation; he thought, wrongly, that it had been imported from Normandy. In fact it was a consequence of post-Conquest dependency. The lands of any particular church remained a discrete unit even while in escheat, in a way that those of a lay baron did not, at least until well into the twelfth century. But Eadmer demonstrated that a successor only entered into office at the point at which the king accepted his homage and seised him with the lands. Ecclesiastical office and tenure had been elided in the same way as lordship and tenure, and for the same reasons. As Eadmer put it, 'all things, spiritual and temporal alike, waited on the nod of the king'.

Baronial resentment at dependence on the royal nod was for the most part suppressed rather than expressed. But in so far as the king was able to impose a semblance of order, he tended to exacerbate the potential for an eventual eruption. Eruptions happened in the immediate aftermath of a king's death, when the individual who was the source of all tenure was no longer there. Here was an opportunity to put right the wrongs which had been done to oneself or to one's ancestors, by grabbing back what might well have been given to someone else. Post-Conquest interregna were nasty, brutish, and short.

The consequences of a king's death were rendered all the more anarchic by the fact that the Normans proved themselves to be incapable of arranging an orderly succession to the throne in England. This seems, to say the least, ironic, in view of the amount of mental effort which had been put into the construction of William's claim to succeed Edward the Confessor. It may be explained in part by the unprecedented complication of dealing with the succession to both England and Normandy. In 1087 William the Conqueror decided that the two dominions should be divided. By Norman custom he could not withhold the duchy from his eldest son Robert, but he was determined that Robert should not become king of England too. He therefore chose his second son William Rufus as his successor in this acquisition, as Norman custom permitted. But this application of the Norman customary distinction between patrimony (or 'inheritance') and acquisition (or 'conquest') to the succession in 1087 shows that the irony of the contrast with 1066 is only apparent, for the Normans had also modelled William's claim to succeed Edward on Norman

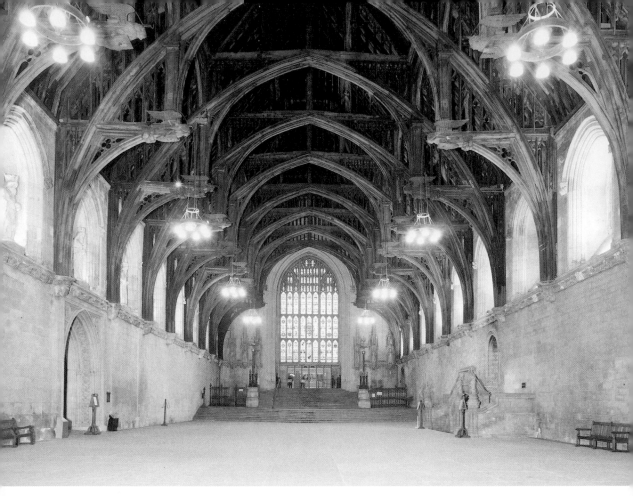

WESTMINSTER HALL. 1097 was another bad year, according to the *Anglo-Saxon Chronicle*, in part because of forced labour on the king's hall at Westminster. At 240 feet long and 67 feet 6 inches wide it was by far the largest hall in England, and probably in Europe. Henry of Huntingdon reports the awe of William Rufus's attendants on seeing the new building in 1099: but Rufus characteristically snapped that 'it was not half large enough'. The hall was re-roofed in the reign of Richard II, but otherwise it is substantially Rufus's.

practice. Edward had allegedly bequeathed the kingdom to William as if it were a piece of land or a chattel, much as succession to the duchy had previously been arranged; now William divided his lands just as one of his magnates might do. Although he must have had some inkling of the chaos which would ensue when Norman conventions were applied in this context, where they could not fit, he proved incapable of breaking out of his primitive Norman mental world; any distinction between public and private was inconceivable. So from his death-bed he orchestrated a pre-emptive consecration for Rufus in his acquisition, which set the pattern for subsequent Norman royal accessions as, in effect, *coups d'état*. The consequent division between England and Normandy in 1087, and the conflict between the brothers, put those barons who also held estates in Normandy in an almost

impossible position, rendering them even more likely to incur Rufus's disciplinary ire, in turn stoking up further resentment.

When Rufus was killed in a hunting accident in 1100, the country again exploded into the anarchic disorder which the chroniclers had described so salaciously in 1087. His younger brother Henry snatched his chance, and was anointed three days later, having paused only to seize control of the headquarters of the governmental machine at Winchester. But with the threat of his elder brother Duke Robert's imminent return from the First Crusade, he felt himself to be in an extremely weak position. He made no attempt to secure the duchy, and rightly feared that Robert would attempt to assert a superior right to the kingdom. In order to garner baronial support in England, he issued on his coronation day a series of promises about how he would exercise his royal lordship. This document or manifesto, which later came to be known as King Henry I's coronation charter or charter of liberties (although it lacks one of the essential qualities of a charter, for it has no recipient, and was termed by William of Malmesbury an 'edict'), provides a check-list of all the causes of baronial resentment. Yet even when he was on his uppers, Henry did not renounce the right to escheat in the case of either lay or ecclesiastical barons, perhaps because it was intrinsic to the tenurial system instituted in post-Conquest England. What he did do was make self-denying promises, most importantly about how he would exploit the rights and incidents which were derived from escheat. For instance, he would take only 'a just and lawful relief' from a baron's heir seeking to redeem 'his' land. Yet the very fact that the heir was offering to pay a relief showed that the land was not in any meaningful sense 'his'; and the concept of a just and lawful relief was an oxymoron, for who could say what was the just and lawful level for a bribe? Similarly, there was no sanction to enforce the new king's other undertakings: about not asset-stripping ecclesiastical estates during vacancies, not exercising rights of wardship over minor heirs, not marrying off heiresses except with the counsel of his barons, and so on. Henry's one surviving pipe roll demonstrates that, once he was secure, these promises were not worth the parchment they were written on. Although many of them explicitly contrasted how he would exercise his powers as lord with Rufus's behaviour, his restoration of the 'law of King Edward with those adjustments which my father made to it' affirmed the post-Conquest system, which had created a law of King Edward in its own image. This was precisely what Rufus had exploited, and what Henry went on to exploit in the same way. Henry married Mathilda, daughter of Margaret, a sister of Edgar aetheling. According to William of Malmesbury, his barons scoffed at his attempts to claim continuity with the English past, nicknaming him 'Godric' and Mathilda 'Godgifu'. They might just as well have ridiculed his specious undertaking to restore the laws of Edward the Confessor.

Revealing as it is, therefore, the coronation 'charter' did nothing to resolve the tensions between king and barons. It could not bind the king because it established

The charter of Henry the first in Exeter

no mechanisms to do so; indeed, because of the king's unique position, such mechanisms would have been inconceivable. Appended to most of Henry's promises was a command to his barons to treat their vassals in turn likewise. It seemed natural to speak of royal and baronial lordship in the same breath: those whom the lord king had made lords exercised lordly powers over their vassals which appeared to be modelled on the king's over them. As with the *antecessor* scheme, itself embodying an assumption of dependent tenurial lordship, the conventions were shared; but, as with the *antecessor* scheme, the common character of the conventions served to underline that the king's position as lord was anomalous.

The anomalous character of royal lordship is evident in the coronation 'charter' itself, much of which is concerned with the immediate consequences of Rufus's death and the three-day interregnum prior to Henry's being made king at his coronation. The urgency of the situation left no time for metaphysical speculation about the nature of royal power: the draftsman was addressing immediate, practical problems. The 'charter' reveals that the problems were such because of the necessarily imperfect analogy between the king and other lords. When it commands, in the new king's name, the restoration to the original holder of anything taken during the interim since his brother's death, the terms in which the clause is framed imperfectly mirror another clause which deals with the king's custody of ecclesiastical lands and vassals which had escheated to him on the death of an ecclesiastical baron. The analogy is necessarily imperfect because the king was the only lord who was not a tenant; by definition, therefore, the kingdom could not escheat to anyone. Yet escheat provided the only framework in which the draftsman could attempt to conceive of the consequences of a king's death. The impossibility of forcing the king to fit into this framework is revealed in the document's opening clause, in which Henry is made to proclaim that he has been crowned king in accordance with 'the common counsel of barons of the kingdom of England'. Since a baron was a tenant-in-chief, a status which depended on a personal relationship with a king, the barons could not be described as the king's when there was no king. Hence the draftsman's unprecedented, nonsensical attribution of them to the kingdom of England. It was a nonsense because a baron could not be attributed to an abstraction, and the neologism was dropped by the draftsman as soon as Henry had been crowned. From that point the king is made to term the barons 'mine'. But the draftsman's initial discomfiture indicates the difficulty that he had in conceiving of the void which followed the death of a king, when there was no lord to whom royal lands, rights, and vassals

HENRY I's coronation 'charter', in Latin (*above*) and Anglo-Norman translation (*below*). The Latin text appends an apocryphal confirmation of Westminster Abbey's privileges. The manuscript also includes copies, with Anglo-Norman translations, of the coronation charters of Stephen and Henry II. J. C. Holt has suggested that it was a preparatory document, drawn up to assist the deliberations of the barons in 1215.

could have escheated. The king was the necessary contradiction of the terms of the system which depended, immediately and ultimately, upon him.

This explains why there could be no mechanisms to bind the king to his expressions of good intention. Non-baronial vassals who felt aggrieved at their treatment by their immediate lords might appeal to the common lord of all, the king; indeed, they had been encouraged to do so by the oath of Salisbury, which had bound them directly to the king. Thereby the king warranted their tenures. There was, therefore, the possibility of giving coercive sanction to the king's commands to his barons about how they should exercise their lordly powers, but none in the case of the lord who had no earthly lord. The point is a simple one, and its importance for the political history of England in the period between the Norman Conquest and Magna Carta can scarcely be overstated. It turns on the fact that, with the occasionally incongruous exceptions of ecclesiastical corporations and emerging town guilds, society was composed of a web of relationships between individuals, the king being in this respect not only no exception, but the prescriptive example. In so far as post-Conquest kings preserved the sinews of what we might term, rather anachronistically, Anglo-Saxon public authority—for they exploited all the relatively sophisticated administrative mechanisms which had not been found in Normandy, a province out in the post-Carolingian sticks—they did so within the context created by this essentially primitive fact. Of post-Conquest England it could truthfully be said that there was no such thing as society, only individuals and their families.

Manifestations of Baronial Resentment

Although Henry I's coronation made him king, it did not make him secure. When his elder brother Duke Robert mounted the invasion of England which Henry had feared from the beginning, according to Eadmer it was Anselm, the archbishop of Canterbury, who enabled him to keep his throne, by summoning groups of barons for didactic reminders about maintaining the faith which they had pledged to the king. Partly for this reason, Robert's invasion was not a success. There followed an uneasy accommodation between the two brothers, based upon that which Robert had reached with William Rufus in similar circumstances in 1091. In neither case did the attempt succeed in institutionalizing the existence of two liege lords for those who were in many cases the vassals of both. In the 1090s the problem was solved, or at least deferred, by Robert's mortgaging of the duchy to his brother in order to fund his participation in the First Crusade. Despite the shamelessly sycophantic special pleading of Orderic Vitalis, the major Norman chronicler of the early twelfth century, it is clear that Henry set about covertly undermining his brother's position in Normandy as soon as the deal between them had been struck, in 1101. Eventually, in 1106, in one of the very rare pitched battles of the period, Henry defeated his brother's forces at Tinchebrai. William of Malmesbury pointed to the divinely

inspired (in his view) irony of this successful English invasion of Normandy, exactly forty years after the Conquest. Duke Robert was captured and imprisoned for life.

The king's victory restored the status quo prior to William the Conqueror's death, with a single ruler in both kingdom and duchy. Thereby it solved the predicament, analysed most astutely by Orderic, which the Conqueror's wilfully primitive death-bed division of England from Normandy had created for those major landholders who held as individuals or as families on both sides of the Channel. It was this predicament which focused and accentuated those causes of baronial resentment in England which flowed from the nature of the Conquest; and it focused them on disputes about succession within the ruling house, making for an intrinsically unstable cohesion of a sort. Insecurity of succession at the top exacerbated insecurity of tenure, and therefore succession, lower down, as Rufus and Henry successively exploited their arbitrary powers to reward their supporters and punish Robert's, and both kings and duke attempted to raise money to fund the struggle. But despite Orderic's depiction of the predicament as abhorrent to the barons—which may not be unrelated to his laboured attempts to justify Henry's take-over in Normandy—it was not an unalloyed catastrophe. It afforded them opportunities to vent grievances which went far wider than doubts about the legitimacy of a particular candidate's claim to the kingdom or duchy, and to do so with at least a measure of impunity; for those who suffered at the hands of one brother were almost certain to be rewarded by the other.

With Henry's victory at Tinchebrai, this safety-valve was removed. He was enabled to ride roughshod over all those baronial grievances addressed with such precision in his coronation 'charter', as his solitary surviving pipe roll demonstrates. It records a level of royal revenue in England which was not exceeded until 1177, and only twice more during the rest of Henry II's reign. So Tinchebrai did not solve the causes of baronial resentment; indeed, in many ways it allowed Henry to exacerbate them. For it made expressing resentment in the conventional manner much more perilous, and largely pointless. There was nowhere for a disgruntled baron to go. Henry had considerable difficulties with Duke Robert's son, William Clito, particularly after his only legitimate son's death in a shipwreck in 1120. But William Clito was troublesome on the frontiers of Normandy, not in England. England appeared more settled than it had ever been; hence the chroniclers' paeans of praise for Henry's ability to keep the peace. The aftermath of the reign revealed that it was a peace of repression, not of settled order.

Stephen's Reign

As soon as news broke in England of Henry's death in Normandy in 1135, the chroniclers record the eruption of the usual violent disorder. Animals in the royal forest, a source of resentment at a social level lower than the baronage, were slaughtered; so

was William Maltravers, one of those asset-stripping apparatchiks whom Henry had rewarded with a confiscated barony—in this case Pontefract—by a vassal of Ilbert de Lacy, heir to his father Robert, who had forfeited twenty years before. The fact that this case is well documented is unusual, but it is likely that incidents of this sort were all too common. It was 1087 and 1100 all over again, but more so. As on both those occasions, it was by no means clear who would succeed, and if the same person would succeed to both England and Normandy. Henry had tried harder than either of his Norman predecessors to stitch up the succession; but his attempt to designate his son William Adelin as future king and duke had foundered with the White Ship in 1120. In the absence of another legitimate son, and with the looming possibility that William Clito might vindicate his claim after all, he was forced to turn to his daughter Matilda. Her marriage to the count of Anjou, a traditional enemy of Normandy, and a designation which preserved the possibility of rescinding the arrangement, should Henry manage to sire another legitimate son, meant that there were many question marks over Matilda's prospects. In the event, England was snatched, in another pre-emptive coup, by Henry's sister's son, Stephen of Blois, the most wealthy baron in England. In Normandy at the time of Henry's death, Stephen had rushed across the Channel and been crowned and anointed before Matilda could move. Not unlike Robert Curthose, she had been in rebellion against her father at the time of his death. The Norman magnates were initially minded to make Stephen's elder brother Theobald duke, but opted for Stephen instead as soon as news of his elevation arrived from England; according to Orderic, they did so in order to avoid another division between kingdom and duchy. The amount of disinformation disseminated about Henry's wishes for the succession is exceeded only by that about Edward the Confessor's. What is clear is that, despite the regime's being founded on William the Conqueror's claim to succeed Edward, the Norman kings remained incapable of orchestrating their own successions, because they continued to try to do so in Norman fashion.

Whether Stephen's reign was doomed from the start by the dubious nature of his claim remains a moot point. Neither Rufus's nor, more strikingly, Henry's had been incontrovertible. At first, Stephen's accession appeared to mark the end of interregnal turmoil, following the by now conventional pattern. But Matilda's claim proved resilient, for it was based principally on the individual pledging of faith to her by the barons of England and Normandy. Moreover, Matilda was able to marshal Angevin military strength to prosecute it, and this progressively undermined Stephen's position, at first in Normandy and, from her arrival in England in 1139, in the kingdom too. In Normandy, under the aegis of her husband Geoffrey of Anjou, the last vestiges of Stephen's influence were expelled in 1144, at which point Geoffrey took the title of duke. Normandy had been conquered again, but not on this occasion by a king of England. In England neither side proved capable of delivering a knock-out blow, although for eight months during 1141 Matilda held Stephen captive, and for

a time it looked as if she intended to assume the title of queen—indeed, she may have done so briefly. There were occasional peace initiatives, seeking to strike the sort of deals made in 1091 and 1101. One of them occurred while Stephen was in prison. But they foundered on the irreconcilable nature of the dispute between Stephen and Matilda: for each of them claimed to be the legitimate successor of Henry I, and he could not be *antecessor* to them both.

In these novel circumstances the barons found that there were in fact considerable advantages in this particular form of the two lords predicament, repeatedly sketched with such horror by Orderic Vitalis. With Stephen and Matilda desperate for support within England, seeking to consolidate shifting spheres of influence, neither could exploit the powers of royal lordship in the way that previous kings had done. Thus a disgruntled baron could simply switch allegiance, taking his lands and resources with him: he could, in other words, renounce faith or 'diffidate' from one party and do homage to the other. The most famous (or infamous) case was Geoffrey de Mandeville, who changed sides at least three times. The conventional

CASTLE ACRE, Norfolk. Almost everything which can be seen here of the castle dates from Stephen's reign. William I de Warenne's original castle—more accurately a modest strong house, built soon after 1066—formed the foundation for the keep constructed in the early 1140s by his grandson, William III, within the massive new circular perimeter wall of the upper ward. Despite its grandeur, Castle Acre was not the family's most important seat in England.

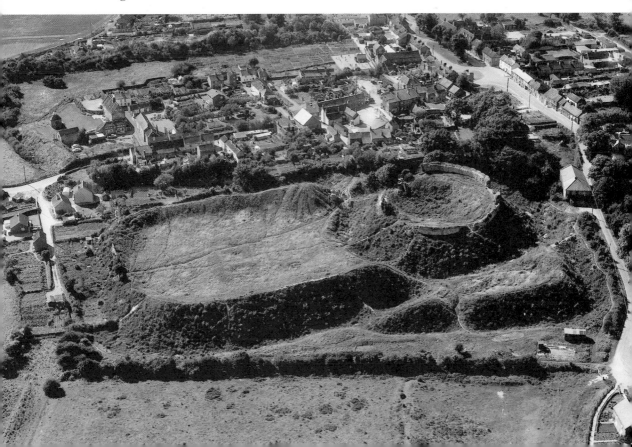

balance of the relationship between ruler and baronage was inverted. It was no longer the barons who felt their position to be precarious.

This transformation in the relationship between king and barons gave the latter far more licence to pursue grievances created by earlier ruthless, arbitrary exercise of the powers of royal lordship. Often these grievances had been nursed for decades. Now the uncertainty of succession at the very top was not confined to the brief period of interregnum, when the disaffected had previously taken the opportunity to seek redress, and those against whom they sought it tried to protect their gains, both attempting to second-guess which of the contenders would become king. From 1139 England found herself in a sort of enduring interregnum, which was precisely how many of the chroniclers presented Stephen's reign. Obviously this meant that rival claimants would line up on the opposing sides, focusing their disputes through the succession conflict. But it would be a mistake to see this as simply exacerbating the slide into what is conventionally termed 'the anarchy'. On the whole both Stephen and Matilda attempted to conciliate rather than alienate the supporters of their opponents: it was a sellers' market as far as fidelity was concerned. In any case it rapidly became clear that neither of them was in a position to offer secure warranty of title, precisely because neither of them could exercise the traditional powers of royal lordship in the traditional manner. Stephen and Matilda, and, after his arrival in England, her son Henry, often issued charters to the same recipients, in effect confirming what the other side had granted, whilst avoiding any explicit recognition that the other side had made the initial grant. It is thus possible to trace progressive, competitive bids for support in, for instance, the series of charters issued by Stephen and Matilda in favour of Geoffrey de Mandeville.

The collapse of effective royal government, manifest in the exchequer's ceasing to function, was the obverse of this emasculation of the powers of royal lordship. It meant that the principal causes of baronial resentment ceased to exist, and the unique kingdom created by the Conquest became far more like contemporary France, with barons erecting castles without royal licence, and issuing their own coinage. As the chronicler William of Newburgh put it, there were as many tyrants as there were castles.

The picture of anarchic disorder given by William of Newburgh, writing towards the end of the twelfth century, is typical of the chronicles written during the reign.

DOMESDAY BOOK. This folio is part of the survey of the 'king's land' (*terra regis*)—i.e. those manors which he had not granted out to his tenants-in-chief—in Hampshire. Note that the king's manors are grouped by hundred; note also how the rubricator has high-lighted the category 'TERRA REGIS', the names of hundreds, and the names of individual manors. This was done to assist royal officials in using the Book. The proof-reader, if any, must have been day-dreaming when he looked over this folio, for it contains two slips, referring to Harold as having 'usurped the kingdom' (in the entry for Hayling, in the right-hand column) and as having 'reigned' (in the first entry for Soberton in the right-hand column).

TERRA REGIS.

Ŕ Rex Willelm̃ tenet in dnĩo Ochā. Herald comes tenuit. Ibi quat xx hide. una hida 7 dim̃ min'. Te se defđ pro xxviii. hiđ. modo ñ geld. Tra. e. lvi. car̃. In dnĩo sunt xv. car̃. 7 c xxxviii. uilli 7 lx. borđ cũ xl. car̃. Ibi .l. serui. 7 viii. molini de lvi. sol 7 vii. den̄. 7 xxi. ac̃ pa. Silua. de .clx. porc̃.

T.R.E. 7 post. ualuit. l. lib ad numeṟu. Modo. l. lib. ad pensã.

De ipso cõ ptin' .ii. hide alod. ii. ecclus eiđ cõ. 7 ibi bt pbr̃. i. uillm̃ cũ una car̃. Val. vii. lib.

De eođ cõ teneñt alii .ii. pbr̃i. ecclas cũ .ii. uirg tr̃e. 7 ibi hñt una car̃ 7 dimiđ. Val. lxvii. sol 7 vi. denaṟ.

In SterchA Ipse Rex ten̄ in dnĩo DERELEI. Rex. E. tenuit. Luuỹ̃
Quot hide sint ibi. ñ dixeṟ. Tra. e. lii. car̃. In dnĩo sunt .v. car̃. 7 liiii. uilli 7 xxvi. borđ cũ xlvii. car̃. Ibi. xvi. serui. 7 vi. molini 7 dimiđ de .iiii. lib 7 xiii. solđ .iiii. denaṟ min'. Mercat̃ de viii. lib. 7 xv. ac̃ pa. Silua. de .cl. porc̃.

T.R.E. 7 post. ualuit. lxxvi. lib. 7 xvi. sol̃ 7 viii. denaṟ. Modo tantđ appciat'. 7 tam̃ redđ de firma. cxviii. lib 7 xii. sol 7 x. deñ.

De isto cõ ablata. e. una v. tr̃e. quã tenuit Leuui foresť. dic hund.

Ipse Rex ten̄ HALIBORNE. Vluuard tenuit de rege. E. Te 7 m̃ p una hida. Tra. e. iiii. car̃. In dnĩo. e. dim̃ car̃. 7 vi. uilli 7 iiii. borđ cũ una car̃. Ibi un̄ seruus. 7 v. ac̃ pa. Silua ad clausurā. 7 un̄ porc̃ de pasnag̃. T.R.E. 7 m̃. l. sol̃. Cũ recep̃.

Ipse Rex ten̄ HALSTIGE. Eddid regina tenuit. xl. sol̃. Te se defđ p v. hiđ. modo ñ geldat. Tra. e. iii. car̃. Ibi sunt viii. uilli cũ ii. car̃ 7 dimiđ. T.R.E. 7 post 7 m̃. ual. l. solđ.

Ipse Rex ten̄ GRETHA. Eddis regina tenuit. Te se defđ p una hida. ñ̃ geldat. Tra. e. iii. car̃. Ibi vii. uilli hñt .iii. car̃. Ibi silua de xxx. porc̃. T.R.E. 7 post 7 m̃. ual. lx. sol̃.

Ipse Rex ten̄ ELDRELEI. Lanch tenuit in alodiũ de rege. E. Te se defđ p. ii. hiđ. modo p dimiđ hida. Tra. e. ii. car̃. Ibi. iiii. uilli hñt. ii. car̃. Ibi silua de xxx. porc̃. Val 7 ualuit. liiii. solđ.

Ipse Rex ten̄ SELESBURNE. Eddid regina tenuit. 7 nunc geldau. De isto cõ d đ p̃ Radfredo pbr̃o dimiđ hida cũ eccla. T.R.E. 7 post. ualuit. xii. sol 7 vi. deñ. Modo. viii. sol 7 iiii. deñ.

In CEPTUNE hund.
Ipse Rex ten̄ in dnĩo CHALPEDRESHA. Vluue tenuit. 7 Mathild regina habuit. T.R.E. se defđ p. xx. hiđ. modo p. xiii. Tra. e xx. car̃. In dnĩo sunt. iiii. car̃. 7 xxxiiii. uilli 7 xv. borđ cũ xv. car̃. Ibi eccla 7 viii. serui. 7 iii. molini de xx. sol̃ 7 v. ac̃ pa. Silua de xxx. porc̃ de pasnag̃. De herbagio. vi. sol 7 iiii. denaṟ.

De hac tr̃a ten̄ Alboľd. ii. hiđ 7 dimiđ. Tedgar tenuit. T.R.E. 7 ñ potuit ire alicubi. h tr̃a geldau sup de dimiđ hida. cũ aliis hiđ. Ibi. e. in dnĩo. i. car̃. 7 v. uilli 7 ii. borđ cũ. i. car̃. 7 ii. serui. 7 una ac̃ pa.

De eađ tr̃a supdicta cõ ten̄ Tebaľd. iii. hiđ 7 dim̃. Ricard̃ de Tonebrige deđ ei. qdo tr̃a de regina habuit. in nesciut p que ten̄. Duo pacheniste tenuer. nec alicubi recede potuer. Ibi. ii. car̃ sunt in dnĩo. 7 iii. uilli 7 viii. borđ cũ ii. car̃. 7 ii. serui. 7 una ac̃ pa. Silua de vi. den̄.

Totũ cõ T.R.E. ualb. xv. lib. 7 post jn und̃. 7 tam̃ qui ten̄ redđ xxxii. lib. pars Alboľd. xl. sol̃. pars Tetbaldi. iiii. lib.

In PORTESDONE hđ.
Ipse Rex ten̄ in dnĩo WIMERINGES. Rex. E. tenuit. Nung̃ hidatũ fuit. In dnĩo sunt. ii. car̃. 7 xvi. uilli 7 vi. borđ. cũ. iiii. car̃. Ibi. ii. serui. Silua de. v. porc̃.

In Cosehã sunt .iii. hide que ptin' huc. ubi T.R.E. erant viii. burs. i. colibta. cũ. iiii. car̃. redđces. l. solđ. viii. denaṟ min'. Ibi. e. in dnĩo una car̃. 7 viii. uilli 7 viii. borđ cũ. v. car̃. 7 u. serui. 7 una salina.

In PORTCESTRE est pars alia huj̃ cõ. nung̃ hidata fuit. Ibi. e. in dnĩo. i. car̃. 7 un̄ uills 7 vi. borđ cũ. i. car̃. Ibi una ac̃ pa. Silua de. x. porc̃.

In BOSEBERG hđ.
Ipse Rex ten̄ in HALIESEI. ii. hiđ 7 dim̃. Leman tenuit in paragio de rege. E. Heraľd abstulit ei qdo regn̄ inuasit. 7 misit in firma sua. 7 adhuc ibi. e. Te se defđ p. ii. hiđ 7 dim̃. Modo p nichilo. Tra. e. i. car̃ 7 dim̃. In dnĩo. e una car̃. 7 un̄ uills 7 viii. borđ cũ dimiđ car̃. 7 una ac̃ pa 7 dimiđ. T.R.E. ualb. xl. sol̃. 7 post. xx. solđ. Modo. lxx. sol̃.

In MENESTOCH hund.
Ipse Rex ten̄ SUBERTUNE. Leman tenuit de Goduino comite. Heraľd qdo regnabat abstulit ei. 7 in sua firma misit. 7 adhuc. e. ibi. Ipse Leman ñ potuit recede quo uoluit. Dicunt u qd fuit in ceprune in paragio. Te se defđ p. iiii. hiđ. m̃ p nichilo. Tra. e. ii. car̃. In dnĩo. e dimiđ car̃. 7 vi. uilli 7 ii. borđ cũ. ii. car̃. 7 ii. molini de. xv. sol̃. 7 una ac̃ pa. Val 7 ualuit sep̃. iiii. lib.

Ipse Rex ten̄ SUBERTUNE. Goduin tenuit de rege. E. in paragio. nec alicubi potuit recede. Heraľd abstulit ei. 7 in firma sua misit. Adhuc. e. ibi. Te se defđ p. iii. hiđ. modo p nichilo. Tra. e. ii. car̃. In dnĩo. e dimiđ car̃. 7 ii. uilli 7 ii. borđ cũ. i. car̃. Ibi un̄ molin de. v. solđ. 7 ii. ac̃ pa. Val 7 ualuit sep̃. xl. sol̃. he due tr̃e redđ. xl. sol̃ plus.

Ipse ten̄ MENESTOCHE. De firma regis. E. fuit. Te se defđ p una hida 7 dimiđ. modo p nichilo. Tra. e. iiii. car̃. In dnĩo. e una car̃ 7 dimiđ. 7 iii. uilli 7 xvi. borđ cũ una car̃ 7 dimiđ. Ibi. iiii. serui. 7 iiii. colibta. 7 un̄ molin de. x. solđ. 7 iii. ac̃ pa. Silua de. x. porc̃. p herbagio. x. solđ.

In MENE hund.
Ipse Rex ten̄ MENES. Stigand tenuit T.R.E. Abb monachoṟu. 7 post quãdiu uixit habuit. Te fuer. lxxii. hide. 7 geldab p xxv. hiđ 7 una v. Tra. e. lxiii. car̃. In dnĩo sunt. viii. car̃. 7 lxx. uilli 7 xxii. borđ. cũ. l. car̃. Ibi. xv. serui. 7 vi. molini de. xl. solđ. 7 viii. ac̃ pa. Silua. de. cc. porc̃. de pasnag̃. p herbagio. vii. solđ 7 vi. deñ. T.R.E. ualb. lx. lib. 7 post. xl. lib. Modo. lx. lib. 7 tam̃ redđ de firma. c. lib ad pensã. Sed ñ potest pati.

De hac tr̃a huj̃ cõ ten̄ Walchelin̄ ep̃s vii. hiđ 7 una v cũ eccla. he hide ep̃i geldau̇g in. iii. hiđ 7 una v. alie ñ geldau̇g.

Astant pontifices · abbates · necne priores · Ceu per quiuerras res ecclesie spolia

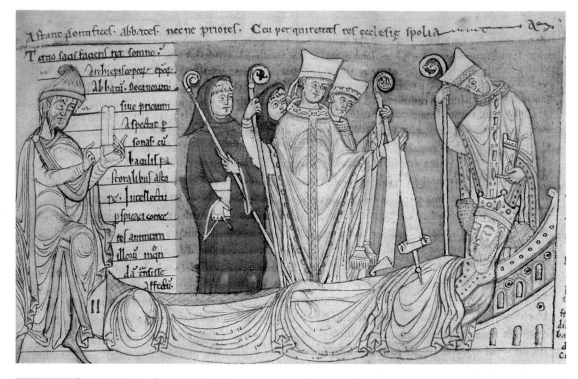

tum vo de feod: steui ad recognitionem
solet puenire. Et p hoc breue summone
btur inde recognitio. Breue de eadem
recognitione summonenda.

Rex vic salt. Sum pts sum xij le z
le. z. qd sint z. par sa. re. utrum
H. teneat unam carr terre in illa uil
la qm R. clamat uersus eum p meum
breue in feod ut in uad. inuadiatam
et ab ipo z. uel ab h. antecessore eu. uel sic
utrum illa carrucata terre. qm R. cla
mat p breue meum u sit z. in illa
uilla sit hereditas siue feod ipsius R. t
uadium inuadiatum ei ab ipo z. uel
ab h. antecessore ei. z uidm. d. ze. z
sum pts su. p h. q z. u. d. qd sit i iud
d. re. jhas. ze. z. d. De eo qui petit
recognitionem occasione eadi au

Terum quoq; cu successoris
igit aliqm tenere alios tenen
tum in uad. itaq; idem mortus saisit

Postremo de illa recognitioe q ap
pellat de noua disaisina restat
dicendum. Cum quis uicz; uista sai
sinam dnm seg. r. intra temp a dno rege
de consilio p certu ad h ititutum. qd qq;
maturi. omniq; minus censet alium in
uiste z sua iudicio dissaisiert de lito te
suo de saisito hui ititutionis biuo
subuenit z tale breue habebit. Breue
de noua disaisina.

Rex vic salt. Questus; i m z. qd R.
inuiste z sine iudicio disaisiuit
eum de lito tenemento suo in illa uilla
p ultimam trassationem meam in
notr. J iō t pcipio qd si fecid; z facias re. illud
re se. de cla. suo p tunc facias re. illum
resaisiri de catall q in ipo capta fuerit.
et ipm te. c̄. ea. esse ut pace usq; ad dau
sum pasca. Et uidm facias. vii. le. He
ho. de vic. uide re. d. j nōia cor ibreuiatu

Most famously, according to the *Anglo-Saxon Chronicle*, putting on a final spurt before the tradition of English vernacular historical writing fizzled out, it was a period of 'nineteen years when Christ and His saints slept'. If so, they were doing very nicely in their sleep, for, despite the impression given by the chroniclers of unremitting violence, the reign in fact saw monastic foundation on an unprecedented scale. Depending on how the figures are calculated, anything between 114 and 175 houses were founded. William of Newburgh termed monasteries 'the castles of God in which the knights fighting for Christ the King could fight against spiritual wickedness'; it is clear that 'castles of God' were being founded on the same ambitious scale as castles of tyrants, and this would not be possible in a country in the grips of anarchic chaos. The founders of these houses were, by and large, those very barons, or 'tyrants', who were supposedly causing the anarchy. In fact their ability to marshal resources on the scale required by William de Warenne, earl of Surrey, to extend Castle Acre, or by William d'Aubigny, earl of Arundel, to build the magnificent Castle Rising, or to found (respectively) Thetford Priory and Buckenham, means that baronial administration must have been both extremely efficient and largely undisturbed by anarchy. Although massive, the military function of these castles is worth pondering: it is, for instance, difficult to see how anyone could fire an arrow through the arrow slits at Castle Rising. The barons also issued coins, as central control over coinage collapsed: a mint was established at Castle Rising probably in the mid-1140s. Baronial minting of coin was not an index of disorder, but of baronial willingness and ability to take up the slack as royal government ceased to intrude in the localities.

This willingness is also manifest in the extant agreements, usually termed 'treaties', between barons, some of which made provision for the parties' owing nominal allegiance to the opposing sides. Spheres of influence were carefully delineated, and arrangements made to minimize the disruptive effect of the war, should it unfortunately intrude into the lands of the parties. Although Ranulf, earl of

ON THE AUTHORITY OF GRIMBALD, Henry I's doctor, depicted as a witness to the left of the drawing, 'Florence' of Worcester's *Chronicle* reports that while in Normandy in 1130 the king was terrified by three successive nightmares in a single night. In the first, a crowd of angry peasants menace him with farming implements; in the second, a group of knights (possibly barons?) threaten to attack him with their weapons; in the third, reproduced here, hostile prelates stab him with the points of their pastoral staves. All are said to have been aggrieved at Henry's financial extortions. Perhaps Henry had a conscience after all; his nightmares were certainly premonitory of his subjects' reaction to his death.

PART OF THE FORMULA for a writ of novel disseisin from a manuscript of Glanvill's *Treatise on the Laws and Customs of England* which was possibly kept in the Exchequer. Note the marginal doodle of the cat and mouse: perhaps the artist was musing about a royal cat catching a baronial mouse. Certainly one of the consequences of novel disseisin was to make it impossible for lords to play with their vassals like mice, for the assize enabled the vassals to bite back.

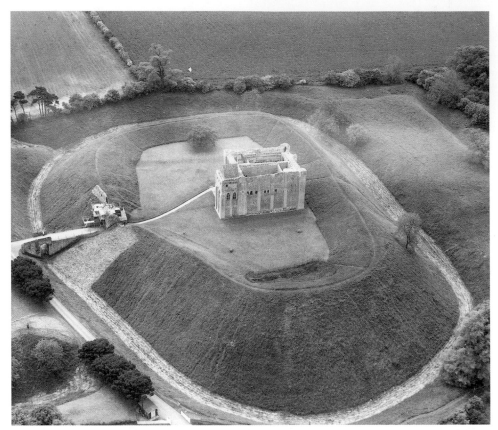

CASTLE RISING, Norfolk. Rising was a mere outlier of the manor of Snettisham until William d'Aubigny's marriage to Queen Alice, widow of King Henry I, and his consequent elevation to an earldom in 1139. Building the castle to mark the event involved moving the existing village: the ruins of the old parish church, enclosed within the inner bailey, are visible in the foreground. William clearly did not do things by halves. The castle keep is not so much a tower as a grandly built hall and chamber. The emphasis is on residential magnificence.

Chester, and Robert, earl of Leicester, recognized that their respective duties to their 'liege lords' might force them into formal confrontation, they agreed between themselves the level of the military support they would render to those lords in attacks they might be obliged to make on each other's lands, conditions for reparations should damage be inflicted in such circumstances, the extent of prior warning that each would give the other of any intention to launch such an attack, positions from which they would not launch such attacks, and so on. Moreover, Ranulf enfeoffed Robert with the castle of Mountsorrel (Leicestershire), thereby becoming his lord. In other words, the relationship between lord and vassal, both in this case barons, formally qualified what had previously been an overriding obligation of

fidelity to the king (or, in Ranulf's view, Matilda) as liege lord. This is only the most striking of a considerable number of surviving 'treaties', demonstrating baronial need and ability to neutralize the disruptive potential of the unresolved dispute between Stephen and Matilda. And as this 'treaty' reveals, the existence of a formal lord–vassal relationship between the principals did not prevent the 'treaty' from being just that: a reciprocal deal, between what to most intents and purposes appear to be equal parties, ratified by the Church as the only surviving kingdom-wide institution. It is therefore no surprise that charters granted to barons by Stephen and Matilda began to assume the characteristics of these 'treaties': Matilda's second charter to Geoffrey de Mandeville is a notable example.

There are two standard interpretations of why this state of affairs was brought to an end, when in November 1153, in the so-called Treaty of Winchester, Stephen adopted Henry, son of Matilda and Geoffrey of Anjou, and by then duke of Normandy (his father having, well before his own death, resigned the position to him), as his heir and successor, to the exclusion of his surviving son William. The first is that everyone, barons included, had tired of the anarchy, the barons having fought themselves to a standstill. Doubts have already been expressed about the extent to which the disorder described by the chroniclers corresponded to reality; figures from the fragmentary early pipe rolls of Henry II's reign, which have customarily been interpreted as offering objective corroboration of the chroniclers' tales, can be shown to do no such thing. The amounts written off as 'waste' in different counties do not correlate with military activity, and may more plausibly be seen as evidence of the rustiness of exchequer machinery, as it began to be cranked into action for the first time in many years. Accountants' headings tend to suit the convenience of accountants, rather than describe reality. It is naïve to accept them at face value. The war-weariness interpretation is therefore at odds with the best evidence for prevailing levels of disorder (as opposed to disruption of royal government), and with the fact that the collapse of effective royal control meant that the cause of most baronial grievances, listed so carefully in Henry I's coronation 'charter', had disappeared. So, although Stephen's reign was hardly an unqualified boon for the barons, there was little reason for them to want to bring this state of affairs to an end; it was certainly preferable to what had preceded it. The last thing they desired was all-out victory for one side, and a return to the *status quo ante bellum*; hence their unwillingness to fight a pitched battle, which carried the additional risk of losing everything. Henry, archdeacon of Huntingdon, one of the most perceptive analysts of baronial motivation, described how, after Duke Henry had invaded England in early 1153, his forces and those of the king in effect refused to fight at Crowmarsh:

They loved indeed nothing better than discord, but were unwilling to commit themselves to battle; for they desired to raise up neither one nor the other of the claimants to the throne, lest by vanquishing one they might become entirely subject to the other. They preferred that, each being kept in fear of the other, the royal authority should not be exercised against them.

And so a deal was struck.

The second, more nuanced explanation for the end of the war is that Stephen's agreement with Henry gave the barons what they had been fighting for: namely hereditary tenure of their estates. Just as hereditary tenure of the throne was established by Stephen's adoption and designation of Henry, runs the argument, so was hereditary tenure of baronial land. The problem with this interpretation is that nowhere in the extant 'treaty' between Stephen and the future Henry II is there any mention of establishing hereditary tenure for barons. The belief rests on chronicle references to an agreement to restore the 'disinherited', for which there is no evidence in the charters subsequently issued either by the king or Duke Henry. All the chronicles in which these references are found are pro-Angevin, and it seems that they are making a rhetorical point about Stephen's prior status as a usurping king, rather than describing one of the major provisions of a treaty. During what had been, in the view of these chroniclers, a *de iure* interregnum, many must have been 'disinherited', as always happened during interregna; with Stephen's acquisition of at least a patina of legitimacy thanks to Duke Henry, this situation would be rectified. Legitimacy would be re-established all the way down, as it were. Only by accepting this polemical point as a principal term of the 'treaty', mysteriously unmentioned in the royal charter which details the terms, may this alternative interpretation stand.

In fact, as will shortly become clear, if the barons had won hereditary tenure of their lands in the 'Treaty of Winchester', the subsequent political history of England up to 1215 becomes largely inexplicable. But the fact that they had not won this prize does not mean that the treaty should not be seen as by and large a baronial achievement. It was a combination of the baronial refusal to allow either Stephen or Henry outright military victory, and the ability of the papacy in the circumstances of Stephen's reign effectively to forbid the consecration of any of his sons as king, which forced the king and duke to come to terms. Those terms institutionalized, for the rest of Stephen's life, the existence of two liege lords within England, to whom all landholders owed homage and fidelity, and made those obligations conditional on the principals keeping to the agreement. Wholesale diffidation would be one consequence of a breach; another would be excommunication, for churchmen were made guarantors. In other words, several of the characteristic developments of Stephen's reign—including recognition of a territorial division between the king's 'part' of the kingdom and 'the duke's part'—were embodied in a compromise forced on the parties by the baronage. The model was the baronial 'treaty'. What the compromise lacked was any explicit attempt to circumscribe Henry's future exercise of his powers as lord, should he eventually become king in accordance with its provisions. Although it enabled Stephen to secure massive landed resources for his surviving son William, from Henry's accession there would be only one liege lord. What it solved was the problem of royal succession which had dogged kings since

the Conquest: when Stephen died less than a year later, Henry, who was in Normandy at the time, showed no hurry to cross the Channel. He eventually became king over seven weeks after Stephen's death. No post-Conquest interregnum had lasted anything like this long. And during this unprecedentedly long gap, the kingdom remained at peace. Henry of Huntingdon was so flabbergasted that he broke into verse to describe the novel situation: 'England lacked a king, but it did not lack peace.' The reason was the provisions of the treaty, which ensured that castles in England were in the hands of Henry's agents from the moment of Stephen's death. But this solution to the long-standing problem of interregnum was not a solution to equally long-standing baronial grievances, as the reigns of Henry II and his sons were to make all too clear.

Angevin Kingship and Magna Carta

With Henry's accession England and Normandy again came under the same ruler. In 1151 Henry's father had left him Anjou temporarily, stipulating that his own body should not be buried until Henry had sworn an oath that he would surrender the county to his brother when he had secured England. In 1152 Henry had married the divorced wife of King Louis VII and gained Aquitaine with her. After his accession in England, he refused to relinquish Anjou, which connected Normandy with Aquitaine. The kingdom of England thus became part of a far larger conglomeration of principalities; but that they were ruled by the same person did not make them a unity. The term 'Angevin Empire', often used by historians, has no contemporary warrant. Each constituent principality was ruled as a distinct entity, with a distinct governmental mechanism ultimately under Henry's control. Despite the disruptions of Stephen's reign, which had made England far more decentralized in the Continental fashion, it remained unique. This is evident in the fact that the overwhelming majority of Henry's surviving charters relate to England, a discrepancy best explained by the finality in England of written evidence of a royal decision in any dispute about lands or rights, as compared with the other, less centralized principalities ruled by Henry. The post-Conquest system had emerged battered and bruised from Stephen's reign, but in its essentials still intact; there had been no attempt to deny the principle of tenurial dependence on the king. In post-Conquest England such a denial was inconceivable. The subsidiarity established under Stephen was therefore vulnerable to any king who could begin to pull the levers of royal lordship again. As we have seen, the 'Treaty of Winchester' failed to impose any overt restrictions on Henry if and when he succeeded to the kingdom; and his undertaking, in his terse coronation charter, to grant to his barons and liegemen everything which his grandfather Henry I had granted might have sounded ominously ambiguous to the more thoughtful among them. But it was not an undertaking to which even the most pessimistic of barons might take exception, for no one

could object to what Henry I had promised (as opposed to what he had done): Stephen himself considered Henry I to be his *antecessor*; and Henry I's reign had been treated as a beacon of legitimacy by both Matilda and Henry. Focusing on his grandfather in this way had the merit, as far as Henry II was concerned, of beginning to suppress evidence of his debt to Stephen: Stephen was eventually written out of the records of Henry's reign almost as systematically as King Harold II disappeared from those of William the Conqueror's reign.

It is not absolutely certain that the exchequer ceased to function under Stephen, but Richard FitzNeal, author of a handbook on exchequer procedure written in the 1180s, says that it did. It was certainly reactivated by Henry as soon as he became king. But it could not function as it had done under Henry I, for the new king was in no position to restore it to full fiscal ferocity straight away. He had a number of overmighty subjects, amongst whom Stephen's son William was predominant. As the chroniclers observed, he was extremely fortunate that death carried off most of them, including William, within a few years of his accession. Many of their heirs were minors, and thus fell into royal wardship, giving Henry long-term control of their estates. Not only were the revenues massive; he had the freedom to implement his proclaimed policy of renewing the times of his grandfather, his *antecessor*.

The most ingenious means that he used were a series of innovations in legal procedure which built on the intrinsic strengths of the king's position as liege lord. Not all the innovations survive, but the most important are dealt with in the treatise known as Glanvill, written in the late 1180s, which is primarily a procedural formulary, but which also attempts to explain some of the procedures as it records the executive instruments, or writs, which initiated them. All of the innovations could be presented as attempts to make the honorial courts of barons function more consistently in dealing with subtenants. They did not constitute new legislation, or even overtly lay down new principles; but by creating regular summary procedures for royal intervention in lords' courts, and by facilitating the transfer of cases from lords' courts to the lord king's court on the initiative of subtenants, their effect was increasingly to vest final decisions in the king's court. What remained of baronial jurisdictional autonomy in dealing with subtenants was thereby undermined. In order to understand how this came about, it is necessary to master some of the technicalities.

The writ of right (*rectum*, perhaps more accurately to be translated 'justice') was a writ issued by the king, addressed to a lord, ordering him to 'do right' to a claimant. Although the writ itself, as an executive instrument, never defined what 'right' was, the court rolls which begin to survive from early in Richard's reign show that being entitled to 'right' meant proving that an ancestor of the claimant had held the land in dispute on the day of Henry I's death. In other words, it defined 'right' in terms of the king's own right (*ius*) to the throne, and demonstrated the continuing determinative influence on tenure of the original Norman claim, for there are obvious similarities with the legal framework of Domesday Book. It provided a regular

mechanism for securing the reversal of decisions made in lords' courts by, in effect, imposing royally determined principles upon them.

The writ *praecipe* was addressed to the sheriff, ordering him to require a defendant to do something for the plaintiff; if not, the defendant was to answer in the king's court for his failure to comply. Beginning as a simple executive order, it rapidly became an instrument for transferring cases into the king's court. Forms of *praecipe* proliferated, as it was applied to a wide variety of grievances. Its effect was not to impose uniform principles on lords' courts, but, on those occasions when it was used by subtenants, to deprive lords of jurisdiction.

The other major procedural innovations are collectively termed possessory assizes. They are, or ended up being, four in number. *Utrum* became an action for deciding whether a particular piece of land was held by a parson in free alms or not; and *darrein presentment* sought to establish who had last presented a cleric for appointment to a particular living. These need not detain us. *Novel disseisin* sought to establish whether the plaintiff had been recently disseised of a particular free tenement 'unjustly and without judgement'; and *mort d'ancestor* whether the plaintiff seeking a free tenement was the adult heir of the deceased, previous tenant, who had held the land as a fief ('in fee'). This was done by a jury of locals answering specific questions in front of royal justices. If, in the former case, it were established that the plaintiff had been disseised 'unjustly and without judgement' within the period of limitation of the assize, then the land in question was restored to him by authority of the king; and if, in the latter case, the jury testified that the plaintiff was the adult heir of the last tenant, then by force of royal authority he secured the tenement. It is clear in each of these cases who was the loser. With *novel disseisin*, the disseisor the justice of whose action was assessed before the king's justices was the plaintiff's lord. The assize offered an easy route for any subtenant to dispute the punishment of disseisin meted out by his lord: by the very act of disputing it in this way, he transferred the case before the king's justices, who thereby became the judges of what constituted just judgement. *Mort d'ancestor* marked an even more epoch-making shift. Its effect was to deprive lords of the right to escheat in any meaningful sense, for it

THIS DRAWING, on an Assize Roll of Henry III's reign, depicts a judicial combat between Walter Bloweberme and Hamo le Stare. Walter was an 'approver', a criminal who had confessed and received a royal pardon conditional on his accusing and vanquishing his accomplices. Walter accused Hamo of complicity in a robbery, and defeated him. Hamo's fate is starkly illustrated. Trial by battle was a Norman import, in both criminal and civil cases; like other ordeals, it was supposed to reveal God's judgement.

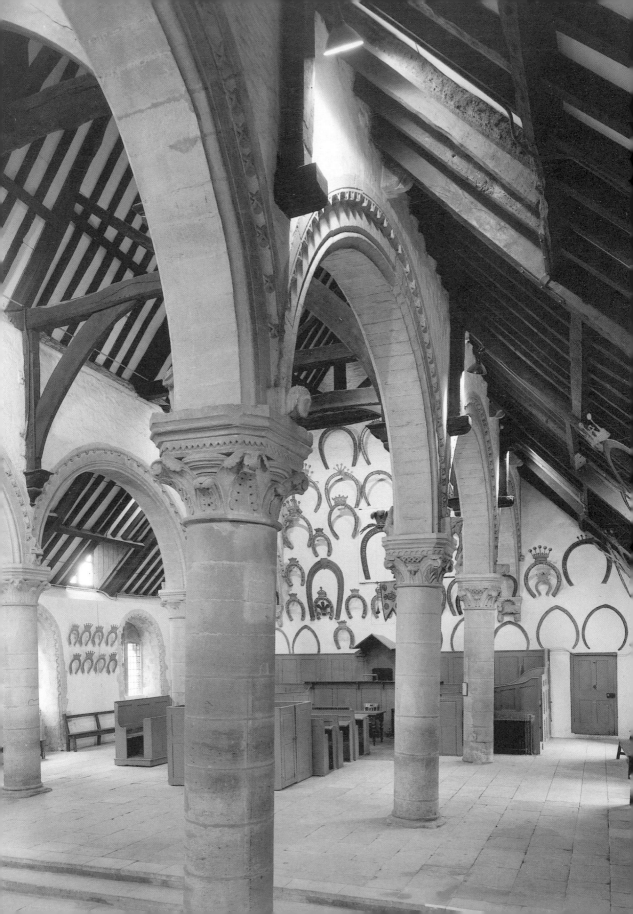

offered royal protection to any adult heir. A lord could no longer screw large amounts of relief out of heirs aspiring to become tenants. Indeed, the assize made it imperative for the lord to accept an heir's homage; for the heir already had royally guaranteed possession of the land prior to his being formally seised by the lord. If the lord refused to accept the homage by which the heir would be formally seised, the heir would hold the land without any duty of service to the lord, and the lord would have neither land nor service. It is therefore no surprise that during the reign of Henry II reliefs for subtenants became fixed duties, routinely paid. *Mort d'ancestor* had fundamentally altered the balance of power between lord and tenant, and made it impossible for a lord to deny the claims of an heir, or to exploit heirs in an arbitrary fashion.

All of these innovations strengthened the rights of free tenants (and their heirs) against lords; none of them strengthened the rights of lords against free tenants. It is difficult to believe that Henry II was unaware of this. In the second quarter of the thirteenth century, the author of the great legal treatise commonly attributed to Bracton thought that the assize of *novel disseisin* had been 'devised in the course of many night watches'; the other innovations must have required similar sessions, with Henry and his advisers sitting up into the small hours. For they were devised with a subtle deviousness: they often developed and adapted formulas found in the writs of earlier kings; they seemed simply to facilitate the smoother operation of traditional feudal justice, and to integrate it more closely with the workings of the lord king's court. But the end result, by creating a consistently applied law defined by the king's court, was to undermine what jurisdictional autonomy the barons had had. While the characterization of lords' courts as entirely autonomous prior to Henry II's reign has been overdone—it is difficult to imagine Henry I having many qualms about intervening in a particular case—there can be little doubt that autonomy had been consolidated during Stephen's reign. It was precisely the regularity and novelty of the procedural reforms, as opposed to *ad hoc* interventions by earlier kings, or (in the case of Henry I's ordinance on shire and hundred courts) to the definition of the respective spheres of jurisdiction of honorial courts and the surviving public courts of Anglo-Saxon England, which made them so insidious as far as baronial jurisdiction was concerned. They were built on that link between king and subtenant which was ceremonially established by the oath of Salisbury, when the fruits of the Domesday survey were presented to the Conqueror; they gave judicial sanction to Henry I's

OAKHAM CASTLE, Rutland. The free-standing, stone-arcaded hall was built in the bailey in the late twelfth century. Its Corinthian capitals reveal the influence of the choir at Canterbury Cathedral, begun in 1175. It is first recorded as an assize court in 1229; it was last used as such in 1970. A 1521 survey of the lordship of Oakham has the earliest mention of a (probably much older) custom whereby any peer of the realm on his first visit to the town had to forfeit a horseshoe to the lord of the manor; hence the horseshoes hung on the walls.

commands in his coronation 'charter' that his barons should in turn treat their vassals as he was promising to treat them, now subsumed in Henry II's blanket confirmation of that 'charter', as he termed it, in his own coronation charter. They created the basis of what we still call common law—justice accessible to all the lord king's vassals, not just his tenants-in-chief.

A moment's reflection will reveal that, logically, there must be one category of vassals who could not benefit from any of these innovations. All of them involved either the lord king's intervention in the workings of a baronial court, or the transfer of a case from a baronial court into the king's court. There was one lord in whose court the king could not intervene in this way, and from whose court a case could not be transferred into the king's court: namely, the lord king himself. So those who held directly of the king could not benefit from that strengthening of the rights of tenants (other than unfree, or villein, tenants) against lords which was in the process of transforming their relationships with their tenants. In other words, the feudal bond between king and tenant-in-chief remained primitive, precisely because the king was the only lord who was not a tenant. The implications may be illustrated by changes in the significance of relief payments. Whereas reliefs for the heirs of all other tenants came to be calculated on a fixed, common scale, those for the heirs of tenants-in-chief continued to be arbitrary exactions. All reliefs except those paid by the heirs of tenants-in-chief had become a sort of death duty; those for the heirs of tenants-in-chief were still a precondition of

A SEVENTEENTH CENTURY FACSIMILE of a charter and seal (both now lost) of Richard Malebisse in favour of Newburgh Abbey, Yorkshire. Malebisse (c.1155–1210) was a considerable landholder in Yorkshire and Lincolnshire. Like many in his class, he was kept on a short leash of debt by consecutive kings, and borrowed heavily from Jews. In 1190 he led a sworn association of landholders who exploited the anti-Semitism whipped up by the Third Crusade to instigate the pogrom of the York Jews and destroy the records of their debts. Collective baronial action, engendered by, yet in defence against, governmental innovations, could take darker forms than Magna Carta.

being seised by the king, for in this one case escheat remained a reality. This did not mean that the heirs of barons ever directly refused to pay; however colossal the sum demanded, it never seems to have put off an aspiring successor. But it did mean that barons could be ensnared by their lord in debt as no other tenant was.

Thus, as Henry II's reign progressed and he managed to reassert residual royal powers over the machinery of government, the barons found that his policy of renewing the times of his grandfather was all too true as far as they were concerned. The effect of the legal innovations was not only to consolidate the king's bond with subtenants, making baronial rebellion an even less auspicious prospect, but also to make it extremely difficult for the barons to recoup their losses *vis-à-vis* the king by exploiting their own powers of lordship, although they tried with feudal aids. They were caught between a rock and a hard place. The one great baronial rebellion, in 1173–4, was a failure, and was in any case largely a Continental affair; in its aftermath, the king was able to tighten the screws even further. His Continental commitments were far more extensive than those of his Anglo-Norman predecessors; as he suffered reverses, the pipe rolls reveal that the demands made on England became increasingly extreme. And it was the barons who bore the brunt of this exploitation.

The accession of Henry's son Richard in 1189, or, on his death in 1199, that of Richard's younger brother John, made no difference to the situation—indeed, Richard's attempts to raise funds to finance his participation in the Third Crusade, and, after he had been taken captive by Leopold of Austria on his return journey, to ransom himself, made it even worse. Pressure from the French king was almost unrelenting, particularly on Normandy. And in 1204 John lost Normandy, subsequently devoting most of his energies to his ultimately disastrous attempts to reconquer the duchy. It was the overriding need for cash which forced these kings to be increasingly inventive in the search for sources of revenue. The real value of fixed customary renders was steadily eaten away by inflation from about 1180, making it necessary both to break tradition and raise the amounts extracted, and to devise new renders. It is no accident that this was precisely the period, from the early 1190s, when the written records of government began to proliferate, as its machinery became more complex and ingenious. One example which, like the possessory assizes, particularly benefited small-scale tenants was 'feet' of fines: the 'foot' was a third part of an indenture recording a legal agreement, say the purchase of some land, reached in the king's court, and it was filed in the Treasury. Hubert Walter, Richard I's justiciar, devised the first one on 15 July 1195. Where these revenue-raising devices were not entirely new, they often pushed the traditional rights of the king to extremes, particularly where tenants-in-chief were concerned. In either case, they were based on the king's arbitrary powers as liege lord; on the fact that his primitive lordship was becoming, as a result of his legal innovations, increasingly distinct from that of any other lord.

Thus was the scene set for the outbreak of civil war, in the aftermath of John's definitive defeat by the French king Philip Augustus at Bouvines in 1214. Normandy had been lost for ever. Having moved beyond the crude plot of 1212 to solve their problems by assassinating John, or deserting him in battle against the Welsh, those who were ranged against the king sought more sophisticated ways of restraining him. They focused on the novelty of many of the devices used by John, and the extremes to which he had pushed the exploitation of those lordly rights—like relief—which were not novel. They emphasized custom, in contrast with the king's behaviour. Thereby they arrogated to the baronial opposition the language of legitimation in terms of the past which had been used by kings since the Conquest. The document which they chose to encapsulate good custom was what had become known as Henry I's coronation 'charter', now resurrected from the archives. As we have seen, it undertook to restore 'the law of King Edward'; restoring the good laws of King Henry therefore entailed restoring those of Edward the Confessor. The king could hardly argue against the coronation 'charter', given the way in which Henry I had been used by his father as *antecessor*, reaffirming what he had termed Henry's charter in his own; nor could he argue against Edward the Confessor, on whom the post-Conquest regime was based. But in early 1215, in a moment of rich irony, he was reduced to seeking (unsuccessfully) a renewed oath of allegiance to himself against all men and against the 'charter' of Henry I. Henry I was such an ambivalent figure precisely because he had been able to ignore all the promises made in his 'charter' as soon as he was secure; the opposition to John had to find some way of binding the king, so that his arbitrary will would no longer be untrammelled.

The barons were not seeking a return to the sort of existence that their ancestors had had under Henry I. Their programme, as eventually articulated in Magna Carta, was far more subtle than reactionary. It showed that they had learnt a great deal from the legal and administrative reforms of Henry II and his sons. They had not been excluded from the processes of royal government, but had, like their vassals, been drawn in as justices and administrators. In other words, they had been educated. In the process they had usually become entrapped in coils of debt; but this was something from which the king might, and did, grant selective remission or deferral. On the whole, debt kept them on a short leash. The baronage was not, of course, an entirely distinct category of tenant: from William the Conqueror's reign, many barons had held some of their lands as tenants of other barons. They were therefore well aware of how subtenants had benefited from Henry II's reforms. Now they were groping for a means of securing those benefits for themselves too; and this could only happen if some mechanism were found for binding the king as they had been bound.

In the first draft document recording baronial proposals, known as the Unknown Charter, Henry I's coronation 'charter' is supplemented by a series of concessions placed in John's mouth. Some amplified clauses of Henry's 'charter', and some dealt

with aspects of Angevin royal government which had not existed in 1100, like the debts which many barons (and others) had been forced to contract with Jewish moneylenders in order to pay the massive sums demanded of them by the king. But even these supplementary clauses remain simply pledges of good intent, whereas in the far more extensive document known as the Articles of the Barons, cast in the form of a petition to which the king accedes, and drawn up shortly before Magna Carta itself, there was a dramatic development. The barons were to elect a court of twenty-five of their own number, any four of whom might act if the king or his agents appeared to be breaking the terms of the concessions he had made. If the king persisted in his actions, the full court of twenty-five could order forceful seizure of the king's lands, castles, and goods, not simply by the baronage, but by what was termed 'the commune of the whole land'. They could make war on everything except the king's person, while remaining formally the king's men, and thus retaining title to their lands. So 'the commune of the whole land' was not just a vague figment of the baronial imagination: the clause envisaged its being constituted by individuals taking an oath, and the king undertook to prevent no one from doing so. The phrase showed just how well the baronage had been taught by the Angevin kings.

One revenue-raising device exploited by kings was the sale of fiscal and jurisdictional privileges and exemptions to individual and collective recipients. In the latter category, charters of liberties were often conceded in perpetuity to towns or cities. Individual citizens could not be the donees, because the perpetual grant had by definition to be made to an undying recipient. Hence the need to invent a legal person, or commune, which did not die. The officers of the commune acted on its behalf, applying its common seal to documents recording its acts. Collectively the officers of the commune acted as its council; that of London, formally established in 1191, happened to have twenty-five members. Both Richard and John hesitated to give it official recognition, but this was eventually extracted from John in May 1215. In the Articles of the Barons and Magna Carta this concept was applied to all free men in the kingdom, as a collectivity.

Although neither the Articles of the Barons nor Magna Carta says so directly, therefore, the court of twenty-five acted on behalf of 'the commune of the whole land', constituted by the voluntary oaths of individual free men. This clause in the Articles states that it is framed to preserve the peace and security 'between the king and the kingdom': in other words, there was an agreement between two parties, expressed in the form of a petition detailing concessions by one, the king, to the other, the kingdom. The preceding clause states that the king is conceding 'all the customs and liberties to the kingdom'. The kingdom is synonymous with the commune of the whole land. The barons had seen that the only way in which to coerce the king into keeping his own promises in perpetuity was to define those promises as concessions to a recipient, and to give that recipient redress against the king should he ever attempt to renege on his grant. Thereby they were forced into con-

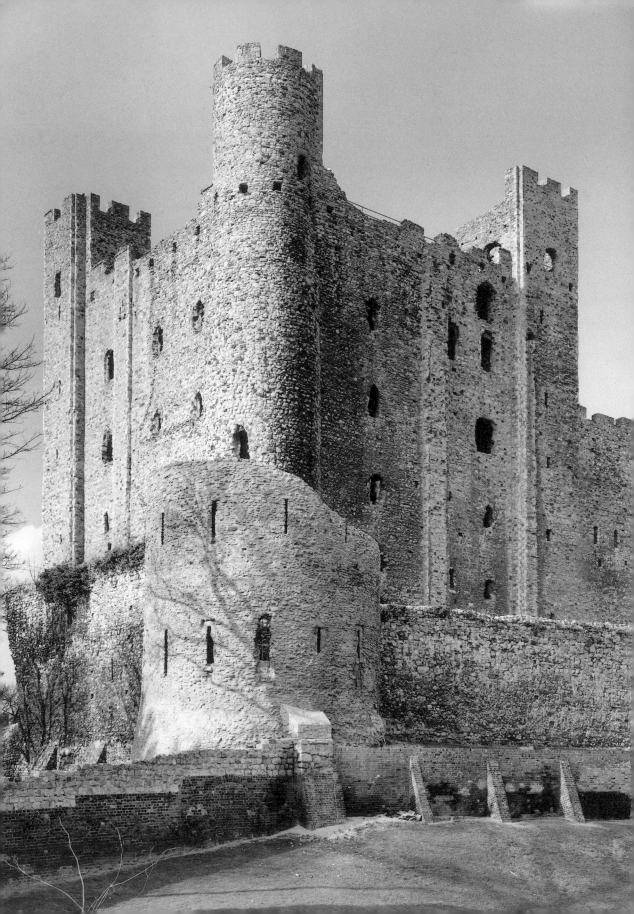

ceiving of the kingdom as an abstraction; it was not simply all the land held either directly or indirectly of the king. They had come a long way from the nonsensical 'kingdom' of the opening clause of Henry I's coronation 'charter', the charter which had not been a charter because it had no donee. Well they might, for they had had good teachers: those kings whose ruthless exploitation of powers arising from their position as lord of all the land had eventually pushed their tenants-in-chief into formulating a notion of the kingdom as an abstraction, consisting of all the king's vassals as a collectivity. No longer would post-Conquest England be a society consisting simply in dependent contractual relationships between individuals: there was an abstraction distinct from the person of the king. The dialectical irony of the development is positively Hegelian.

The use of 'kingdom' in this sense is not repeated in the security clause of Magna Carta itself, but 'the commune of all the land', its synonym, is, and there are several references to the perpetual nature of the concessions being made. Many of these concessions extend to barons the sort of benefits which subtenants had long enjoyed: for instance, the second clause established a fixed relief for a barony, disingenuously terming it 'ancient' (the haggling must have gone on to the very end of negotiations, for no sum is specified in the corresponding clause in the Articles). This extension of security up the tenurial scale is evident in the repeated emphasis on the fact that concessions were made to 'free men'. This was a blanket term for all free tenants, including tenants-in-chief; the barons wanted for themselves what had already been secured for every other category of free man by the Angevin reforms.

The point is well illustrated by what has become, as far as posterity is concerned, the most important of all the clauses of Magna Carta (cap. 39): 'No free man shall be taken or imprisoned or disseised or outlawed or exiled or in any way ruined, nor will we go or send against him, except by lawful judgement of his peers or by the law of the land.' In the seventeenth century this was considered to be the foundation of English liberty; in 1215 it was clearly aimed against arbitrary disseisin, arrest, imprisonment, and so on, by the king. The clause applies to all free men, but the victims of John whom the barons had in mind were barons. All free men except barons had long enjoyed the protection of regular procedures when being disciplined by their lords, either in the lord's court or by arbitrary action; a free tenant could easily appeal to the king's court against a judgement passed on him 'by his peers'—his fellow vas-

ROCHESTER CASTLE, Kent. The first castle was probably built immediately after the Conquest. It became the headquarters of the baronial rebellion against William Rufus in 1088 and was successfully besieged by the king. The castle was then rebuilt in stone, and in 1127 Henry I assigned it to William de Corbeil, archbishop of Canterbury, and his successors in perpetuity. William built the present keep, shown here. In September 1215 Archbishop Stephen Langton, in King John's words that 'notorious and barefaced traitor', let in the king's enemies. There followed a second siege: John stormed the keep in November, having undermined the south-east quarter, the mine being sprung by fire fed with the fat of forty pigs.

sals—in his lord's court; the king's court therefore became the arbiter of what constituted 'lawful judgement'. If the judgement were deemed unlawful by the king's justices, then the free man could secure redress according to common law, here termed 'the law of the land'. But, as we have seen, prior to this point barons had been necessarily excluded from these procedures: for them there could be no external arbiter of whether judgement had been arrived at lawfully in the lord king's court of vassals; and they had been excluded from any access to 'the law of the land' by the logic of their position. This clause attempted to ensure that henceforth the king would act towards all free men, including barons, in accordance with regular procedure, as other lords had already in effect been forced by the king to do towards their vassals. The protection conceded to other free men against the arbitrary will of the king was of little immediate importance; that extended to the barons, with an echo of the terms of the assize of *novel disseisin*, was the point of the clause. Although barons continued to be debarred from seeking redress through the procedures of 'the law of the land', henceforth they could be disciplined only 'by lawful judgement of [their] peers' in the lord king's court, and what constituted 'lawful judgement' was likely to be determined by the principles established by 'the law of the land'. For in any dispute the court of twenty-five would have the final say.

While the barons could not avail themselves of the procedures of 'the law of the land', therefore, in Magna Carta they attempted to secure for themselves what it had already secured for their vassals. If 'the commune of the whole land' was in this respect a creation of 'the law of the land', then the barons were forced to invent it,

THIS MARGINAL DRAWING, which complements the obituary of King John in this illuminated manuscript of Matthew Paris's *Chronica Majora*, encapsulates the reign. The inverted shield is inscribed 'Thus died John, king and first tributary of England'; and the falling crown 'Woe to the tottering crown of England'. John was a 'tributary' because of his homage to Pope Innocent III; but in Matthew's view this was merely a symptom of a much deeper malaise. If John's crown may be taken to symbolize the characteristics of Norman kingship which were grounded in the Conquest, Matthew was not far wrong.

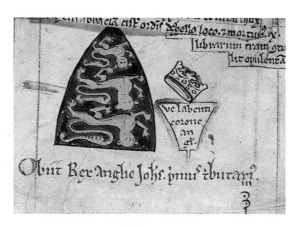

and to act on its behalf, precisely because their immediate dependence on the lord king meant that they were the last category of free men to enter into it.

In the very short run, Magna Carta was a failure. The kingdom soon dissolved again into civil war. At an earlier stage of the crisis, in 1213, John had done homage to Pope Innocent III (in the person of his legate), transforming the kingdom into a papal fief; he now secured papal annulment of Magna Carta, on the grounds that he had been coerced into granting it, and that it impaired his rights and dignity. The charges were true, but John's death in 1216, and his son Henry III's accession as a minor, was rapidly followed by a reissue in the new king's name. It proved impossible to withdraw or suppress the liberties that had been granted to all free men in the kingdom in perpetuity. The nature of the original grant and of the donee explain Magna Carta's enduring importance down to and beyond the seventeenth century, however much the document was distorted in subsequent debate. Like the rest of the Charter, they resulted from and responded to the peculiar powers enjoyed by kings in England as a result of the way in which the Conquest had been justified.

4 Late Medieval England
1215–1485

∾∾ Chris Given-Wilson ∾∾∾∾∾

To start at the end: what, by 1485, were the most fundamental changes to have occurred in English political life since 1215?

In the first place, the Anglo-French territorial links created by the Norman Conquest of 1066, which for four hundred years had been the determining factor in England's relations with her neighbours, had at last, with the ending of the Hundred Years War in 1453, been severed.

Secondly, parliament had by now become the political forum of the nation. In 1215 no one would have known what the word 'parliament' meant; its first recorded use only dates from 1236. By the early fourteenth century, however, parliament had already established its central role in English political life, and within another hundred years it had acquired most of the powers and responsibilities which it was to exercise until the great reordering of the mid-seventeenth century.

One reason why it did so—and this is a third fundamental change—was because it had succeeded in 'tying in' to the political process a fair proportion of

HENRY VI petitioned by the lords and commons, from the foundation charter of King's College, Cambridge, 1446. The stripes on the lords' robes designate their ranks.

those who mattered at not only the national, but also the local, level—that is, the merchants and gentry as well as the lords—and thereby provided both an outlet and a platform for their aspirations and concerns. To a considerable extent, political influence and social status were still closely linked at this time, and those who carried the greatest individual weight in policy-making were certainly the lords—those sixty or so heads of great families who constituted the parliamentary peerage; yet in many ways the most significant change which the institutionalization of parliament brought to the late medieval English polity was in affording the gentry a recognized, and ever more significant, role in that process.

The great majority of those who sat in fifteenth-century parliaments were laymen. For the first century or so of parliament's existence, however, the Church—the lower as well as the higher clergy—had enjoyed much more substantial representation in parliament, and the fact that the lower clergy had dropped out during the first half of the fourteenth century is symptomatic of a fourth major change in English politics during the late middle ages: the retreat of clerical influence. This was due partly to international developments such as the decline of papal monarchy, and

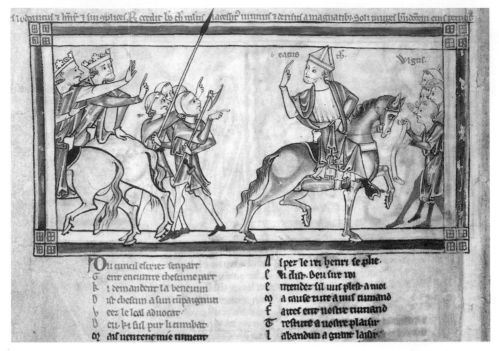

THOMAS BECKET bids an acrimonious farewell to Henry II and Louis VII of France. Such Church–State confrontations were common in England in the twelfth and early thirteenth centuries but rare in the later middle ages.

partly to social and political changes within England, such as the laicization of public and private administration which followed from growing lay literacy. The consequences were far-reaching: the great Church–State quarrels of the twelfth century, such as Becket's clash with Henry II, were by now a thing of the past. By the 1290s, Edward I could cow the English Church into submission and ignore the threats of Pope Boniface VIII, and over the next two centuries royal control over the resources of the English Church became ever more effective.

The increasingly State-dominated Church of late medieval England points to a fifth significant development of the time—the gradual transformation of 'feudal monarchy' into 'national monarchy'. This is easier to assert than to describe, but it can safely be said that many of the feudal institutions which appear characteristic of, say, the twelfth century, had lost much of their relevance by the fifteenth. Military service provides an example. By the early fourteenth century, the feudal army was an anachronism; the armies that fought the Hundred Years War were contract armies, raised through personal contracts ('indentures') between the king and his captains, and paid from the proceeds of national taxation. The taxes used to pay them are similarly symptomatic of the growth of national monarchy: feudal theory made no allowance for the concept of national taxation (the right of a king to tax *all* his sub-

jects in the national interest), yet gradually through the thirteenth century, and more insistently during the fourteenth, English kings claimed and exercised the right to national taxation to such effect that between 1350 and 1420 they were taking, on average, about £90,000 a year from their subjects. The result was a fundamental shift in the basis of Crown finance. The 'ordinary' revenues of the Crown became marginal, and taxation became the *sine qua non* of government solvency.

How and why, then, did these changes occur?

English Politics c.1216–1290

Frequently it was the pressures of war which provided the catalyst for change, yet for much of the thirteenth century foreign warfare played surprisingly little part in English politics. Relations with Scotland were remarkably harmonious, and despite the fact that there were still plenty of outstanding issues to be settled with France over the question of the 'Angevin empire', only occasionally did these lead to hostilities. Henry III was only 9 when his father died, and not until 1230 was he in a position to attempt the reconquest of the Angevin lands. Henry led three expeditions to France: to Brittany and Poitou in 1230 and 1242, and to Gascony in 1253. Little was achieved, however, and by the mid-1250s the king was ready to negotiate. The French king Louis IX (1226–70), ever-eager to devote his energies to crusading, also wanted peace, and in the Treaty of Paris of 1259 a compromise was effected. Henry abandoned his claims to the northern territories of the old Angevin empire (Normandy, Anjou, Maine, Touraine, and Poitou), and in return was allowed to retain the south-western duchy of Gascony, which henceforth was to be held from the French king by liege homage. Later, when the goodwill which underlay the Treaty of Paris had evaporated, its terms were to be the subject of bitter disagreement, but for the next thirty-five years it was sufficient to preserve the peace.

In any case, most of the English baronage had other matters on their minds by this time. If Henry's French policy was less than successful, his domestic rule was little short of woeful. Once the overbearing justiciar, Hubert de Burgh, had been disgraced in 1232 the court came to be dominated by the king's Poitevin and Savoyard relatives. Hostility to their influence was vehement, and did not lack justification: the Poitevin Peter des Rivaux, for example, at one time held the offices of treasurer of the household, keeper of the king's wardrobe, keeper of the privy seal, and the sheriffdoms of twenty-one counties simultaneously. The repeated demands for the aliens' expulsion reflect not only widespread resentment among the English baronage at their virtual monopoly of royal patronage, but also the growing sense of Englishness among the thirteenth-century nobility, now that the territorial and political connections with northern France had been severed. Henry's predilection for ruling for long periods without formally appointed ministers such as a chancellor also created tension, reducing as it did the possibility of ministerial checks on the aliens'

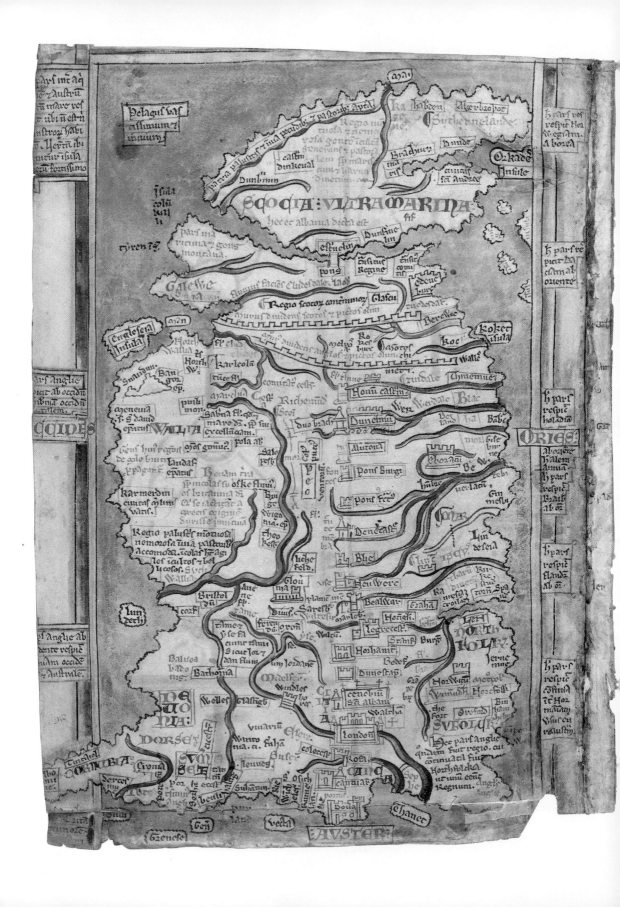

activities. These two grievances—the expulsion of aliens, and the appointment of publicly accountable royal ministers—were usually to the fore in times of crisis.

And crises there were, in plenty. The king's own brother, Richard earl of Cornwall, rose in arms in 1238, and six years later Henry was presented with the 'Paper Constitution', a baronial ultimatum to make the royal government more open to scrutiny. It was during the 1250s, however, that the great crisis of Henry's reign unfolded. The catalyst was the 'Sicilian Venture', a scheme whereby the pope offered Henry's second son Edmund the crown of Sicily in return for Henry's promise to finance a 'crusade' to drive the pope's enemies, the 'viperine breed' of the Hohenstaufen, from the island. Within three years the plan had collapsed, leaving the king humiliated and with debts of about £100,000. Threatened with excommunication if he failed to pay, Henry summoned a parliament to Oxford in June 1258 to request a tax, only to find himself engulfed by baronial wrath. The 'Provisions of Oxford'—the baronial plan of reform—sidelined the king and placed power instead in the hands of a council of fifteen. This council was to supervise ministerial appointments, local administration, and the custody of royal castles, while parliament, which (so the Provisions demanded) was to meet three times a year, was to monitor their performance.

Such ideas were unacceptable to Henry, and the next seven years witnessed a bitter struggle between the king and his opponents over their implementation. The inability to find a solution to the crisis was partly because of the deep-rooted nature of the grievances, and partly because of the obduracy of both the king and the man who emerged as the leader of the opposition, Simon de Montfort. Although himself a Frenchman, Simon was vehemently opposed to the aliens who swarmed around the royal court, and he enjoyed much support not only among the baronage, but also from the 'knightly class' and leading figures in the Church. He took his stand on the Provisions of Oxford, and seems to have had (or at least certainly expressed) a genuine passion for reform of royal government not only at the centre but also in the localities. He was an uncompromising man, however, and in 1264 civil war broke out. Despite Simon's victory at the battle of Lewes that year, in the following year his army was defeated, and he himself killed, by a force led by the king's eldest son, the future Edward I, at the battle of Evesham.

The prolonged crisis of 1258–65 raised fundamental questions about English kingship and government. For example, the emphasis on the reform of county government (the crux of which was a desire for local offices to be representative of their localities rather than sinecures in the gift of the court), and on the central role of both the royal council and the parliament, were important pointers to the way in

MAP OF GREAT BRITAIN drawn by the St Albans chronicler Matthew Paris, showing the Roman walls dividing England from *Scotia ultra Marina*. Anglo-Scottish relations were good in the thirteenth century, but the two countries were almost constantly at war in the fourteenth and fifteenth centuries.

which the English polity was widening during the thirteenth century. The parliament which met in London under de Montfort's auspices in January 1265 was the first at which both knights and burgesses were present. Expediency and self-interest may well have lain behind Simon's decision to summon them, but this was nevertheless a precedent of the greatest significance, and one which Edward I would soon follow.

By the time that Edward I came to the throne in 1272, he was 33 years old, a vigorous, worldly wise and unequivocally kingly figure in the prime of his life, a man who knew his own mind and was implacable in the pursuit of his goals. The first

WALES in the late middle ages. The shaded area shows the principality of Wales annexed to England in 1284; the rest of Wales was divided into Marcher lordships held by English lords. Edward I's castles in Wales are also shown.

twenty years of Edward's reign were years of undoubted achievement. A wide-ranging series of statutes was passed, dealing with matters as diverse as property inheritance, law and order, the regulation of mercantile affairs, land grants to the Church, and the feudal and administrative rights of the Crown. These statutes did not stem from any new theory of kingship or philosophical approach to the relationship of law and government; as is usually the case, law followed social change rather than vice versa. However, the thoroughness with which they tackled the issues of the day, and the decisive nature of the solutions adopted, marks them out as the work of a government with a clear perception of its mission. Nor was Edward afraid to offend even his most powerful subjects. The Statute of Mortmain (1279), for example, which forbade the granting of lands to religious houses, provoked a storm of opposition from the Church. The Statute of Gloucester (1278), which required all landholders to demonstrate before royal justices by what warrant (*quo warranto*) they exercised certain kinds of judicial and financial rights ('franchises') within their lordships, similarly antagonized many members of the baronial and knightly classes.

Edward was eventually forced to compromise (by the Statute of Quo Warranto of 1290) on the question of what constituted an acceptable warrant. But by and large 'compromise' was not a familiar term in Edward I's vocabulary of kingship, and certainly not in relation to the second major achievement of his early reign, the annexation of Wales. By the mid-thirteenth century most of the south and east of Wales was already in the hands of English 'Marcher lords', while the north and west remained under the control of native Welsh princes, the most powerful of whom was Llywelyn ap Gruffudd of Gwynedd. Llywelyn took advantage of the disturbed state of English politics under Henry III to gain recognition as Prince of Wales in 1267, but when he resisted Edward I's demand for homage in 1274–5, he was forced to pay a heavy price. Edward's first campaign of 1276–7 rapidly subdued Llywelyn, and although he was allowed on this occasion to retain his princely title, when he and his brother David rebelled again in 1282–3 there was to be no mercy. The deaths of Llywelyn (in a skirmish) and David (executed as a traitor) extinguished the native dynasty of Gwynedd, whereupon Edward took the opportunity, in the Statute of Wales (1284), to declare that 'the whole land of Wales shall be entirely annexed and united to the crown of our kingdom ... to be a dominion of our ownership ... part and parcel of the body of our crown and kingdom.' He did not really mean the 'whole land', for the Marcher lordships in the south and east continued to be held by their English lords; it was the native principalities which were annexed. Welsh criminal law was abolished, and a new administrative structure, modelled on the English pattern and accountable to Westminster, was imposed. To make sure that the annexation was effective, a ring of massive stone castles was built around Snowdonia, the heartland of Welsh resistance. In the same year as the Statute of Wales, the future Edward II was born at Caernarfon, and seventeen years later, in February

EDWARD I creating his son, the future Edward II, Prince of Wales in 1301. The investiture took place at Caernarfon Castle, where princes of Wales are still invested with their title.

1301, he was created prince of Wales by his father. From this act stems the tradition that the eldest son of an English monarch bears that title.

The annexation of Wales and the legislation of the first twenty years of the reign were the work of a tidy-minded and forceful king—a king all too well aware of the rights of the Crown, but far less so of the rights of others. Yet Edward's achievements were not without their price: forceful kingship bred resentment; as the storm clouds gathered in the early 1290s, the king would soon discover who his real friends were. He had sown the wind; now he would reap the whirlwind.

War and Deposition, c.1290–1330

During the 1290s England became involved in wars with both Scotland and France which were to last, intermittently, almost until the end of the medieval period. Scotland and France thus allied with each other, while England wooed Flanders. This quadrangular relationship was at the heart of English foreign policy during the period which led up to the Hundred Years War.

Anglo-Scottish hostility was precipitated by the deaths of the Scottish king Alexander III in 1286 and his 7-year-old heiress Margaret, the 'Maid of Norway', in 1290, leaving Scotland without a self-evident heir to the throne. In order to determine the succession, the Scottish magnates and prelates embarked on a complex process (the 'Great Cause'), in which Edward I was asked by the Scottish lords to participate. He accepted, naturally, though not quite on the terms in which the offer had been made. The Scots hoped that he would act as an independent arbitrator. As far as Edward was concerned, he was acting as feudal overlord of the Scottish kingdom, and once the decision had been made (in November 1292) that John Balliol—rather than the other main candidate, Robert Bruce—should be king, Edward soon made his position clear. King John of Scotland was required to perform military service in the English army, and to allow appeals from his courts to be heard at Westminster. Balliol, afraid of the consequences of refusal, veered between compliance and defiance, but eventually opted for the latter. During the winter of 1295–6, urged on by his more forceful compatriots, he allied himself with the French king, Philip IV (1285–1314). This was the origin of the 'Auld Alliance'. Since England and France were by this time at war, it made war between Scotland and England virtually inevitable.

For Philip IV, the Scottish alliance was also a way of repaying Edward in kind for his alliance with the Flemish count, Guy of Dampierre. Flanders' relationship with France was not dissimilar to that of Scotland with England. Feudally a part of the French kingdom, Flanders was one of the wealthiest and most urbanized regions of Europe. But in order to feed the cloth industry upon which its wealth was chiefly based, it was heavily dependent on English wool. It also had a fierce tradition of independence, which Philip IV was determined to break. Like Edward in Scotland, Philip used his position as feudal superior to undermine Count Guy's authority. The count reacted by appealing to Edward, and in August 1294 an Anglo-Flemish treaty was drawn up. This could only be interpreted by France as an act of hostility.

The Anglo-French war, which had broken out earlier in 1294, centred on the issue of sovereignty in Gascony, and here too feudal notions were of paramount importance, Philip claiming the right to act as Edward I's feudal lord, Edward as far as he could resisting Philip's demands. Mounting tension was inflamed by skirmishes between English and French privateers, and in May 1294 Philip declared the duchy confiscated. Within a further two years, as we have seen, the familiar battle lines of Anglo-French struggle through the fourteenth century had been drawn up.

From the mid-1290s until the mid-1330s England was only occasionally at war with France, but almost continuously with Scotland. The war in Gascony involved little actual fighting, and was brought to an end in 1303 by a peace which more or less restored the status quo ante 1294, but the Anglo-Scottish war was a much bloodier affair. Between 1296 and 1307, nine English armies marched northwards. Edward soon made it clear that his aim was conquest. The 1296 campaign resulted in the deposition of John Balliol, the removal of the Stone of Destiny (the ancient seat of the kings of Scots) from Scone to Westminster, and the appointment of an English governor of Scotland; and although Scottish resistance, led by brave men such as William Wallace and Andrew Moray, made it hard for Edward to realize his ambitions, nevertheless by 1305, when Wallace was captured and led off to a barbarous fate at Tyburn, it seemed that Scotland had been subdued. Within six months of Wallace's death, however, a new Scottish champion had materialized: in February 1306, Robert Bruce—grandson of his namesake, the claimant of '1290—rose against Edward and proclaimed himself king.

CLOTH being woven on a treadle-loom. Flanders' reliance on English wool for its cloth industry was a chief reason for its political attachment to England for much of the fourteenth century.

The next twenty-three years would see him not only make good his claim, but also secure his nation's independence.

Of course, Bruce enjoyed his share of good fortune: Edward I's death in July 1307 allowed him a breathing-space to establish himself in Scotland, and the new English king, Edward II, was but a vacuous and fumbling parody of his father. Edward's first act as king was to abort the campaign to Scotland which Edward I had been leading when he died, and, apart from a poorly supported expedition in the winter of 1310–11, he did not set foot in Scotland again until June 1314. Bruce took his opportunity: one by one he picked off the English-held castles, destroying them as he did so to prevent their re-occupation. In 1311 he launched his first raid into England. Then, on Midsummer Day 1314, at Bannockburn, near Stirling, he delivered the *coup de grâce*: an English army of some 20,000 men, led by Edward himself, was overwhelmed by a Scottish force about half that size, commanded by Bruce, in the marshy fields around the Forth. It was the most humiliating defeat of an English army during this entire period. It threw England into political turmoil, and drew Bruce's hold on both his own kingdom and the northern English counties into an iron grip. Scottish raids into England now became annual—devastating, demanding tribute, mocking Edward's kingship in the north. In 1318 Berwick fell to the Scots. Eventually, in 1323, Edward agreed a truce: he would leave Scotland to Bruce, if Bruce would cease raiding. This, however, was only tacit recognition of Bruce's title, and it took him another five years, and an English revolution, to press home his advantage. In 1324 the Gascon impasse once more erupted into Anglo-French war, and Bruce responded by renewing the Franco-Scottish alliance. Then in January 1327 Edward II was deposed by his own queen, the French princess Isabella, and her lover Roger Mortimer, and Bruce got what he really sought. By the Treaty of Northampton of 1328 (the 'shameful peace' to the English), Isabella and Mortimer recognized Bruce as king of an independent Scotland. In the following year Pope John XXII, hitherto ever-anxious to placate the English, granted the Scottish kings full rights of coronation and anointing. Thus by the time he died, in June 1329, King Robert bequeathed to his successor a kingdom free from every taint of inferiority. It was a masterly achievement. Medieval Scotland would not see his like again.

The pressure of constant warfare from the 1290s onwards created new tensions in English political life. Military service itself was a bone of contention: with paid armies gradually replacing feudal armies, there was much uncertainty about who was obliged to fight for the king, where, and under what conditions. At the Salisbury parliament of April 1297, Edward I's demand that his magnates go to Gascony was met with a simple refusal from, among others, the constable and marshal of the royal army. 'By God, Sir Earl, either you go or you hang,' Edward declared to his marshal (the earl of Norfolk), to which Norfolk retorted, 'By the same oath, O King, I shall neither go nor hang'—and nor did he. Service overseas was the sticking-point on this occasion, but Edward II encountered similar problems (though often for

more personal reasons) in persuading some of his earls to accompany him to Scotland. By the time of the Hundred Years War, however, with contract armies now the norm, disputes over military service receded.

Much more problematical in the long run was the question of the financing of the war. War on the scale that Edward I waged it during the last dozen years of his reign demanded vast sums. Between 1294 and 1297, Professor Prestwich has estimated, the king's wars cost £750,000. There was only one way to find such sums: regular and heavy taxation. Taxation itself was not a novelty—the first real tax in England was the thirteenth raised by King John in 1207 (so-called because it was assessed at one-thirteenth of the value of each taxpayer's moveable goods), and taxes had occasionally been granted to Henry III—but the rate and frequency of taxation in the 1290s were unprecedented. Compulsory seizures of provisions, the imposition of vastly increased export duties (known as the maltolt, or 'bad tax') on England's chief export, wool, and regular defaulting on tallies (notched sticks used by the Crown as IOUs) all aroused bitter hostility, and brought the country by 1297 to the verge of rebellion. In the autumn of that year the king was forced to climb down. The maltolt was abolished, and it was agreed that in future no taxation would be levied 'except by the common consent of all the realm, and for the common profit of the said realm'. This (no doubt deliberately) vague form of words masked the reality that by now it was coming to be accepted that the place where consent for taxation should be obtained was in parliament. Indeed, the period from about 1290 to 1330

EXCHEQUER TALLIES (credit instruments) of the thirteenth century. The amount payable was indicated by the size of the notches on the stick, and the source of the payment written on it. However, tallies were often discounted or dishonoured at times of financial pressure.

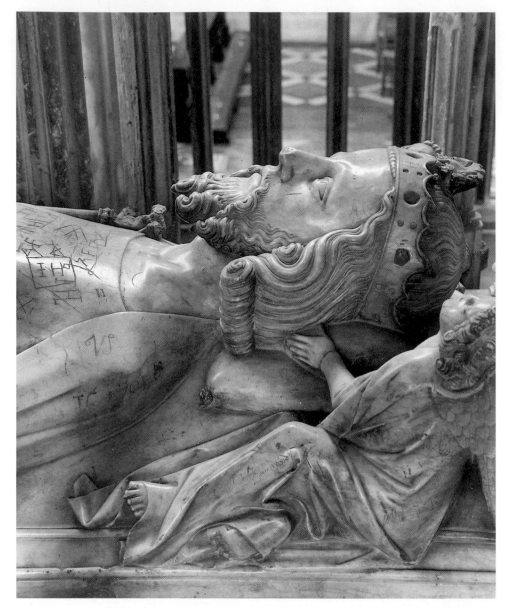

EDWARD II, from his effigy in Gloucester Cathedral, where he was buried following his murder in Berkeley Castle in 1327.

was, in all sorts of ways, crucial in the history of parliament. To its original role as a judicial court new functions were being added, such as the granting of taxation and the making of legislation; more communal petitions—from towns, counties, trade associations, and so forth—were also being heard, thereby expanding its role as a national forum for the redress of grievances; and, in order that it should be more rep-

resentative of 'the common consent of all the realm', it became increasingly usual to summon the knights and/or burgesses as well as the magnates and prelates to its meetings. After 1327, assemblies which did not include both knights and burgesses ceased to be referred to as parliaments: the commons had their place in parliament.

However, the political role of the commons was still limited, and the turmoil of Edward II's reign revolved largely around the personal, familial, and political quarrels of the king and the magnates. Edward II was utterly unsuited to kingship. Weak, cruel, and visionless, he inspired no loyalty, and squandered the resources of the Crown on greedy and worthless favourites. The first and most notorious of these was Piers Gaveston, the son of a Gascon knight to whom Edward granted the earldom of Cornwall. Three times Gaveston was banished from the realm—once by Edward I, and twice at the insistence of the magnates. Each time he came back. Eventually, in June 1312, a group of nobles led by Edward's cousin, Thomas earl of Lancaster, seized him and put him to death. Edward never forgave Lancaster, and, when the time came, took his revenge in kind. Several of the magnates, aghast at such a precedent, returned to the king's allegiance, but the disgrace of Bannockburn placed Edward once more at Lancaster's mercy, and for the next few years the country hovered on the brink of civil war, which eventually broke out in 1321. The catalyst to the 'Despenser War', as it is called, was the king's connivance at the rapacity of his new favourites, the two Hugh Despensers, father and son. On this occasion the power of the Crown was decisive: Lancaster and his allies (principally the Welsh Marcher lords) were routed, and Lancaster himself was captured and executed by his jubilant cousin at Pontefract in March 1322. Four years of tyranny followed, during which all opposition was suppressed and the 'Contrariants' of 1321–2, their heirs, and their widows were subjected to casual brutality and systematic spoliation, while the king and the Despensers waxed fat on the proceeds. But Edward underestimated his queen, Isabella. She loathed the younger Despenser, and refused to come to court while he was there. In 1325 Edward sent her to Paris, where she met and began an affair with Roger Mortimer, a Marcher lord who had escaped from the Tower in 1323. In September 1326 Isabella and Mortimer returned to England with a small army and the country, almost unbidden, rose against the king. Edward and the Despensers were captured in South Wales; the Despensers were executed forthwith, the king formally deposed in London in January 1327. The remaining few months of Edward's shoddy life were spent in Berkeley castle, where, on the night of 21 September 1327, he was murdered, doubtless on Isabella's and Mortimer's instructions.

This first deposition of a reigning English monarch was a surprisingly inconsequential affair. Edward III was acclaimed as his father's successor, so there was no dynastic sidestep, nor was there any notion that the experience of Edward II's reign should result in a curtailment of kingly powers. Least of all did it contribute in any way to the enhancement of parliament's powers *vis-à-vis* the king; the authority by

which Edward II was deposed was not parliamentary, and the idea that parliament might make and unmake kings would have been unthinkable to contemporaries. Nor, unfortunately, did the deposition put an immediate end to the bloodshed: with Edward III only 14, power for the moment remained with Isabella and Mortimer, who soon proved themselves almost as vicious and corrupt as those whom they had replaced. By 1330 Edward knew he must act. Surprising his mother and her lover in Nottingham castle, he hurried Mortimer away to execution in London and dispatched Isabella to honourable confinement. Thus, in November 1330, having just passed his eighteenth birthday, Edward III set out upon his personal rule. It would last another forty-seven years, and bring undreamed-of glory.

Edward III and Richard II, 1330–1399

Edward III's reign was dominated by warfare, and fortunately he was very good at it. Initially this meant war with Scotland, where Edward was determined to reassert English overlordship. He wanted to deal with France and Scotland separately. However, despite early successes such as his victory at Halidon Hill and recapture of Berwick in 1333, he soon found this impossible. David Bruce, the 10-year-old son of Robert, fled to France in 1334, and later that year Philip VI of France—Philip of Valois—declared that he would not come to any agreement over the perennial problem of Gascony unless Scotland were included. Edward's response was to rekindle the Anglo-Flemish alliance; further tension arose from Edward's claim, through his mother Isabella, to the French throne, which, although not a direct cause of the outbreak of hostilities, was to prove a consistently useful bargaining-counter throughout the war, as well as a focus of opposition for Frenchmen discontented with the Valois monarchy. By 1337 Anglo-French relations had reached breaking-point, and

THIS DEPICTION of John's coronation, on 27 May 1199, is one of a series of miniatures of English coronations in this copy of the *Flores Historiarum*. Hubert Walter, archbishop of Canterbury, officiated at the coronation, and is shown here on the left, anointing John. Archbishop Hubert had been Richard I's chief justiciar; John recognized his importance in royal administration by making him chancellor on the day of the coronation.

FONTEVRAULT ABBEY (a community of nuns and monk-priests, ruled by an abbess) is located in the borderlands of Anjou and Poitou, and was much favoured by the counts of Anjou and the dukes of Aquitaine. It is not clear when, if at all, Henry II decided that he should be buried there; his wife, Eleanor of Aquitaine, ensured that he and their son Richard I were, and was then buried there herself. The date of their painted freestone *gisants* (sculpted recumbent effigies) is not certain; but on stylistic grounds they seem to predate the wooden one for Isabella of Angoulême, John's queen. She died there in 1246, having taken the veil, and was first buried with the nuns. In 1254 her son Henry III had her remains moved to the royal crypt, and presumably erected her *gisant*. The three visible in this photograph are (*front to back*) Eleanor, Richard, and Isabella.

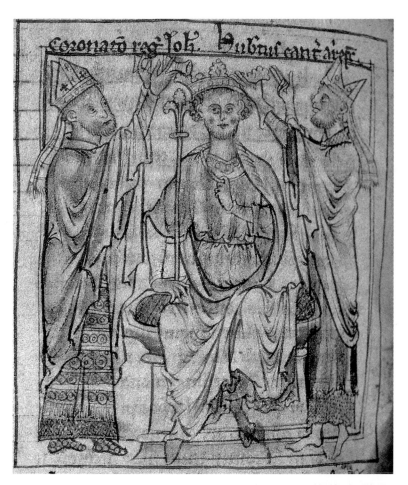

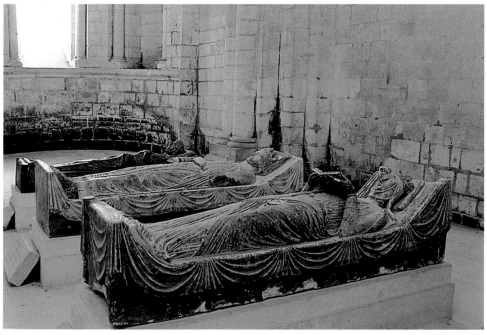

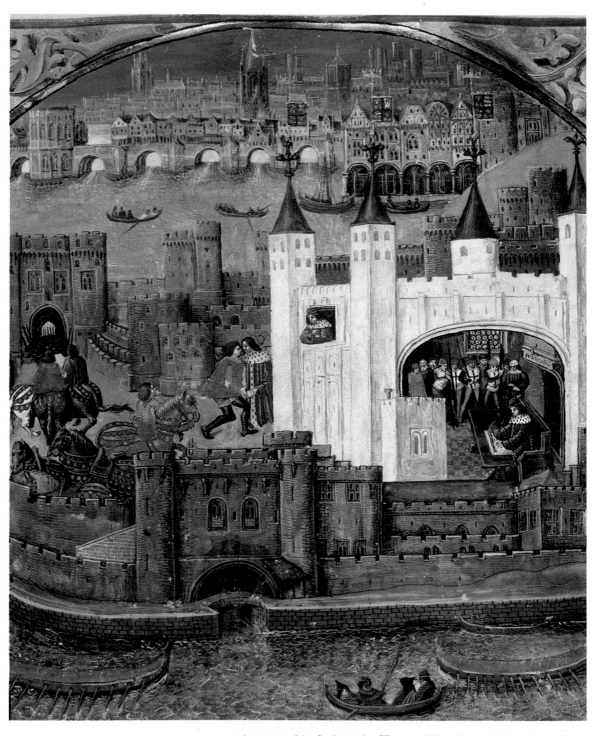

CHARLES, DUKE OF ORLEANS, a prisoner at his desk in the Tower of London, with a view of London in the background. He was one of numerous French nobles captured at Agincourt.

in May Philip declared Gascony confiscated. Edward promptly styled himself king of France, and the Hundred Years War had begun.

Edward III's reputation as a warrior-king was made during the first phase of the war (1337–60), and more particularly between 1346 and 1360. To begin with, in fact, the war went far from well. Despite a morale-boosting naval victory at Sluys in June 1340, English campaigns to France and Scotland between 1338 and 1343 achieved little and cost a great deal, leaving Edward with enormous debts. The king's response was a wholesale purge, in December 1340, of the ministers whom he accused of failing him. In the parliament of April 1341 he was forced to moderate his demands, however, and, having thus defused the crisis, he also seems to have learned the appropriate lessons from it. From now on he was more tactful in his dealings with parliament, and took care to enlist the support of his magnates through such popular measures as his foundation of the Order of the Garter in 1348. The war too took a turn for the better. A French army led by Philip VI was overwhelmed by English longbowmen at Crécy in August 1346, and two months later David II of Scotland—having returned to his kingdom in 1341—was captured at the battle of Neville's

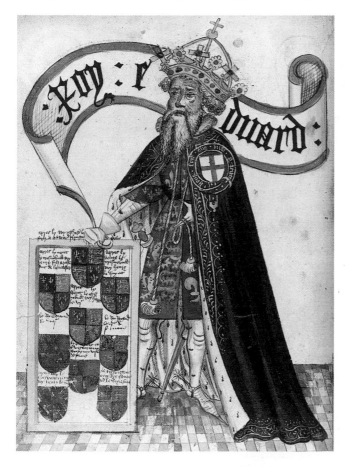

EDWARD III as founder of the Order of the Garter, which he instituted in 1348.

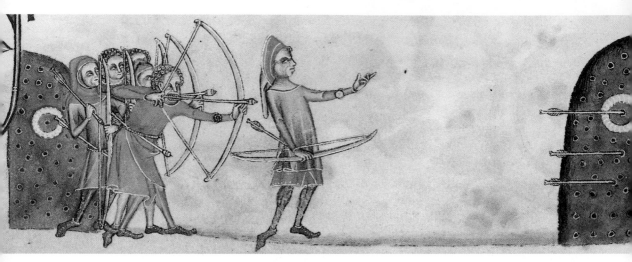

ENGLISH VILLAGERS practising archery. It was the longbow which provided the English with the tactical superiority to win the battles of Crecy, Poitiers, and Agincourt, and Englishmen were regularly exhorted to practise their bowmanship.

Cross, near Durham. In the following year Calais fell to Edward's army after a siege of some ten months; it would remain English for more than two centuries.

The Black Death, which swept through Europe in 1348–9, forced a lull in hostilities, but with the renewal of the war England's run of success continued, culminating in September 1356 with the defeat and capture at Poitiers of the French king John II (who had succeeded Philip VI in 1350) by Edward III's eldest son, the Black Prince. The Valois monarchy was abased, and France plunged into disarray. By the Treaty of Brétigny (May 1360), the seal was set on Edward's military triumphs. Gascony, enlarged to include its debatable borderlands, was granted to Edward in full sovereignty, along with Calais, Ponthieu, and various other towns and lordships in the north. King John was permitted to return to his kingdom, but only in exchange for a ransom of half a million pounds, while Edward agreed to renounce his claim to the French throne—not a heavy price to pay for the dismemberment of France.

The peace lasted only nine years, however, and when war broke out again it was England's turn to suffer. This was partly a matter of leadership, partly of strategy. France was now ruled by Charles V (1364–80), a far more capable character than either his father or his grandfather; he and his constable, the former mercenary leader Bertrand du Guesclin, adopted the inglorious but effective approach of refusing to offer open battle to the English, concentrating instead on a strategy of harassment and siege warfare, and so fruitful was this that by 1375 they had recovered most of what had been lost at Brétigny. England, meanwhile, staggered from military defeat to political crisis. Edward III was growing senile, and the Black Prince was dying (he predeceased his father in June 1376). Anger at the government's fail-

ure abroad and corruption at home found its expression in the Good Parliament of 1376, when the knights of the shire, meeting in the chapter-house of Westminster Abbey, and led by the first elected Speaker of the commons, Sir Peter de la Mare, rounded on the doddering king's courtiers and ministers, impeaching and dismissing several of them from office and securing the appointment of a council to oversee the administration. A year later, in June 1377, Edward III died; it was a sad end to what had been, for the most part, a remarkable reign.

Worse was to come, however. The new king, Richard II, was only 10 at his accession. The eldest of his three surviving uncles, John of Gaunt duke of Lancaster, was the obvious person to provide political leadership, but the domineering Gaunt was thoroughly unpopular, and the combination of heavy taxation, military stalemate, and rivalry at court boded ill for the minority. England also crackled with social and religious tensions. The former exploded into violence with the Peasants' Revolt of 1381, the most celebrated popular uprising in medieval English history, a protest partly at landlord and government oppression in the aftermath of the Black Death, and partly at the record levels of taxation which had been imposed during the 1370s. Several thousand rebels from Kent, Essex, and London, led by Wat Tyler and the demagogue priest John Ball, occupied the city for three days; the chancellor and treasurer were decapitated on Tower Hill, and hundreds of others—lawyers, foreigners, lesser officers of the Crown—murdered in the streets; looting, burning, and private grudge-settling abounded. Anti-Church sentiment also featured

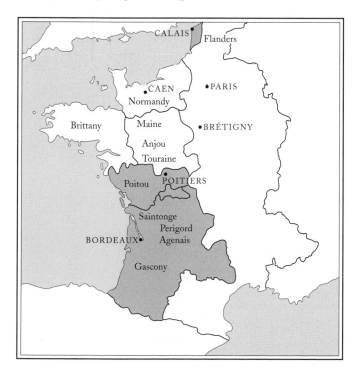

FRANCE, showing the lands of the Angevin Empire and the territories (shaded) ceded to Edward III by the Treaty of Bretigny in 1360.

prominently in the rebels' rhetoric, reflecting the fact that England was experiencing her first serious outbreak of heresy for nearly a millenium. Lollardy, as it is called, drew its intellectual inspiration from the radical theological speculation of the Oxford master John Wyclif on matters such as transubstantiation and predestination, but its popular appeal owed as much to a deep grain of anti-clericalism at all levels of fourteenth-century English society as to any widespread dissemination of Wyclif's leaden prose. Lollardy was not simply the little people's heresy: seduced by its Erastian overtones, no less a man than John of Gaunt patronized Wyclif, and on several occasions groups of sympathetic knights submitted petitions to parliament demanding the disendowment of the Church. The support which Lollardy attracted from the landed classes presented a real threat to the Church, and helps to account for the government's sluggishness in tackling the problem. Not until after the 'Lollard Rising' of 1414 had equated Lollardy with treason would an English king—Henry V—unequivocally align the power of the State with that of the Church to try to eradicate it.

Thus England in the 1380s and 1390s was a defeated and deeply divided realm, and unfortunately the orderly management of decline was beyond the capabilities of Richard II. Richard—wilful, hot-tempered, and imbued with a whimsically lofty notion of kingly office—was a man who, like Edward II, allowed his personal likes and dislikes to bulk too large in the council chamber. Those whom he favoured—such as Robert de Vere earl of Oxford, and Michael de la Pole (whom he created earl of Suffolk and chancellor of England)—were also those whose advice he sought. As a result, resentment spread among the less favoured but (in their own estimation) more deserving men, such as Thomas Woodstock duke of Gloucester (the king's uncle), Richard Fitzalan, the irascible earl of Arundel, and his more circumspect but

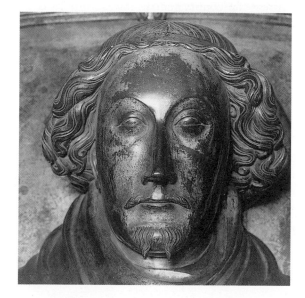

WESTMINSTER ABBEY (*left*). The chapter-house, described in 1376 as the accustomed meeting-place of the commons in parliament.

RICHARD II (*right*), from his effigy in Westminster Abbey.

no less formidable brother Thomas Arundel, who eventually rose to the archbishopric of Canterbury. Richard's government during the 1380s gives the impression of being (to use a phrase of recent notoriety) in office but not in power. With the support of his friends, Richard began to develop a policy of conciliation towards France. This was anathema to hawks like Gloucester and the Arundels, and in 1386, with the government bankrupt and the French threatening to invade England, matters came to a head. The 'Wonderful Parliament' of that year impeached de la Pole and set up a Commission of Government to administer the country. A brief civil war in the following year resulted in the rout of a royalist army led by de Vere at Radcot Bridge (near Oxford) in December 1387, and in the 'Merciless Parliament' of February 1388 eight of the king's supporters were executed for treason and many more exiled or dismissed from court. It was a brutal verdict both on Richard's kingship and on the inadequacies of English policy over the previous twenty years.

These inadequacies included not only the mismanagement of the war during the 1370s and 1380s, but also the failure to take account of long-term changes in the English polity during the fourteenth century. The most significant of these was the growing influence of the gentry, for which there were two underlying reasons. First, the gentry's increasing control of the chief offices in the shires, such as those of sheriff and justice of the peace: the time when a Peter des Rivaux might hold twenty-one sheriffdoms simultaneously had long gone. Persistent pressure from the localities had made of this office something more genuinely representative of the 'community of the shire' rather than merely the agency of the royal will—although naturally sheriffs were still the latter as well; they were, by and large, local men, knights or esquires with substantial local interests and standing, drawn from that local landholding élite which numbered perhaps fifty or so in an average-sized shire—the 'county gentry'. It was from the county gentry also that the justices of the peace were generally selected. The office of JP had evolved gradually during the fourteenth century, largely in response to similar pressures—that is, a greater degree of local control of local affairs—but it was the labour laws and other social legislation of the post-Black Death period which really led to their emergence by the last quarter of the century as the chief enforcers of order and conformity in the shires. Meanwhile—and this is the second reason—the evolution of parliament gave many of these same men a voice in national affairs. By the mid-fourteenth century, the composition and procedure of parliament were hardening into custom. Statutes of 1340 and 1362 gave the commons the right of consent to all direct and indirect taxation, and with it the bargaining-counter they needed to exercise political influence. Legislation was now usually based on their petitions, and if it came to it (as in the Good Parliament of 1376, for example), taxation might be refused unless petitions were granted. This is not to suggest that the commons' attitude was one of fundamental opposition to the Crown; but they did not expect to be overmastered or ignored.

Richard II tried to bully his parliaments and failed to build up support among the gentry and the magnates for either his policies or his ministers. The carnage of 1388 was the result. Yet within a year Richard had resumed power, and at first it seemed as if he had learned his lesson. He was more cautious in his dealings with the magnates, and began systematically recruiting prominent members of the gentry to his cause, which helped to make the parliaments of the 1390s less fraught than those of the previous decade. The truce in the French war after 1389 also helped, allowing a substantial measure of financial recovery. This did not mean, however, that foreign policy ceased to be a contentious issue, for although war-weariness might induce the two sides to prolong the truce, finding an acceptable formula for peace was a different matter. At the root of the problem, as ever, lay Gascony: by whom, and from whom, should the duchy be held—by the English king himself (as the Gascons wished); by an English lord (John of Gaunt was the preferred candidate) from the French king (which was the most that the French would concede); or by an English lord from the English king (as had been conceded at Brétigny, and as Gloucester, Arundel, and others continued to insist was the only honourable solution)? Gradually, as Richard's desire for peace appeared to be edging him closer to compromise with the French, opposition grew—from the hawks, from the commons in parliament, and from the Gascons. Matters were further complicated when in 1392 the 24-year-old French king, Charles VI (1380–1422), suffered his first bout of madness. Two years later the Gascons rebelled in protest against the proposed terms. In the end, therefore, the two sides settled for a twenty-eight year truce, sealed in 1396 by Richard's marriage to Isabella, Charles VI's 7-year-old daughter. It was not a peace; indeed, the negotiations of the 1390s had demonstrated the virtual impossibility of finding a solution to the Gascon question. But it did at least promise an end to Anglo-French hostilities for a generation.

It may also have lulled Richard into an illusion of security. With the French question settled, revenge for the humiliation of 1387–8 could now be exacted. Gloucester was arrested in 1397 and murdered, gruesomely suffocated with a 'featherbed' in the back room of a Calais hostel; the earl of Arundel was beheaded for treason, and his brother, now archbishop of Canterbury, exiled. And now Richard's ambition began to soar. Attaching to himself a willing crew of leeches, he laid plans for the seizure of vast new territories, and when a quarrel arose between two of his remaining opponents from 1387–8—Henry Bolingbroke, heir to the Lancastrian inheritance, and Thomas Mowbray, heir to the Norfolk inheritance—he took the opportunity to banish them both. Six months later, following John of Gaunt's death in February 1399, he announced the confiscation of both their inheritances, then promptly set sail for Ireland. Bolingbroke seized his chance: he returned to England early in July, and support for the king crumbled. Richard, returning too late from Ireland, was cornered at Conwy castle in North Wales, taken to London, and deposed, whereupon Bolingbroke promptly had himself crowned as King Henry IV. Five months

later Richard died in Pontefract castle, almost certainly murdered. The new century thus saw England with a new—Lancastrian—dynasty.

Lancastrian England

The second deposition of the fourteenth century was of far greater consequence than the first, for, even allowing for Richard II's childlessness, Henry IV was not the primogenitary heir to the throne: that right belonged to Edmund Mortimer, the 7-year-old heir to the earldom of March, through his descent from Lionel duke of Clarence, second son of Edward III, whereas Henry's father, John of Gaunt, was Edward's third son. However, March's descent came through a female line, so Henry could at least claim to be the male heir, for there was, after all, no written law governing the succession in the middle ages, and precedents from the twelfth century and earlier pointed in different directions. Yet there were undoubtedly many who regarded Henry as a usurper, and this perception of their flawed title was something which the Lancastrians never quite overcame. It did much to weaken Henry's own authority, and fifty years later it would return to haunt, and ultimately help to destroy, his grandson.

Nevertheless, Henry IV did keep his throne, although for the first eight or nine years of his reign his survival hung by a thread. In addition to four magnate rebellions (in 1400—led by a group of Ricardian earls—and in 1403, 1405, and 1408—led by his former allies, the Percy family), he had to contend with chronic bankruptcy and a series of acrimonious parliaments—most notably that of 1406, which lasted from March to December, making it comfortably the longest English parliament to date. During the last few years of Henry's reign, however, things improved considerably: the house of Percy was finally broken in 1408, a semblance of financial normality returned, and parliamentary disaffection eased. By this time too, the most dangerous threat to English hegemony within the British Isles during the fifteenth century—Owen Glendower's Welsh revolt—had more or less been suppressed.

The acquiescence of Wales to English rule during the fourteenth century is in some ways rather surprising, for elsewhere in the British Isles English authority was in decline. In Ireland, English lordship had pressed steadily forward during the thirteenth century, so that by 1300 something over half of the land was under English control. However, a series of disasters during the first half of the fourteenth century—the invasion of Edward Bruce (brother of King Robert of Scotland) in 1315, and the early deaths of several of the great Anglo-Irish lords—saw the initiative pass to the native Irish chiefs, who gradually during the fourteenth century rolled back the limits of English administration. As England's population began to decline, the migration to Ireland which had underpinned English expansion there also dried up; more and more of the Anglo-Irish either sold up or became absentee landlords, while those who remained, such as the Fitzgerald earls of Desmond and Kildare,

became increasingly critical of the English government's failure to support them, and increasingly Irish in their lifestyle and (to some extent) sympathies. This was the situation which Richard II—the first English king to visit the island since John—tried to remedy; he failed to do so, and the fifteenth century saw Ireland slip ever further from England's grasp. The same was true of Scotland: in the early 1330s, after Halidon Hill, Scotland's very survival as a nation had lain in the balance. However, half a century of warfare had bred a deep sense of nationhood among the Scots, and simultaneously severed the territorial and aristocratic links with England which had proved so divisive at the outset of the Wars of Independence. By the 1350s Edward III had finally become convinced of the impracticability of trying to impose English rule on Scotland. As a result, in 1357 David Bruce was released from the Tower (where he had remained since his capture at Neville's Cross) and allowed to return to his kingdom. Not that Anglo-Scottish warfare now ceased—far from it; but it was no longer, for Scotland, a war of survival, rather a war of attrition, of border raids, cattle, and booty.

Wales was, in other words, the only part of the British Isles to undergo a strengthening of English rule during the fourteenth century. Owen Glendower was bent on restoring Welsh self-respect. Glendower, who was descended from ancient lines of

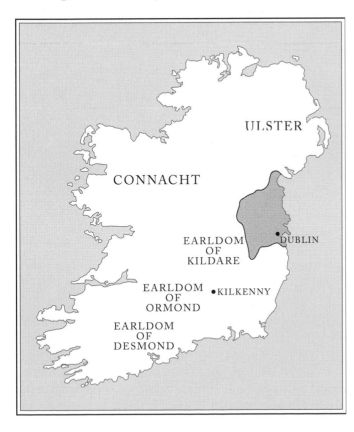

IRELAND in the late middle ages. The shaded area ('the Pale') shows the extent to which the effective area of English rule had shrunk by the late fifteenth century.

THE SIEGE OF ROUEN in 1418, from *The Life and Acts of Richard Beauchamp earl of Warwick*. The fall of Rouen in January 1419 completed Henry V's conquest of Normandy.

Welsh princes, was an esquire from Glyndyfrdwy ('Glen of the Water of the Dee') in Clwyd, a member of that class which, but for English domination, would have provided the Welsh with their natural leaders. His rebellion arose out of a dispute with his neighbour, Reynald Grey of Ruthin, but it soon escalated into something far bigger and more threatening to English rule. For three or four years, from about 1402 to 1406, he succeeded, by ruthless guerrilla tactics, in virtually turning large

parts of Wales into no-go areas for the English. Styling himself 'prince of Wales', and adopting the red dragon as his standard, he seized Aberystwyth and Harlech castles, captured and ransomed Reynald Grey, and even persuaded the French to send a force to his aid in 1405. Nor was he simply a warrior: he held Welsh 'parliaments' at Harlech and Machynlleth and drew up detailed plans for the Welsh Church, including the foundation of two universities. Yet much of Owen's success was due to the distractions facing Henry IV in England, and once these receded his fortunes waned. Aberystwyth and Harlech were retaken by the English in 1408–9, and Owen driven into hiding. By the time that Henry IV died in 1413, English authority in Wales had been re-established. Owen himself was never taken, however. What became of him is not known: Henry V offered him a pardon in 1415, but he refused it. Within a further two years he was almost certainly dead. The place of his burial has never been established, but were it known, it would assuredly be a place of pilgrimage, for Owen's courage, his personal magnetism, and his embodiment of the aspirations of a nation have made of him one of the undying heroes of Welsh history—as he remains to this day.

England, too, produced her heroes in the fifteenth century, and none more so than the 25-year-old prince who succeeded his father in March 1413, and ruled England for the next nine and a half years as King Henry V. Henry's brief reign was spent largely in warfare, at which he was stunningly successful. There is no doubt that he was fortunate too, for the French king, Charles VI, was by this time chronically insane, and his kingdom had spiralled into civil war between the Burgundian and Armagnac factions. Allying himself (secretly at first) with the Burgundians, Henry pressed for recognition of his claim to the French throne (inherited from Edward III, so he asserted); when this was rejected, he led an army to France and inflicted an overwhelming defeat on the French at Agincourt in October 1415. Two years later he returned; by early 1419 he had overrun Normandy, parcelled it out among

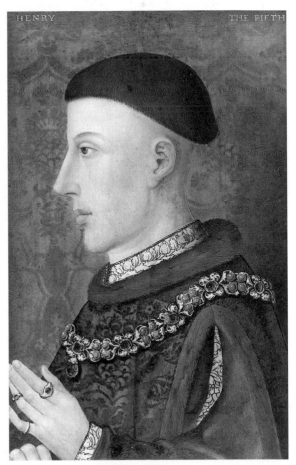

HENRY V (1413–22). Portrait by an unknown artist.

CHRIS GIVEN-WILSON

English lords, and imposed English administration. This was a different kind of war from that fought by Edward III: a war of conquest and colonization, not merely of terror and plunder; a war for land and lordship on a permanent basis. Not surprisingly, the French took fright: the Dauphin Charles, leader of the Armagnac faction, agreed to meet Duke John of Burgundy, to try to settle their differences. A date and a place were fixed: 10 September 1419, at Montereau-faut-Yonne, fifty miles south of Paris. Once again, however, events played into Henry's hands. The two men met in the middle of the bridge at Montereau, but just as Duke John knelt to greet the Dauphin, one of Charles's attendants stepped forward and split his head open with an axe. A century and more later, when John's shattered skull was shown to the French king, Francis I, he is reported to have said, 'This is the hole through which the English entered France.' He was not far wrong, for talk of compromise was now at an end. Philip, the new duke of Burgundy, now came out openly on the English side, and in May 1420 he and Henry sealed the Treaty of Troyes, which recognized Charles VI as king of France for as long as he lived, but declared Henry to be his successor, and, to bolster his claim, gave him Charles's daughter Katherine in marriage. Charles VI was also a party to the treaty—though he barely knew what he was doing—as was his wife, Queen Isabeau, who thereby disinherited her own son, the Dauphin.

The Treaty of Troyes marks the apogee of English diplomacy in the Hundred Years War. Like Brétigny, it rewarded England's unquestioned military superiority. Unlike Brétigny, it envisaged no end to the war, for the Dauphin and his supporters—the majority of Frenchmen—utterly rejected it, and before real peace could be achieved they would have to be defeated. Barely had Henry set about this task when, in August 1422, he died of dysentery. Thus he never became king of France, but his infant son (Henry VI was only 9 months old when his father died) did—indeed he was the only medieval king of England actually to be crowned king of France—and for a decade or so after Henry V's death it was still possible to believe that the dual Lancastrian monarchy of England and France might become a reality. Under the astute regency of John duke of Bedford, Henry V's oldest surviving brother, the English stranglehold on north-eastern France was tightened: Normandy was colonized, Maine conquered, Paris occupied, and by 1429 the English had pushed southwards to Orleans. It was as far as they were to go, however: emboldened by Joan of Arc, the forces of the Dauphin (now Charles VII) raised the siege of Orleans and began to push the English back. In 1435 the Anglo-Burgundian alliance collapsed at the Treaty of Arras when Duke Philip and King Charles made their peace and brought the French civil war to an end; Bedford died in the same year, and in

ILLUSTRATED CHART showing Henry VI's claim to the French throne. He was the only medieval king of England to be crowned king of France, but ended by losing both his French and English thrones.

❦ 128 ❦

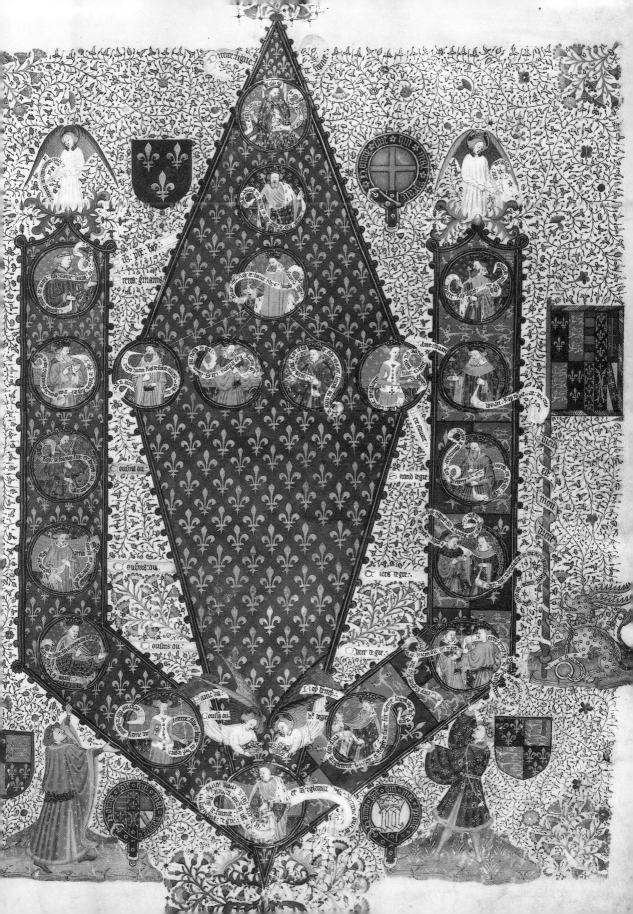

the following year Paris fell. Thus, by the time Henry VI began his personal rule in 1437, the English Crown was once more on the defensive.

Nor was it only in France that this was so. Henry V's triumphs abroad had done much to vindicate his father's usurpation, while at home he had dealt firmly and decisively with open challenges to his rule such as the Lollard Rising of 1414 and the 'Southampton Plot' of 1415 (a conspiracy against Henry's life which aimed to put the earl of March on the throne), but at the same time bore no grudges against families such as the Percys who had opposed his father. His championing of orthodox religion also made him many friends among the Church hierarchy. As a result, he was strong enough to demand, and receive, remarkable sums of money to finance his French war. Yet even before Henry's death there were signs of disquiet over taxation, and once he was in his grave reaction set in. The parliaments of the 1420s were reluctant in the extreme to grant direct taxation, and the minority council which governed in Henry VI's name lacked the authority to make them do so. Nor was all well within the council: on the whole, it performed a demanding task with considerable success, but rivalries were almost unavoidable—especially as the young king grew to manhood, and considerations of future influence and patronage loomed ever larger—and at times the mutual enmity of Humphrey duke of Gloucester (Henry V's youngest brother) and Cardinal Henry Beaufort (his half-uncle) threatened to erupt into violence. Fortunately this was avoided, but the signs were ominous: debt, faction, and discomfiture abroad were always going to make Henry VI's inheritance a brittle one.

It would be difficult to imagine anyone less capable than Henry VI of coping with such problems. 'Simple' is the word most commonly used to describe him: simple in his habits (no bad thing), but also simple in mind. He was peace-loving, compassionate, pious to the point of prudery, and generous to his friends; but he was also naïve, injudicious, and at times irrationally suspicious of those who disagreed with him. He disliked war and, like Richard II before him, tried—partly under the influence of his French-born wife Margaret of Anjou—to bring the war with France to an end by compromise. This was against the wishes of many of the magnates, and, foolishly, Henry resorted to duplicity. In return for a truce in 1445, he

GOLD AND WHITE enamel pendant livery badge of the early fifteenth century, known as the Dunstable Swan Jewel.

secretly agreed with Charles VII that Maine would be handed over to the French in the following year. When news of this leaked out, it caused consternation in the council and among the English captains in France, who initially refused to surrender their castles, claiming that Maine was the essential buffer-zone to the defence of Normandy. Eventually, in the spring of 1448, they were forced to comply, but hardly had they done so before their predictions were fulfilled. In August 1449 Charles VII launched his newly remodelled army against Normandy, which by the summer of 1450 was once again, after thirty years of English occupation, in French hands. Between 1451 and 1453 Gascony too fell to the French, thus ending three hundred years of English rule in the duchy. Calais apart, the English had been expelled from France. The Hundred Years War had ended in defeat.

It was in the same year, in August 1453, that Henry VI suffered his first attack of insanity. For the next seventeen months, according to Professor Griffiths, 'Henry recognized nobody, understood nothing, and, when it was all over, remembered nothing.' This was a disaster, but it was also the culmination of a series of disasters which had shaken Henry's authority over the previous decade. Opposition to his conduct of the war was but one of a growing list of complaints against Henry's rule in the 1440s: the king's household was too expensive, his patronage was extravagant and skewed towards unpopular favourites, he allowed his courtiers to lord it unchecked in their 'countries' (especially the hated duke of Suffolk in East Anglia), he was financially incompetent, judicially partisan, and so forth. Most of it was true. By 1449, the Crown's debts stood at about £370,000. Henry, rather than acting as the independent arbiter of disputes between his magnates, allowed himself to be drawn into their quarrels: in the north, he supported the Percys against the Nevilles; in the south-west, the Courtenays against the Bonvilles; at court, he favoured Suffolk and the Beauforts against his own successive heirs presumptive, Humphrey of Gloucester and Richard duke of York. The result was that those who were not favoured—the Nevilles, Bonville, York—drew closer together; local factions coalesced into a national—a Yorkist—faction. Thus when, following Henry's mental collapse, York was made Protector of the Realm in April 1454, the effect was to replace the head of one faction with the head of another in government, and the same was true when, just after Christmas 1454, Henry recovered and resumed his personal rule. It was against this background of uncertainty and schism that the first battle of the so-called Wars of the Roses was fought at St Albans in May 1455.

The Wars of the Roses, 1455–1485

England's slide into civil war was primarily the consequence of Henry VI's incompetence. On the other hand, given the composition of the rival factions, it is hardly surprising that the question of the succession soon came to the fore, for between the death of Gloucester in 1447 and the birth of Henry VI's only son Edward in Octo-

ber 1453 there was no heir to the throne in the direct Lancastrian line. York certainly regarded himself as a candidate—indeed, he was later to argue that since he was descended from the Mortimers he actually had a *better* claim than Henry. Another possibility, although it was not openly voiced until later, was that the crown might pass to a Beaufort. The Beauforts were descended from John of Gaunt and his third wife, Katherine Swinford. Born out of wedlock, they had been legitimated in the parliament of 1397; but, when Henry IV confirmed their legitimation in 1407, he declared that they could inherit all kinds of dignities and honours *excepta dignitate regali*—that is, the crown excepted. This was fairly unequivocal, but the problem was, did Henry IV have the right to alter the 1397 act of legitimation in this fashion? Between 1444 and 1455, the chief representative of the Beaufort clan was Edmund duke of Somerset, a steadfast supporter of the king and certainly no friend of York's. Their common ancestry may not have been the original cause of their bitter personal rivalry, but we may be sure that it did nothing to blunt it.

The birth of Prince Edward in 1453 should have put paid to the succession issue, but by this time the government was so discredited that desperate remedies were being sought. Suffolk, impeached in the parliament of 1450, was exiled for his own safety but intercepted and beheaded by a crew of privateers off the Kentish coast. This was followed almost immediately by 'Jack Cade's Revolt', the most serious popular uprising in England since 1381, and then, during the next year or two, by the news of defeat in France. Little wonder, then, that when Henry recovered at Christmas 1454 there were many who wondered whether it was truly a cause for rejoicing. Somerset was restored to office and influence; York, with the Nevilles and his other supporters, were cast once more into the political wilderness. At St Albans on 22 May 1455 they took their revenge: it was little more than a skirmish, but among the dead were the duke of Somerset and the earl of Northumberland. There was no intention on the Yorkist side at this stage to press for a change of dynasty, but five years later, by which time Henry had suffered a further bout of insanity, it had become clear that the time for half-measures was past. In October 1460 York marched theatrically into parliament, laid his hand on the throne, and publicly stated his right to the crown. The dumbfounded lords suggested a compromise: Henry would remain king while he lived, but York would succeed him. This, of course, was anathema to Queen Margaret, whose overriding concern by now was to ensure her son's succession. Within two months civil war had broken out, and although York himself was slain at the battle of Wakefield in December, in March 1461 his eldest son Edward defeated the Lancastrian army at Towton (Yorkshire)

THE TITLE-PAGE of Roger Dymock's anti-Lollard tract, *Liber contra duodecim errores et hereses Lollardorum*, a presentation copy made for Richard II; his portrait is in the initial, his arms in the right-hand margin, and his badges of the white hart in the lower margin.

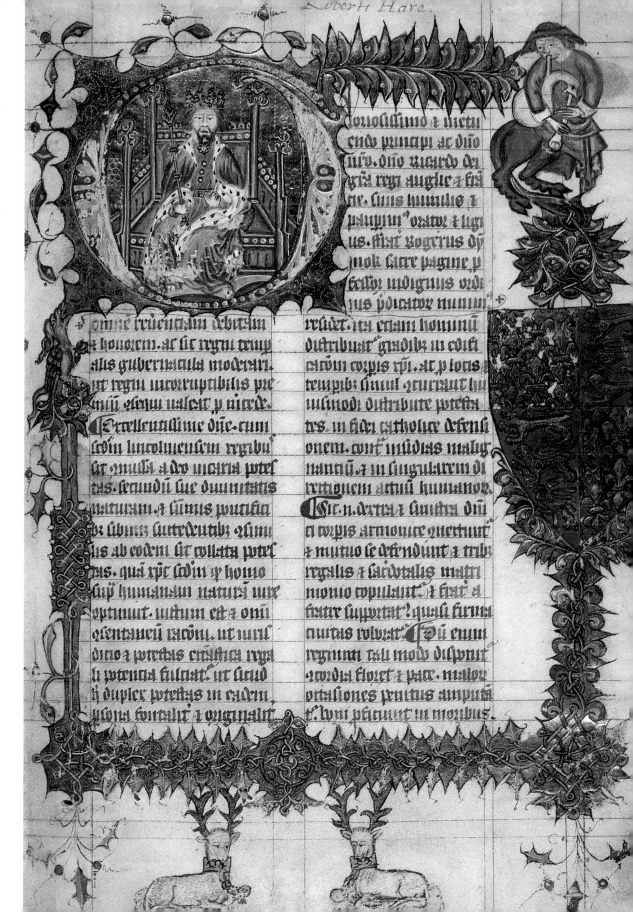

riosissimo z metu
endo principi ac dño
nro. dño ricardo dei
gra regi anglie z fri
cie. suus humilis z
pauperrim orator z ligi
us. ffrat rogerus dy
mok sacre pagine p
fessor indignus ordi
nis pdicator minim

omnem reuerenciam debitam
z honorem. ac sic regni trimp
alis gubernacula moderari.
ut regni incorruptibilis pre
mium eternum valeat p uincere.
Excellentissime dñe. cum
scdm lincolniensem regibus
sit omnis a deo uicaria potes
tas. secundum sue diuinitatis
naturam. z cuius puiticia
ex subditis subtrahentibus z simi
lis ab eodem sit collata potes
tas. qua xpc scdm q homo
sup humanam naturam iure
optinuit. iustum est z omni
esentaneum racôni. ut uniu
dicio z potestas ecclesiastica rega
li potencia fulciat. ut sicud
ĥ duplex potestas in eadem
psona ficialit z originalit

reudet. ita etiam hominum
distribuat gradibus in edifi
cacôm corpis xpi. ac p locis z
tempib; simul zcurunt hu
iusmodi distribute potestes
tes. in fidei catholice defensi
onem. cont insidias malig
nantium. z in singularem di
rectionem actuum humanor.
Sic. ñ. dextra z sinistra dñi
et corpis armonice quierunt
z mutuo se defendunt z trib;
regalis z sacdotalis matri
monio copulant. z ficiat a
fratre supportat? quasi firma
ciuitas robustet? Dum enim
regimen tali modo disponit
zcordia floret z pace. maior
occasiones preunitis amputa
t. boni psurunt in moribus.

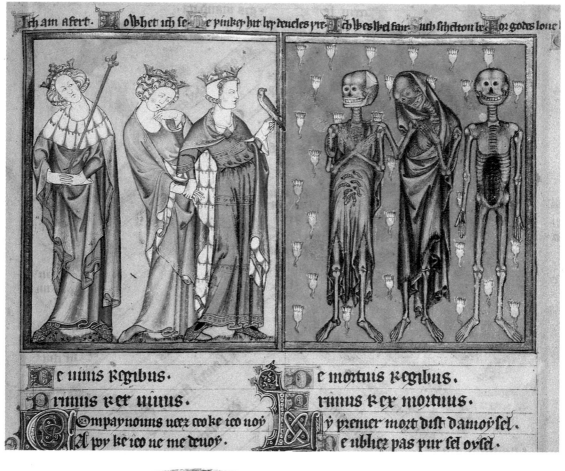

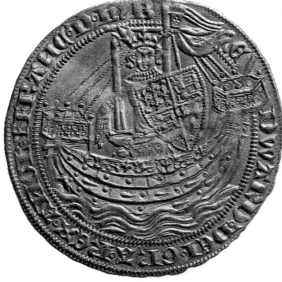

DANSE MACABRE. The art of the gruesome became ever more common in the aftermath of the Black Death of 1348–9.

GOLD NOBLE of Edward III, showing the king in a ship, commemorating his naval victory at Sluys in 1340. The first English gold coins were minted in 1344.

and declared himself king. Henry and Margaret fled to the north, while the 18-year-old Edward, now Edward IV, made for London to claim his kingdom.

And so, for the next twenty-four years, barring a brief interlude during the winter of 1470–1, England was ruled by 'Yorkist' kings. It is doubtful whether either Edward IV or Richard III ever quite felt secure on the throne, but Edward at least demonstrated the capacity to learn from his mistakes, and following his restoration in 1471 England enjoyed a decade of relative calm. The 1460s, however, were fraught with danger. Margaret of Anjou, who had by now assumed the leadership of the Lancastrian cause, lurked menacingly in the north, and not until the defeat of her forces at Hexham in 1464, and the eventual capture of Henry himself in the following year, was Edward able to exert any real control there. Moreover, Edward compounded his own problems when, defying his chief ally the earl of Warwick (the 'Kingmaker'), he secretly married Elizabeth Woodville in 1464. Warwick had been negotiating a foreign match for the king, and never forgave the slight. His estrangement from Edward was further fuelled by the lands and favours which Edward heaped on the new queen's relatives, and by 1470 his relations with Edward had deteriorated to the extent that he now put together the unlikely coalition of himself, the exiled Margaret of Anjou, and Edward IV's own disaffected brother, George duke of Clarence, who together invaded England in September 1470. Edward, deserted, fled to Flanders, but six months later he was back; Clarence turned coat once more, and at the battles of Barnet (April 1471) and Tewkesbury (May 1471), Edward overcame first Warwick (who died at Barnet), and then Margaret. The 17-year-old Prince Edward, the Lancastrian heir, was killed at Tewkesbury, and two weeks later Henry VI died in the Tower 'of pure displeasure and melancholy', as Edward disingenuously put it. The senior line of the house of Lancaster was thus extinguished, and, if the Lancastrian claim were to be pursued, it would have to be through the Beauforts; fortunately, Somerset's elder brother John had left a daughter, Margaret, who had married Edmund Tudor, earl of Richmond. Their son, born in January 1457, was called Henry.

Henry Tudor's time would come, but not yet. For the remaining twelve years of his reign, Edward IV was virtually unchallenged. With Warwick dead, he could place a far greater degree of reliance on the magnates: Richard duke of Gloucester, the king's youngest brother, was given charge of the north, while the king busied himself building up a network of lords and gentry in the shires. Efficient financial management—achieved partly through the avoidance of warfare, and partly through the use of the king's Chamber to handle royal revenues—also meant that Edward IV was the first English king since Edward II to die solvent. What he failed to do, however, was to leave an adult heir to his throne. His two sons were only 12 and 9 respectively at the time of his death in April 1483. The elder thus became Edward V, while his uncle Richard of Gloucester became Protector. Why Gloucester did what he did next will never be known for sure: was he genuinely afraid that

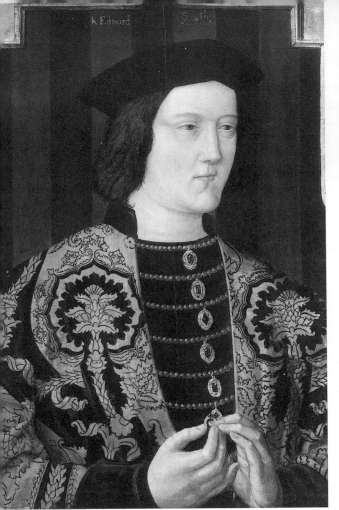

EDWARD IV (1461–83) (*left*). Portrait by an unknown artist.

RICHARD III (1483–5) (*right*). Portrait by an unknown artist.

his hostility towards the Woodvilles would result in his own destruction, or was his ambition simply unable to resist the chance that now presented itself? Whatever his thinking, he wasted little time: before June was out, he had executed several prominent supporters of the old regime, declared his two nephews to be illegitimate and imprisoned them in the Tower, and seized the throne for himself. On 6 July he was crowned King Richard III. The 'princes in the Tower' were never seen again. Despite much speculation on their fate, the most likely explanation remains that they were murdered on Richard's orders.

Richard only enjoyed his bloody inheritance for two years, however. Revulsion at the deeds of which he was suspected turned opinion both at home and abroad against him. Henry Tudor, awaiting his opportunity in Brittany, received material aid from the French and promises of support from many Englishmen. Eventually, on 7 August 1485, he landed at Milford Haven, and on 22 August his army of some

5,000 men confronted Richard's, which was at least double that size, at Bosworth in Leicestershire. Richard, trying to bring Henry to personal combat, was cut off from his men and killed, and his army defeated. Henry Tudor thus became Henry VII, and in the following January he married Elizabeth, the eldest daughter of Edward IV. It was a deliberately symbolic reconciliation of the houses of Lancaster and York, an attempt to draw a line under the 'Wars of the Roses'—and, thanks to Henry VII's remarkable abilities, it worked. He ruled England for twenty-four years, and when he died, in April 1509, the crown passed to his son, Henry VIII, without a whisper of dissent.

If the history of England during the later middle ages all too often seems like a ceaseless litany of war, rebellion, and political infighting, one response might simply be to say, 'well, *plus ça change*'. Equally valid, however, would be to emphasize the underlying continuity and development of political institutions during this period. During the Wars of the Roses, just as during the baronial wars of 1258–65, it was the king and the lords who dominated English politics; it would be another two centuries before that really began to change. On the other hand, there is no doubt that the English polity had broadened significantly during the fourteenth and fifteenth centuries: the role of parliament, and more particularly of the commons in parliament, was the living proof of that at the national level, just as the role of the gentry in the shires was the living proof of it at the local level. However, talk of the growing power and responsibility of parliament should not deceive us into imagining that fifteenth-century England was in any sense a 'parliamentary democracy' or a 'limited monarchy'. Kings were still every inch kings. Could anyone seriously argue, for example, that Henry VIII's authority as a ruler was more 'limited' than that of, say, Henry II? In truth, it makes more sense to say that, for the most part, the late medieval parliament, a consummately and unashamedly upper class assembly, enhanced rather than diminished the power of the monarchy.

The fundamental reason for this is that between the king, the lords, and the commons there was an essential community of interests, forged not only through common assumptions, aspirations, and prejudices (as demonstrated in, for example, the repressive labour legislation of the post-Black Death period), but also through regular co-operation in a great variety of military, judicial, and administrative tasks. This community of interests was the keystone of the English state in the late middle ages—and 'the English state' is undoubtedly the correct term by now. To some extent, the drawing-in of England's horns—from France, from Scotland, and from Ireland, if not from Wales—may have helped in the process of state-building, unwillingly though it was done: twelfth-century England, with its all-pervasive French connections and its constantly shifting orientation within the British Isles, was an imperfectly defined and unfocused political entity; fifteenth-century England was more clearly and exclusively *English*. This is not to deny that the continuous pressure of foreign warfare was often the forcing-ground for some of the most

lasting developments in late medieval English political life. It was warfare which demanded taxation, for example, and taxation, besides being in itself a powerful tool of statecraft, was also a key factor in determining the direction in which the English parliament would develop. Developments abroad also had a major part to play in the process. It was the genuinely dual allegiance of the English clergy, for example, to an ever-expanding papal monarchy as well as to their king, which created such problems for them and for kings such as Henry II and John in the twelfth and early thirteenth centuries. And it was the decline of papal power and prestige during the fourteenth and fifteenth centuries which allowed English kings of this period to rein in the Church, so that, in the words of Dr Catto, 'in all but name, more than a century before the title could be used, Henry V had begun to act as the supreme governor of the Church of England'.

'Bastard feudal' is still a popular (if much-abused) term to describe late medieval English society, and as long as its use is restricted to its fundamental meaning—that is, to describe a society which still recognized feudal institutions in theory but paid decreasing heed to them in practice—it remains a useful catch-all for fourteenth- and fifteenth-century England. For the imprint of feudalism was indeed much faded by this time: feudal armies had been replaced by contract armies, feudal justice had largely given way to royal justice, and feudal rules of land inheritance had been undermined by legal devices such as entails (conditional grants) and enfeoffments-to-use (trusts), thus edging tenurial law and custom closer to the concept of freehold. Parliament may have begun life as the expanded feudal court of the king, but no one could deny that by the fifteenth century it had become a national assembly. It was the chief political legacy of the late middle ages, both cause and effect of England's evolution as a nation-state.

5 The Economy and Society

~~ **Christopher Dyer** ~~~~~~

After Britannia 400–600

The people of the former Roman province of Britain in the fifth and sixth centuries had to make their living in difficult circumstances. Around them lay the ruins of imperial grandeur. In the cities, public buildings and private houses were in decay; on the frontiers, the forts were abandoned; in the country, the aristocratic villas were crumbling. This was not just a matter of physical decline or political change because, as the Roman state was dismantled, so roads, bridges, and ports were neglected, the coinage disappeared, government spending ceased, and the élite of the armed forces and civil administration were no longer employing labour or consuming goods on a large scale. Trade dwindled, and the former mass-producing industries collapsed. The native British population faced major upheavals in their way of life, including unemployment and a breakdown in law and order. The German immigrants from across the North Sea, who had been attracted by the opulence of the province, had to adapt to a society in flux.

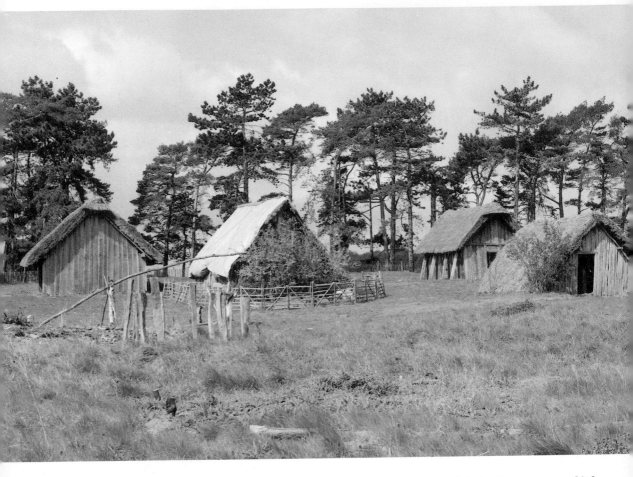

The British could attempt to cling to the wreckage of their former way of life. Well into the fifth century the Roman tradition survived in Verulamium (the Roman predecessor of St Albans) and the city authorities continued to lay water pipes in the civilized fashion of the empire. Cities still served as centres of government, but now as the capitals of 'princes', at sixth-century Gloucester and Cirencester, for example. The inhabitants reduced their standards of living, and built houses of timber, in the rubble of collapsed stone structures.

But without trade, easy communications, or imperial government, the cities could not provide a living for a large population, and almost everyone lived in the countryside. Here again they had no alternative but to adapt to a restricted economy. Apart from problems of security, there would be no more large surpluses to be sold in the towns. The villas were taken over by succeeding generations of native British or Anglo-Saxon immigrants, who put up buildings of wood. In some cases the territory around the villa persisted as an estate unit, and the owners obtained tribute from the local peasants.

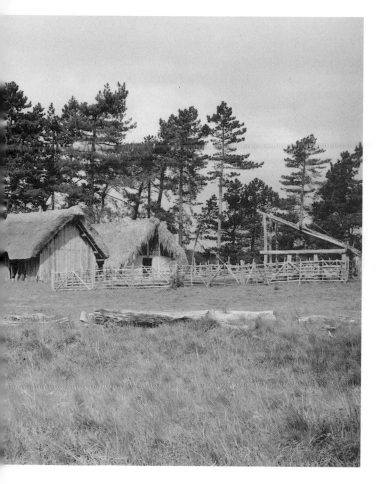

SETTLEMENT at West Stow, Suffolk, dated to the fifth and sixth centuries, reconstructed after excavation. Some of the buildings were used as dwellings, and others had more specialized purposes, such as weaving sheds.

The priority of country-dwellers lay in providing for their own subsistence. In southern and eastern England they lived in timber houses often measuring 15 by 30 feet (5 metres by 10 metres), associated with smaller structures with sunken floors, built for storage, craft work (such as weaving), and accommodation for servants and dependants. If houses stood in a group, they were not usually numerous—at West Stow in Suffolk five households formed a hamlet. This settlement is typical of the period in practising mixed farming which would provide subsistence needs of grain, meat, dairy products, skins, wool, and other raw materials. They used the land with less intensity than under the Roman economy, so that in parts of the west and north trees and bushes were allowed to grow on previously cultivated fields, and in the south and east some corn-growing land was replaced with grass.

Even in the reduced circumstances of the post-Roman recession, households could not meet all of their consumption requirements from their own resources. They wove their own cloth (leaving broken loom weights to litter their settlements) and no doubt built their own houses, and made implements from wood. But they

needed iron weapons and farming tools, and women wore ornate jewellery manu-
factured from copper alloy. These could only be supplied by specialists with craft
skills and raw materials, so some surpluses from the land were exchanged. Imported
goods from the Continent, such as glass vessels and jewels made of rock crystal, were
acquired most commonly by the inhabitants of Kent.

A society with an emphasis on production for use, and which had limited facili-
ties for exchange, was not likely to be deeply stratified. Élites collected foodstuffs
from the peasants in some form, but they had limited ways of disposing of goods
once they had fed and clothed their followers. The accumulated treasures of the
kings of East Anglia that were buried with King Redwald in about 620 included
Frankish coins, Byzantine silver plate, and other luxuries, but these had been
obtained as gifts, not by commerce. In the west, however, commercial contacts with
the Roman world persisted, and the Cornish chieftain or prince who occupied the
rocky peninsula of Tintagel was able to eat from tableware made in north Africa and
Asia Minor and to include wine, olive oil, and other exotics in his diet, presum-
ably by organizing the trade in Cornish tin with merchants from the Byzantine
empire.

While the inhabitants of fifth- and sixth-century England adapted successfully to
their post-imperial world, this was still a traumatic process. The losses of population
far outweighed the gains from migration, partly as a result of plague epidemics in the
sixth century, but more as uncertainties and the lack of economic opportunity dis-
couraged marriage and child-rearing. We can only guess at the overall figures, but
the sparsity of settlements, the abandonment of towns, and the retreat of cultivation
could point to at least a halving of the population. Thus numbers fell from a peak of
perhaps 5 million in the second century, to less than 2 million by *c.*600.

Growth and Innovation, 600–1050

A variety of initiatives were undertaken in the period between the seventh and the
eleventh centuries, with the result that by 1050 the structures of production and
social organization were established—villages, towns, class hierarchies—which
were to provide the framework for succeeding centuries.

Both the small kingdoms of the period before the Danish invasion, and the later
English state, made some contribution to economic development. Kings minted
coins to enable them to collect taxes in convenient and portable form, and to assert
royal rule in the manner of Roman emperors and rulers on the Continent. They pro-
duced small silver coins, *sceattas*, from the seventh century, which were replaced by
the larger silver penny in the late eighth. In this way, kings provided a convenient
medium for commerce. They also developed centres at which traders and craftsmen
settled. The first of these towns in the period before 900 were usually called *wics*,
and were sited strategically to serve as trading places (Bede used the word *emporium*

for the largest of them, at Lundenwic), but others lay along the south and east coast at Southampton (Hamwic), Sandwich, Ipswich, and York (Eoforwic). The inhabitants of these settlements traded in goods such as wool, cloth, wine, and millstones, and made objects of metal, bone, and stone. There were also some inland points of exchange, like the salt-making centre at Droitwich in Worcestershire, and kings encouraged the development of trading settlements around their major residences, churches, and centres of government, such as Hereford, Tamworth, and Winchcombe in the Mercian territory in the eighth century. But this first phase of town development tended to be transient (the sites of Lundenwic and Hamwic were eventually abandoned) and the inland centres were of modest size. More permanent and large-scale developments came around 900 when the rulers of Wessex and the Scandinavian states founded centres of government and defence, the boroughs. Large numbers of immigrants were attracted to them to trade and to practise their crafts, protected by strong fortifications, and confident of a steady flow of customers visiting courts, paying taxes, and attending the important churches which were often enclosed within the walls. Towns were settled intensively, with houses packed together and accumulated rubbish already by the tenth century created a pollution hazard. By the late eleventh century more than a hundred towns had developed, with a combined population approaching 200,000.

The aristocrats served the kings, but also enjoyed power and wealth on their own account. We know of their lands through the charters by which a substantial share of the country's agricultural resources were transferred to bishops and monasteries. In the early phase of Christianity, in the seventh and eighth centuries, great estates were granted by kings and aristocrats, and we often find that these covered five or ten square miles. Such large units of land were often subdivided for easier management, and their main purpose was to provide the lord with rents in kind. Each estate would have a residence for a lord, and every year the king, great aristocrat, or bishop would descend on the place with a large household and eat and drink the estate produce for a few days. Occasionally the provisions are recorded—barrels of ale, sacks of corn or hundreds of loaves of bread, cheeses, cattle and sheep, and pork. The land and its peasants could bear these burdens without too much difficulty—the lord was satisfied with an annual feed, and his estates were many and large. But in the ninth and tenth centuries the landed aristocracy became more numerous and more demanding. The companions, servants, and officials of the great magnates required a stable landed endowment and, as government and warfare became more complicated, the rulers wished to reward and sustain an ever more numerous body of these supporters, the thegns. So we find that the great estates were broken down into smaller parts (which had often existed before, but as subdivisions of large units), and granted to thegns. In the tenth century land holdings appear on a manageable scale of one or two square miles, and often such an estate or manor would be the sole means of support for a thegn and his family. Such people needed to exploit land

much more intensively than had been the practice in the past. Already as early as the seventh century estates had been divided between tenants' land and land under the direct control of the lord (later called a demesne), and the peasant tenants were expected to provide the labour to work the lord's land. This system of production, ideally suited to an economy where labour was in short supply, was applied more universally in the ninth and tenth centuries, and by *c.*1000 it could be assumed by the author of a treatise on estate management that the peasants with holdings of a yard-land (about 30 acres) would work for the lord for two or three days per week, in addi-tion to paying rent in kind of barley, hens, and sheep. The same document shows that essential work on the estate, such as looking after animals, came from slaves, who were fed by the lord.

The peasants look like the losers in the formation of these more productive and repressive manors, as their commitment, especially of labour, increased. But they were not just victims. Lists of services must have involved some bargaining between lord and tenant. A factor in the decline of slavery was the difficulty in obtaining efficient work from people resentful of their condition. Tenant obligations in the tenth and eleventh centuries included modest payments of cash, so they had to sell produce to pay their 10*d.* per annum. But they also bought a few goods such as cloth, the weaving of which was increasingly taken over by town-based craftsmen. In east-ern England the finds of pottery manufactured at Stamford and Thetford in dozens of rural locations prove the widespread distribution network over the countryside for the products of an urban industry.

Place names were mainly formed between the sixth and the eleventh centuries, and, as they were coined by local people, they provide important insights into pop-ular perceptions of the rural world. First, they reflect the overwhelming triumph of the English and Scandinavian languages, as few British or Latin names survived. Secondly, the large number of names containing the name of a lord (Ardwick, for example, records the farm of an owner called Æthered) shows the importance of lordship. But above all, the names tell us a great deal about the state of the land at the time when they developed. Names ending in -ley or -field were descriptive of clearings in woods or open country near to woodland, and -hurst, -grove, and -shaw refer to the woods themselves. Such names are distributed most closely in specific localities such as western Wiltshire, northern Sussex, or central and north-eastern Derbyshire which are known to have supported considerable areas of woodland in later periods. Only occasionally do we find woodland names in places which have subsequently developed a mainly grain-growing agriculture—examples might be

REGULARLY PLANNED VILLAGE at Carlton, County Durham. This aerial photograph shows the modern buildings of a still-flourishing village, but the main street and many of the property boundaries of the tofts (enclosures) in which the houses lie probably date from *c.*1200 or even earlier. The orderly and symmetrical plan must have been the result of deliberate decision making.

part of the Cotswold hills, or Bromswold on the borders of Northamptonshire and Bedfordshire.

Confirmation of this finding comes from the mass of minor names, recorded as estate boundary-marks in the tenth and eleventh centuries, but again reflecting the everyday language of ordinary country-dwellers. Names referring to woods account for no more than 3 per cent of the total, and they are often found in districts which were wooded in later centuries, like north-east Worcestershire, which later became the royal forest of Feckenham. In districts dominated by arable farming in later times, we find charter boundaries like that for Hardwell in Compton Beauchamp on the edge of the downs in Berkshire, probably written in 903, which defines the edge of a manor by picking its way through the strips and headlands of a cultivated field system. There would have been local shifts in the use of land from wood and pasture to more corn-growing as the population expanded, but the Anglo-Saxons did not need to clear thousands of acres of dense primeval forest in lowland England because such wild country had been opened up well before the fifth century, and much of it had remained in continuous agricultural use.

The formation of nucleated villages and the laying out of large tracts of open fields represent great creative achievements of this period, surpassing in number the major churches or royal and noble fortifications. Before c.900 most people lived in small farms or hamlets, but from around that date until c.1200, hundreds of thousands of peasants abandoned their scattered settlements, and congregated in villages of between a dozen and fifty households. The villages in many cases were planned, often as neat rows of houses ranged along streets, each house standing in a rectangular 'toft'. At the same time, the village territory lay in two or three great fields, and these were in turn split up into rectangular blocks (furlongs) of 5–10 acres each, further subdivided into strips 18 to 36 feet (6 to 12 metres) wide and 600 feet (200 metres) or so long. The pattern of strips and furlongs was accommodated to the contours of the land, so that water would tend to drain down the furrows which defined the edge of the strips. The rest of the village land was allocated as meadow, pasture, and wood.

We do not know whether villages were formed suddenly, in a single season, or whether the change was accomplished over decades or centuries of evolution. If its origins are obscure, we can nevertheless recognize the internal logic of the system. The fields achieved a balance between a large area of cereals, and grazing for animals. If everyone surrendered the management of their land to the village, and planted only on one field (in a two-field system) or two (in a three-field system), this left the remaining field as fallow for grazing, and gave the land time to recover from continuous cropping. The system represented a compromise between individual initiative, as everyone was responsible for the cultivation of their strips, and observance of collective routines and decisions which governed rotations, the limits on the numbers of animals, and the times of planting and the fencing of grazing land. To ensure that all villagers received equal benefits (and disadvantages) the strips

were scattered over the whole territory on both good and bad land. As everyone lived in the same settlement, they all had similar journeys to the different strips. Communal grazing of animals, which could be put in the hands of a single common herdsman, saved labour. The reasoning behind the system lay in maximizing the well-being, or at least survival, of the whole community, not to encourage individual acquisitiveness.

The decision to adopt this method of land management was taken in a belt running through the middle of England which left landscapes of hamlets with irregular and sometimes enclosed fields in East Anglia, the south-east, and the west.

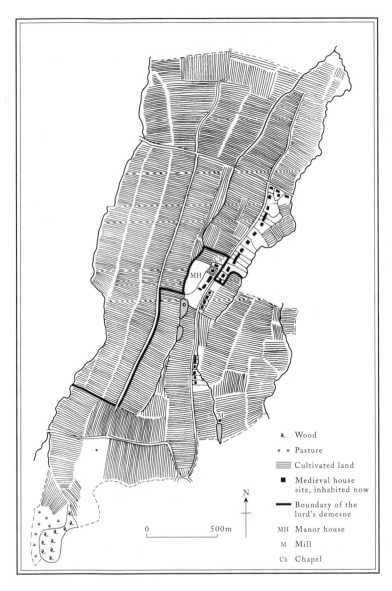

NUCLEATED VILLAGE and its fields at Admington, Warwickshire. The plan has been reconstructed from later evidence, much of it modern, but the row of village houses and the site of the manor were probably established by the eleventh century. The territory was filled with strips of arable land in order to maximize grain production.

꙼ Wood

⁎ ⁎ Pasture

≣ Cultivated land

■ Medieval house site, inhabited now

▬ Boundary of the lord's demesne

MH Manor house

M Mill

Ch Chapel

N

0 500m

People in these regions sometimes planned their settlements, with houses disposed in an orderly fashion at intervals along roadsides or on the edge of pastures. They did not lack a collective element in their farming, as they often shared common fields and grazing, but they tended towards individualism and more pastoral farming than the corn-centred villages.

The differences between the 'village belt' and the regions of scattered settlements might have been determined by soils, relief, and climate. It is true that the densest and most permanent woods occurred on the most inhospitable soils and steepest slopes in the weald of Kent and Sussex, or in the Forest of Dean on the Welsh border; so sometimes the natural environment had a strong influence on the rural economy. But these are extreme cases, and we are much more conscious of a landscape that was moulded and manipulated by its cultivators, in short, 'man-made'. The boundaries of village territories deliberately took in a variety of types of land, for example, for the benefit of the mixture of resources that this made available. Aristocratic estates would achieve a balance of land types over their scattered manors. If one estate specialized in corn-growing, and lacked wood and pasture, it was attached to an area of distant woodland, like Tenterden in the weald of Kent, to which Thanet, thirty-six miles away, sent its pigs to fatten on acorns, and where building timber and firewood were obtained. And the character of the land was drastically changed by turning woods into open pastures, by clearing woodland for cultivation, and by the drainage of wetlands. We should not think of the human influence on the landscape always leading to the taming of wild country by converting woodland and pasture to cultivated fields. These 'wastes' were carefully managed assets. Some woods were fenced to keep out animals, and trees were pollarded and coppiced as a renewable resource to provide the desired variety of products: timber, poles, faggots, and so on. And from the tenth century and probably earlier, kings and lords protected woodland and pasture for hunting, and occasionally land reverted from cultivation to woodland. Conservation was not just a matter of asserting aristocratic privilege, as communities of peasants often had rights of common in woods and hills—on a large scale in the fells of the Lake District for example, or in the Chilterns—and they were concerned with preventing encroachment by individuals putting up fences or bringing land into cultivation.

The Great Expansion, 1050–1300

Many impersonal developments lay behind the great economic expansion of the eleventh, twelfth, and thirteenth centuries. The climate improved, so that crops could be grown more reliably, and in inhospitable places. The threat of epidemic disease receded. Great geopolitical trends, like the movements of nomads in central Asia, tended to give western Europe an advantage in its trading relations with the east. And there were periodic fluctuations in the supply of precious metals, notably

the opening of major silver mines in Germany in the late twelfth century, which flowed into England to cause sudden inflation. But the changes of the period came from decisions made by groups and individuals, which cumulatively had the effect of increasing population, agricultural production, the numbers and size of towns, and the volume of trade. We can look at the contribution that each group made to this growth.

LANDLORDS

The aristocracy had an enormous impact on the whole of society because of their power exercised privately as lords, and through their influence on the state. Their numbers were relatively small—at the time of the making of Domesday Book in 1086 there were about 1,100 tenants-in-chief (landholders directly under the lordship of the king) of whom about 170 were seriously rich earls and barons. Another 6,000 subtenants had substantial holdings of land—worth mostly in excess of £5 per annum—and can be regarded as a lesser aristocracy. By 1300 there were about a hundred earls and barons, 1,100 knights, and 10,000 lesser gentry. Among the ecclesiastical landlords, the bishops increased only from fifteen at the time of the Conquest to seventeen in 1300, but the number of monasteries rose from sixty-one in 1086 to more than 800 at the end of the thirteenth century. From these figures we can deduce that there were more lords in 1300 than earlier, and the rest of society had to afford a large non-productive sector—one of the defining characteristics of the aristocracy, more important than high birth or their obligation to service, lay in their distinctive style of life, which entailed abstaining from manual work. As well as becoming more numerous, lords increased their wealth. The archbishop of Canterbury, to take as an example a single magnate, had been worth about £1,200 per annum in the eleventh and mid-twelfth centuries, but enjoyed an income of £2,600 annually in the 1290s. The total income of all of the secular aristocracy, together with bishops and monasteries, has been estimated in 1086 at £100,000 and in 1300 at about £600,000. It is true that the increase in the Canterbury revenues barely kept pace with the inflation of the thirteenth century, but the multiplication in the incomes of the whole aristocracy suggests that overall they achieved a real growth in wealth.

Much of the acquisitive and competitive energy of the aristocracy was absorbed in transferring land from one individual or institution to another, rather than in increasing productivity. The most comprehensive reallocation of property followed the Norman Conquest, when hundreds of Norman and northern French immigrants obtained the lands of the Anglo-Saxon aristocracy both by royal grants and by seizure, which has been euphemistically called 'private enterprise'. The reshuffling of land continued, by grants from royal patrons, through marriage and inheritance, by gifts to the Church, and through acquisitions by laymen from the Church, so that the ecclesiastical landlords could provide the king with military service.

Smaller units of land holdings may have contributed to growth. Manors were divided by inheritance, the market for land, gifts, and grants for service. The great expansion in the numbers of lords came at the lower end of the aristocracy, with the proliferation of minor gentry landholders, and modestly endowed monasteries—most landlords at the end of the thirteenth century received incomes below £20 per annum. These lesser lords were obliged to manage their lands with great care, often supervising cultivation or rent collection in person, and taking every advantage of market opportunities.

Aristocratic competitiveness also had implications for the lords' consumption of goods. One of the great changes of the twelfth century came from the acceptance of new standards of behaviour associated with the idea of chivalry. The knight was the new role model, not the vigorous and barbaric warrior of earlier centuries, but a gentlemanly figure who combined prowess in war with generosity and courtly refinement. War itself—fine horses, armour, and fortifications—cost more, but good food served ceremoniously at table, fashionable clothing, and imported luxuries were all needed to maintain the right style. Some families miscalculated, and fell into debt and ruin, but in general aristocratic demand grew and stimulated sections of industry and trade.

But the lords' main contribution to growth must have come from their management of their lands. Some of them chose to make radical innovations to increase production. The Cistercian monks, who account for more than seventy of the new monasteries, deliberately chose sites in remote places, and then developed these 'deserts' by assarting woodland (clearing the trees for cultivation) and developing the hills and moors as sheep runs and cattle ranches. In more settled areas, the Cistercians pursued a policy of consolidation, buying and exchanging land to create compact territorial blocks, often amounting to 400 acres, and run efficiently as a single 'grange', with labour from lay brothers or (more often) hired workers. Lords also found that they could increase their profits by establishing markets and founding towns. At the modest cost of obtaining a charter, survey work in laying out house plots on the new site, and occasionally diverting a road to bring travellers through the town, they could charge new urban tenants rents of 12*d*. per quarter-acre plot, four times the rate for agricultural land, and collect additional revenues from the borough courts and tolls.

The real test for the lords' management skills came with the great inflation around 1200. Previously they had enjoyed a steady income by leasing out their lands for a fixed annual rent or farm. But suddenly these sums diminished in value, and instead they put local officials in charge of each manor, with orders to pay the revenue from peasant rents and the sale of produce directly to the lord. The new system presented lords with a series of difficult decisions, taken with the advice of a professional body of auditors, stewards, and lawyers (providing employment for the lesser gentry). One dilemma was whether to change the agricultural system—for example

to consolidate and specialize in the style of the Cistercians. There were a few who opted for this, notably northern lords who, confronted with the need to make efficient use of upland pastures, created sheep and cattle farms. The earl of Lincoln, for example, kept 2,500 cattle on his Lancashire vaccaries in 1296. Another question was: should the lords invest in agricultural improvements and pay large sums for drainage, new buildings, spreading marl on the soil, and experiment with new crops and breeds? Some lords did spend in this way, the most famous example being Henry of Eastry during his period in charge of the estates of Canterbury cathedral priory (1285–1331). But such cases of 'high farming' did not involve very high levels of investment, and were outnumbered by instances of lords sticking to a routine. Estate owners showed a certain astuteness in adapting their farming to local circumstances, whether employing the intensive methods appropriate to the fertile soil in eastern Norfolk, or putting a good deal of planning, care, and investment into the most profitable sectors of agriculture, such as sheep-rearing. Another choice to be made was whether to use labour services of tenants on a large scale, or whether to convert the peasants' work into cash rents, and depend mainly on farm servants and

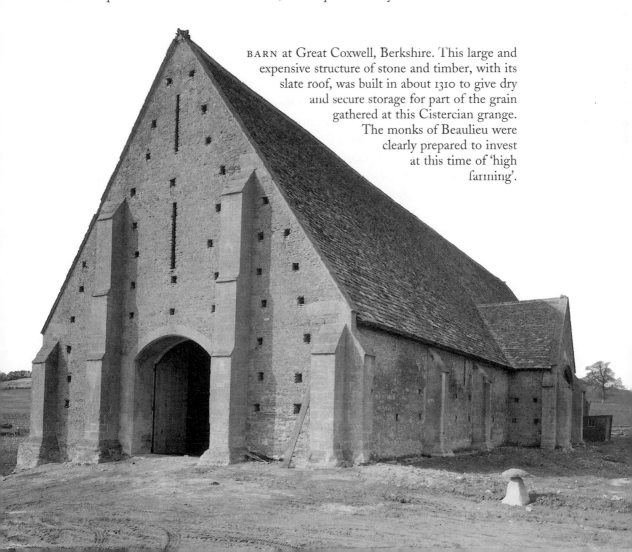

BARN at Great Coxwell, Berkshire. This large and expensive structure of stone and timber, with its slate roof, was built in about 1310 to give dry and secure storage for part of the grain gathered at this Cistercian grange. The monks of Beaulieu were clearly prepared to invest at this time of 'high farming'.

hired labourers. Most lords opted gradually during the thirteenth century for the latter strategy, partly because they found that wage labour was more productive.

Lords often made wise decisions, and expanded their incomes by improving the profitability of agriculture; but at least as important, they took as much as possible from their tenants. At the end of the twelfth century the Crown was anxious to establish which sections of the population were subject to the royal courts, that is, were free, while lords whose incomes were threatened by inflation wished to secure their rights over their tenants. Eventually a solution was devised whereby about 40 per cent of the peasantry were classified as villeins (serfs) and therefore subject to the justice of their lords. The lords claimed almost total control over these people, so that the serfs in theory owned no goods, had no free choice over their working lives, and were unable to leave the manor or to bequeath and sell land. In practice, they could do all of these things, and many serfs prospered; but they had to pay for these activities, and usually in cash. Their obligations included, as well as annual money rent, numerous financial payments including entry fines when their holdings were inherited or changed hands, and marriage fines. A tenant of a 30-acre holding could be expected to pay an entry fine of £5 or more, and a marriage fine of 13s. 4d., when the annual cash rent would commonly amount to 10s.–15s. By exploiting such rights, lords were able to cream off some of the profits that the tenants made in the market.

PEASANTS

The attitudes and policies of lords are known to some extent from letters, memoranda, and textbooks written for estate managers. Because the peasants were illiterate, we must deduce their ideas from the records kept by their superiors.

In the first place, it is worth saying that peasants were by no means passive in accepting the demands made by the lords. Individuals resisted the initial classification of free and unfree in the royal courts around 1200. Throughout the thirteenth century communities brought lawsuits against their lords, using the legal loophole that tenants of former royal estates, 'ancient demesnes of the Crown', were protected from increased rents and services. Such communities were inspired by ideas about their ancestral freedom, which they believed went back to pre-Conquest times. Almost invariably the royal courts found against the peasants, and in the manor courts they were punished for disobedience, but the legal proceedings were not just futile gestures, because they helped to set limits to the demands of lords, and strengthened the peasants' bargaining over such matters as the conversion of labour services into cash rents. Lords and peasants were not in a state of constant open conflict. Part of the skill of successful estate management lay in recruiting the leading peasants as administrators, so we find manors run from day to day by peasant reeves, and the lords' courts depended on the co-operation of peasant jurors. The lord gained from the expert knowledge of local people, and demands for labour and money were more likely to be accepted if they came from respected neighbours than

from some remote official. On their side the peasant administrators gained some material rewards, but also acquired status and authority within their community. Village self-government was strengthened by its use by the lord, and was valued by the State and Church. By *c.*1300 villages were carrying out many tasks, in recruiting foot soldiers for the royal army, for example, or taking responsibility through the churchwardens for the fabric and fittings of the parish church.

Peasants, then, were neither powerless nor crushed by their superiors, and contributed to economic growth in a number of ways. They welcomed new opportunities from the growth of the market. They were anxious to discharge their dues to their lords in money rather than labour, and this must have encouraged the switch to cash rents. About half of the peasants in the late thirteenth century had holdings of between 15 and 30 acres (a half to a full yardland), which would have yielded saleable surpluses of grain and animal products worth between 10s. and £2. They were encouraged to produce for the market because the prices of grain, wool, and animals more than doubled in the course of the century. In addition, peasants supplied products which lords did not grow much—fruit and vegetables, industrial crops such as hemp and flax, and honey.

A considerable proportion of the money gained by peasants went to the lord in rents and to the state as tax. But peasants were able to spend some of their money income: they consumed food and drink, such as bread and ale, which were more conveniently bought in a prepared state, and fish which could not come from their holdings. They also bought manufactured goods, notably clothing and utensils. In the thirteenth century peasant houses were based on stone foundations, and the carpentry of the timber frame achieved such a high quality that occasional examples are still standing and inhabited. Specialist craftsmen built these durable structures, and peasants paid their wages and the cost of materials, totalling as much as £2 for a small house.

Smallholders were potentially damaged by the advance of the market—for, unable to produce much grain from their few acres, they had to buy their food at high prices. Some compensation for them came from the greater employment opportunities offered by demesne agriculture and by the wealthier peasants, and from the extension of industries in the countryside. Many villages contained a carpenter, weaver, or tailor, and in localities with the right resources whole communities found employment in mining, fishing, digging peat for fuel, or in exploiting the raw materials of the forest for burning charcoal, and making barrels, ropes, and pottery. Smallholders also responded to the commercial world by becoming petty retailers, especially by brewing and selling ale.

Peasants were anxious to buy and sell land, and the lords usually allowed this, providing that the transactions were made through the manorial court, so that dues could be collected and the new tenant's name recorded. Tenements changed hands regularly, and by the late thirteenth century in East Anglia dozens of parcels of land

gaudebunt campi ꞇ omnia que in eis sunt

PEASANTS harvesting grain in the early fourteenth century, from a manuscript prepared for a Lincolnshire knight, Sir Geoffrey Luttrell. Such aristocrats liked to see peasants portrayed in their proper role—at work. The depiction shows accurately the participation of the whole workforce at this time of peak effort, with women cutting corn with sickles.

were transferred every year in each village. Better-off peasants accumulated even more land, especially in years of bad harvests when their poorer neighbours were driven to sell. Larger holdings tended not to survive for very long, and smaller holdings multiplied in the long term. At the time of Domesday Book in 1086 40 per cent of the rural population held a yardland of about 30 acres. By the late thirteenth century many of these holdings had been divided into halves and quarters, and smallholdings proliferated, so much so that in parts of East Anglia the majority of tenants had less than 5 acres. This worked to the lords' advantage, because more tenants meant more revenues, but a great deal of pressure for subdivisions also came from the peasants who wished to provide land for younger sons and daughters, who in most parts of the country were excluded by the rule that the eldest son inherited. The peasants relaxed their normal convention that marriage should be based on a secure living, because the new opportunities for employment and small-scale trade seemed to offer a future income for couples without much land. This change in attitude to marriage helps to explain why the population increased so rapidly, from perhaps 2.5 million in 1086 to 6 or 7 million in 1300.

Peasants took initiatives in raising production in the countryside. They assarted more land than the lords, eating into the woodlands, heaths, and moors with numerous clearings of an acre or two, which cumulatively by 1300 increased the area

under cultivation by about a million acres (from a total of about 7 or 8 million acres in 1086). Village communities organized collective drainage schemes which brought much of the fenland and marshland of eastern England into agricultural use. Again, both as individuals and communities, peasants increased the productivity of land by cultivating it more intensively. In the open-field villages, fields were managed flexibly, regardless of any 'system'; for example, the two-field arrangement (whereby half of the land lay fallow each year) was modified with 'inhocs' in which part of the fallow was cultivated. In densely populated parts of eastern England the land was weeded and manured with great care, and could be cropped for many years together, with few fallows. In order to continue to feed stock which had no fallow to graze, peasants grew crops for animal feed, such as vetches and beans. Everywhere they built better barns and accommodation for animals—some peasants, like their lords, protected their sheep from the winter weather in specially designed buildings, sheepcotes. Though they are often represented as cautious and conservative, peasants could be more innovative than their lords, notably in their adoption of horses as draught animals, using them to pull carts to market, and for ploughing.

Some projects were too expensive for peasants to contemplate, such as building mechanical mills, and the bulk of these, already numerous by 1086, belonged to the lords of manors. Mills increased in number in the twelfth and thirteenth centuries, especially with the adoption of windmills after 1180, mainly in areas which lacked fast flowing streams. The invention, like so many medieval technical advances, was made by a practical craftsman, working by observation and trial and error, who had the brilliant notion of turning a milling mechanism upside down, attaching sails, and harnessing the wind rather than the power of running water. The idea was taken up with enthusiasm by lords, who gained revenue from tolls. Even in this area of lordly initiative, peasants had a part to play, because by the twelfth century some peasants acquired watermills at low rents, and were able to manage and develop them for their own profit. And although in theory peasants were forced to take their corn to their lord's mill, they exercised some choice, and lords found themselves competing to provide peasant consumers with this labour-saving service.

TOWNSPEOPLE AND TRADERS

The growth of towns between 1050 and 1300 depended on imaginative planning and risky speculations. The town planners realized that to achieve success they needed to choose the right site, arrange the new properties, streets, and market-places in the most convenient way, and offer settlers attractive privileges. They could not compel tenants to take up the new burgage plots—immigrants would be drawn into the new town only if they could be sure that the new site offered opportunities for manufacture and trade. Indeed, in eastern England, towns like Attleborough in Norfolk or Westminster, near London, did not receive specific privileges from a lord, but grew mainly because their sites provided a good living. New towns sometimes failed, but

most acquired urban characteristics, in which a majority of the population lived from a variety of non-agricultural occupations. Such places would not necessarily be very large—a town could have as few as 300 inhabitants, but most exceeded 500.

So many people went to live in new towns, or swelled the size of the older ones, that about 600 towns were functioning by 1300, forty or so with populations in excess of 2,000, of which perhaps twenty contained more than 5,000. London probably had 80,000 or more. The proportion of the whole population who were town-dwellers, which had approached a tenth in 1086, rose to about a fifth in 1300. These numbers do not account fully for craftsmen and traders, many of whom lived in hundreds of market villages and industrial villages.

The patterns of immigration are revealed by surnames which in many cases record people's places of origin. Richard de Wenlok, for example, who worked as a baker in Shrewsbury in 1297, had either himself moved twelve miles to the town from Much Wenlock in the same county, or his father had done so. The larger the town, the greater its ability to pull settlers over large distances—Stratford-upon-Avon's population came from within a sixteen-mile radius, while Nottingham could draw a third of its people from thirty miles or more, and at least half of London's immigrants had travelled in excess of forty miles. Some relatively prosperous migrants moved from small to large towns, just as Richard de Wenlok had migrated from a small market centre to the county town, presumably in search of a larger and more rewarding business. More often the rural poor, often young people and a high proportion of women who were unable to find work in their own villages, moved in search of employment as servants. More dangerous for the social health of the towns, beggars and criminals also found that the towns could provide them with a living.

Newcomers were often eventually able to improve themselves. Those who began as servants, either through experience or by means of a formal apprenticeship, picked up the skills of a craft or trade in their teens and early twenties. After that they might enter the adult labour market as wage-earning employees, and could hope eventually to set up in business with their own workshops. For some it was easy—they inherited a business, or married their master's daughter. For many the barriers for acceptance were much harder to overcome. Every town had a privileged minority of burgesses, or members of the guild merchant, who enjoyed full trading rights, and entry into that élite was restricted. But prospects were not as bleak as the regulations suggest, because the rules were often not enforced. Towns offered chances for informal trade to flourish, like the dozens of huxters or petty traders who went

TOWN of Bury St Edmunds, Suffolk, from the air. The monks of the abbey, the site of which is visible to the right, laid out an ambitious gridiron of streets in the late eleventh century, with a large market-place visible in the top left-hand corner. The town was a great commercial success, and its population grew to 6,000 in the thirteenth century, but the townspeople quarrelled constantly with their monastic lords.

with baskets in the streets or from door to door, selling eggs, or fruit, or loaves, at modest profit. In the smaller towns, the social and business hierarchy was rather shallow, and the most successful burgesses were craftsmen or food traders. In the large places there was a wider range of occupations—fifty or more different crafts and trades, rather than twenty in a small market town. Also there was likely to be some specialization; the entrepreneurs of a large town like Lincoln, with its international trade links, might build up its reputation for woollen cloth, and so provide work for concentrations of textile workers. But the great difference between cities like Lincoln and market towns such as Much Wenlock lay in the opportunities that the larger towns gave for merchants, wealthy traders who either dealt in large quantities of relatively cheap goods—especially when these were traded over long distances, like wool and fish—or high-value luxuries such as wine and spices. To qualify for such lucrative businesses, enterprise and initiative were not enough: capital, family, and influence were all necessary to gain access to an élite which exercised a great deal of political as well as economic power.

Townspeople aspired to self-government—not the political independence enjoyed by their contemporaries in Italy, because that would be impossible under the centralized English monarchy—but the ability to regulate trade, levy taxes, and hold courts. This was a difficult aim for the majority of towns to achieve because they were subject to a lord who appointed his own bailiffs and sent a steward to preside over the borough court. In most cases, the leading townspeople came to a tacit agreement with the lord that the bailiff, jurors, and other officials would be chosen from the ranks of the élite, and in some towns all the better-off traders belonged to a religious fraternity which acted as a shadow government, making decisions in council meetings before the borough court gave its formal approval. This *modus vivendi* usually seems to have worked, but monastic lords found these compromises hard to make, leading to struggles that could be prolonged and bitter. At Bury St Edmunds, the successful capital of western Suffolk, which had been founded at the gates of a wealthy and conservative monastery, the townspeople felt that their political privileges did not match their economic status, and fought through the thirteenth century and for much of the fourteenth for the right to form a guild merchant, and elect town officials.

The royal boroughs, which included most of the larger towns, achieved the highest degree of self-government. In the late twelfth century they purchased charters allowing them to farm their revenues, so that the town collected rents for land, fines in the court, and tolls in the market, and paid a lump sum (£108 per annum in the case of Norwich, for example) to the exchequer; they were also able to manage their affairs through a mayor and council. Such towns tended to be run by the wealthier townsmen, many of them merchants, and there were inevitably disputes between factions within their ranks, and resentments expressed by the rest of the townspeople at biased judgements. The élites made much of civic pride, and always

claimed that self-government was in the interests of the whole community, for example by giving them the resources to pave the streets and build guildhalls. But many contemporaries experiencing their rule, who also felt strong loyalties to their town, suspected that the government was run in the interests of the rich. It was said at York in 1305 that the tax assessments had been manipulated so that wage-earners contributed, but merchants did not pay their share.

Towns responded to the needs of consumers. Aristocratic households were still itinerant, travelling from manor to manor, and obtaining much of their food from their own resources. But even such self-sufficient households went to the towns regularly to buy joints of meat, baskets of fish, or ale, and they spent a great deal on wine and spices. Most aristocrats used just over half of their income to buy food and drink, so this left a substantial amount of money for other goods and services—probably a total in excess of £200,000 each year. A great deal of that sum went on buildings—by the thirteenth century the magnates lived in stone castles and houses, with expensive fittings such as lead roofs and glazed windows. Castle architecture reached its peak of development, and many major churches were rebuilt in the new Gothic style. The lesser aristocracy at least provided their houses with stone foundations, and high-quality timber superstructures. The thirteenth century marked the heyday of moat digging: minor gentry—and some people even who hoped to be counted as gentry—thought that this basic fortification around their houses would give them a claim to aristocratic status, as well as providing some protection from theft and raids by local rivals. All of this ensured regular employment for many thousands of masons, carpenters, tilers, glaziers, plumbers, and other construction workers, based both in towns and in the country, constantly travelling between sites.

Aristocratic consumers also demanded textiles, for their own clothes, for the liveries in which they dressed their servants and followers, and linen sheets, towels, and table-cloths for their households. Clothing came with accessories and trimmings, notably furs, much admired by the rich. They spent a good deal on transport and travel, including horses of various types, their harness, and fodder. They also bought fuel and candles, furnishings, household utensils, the services of doctors and lawyers, and much else. In the thirteenth century many of these goods were imported—the finest cloth, for example, was produced in Flanders, and furs and wax came from the Baltic. Purchases were often made at the large international fairs, such as those held at Boston, Winchester, and St Ives, which were attended by foreign merchants. But the main impact of aristocratic spending in England benefited the wealthier merchants of the largest towns and especially London, who could supply goods of the desired quality and in great quantity—preserved fish, for example, was bought in bulk, with barrels of smoked and pickled herrings, and dried cod by the hundred.

The traders of the smaller towns supplied the more mundane goods—foodstuffs, cheaper textiles, leather goods, ironmongery, wooden implements, and furniture,

and above all the grain, animals, fuel, and raw materials demanded by a large clientele of peasants, artisans, and wage-earners. The traders supplied goods in very small quantities, and served a limited hinterland—many customers travelled less than six miles to market towns.

The consumer often bought directly from the producer. A customer would go to a shoemaker's house, where the artisan made the shoes in a workshop helped by a servant or apprentice, and often depended on his wife to negotiate the sales. Such shops, based on family labour, in which workplace and living space were combined, produced a high proportion of manufactured goods. But thirteenth-century trade developed many complexities. Our shoemaker, for example, would have needed to buy his leather from a tanner, or a dealer. The shoemaker would often himself become a leather dealer, keeping a stock for his own use but selling on to lesser artisans. The hides would be bought and sold on credit—the shoemaker would, for example, wish to delay payment until the peak demand for shoes in October and November. And households did not specialize narrowly, but often had more than one source of income—the shoemaker's wife would often brew and sell ale.

Much more complex were the arrangements in cloth-making, for which a large-scale trade developed in raw materials—wool, alum, dyestuffs, oil, potash—and manufacture was divided into a succession of specialist tasks—carding, spinning, weaving, fulling, shearing, dyeing, and so on. Here there was much more opportunity for entrepreneurs to organize production, supply materials and credit, and sell the finished cloth. But the most successful businessmen came from the Continent, and high-quality wool was exported to Flanders to be made into cloth which was then brought back into England.

CRAFTS from a fifteenth-century manuscript. Woollen cloth-making is shown in its early stages: combing and carding the wool to separate the fibres (*right* and *centre*) and spinning with a distaff (*left*). Above, the yarn is prepared for weaving. At least another five processes were needed to produce the finished cloth. Women were employed in large numbers in the textile trades, especially in these (poorly paid) preparatory tasks.

Growth of demand stimulated a high volume of trade, which reached a peak around 1300, when merchants were bringing into England annually 5 million gallons of wine from Gascony, and hundreds of thousands of squirrel furs from the Baltic. To supply the market for household pewter, the miners of Devon and Cornwall were extracting annually 800,000 pounds and more of tin, though much of this was exported to the Continent. Great fortunes were to be made from commerce, above all in the wool export trade, which attained a level of 40,000 sacks per annum in the years immediately after 1300, representing the fleeces of more than 10 million sheep. Around 1300 the Ludlow family of Shrewsbury were handling between 50 and 200 sacks per annum, at profits running into hundreds of pounds. Lawrence de Ludlow, so active a trader that he drowned in a shipwreck off Zeeland in 1294, was able to buy land and build a fortified house at Stokesay in aristocratic style. But before 1300 much of the wool trade was handled by foreign merchants.

Technical facilities were developed to make trade possible. Transport systems were improved for example. By 1300 the main roads were well supplied with bridges, and goods could be carried with reasonable efficiency. Contrary to the common myths about roads blocked by mud and pot-holes, heavy cargoes of timber and building stone, and delicate ones such as barrels of wine, and cartloads of pottery, could be moved without apparent difficulty, though of course water transport, where it was available, gave a cheaper service.

Customers made their purchases with silver pennies, which were maintained at a high standard of weight and purity and increased greatly in numbers. In about 1086 as much as £37,500 could have been in circulation. By 1180 this figure had increased to £125,000, and by 1300 to £900,000. Sophisticated credit arrangements such as bills of exchange were not as well developed as in Italy, the business centre of Europe, but

POLYCHROME JUGS from south-western France. This pottery was brought into England in quantity around 1300 with the expansion of the Gascon wine trade. The pitchers were made near to the wine port of Bordeaux, and no doubt the drink was served in these decorative containers.

SILVER PENNY of Edward I, minted in London. English coinage gained a reputation for stability and purity and reached a high point in quantity, with 50 million pennies produced, in the recoinage of 1299–1301. Money was in widespread and constant use, though the penny, the main coin, was ill suited to large transactions (paying £100 meant assembling, counting, and transporting 24,000 coins) or everyday dealings, as loaves of bread and jugfuls of ale cost a farthing (¼ *d.*).

purchases of goods and services were aided by countless transactions made on the promise of eventual payment, backed up by notched wooden tallies recording the sum owed, or by written records of debt.

Crisis, 1300–1350

The English people had achieved a great deal by 1300—much land had been brought into productive use, and a dense commercial network extended everywhere. But the expansion was ending by 1300, and the next fifty years saw a series of catastrophes. Poor harvests had already brought hardship in the 1290s, but there were even more bad years at the beginning of the new century, and a disastrous series of wet summers in 1315, 1316, and 1317 caused a famine. At least half a million people died; and land sales on an unprecedented scale, and a crime wave, are clear evidence of social distress. In some places population recovered after the Great Famine, but numbers usually stagnated or declined. By 1340 much land in the midlands lay uncultivated, and reclaimed wetlands on the south and east coasts were being invaded by the sea. In 1348–9 the Black Death killed about half of the population. These were not just a series of unfortunate accidents caused by bad weather and the arrival of new bacteria. Growth was ending before the disasters—land was no longer assarted on a large scale and, after reaching a peak soon after 1300, the volume of trade began to shrink. New towns and markets were no longer being founded. When the famine came, it struck an already undernourished population. Prosperous, confident societies recover from natural disasters. The crises of the fourteenth century exposed the principal weakness of medieval development—it had left millions of smallholders in the country and labourers in the towns who could hope to earn no more than 30s. in a year, and that was not enough to support a family. They could make ends meet in good years with wives and children contributing their earnings, but any large rise in the price of grain threatened their lives. Had the Black Death been a simple outbreak of disease, there would have been rapid recovery; instead the plague recurred in the 1360s and there seems to have been no sustained rise in births to replace the losses.

Various explanations have been offered for this reversal of fortunes. It is argued

that the commercial growth which had sustained the expansion ended because the market was glutted: in other words, that society could support an urban proportion of roughly 20 per cent and no more, and that only a further rise in productivity could break the impasse; that was not forthcoming. Alternatively, it is suggested that the problem was associated with an over-extension of cultivation, which had taken in poor land and had caused imbalances between pastoral and arable farming, to the detriment of grain crops deprived of manure. On the other hand, technical solutions could have been found for such problems, and the recession was not confined to arable—it hit regions specializing in pastoral farming. Perhaps, in that case, the high level of rents prevented the peasants from escaping from the trap of low productivity. Or perhaps the heavy taxation from the 1290s added a last straw to the burden of rent. Or perhaps society had become too hierarchical, with the urban and rural élites holding back more enterprising spirits. Or, as a final possibility, could the aristocrats have served as unproductive role models, encouraging the rest of society to spend rather than invest?

It is hard to say. We are searching for explanations of a complex social malaise which affected the whole of western Europe, and which lasted for more than a century. The crisis must be compared in the complexity of its causes with the fall of the Roman empire in the fifth century, or the decline of Britain in the twentieth.

Response to Recession, 1300–1500

Living through the Black Death was a deeply shocking experience. It was a new and unknown disease. Its pneumonic form, when bubonic plague coincided with pneumonia, killed its victims rapidly and inexorably. Everyone knew many victims—those communities which escaped lightly still lost a third of their inhabitants. The survivors coped with the emergency, burying the victims in an orderly fashion, and dealing with the problems of widows and orphans, giving remarkable proof of the essential stability and resilience of medieval society. Government quickly resumed, and in a few years after the epidemic production returned to near normality. But sustained recovery did not come—in 1377 the poll tax suggests a population of about 2.5 million, less than half the figure in 1300, and numbers remained as low until well into the sixteenth century. The landscape everywhere gave proof of physical decay—houses had collapsed; fields were grassed over or were being invaded by bushes; manor houses were abandoned; some parishes could no longer maintain their churches. It is said that the prevailing mood was of gloom and despair. Churches were painted with the 'dance of death' in which triumphant skeletons carried popes, kings, and every other rank to the grave. Tombs depicted the decaying corpse in contrast with the pomp and confidence of the conventional effigy—remember that you must die, said the inscriptions. But these powerful images cannot be connected directly with the Black Death.

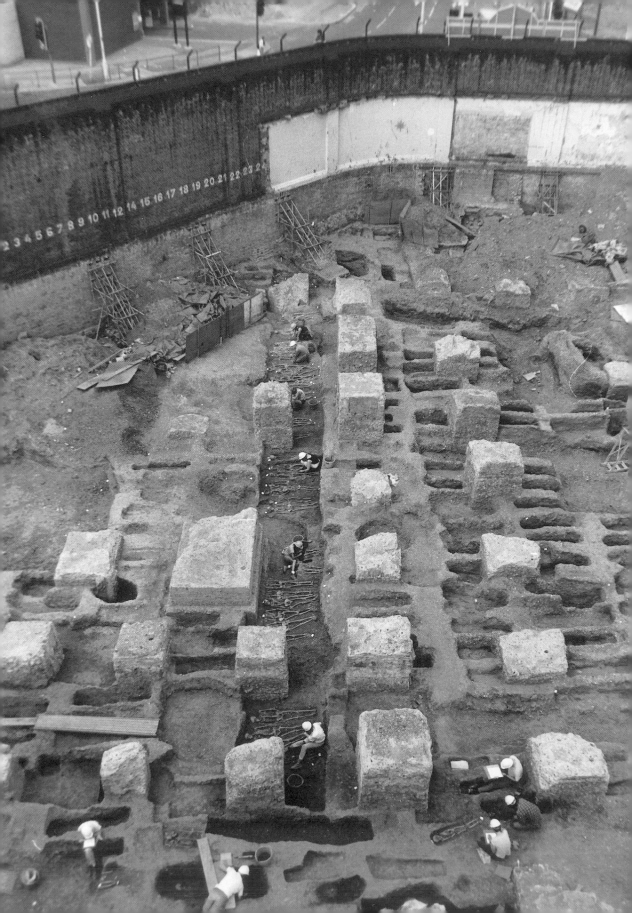

On the other side of the coin, the plague mortality gave the survivors, once they had recovered from the shock, opportunities and even pleasure—land was plentiful; labour was well rewarded; the socially disadvantaged could improve themselves; those who were left could look to a better life, with more leisure.

ADJUSTMENT AFTER THE PLAGUE: THE FIRST THIRTY YEARS

The Black Death, and the subsequent fall in population, liberated the lower ranks of society. The wage-earners, both the labourers who had a cottage of their own and the servants who lived with their employers, were relieved of the fear of unemployment. Now they were given many offers of work, and could pick and choose between them. They insisted on higher wages, of course, and at the same time they were freed from drudgery and dependence, because they could refuse to accept annual contracts of employment, and work from day to day, taking time off once they had earned enough. For example, Robert Boket of Essex, a tiler and potter, in 1378 was said to be idle for the whole year and 'will not work unless for excessive pay'. Workers felt a new liberty to move from employer to employer, from place to place, and from one occupation to another.

The new era seemed to offer other freedoms. Serfs realized that they were better able to bargain with their lords for reduced rents and for the removal of servile duties. Serf and non-serf saw in the new era release from poverty. Some wage-earners were able to acquire land, and tenants generally found that they could expand the size of their holdings. Wages increased, slowly at first, but the well-being of those dependent on wages rose decisively after 1375, when grain prices fell after a period of poor harvests. Bread was now cheap.

The upper classes felt threatened. Workers had become expensive and ill-disciplined, and tenants were restless for better conditions. The price of manufactured and imported goods—building materials and wine, for example—rose because of the higher costs of production and transport, but landlords received less for the agricultural produce that they sold, such as grain. The lords' initial reaction was to prevent their world falling apart. Before 1348 there had been disagreements between them over Edward III's prosecution of the war against France, but now they all closed ranks. New labour laws attempted to peg wages at the pre-plague level, and to force workers to accept contracts of employment. Specially appointed justices vigorously enforced the law in the localities. On their manors lords held to the old rules, enforcing serfdom and resisting rent reductions. They actually

A BLACK DEATH cemetery, being excavated at East Smithfield, London. Contemporaries believed that 50,000 Londoners died in the epidemic of 1348–9, and recent research suggests that this figure could be correct. The mass grave at East Smithfield consisted of a large trench, in which the excavators are here seen at work. The arrangement of the skeletons in neat rows suggest that the catastrophe did not lead to a breakdown in orderly and decent disposal of the remains.

increased the revenues from their courts, putting a great deal of financial pressure on the reduced number of tenants. A Suffolk landlord, John Monceaux, behaved in a precipitate manner characteristic of the time, to recover a serf, Thomas Reynburgh, who had absconded in 1363. He sent a raiding party to force the peasant to surrender by threatening to burn down the house in which he was living.

The upper ranks of society were troubled at a world that seemed to have turned upside down, and they repeated the ancient idea that society consisted of three orders: fighters, prayers, and workers. Peace and harmony, they claimed, depended on mutual respect and co-operation. Everyone had a God-given function, and a duty to provide for the needs of others—the workers, for example, were obliged to support the nobility and clergy with material goods in return for protection and spiritual services. This was clearly not an accurate depiction of the real world and bore witness to the concerns and fears of those who had most to lose from the disintegration of traditional society. In 1363 parliament attempted to control outward display of wealth through a sumptuary law which defined the style of dress of the different ranks. It was an impractical expression of dissatisfaction with social trends, and was not enforced. One sees in the writing of the period, as well as its legislation, signs of a moral panic, directed towards the lower classes in general who were becoming too rich and too assertive. Beggars were denounced as wasters and criminals. The idleness of these people affronted those who could not find enough workers, and charity was given with much more discrimination. The moral panic helped to change tax policy, when in the 1370s the government searched for ways of forcing the newly prosperous wage-earners to make a contribution. The poll taxes of 1377–80 insisted that everyone should pay at least 4*d*. (a craftsman's daily wage), and when mass evasion was investigated in the summer of 1381 the people of the southeast rose in revolt.

So dramatic was the uprising, rightly called the Great Revolt, that those in

COOKING POT of Ipswich ware. This type of pottery was made at the east coast port of Ipswich in the period 650–850. Although lacking in beauty, the pottery was well made and served a useful function. Craft specialization was clearly a feature of these early towns, and the ware's distribution over eastern England indicates a wide trading network.

POTS of Pingsdorf ware (*left*) and Stamford ware (*right*) reflecting industrial and commercial growth from the late ninth century. Pingsdorf ware from the Rhine valley is found in the rubbish deposits of many eastern English towns, demonstrating the extent of their overseas contacts. Stamford ware, a technically accomplished product of an urban industry, was traded over much of eastern and midland England.

WATERMILL, from a thirteenth-century manuscript. The artist was anxious to show the details of the mill machinery, both the external water-wheel and the millstones and hopper inside the mill building. The miller is depicted as a greedy and aggressive character: millers were widely suspected of taking excessive tolls.

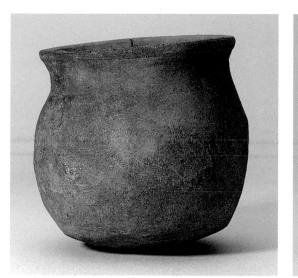
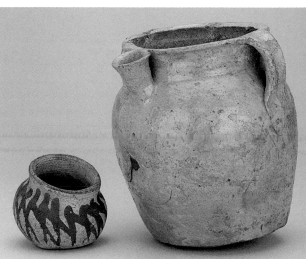

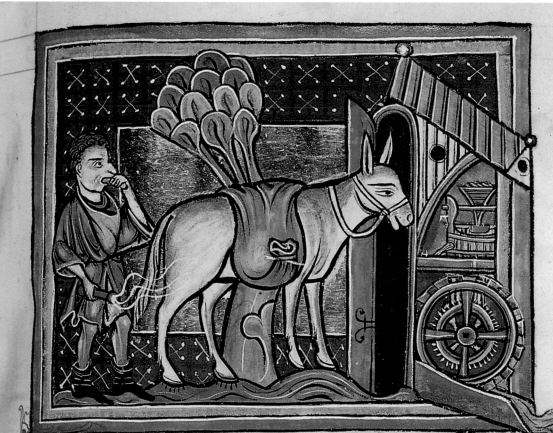

finus & afellus afedendo dictuf. qt afe
duf. fed hoc nomen qd magif equif co
uemebat: ideo hoc animal fumpfit. er
priufqin equos capent homines. hunc prefider

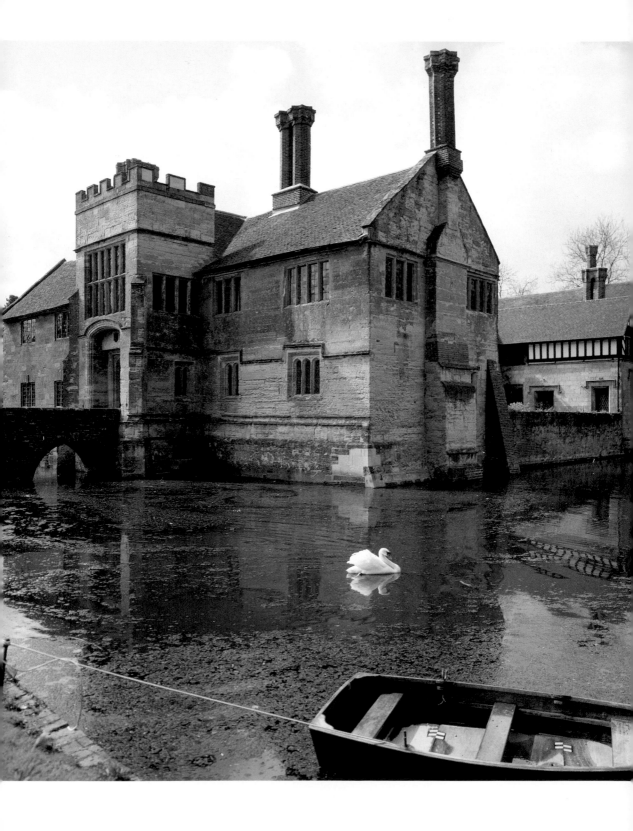

authority thought that the lower orders had gone mad. A recurring image of those writing about the rebels compared them to animals—it was said that they had lost their capacity to reason. But a close examination of the thinking behind the Revolt suggests that it had a rational basis: it drew on ideas that went back for centuries, and also expressed the frustration of the tense thirty years that had followed the Black Death. We still do not know why the rebels killed people of Flemish origin—but most of their behaviour and demands had a remarkable coherence. In the south-eastern counties the rebels carefully selected targets—they attacked officials involved in collecting the poll tax and in administration of the law; they also burnt the manorial records which contained evidence of their servile status. From Essex and Kent they went to London and met the king on successive days at Mile End and Smithfield. Although the revolt had been provoked by the poll tax, the principal aim of the rebels was the removal of serfdom. They realized that only the Crown had the authority capable of changing the law. They had persistently appealed to royal justice to claim freedom since the early thirteenth century, and the popular ideal of a protective monarchy went back even earlier. They believed themselves to be the king's loyal subjects, and came to the capital to purge the government of its traitors, and to forge a direct alliance with the king.

These rebels were not drawn from the desperately poor, but can be identified as better-off peasants and artisans, who had become more prosperous since the Black Death, but felt that social oppression and corrupt authority held back their progress. Nor can they be seen as outcasts: they occupied positions of trust and authority as reeves, jurors, and constables; they could conceive of governing their own villages without interference from either lords or lawyers. The rebellion was well organized, with messengers carrying letters and instructions from village to village and, once recruited, the bands moved in a co-ordinated fashion. The rising expressed confidence and hope, not despair. When it was all over, when the 'prime movers' had been executed or had fled, the lords of manors attempted to return to normal. But the government had learnt a lesson and gave up both the poll taxes and the desultory war for which the money was intended. Serfdom, which the peasants had regarded as ripe for removal, did indeed disappear in the next hundred years, not by abolition or mass manumission, as they had hoped, but through gradual erosion—above all because the serfs moved away from their manors, and in new homes their status was forgotten. When lords bargained with their tenants in the fifteenth century, they were probably more ready to make concessions because of their long collective memory of the angry but purposeful crowds of June 1381.

MOATED SITE at Baddesley Clinton, Warwickshire. This is typical of the thousands of moated houses built in the thirteenth century for all types of owners, and especially the lesser gentry, for security but also to display their status. In this case fifteenth-century and later buildings have replaced the original timber structures.

INNOVATION, 1382–1500

In many ways the generations after the plague and the Great Revolt experienced depressed and depressing times. It is true that the wage-earners had never known such a high standard of living. The lords, however, saw their rents go into long-term decline. The assertive peasantry could acquire more land, but could they make a profit if they paid high wages and received such low prices at market? Townspeople grumbled that they could no longer afford to pay their farms to the Crown, and that their communities were shrinking in size. Money was in short supply, especially when mining of precious metals declined in the fifteenth century. Those who lived through those difficult times adapted to new circumstances.

The first change affected the role of women and attitudes towards the family. With the fall in population and the consequent labour shortage, women's work became more valuable, and we find them doing jobs previously regarded as men's. Their rates of pay increased, and they took on more responsibilities. Widows in particular enjoyed more independence, and in towns they increasingly took over their former husbands' businesses: in York we find a widow apothecary, and another trading as an armourer. Women were clearly ready to seize opportunities, though we should not exaggerate the improvement that they experienced—they were still largely excluded from public life and strong prejudices remained that appropriate work for women was in the less skilled and less well-rewarded occupations in the food and drink trades, and in textiles. These changes may have influenced marriage because young women worked as servants for a time before they married, contributing their savings to the new household, and had a say in choosing whether to marry, and who to marry.

The land hunger before the plagues had been a wonderful aid to family loyalty. Young people in the fifteenth century established their independence and often moved away from their native village to find a marriage partner and acquire land or work. Individuals had become more mobile, were less likely to live near to relatives, and were no longer strongly attached to their family's holding of land. These developments may be connected with a mystery of the period, the failure of increased well-being and job opportunities to result in a rising population. Recurring plagues explain the sharp drop in numbers of the late fourteenth century, but the long-term stagnation of the fifteenth seems to have been caused by both high mortality and a low birth rate. Perhaps the age of marriage rose and a significant proportion of people decided not to marry at all.

The individual self-reliance which affected family life at this time did not necessarily lead to a decline in social cohesion. We are aware of the growing activities of town councils, for example, in ensuring that craft masters formed fraternities which regulated such matters as apprenticeship, pay, and working hours. Community organization seems to have been stronger than ever. Processions in towns like Coven-

try, in which almost every section of society participated, displayed to the outside world a show of unity, though also highlighting the dignity of the civic élite. Villages produced a stream of by-laws regulating every issue, from football games to the numbers of animals kept on the common. Parishes rebuilt their churches and ornamented them more elaborately than ever before. The parish became the focus for intense social co-operation, organized both by fraternities and by the churchwardens, who raised funds with church ales and built church houses in which to hold these festive occasions. To some extent the community was an illusion, because the regulations were not enforced, and selfish individuals could not be disciplined. But we can see new attitudes developing, including a novel relationship between the poor and the community. Before the plagues a great deal of relief of poverty depended on family support. Now charity was provided more formally as wealthy individuals or

DESERTED VILLAGE at Walworth, County Durham. This aerial photograph taken after a light snowfall shows the foundations of peasant houses visible as low mounds. The houses lie in rectangular enclosures (tofts) which are arranged in rows around a central green. In the centre of the former green stands the modern farm, indicating that a single large unit of production had replaced numerous peasant holdings.

A DECAYED TOWN at Hedon in the East Riding of Yorkshire. Hedon was founded in the twelfth century and enjoyed high privileges and prosperity in its early days. It suffered from competition from such rivals as Beverley and Hull, and shrank. On the left-hand side of the aerial photograph, one of the original grid of streets can be seen now to lack houses, and alongside lies an abandoned harbour.

groups built hospitals and almshouses in which the poor could live and receive help from their neighbours. We find parishes connecting almsgiving with tax-gathering, and maintaining a 'common box' funded by compulsory levies. This was designed to help the poor, but it was also an aspect of social discipline: the paupers were carefully selected and the undeserving, feckless, or drunken applicants excluded; the inmates of the almshouses were expected to behave in a seemly fashion.

People moved constantly, almost restlessly. Mobility was not a novelty, but it reached a new intensity, with the removal of such restrictions as serfdom, and above all with the opening of vacancies for tenants and employees. Every village and town saw a constant turnover as those who moved out were replaced by immigrants. But often the flow was unbalanced, with some villages and towns losing more than they gained. The outflow from less favoured places had its most dramatic effects in the

case of the 3,000 or so villages which were completely deserted. The most vulnerable settlements tended to be smaller than their neighbours, to have no strong involvement in industry, and to lack facilities such as churches. These communities had often gone through an episode of shrinkage in which individuals took over their neighbours' land. The rhythms of agriculture were disrupted by labour shortage and the activities of the tenants of multiple holdings, who developed pastoral farming because animals needed less labour than grain cultivation. The threat to the common fields made these declining villages even less attractive, and the loss of people accelerated. Sometimes the remnants of the village were finally removed by the lord, who could get a better income by renting it as a pasture.

Few towns were completely deserted, but many lost a high proportion of their population, again because their inhabitants moved to better opportunities, and because potential immigrants were deterred. Winchester, for example, with about 11,000 people in 1300, had less than 8,000 in 1400 and as few as 4,000 in the early sixteenth century. Other county towns like Gloucester and Leicester seem to have been vulnerable to this decline, as also were east-coast ports such as Boston and Lynn. Competition from London merchants for the trade in luxury goods damaged larger provincial towns, as did the rise of country or small-town cloth manufacture, and the decline in the wool export trade. There were some real success stories—Coventry and Colchester grew in the boom of around 1400, however short-lived this may have been; and small towns active in cloth-making expanded, like Crediton in Devon. London is an example of a city of the big league—comparable with the great centres of Italy or the Low Countries, which certainly lost population, but suffered no great economic decline because the merchants acquired so large a share of foreign trade. The overall pattern of migration did not much change the balance between town and country—about a fifth of the population lived in towns in 1500, as in 1300. But there were important shifts between regions with increasing wealth in the south-western counties and the London area, including Essex and Suffolk, as cloth-making expanded.

Enterprising individuals seized the opportunities for making money from new products or new methods. We have already seen that exports of wool were in decline and more of this high-quality raw material was woven in England, until in the fifteenth century cloth became a major export. Key figures in this development were the clothiers based either in industrial villages or relatively small towns in the south-west, East Anglia, and the West Riding of Yorkshire. These men invested in fulling mills, sheep pastures, and warehouses, but above all responded to the growing demand by co-ordinating the work of the artisans, and marketing the finished product. They reversed the pattern of trade in a few generations—England, once an exporter of raw materials, now supplied European markets with manufactured goods.

Innovation in agricultural production has similarities with advances in industry.

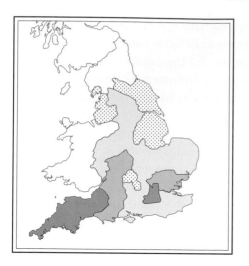

CHANGES in the distribution of wealth between 1334 and the early sixteenth century, based on taxation records; the darker the shading, the greater the increase of wealth. The main factor behind the growing wealth of the south-west and some south-eastern counties was the expansion in cloth-making.

Key figures were entrepreneurs, largely of peasant origin, who produced on a large scale by taking over the leases (farms) of the demesnes of lords, or by putting together a number of former peasant holdings. Thomas Goddard, for example, became the farmer of the demesne of the manor of Aldbourne in Wiltshire where he had previously been a peasant tenant. He was able to raise a good deal of capital, because he bought the lord's flock of 825 sheep for £61 17s. 6d. Farmers sought to reduce labour costs by specializing where possible in stock-raising: one shepherd could replace the dozens of workers needed to cultivate fields of corn. Farmers were responding to demand, as changes in diet meant that a large section of the population had become regular consumers of meat. And they sometimes rationalized production radically by enclosing and converting former fields to grass, leading to a chorus of complaint at the end of the fifteenth century about the 'putting down of towns'.

Peasants, that is those tenants who did not become farmers with hundreds of acres of land, none the less took over their neighbours' holdings, and managed 40 or 50 acres when their ancestors had rarely held more than 30. In the corn-growing villages they found that they could switch to feeding more animals by agreeing to grass over part of the arable as 'leys' and by organizing exchanges and enclosing parts of the common fields. But in the uplands and woodlands, where the pastoral element had always been stronger and land-holding more individualistic, they accomplished the swing to animal husbandry much more easily, and in north Devon, for example, specialized almost exclusively in grazing. The success of peasants' economic management can be judged from the hundreds of new timber-framed houses that still survive from many thousands originally built in the period 1380–1520. In the midlands and north these were 'cruck' structures, but the wealth of the south-east is reflected in the grander 'wealden' houses of Kent, Sussex, and Surrey, in which the central room, the hall, was open to the rafters, but was flanked by wings of two storeys.

Finally, although the aristocracy cannot be regarded as new men, they showed a remarkable capacity to adapt to realities. Although they closed ranks at the upper levels—it was during the fourteenth century that the seventy or so top families were regarded as peers, and new ranks such as duke distinguished a super aristocracy—

the class remained open. There was much intermarriage among the gentry with London merchant families, and the gentry accepted a stream of recruits from the merchants, lawyers, entrepreneurs, and war captains. Indeed, the ranks of the gentry were widened by the inclusion of the new category of 'gentlemen'.

The upper classes accepted that they could no longer cultivate their demesnes and run their manors in the old style, in view of the declining prices of produce and the high cost of labour. The larger landlords in particular rented out their lands to farmers, and acquired new skills of estate management to ensure that rents were fully paid. They were faced with a continuing decline in rent income, but avoided ruin by adjusting their style of life—by taking care over their household accounts, and if necessary reducing wine consumption and the numbers of servants employed. Cost-saving led them to concentrate building expenditure on a small number of houses, and to let the others fall down. The result is that we see splendid new houses of the period like the pretty brick castles of Tattershall (Lincolnshire) or Herstmonceux

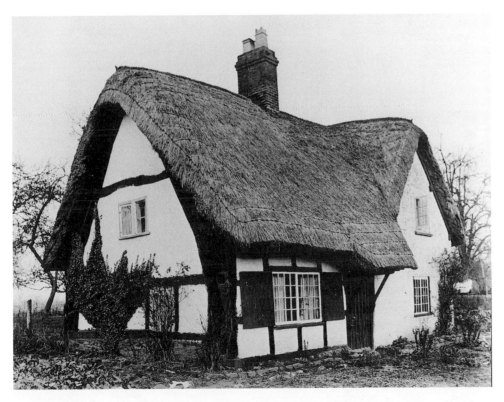

CRUCK HOUSE at Hampton Bishop, Herefordshire. The crucks, two large curved timbers providing the main support for the frame, are visible in the end gable. They stand on a low stone foundation, and the spaces between timbers were filled with panels of wattle and daub. Hundreds of peasant houses of this type built between 1380 and 1520 still survive, thanks to the quality of the materials and the carpenters' skills.

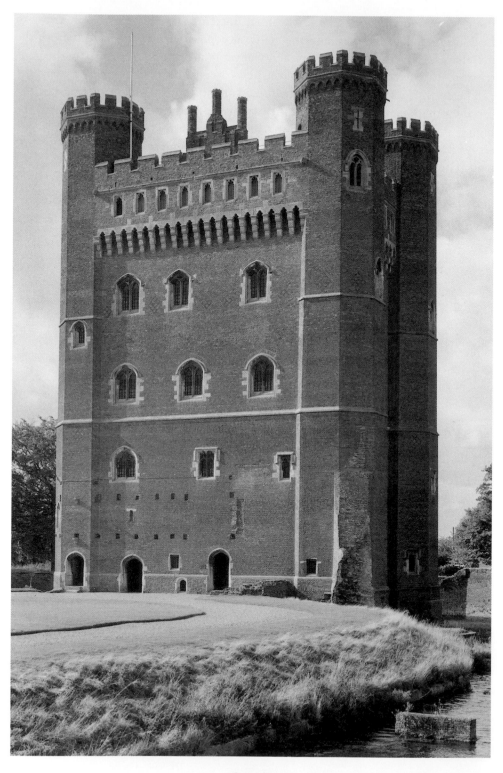

(Sussex), but tend to forget about the hundreds of redundant manor houses. A growing number of gentry acquired incomes from their legal skills, or received fees from the monarchy or the magnates by serving in their retinues. Above all, the aristocracy continued to pursue the acquisition of property at the expense of other families by marriage negotiations, by political alliances, and sometimes by recourse to 'forcible entry' and other extra-legal means for prosecuting claims in convoluted property disputes. Families conserved their own inheritances and controlled the descent of property through the growing use of the 'enfeoffment to use', by which land was kept out of the hands of a feudal overlord, but passed to trustees who were issued with instructions to hand the land to the next generation.

By 1500 not only had the distribution of wealth and social power formed into new patterns, but a different outlook had developed. Family values had changed, with more emphasis on the choice of individuals, and less on tradition and the welfare of the group. Communities saw themselves in a new light, so that the poor were regarded as a solvable problem. Production of goods, in both farming and industry, was carried out on a larger scale, with greater emphasis on sales. People were less deferential, and were given more opportunities for mobility. Of course many traditional features of society, such as the dominance of oligarchies in towns or the assumption of aristocratic superiority, remained; but the crisis of the last two medieval centuries saw shifts in both social reality and perceptions which represent a first stage in the eventual transformation of England into the 'first industrial nation'.

TATTERSHALL CASTLE, Lincolnshire, typifies the new generation of fifteenth-century castles in its ornate appearance and comfortable interior. It was built in brick, a relatively new material for aristocratic houses. Between 1434 and 1446, together with an adjacent college, it cost its *nouveau riche* builder, Ralph Lord Cromwell, £5,000.

6 Piety, Religion, and the Church

∾∾ Henrietta Leyser ∾∾∾∾∾∾∾

Missions, Missionaries, and Minsters

On 9 June 597, St Columba, founder of the island monastery of Iona, prepared for his death. He had been putting the task off for some time—to have chosen spring would have spoiled the Easter celebrations of his community; June would be better. When 9 June came, there had already been a good harvest; Columba could see from the piles of grain that his monks would have enough bread for the coming year. Accordingly he blessed the barn where the grain was stored; then, turning to the servant who was with him, he broke the news to him that at midnight he would die. Together Columba and the servant made their way back to the monastery. At a half-way stopping-point, a white horse came to meet them. It is from Adomnan (627/8–704), Columba's biographer, that we have the tale. The horse was:

the loyal work-horse which used to carry the milk-pails from the booley [cattle-pen] to the monastery. It approached the saint and—strange to tell—put its head

against his bosom, inspired I believe by God for whom every living thing shows such under-standing as the Creator bids; it knew that its master would soon be going away so that it would see him no more, and it began to mourn like a person, pouring out its tears in the saint's bosom and weeping aloud with foaming lips. The servant seeing this started to drive off the weeping mourner, but the saint stopped him saying:

'Let him be! Let him that loves us pour out the tears of the bitterest mourning here at my breast. Look how you, though you have a man's rational soul, could not know of my going if I had not myself just told you. But according to his will the Creator has clearly revealed to this brute and reasonless animal that his master is going away.'

Very different kinds of stories surround the event for which the year 597 is more cel-ebrated in the history of Christianity in Britain. The scene is another island, though one far from Iona: the island of Thanet, off the coast of Kent. The occasion was the landing of St Augustine, the missionary whom Pope Gregory had dispatched to reclaim England, as a lost Roman province, for the Christian faith. Augustine and his companions, a band of about forty, so Bede (c.673–735) tells us in his *Ecclesiasti-cal History*, had been less than keen at the prospect of the task Gregory had imposed on them, 'paralysed with terror' at the very thought of going to work among a 'bar-barous, fierce, and unbelieving nation'. The missionaries' initial reception in Eng-land can have done little to allay their fears. Æthelbert, king of Kent, insisted on meeting the missionaries in the open air: 'He took care that they should not meet in any building, for he held the traditional superstition that, if they practised any magic art, they might deceive him and get the better of him as soon as he entered.' But, Bede continues, the missionaries 'came endowed with divine not devilish power and bearing as their standard a silver cross and the image of our Lord and Saviour painted on a panel'; Æthelbert listened to their preaching, accepted that their inten-tions were honourable, and gave them a mission base in the capital of his kingdom at Canterbury; Augustine thus became its first archbishop.

Back in Rome, news of Augustine's early successes caused Pope Gregory to be jubilant. The conversion of England none the less took the better part of a century to complete; Anglo-Saxon paganism, little though we know of it, was far from moribund; the names of our mid-week days and of Easter are a reminder of the strength of loyalties to the pagan gods of Tiw, Woden, and Thor and to the goddess Eostre; they hint at a process of accommodation between pagan and Christian sen-sibilities that our Christian sources largely hide from us but which the archaeology of cemeteries and pagan cult centres has recently helped to substantiate. The con-version thus demanded from the missionaries persistence, unremitting powers of persuasion, and patience in the face of apostasy. Only in c.686 did the last pagan stronghold, the Isle of Wight, accept Christianity.

In the story of the conversion diverse missionaries—from Ireland, Italy, France, and Celtic Britain—had roles to play, but best known and, as presented by Bede, best loved are the Irish, the spiritual sons of Columba of Iona. Although it is not

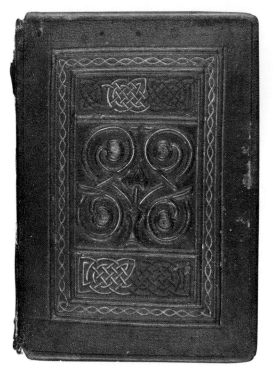

THIS COPY of the Gospel of St John, with its original binding of red goatskin, was found in the tomb of St Cuthbert on the occasion of the translation of his relics to the new cathedral of Durham in 1104. It is thought to have written at the monastery of Monkwearmouth/Jarrow shortly after Cuthbert's death.

clear that Columba himself had missionary goals, it is beyond doubt that even in his lifetime Iona was a community whose interests and influence were far-reaching. The Columba for whom the white horse wept was also an Irish nobleman, deeply implicated in his family's politics, a saint whose influence was such that angels could entrust him with the task of ordaining a ruler for the neighbouring Scottish kingdom of Dalriata. Even after death, Columba kept his political clout. In 634, on the eve of battle it was (so Adomnan tells us) a vision of Columba which secured the English kingdom of Northumbria for Oswald, the 'rightful' claimant and a son of Iona: for it was during years of exile among the Irish that Oswald had been baptized. Once he was king, it was to Iona that Oswald appealed for monks to further the Christianization of his people. A community established itself at Lindisfarne, the monastery which by Bede's day was already renowned as housing the shrine of St Cuthbert, bishop of Lindisfarne from 685 to 687, the saint in whose memory the Lindisfarne Gospels had been made.

None the less, it is no longer possible, as it once seemed to be—especially as Bede encouraged his readers so to do—to explain and describe the conversion to Christianity in England only in terms of the triumphs, failures, and quarrels of the Irish missionaries summoned by Oswald and the Roman missionaries first brought by Augustine to Canterbury. Very likely the major turning-point in the early history of the Church in England was less the synod of Whitby of 664 (highlighted by Bede) called to settle the question, disputed between Irish and Roman aficionados, as to when Easter should be celebrated but rather the council of Hertford of 673.

Archbishop Theodore

The council of Hertford was the first council of the whole English Church ever to be held, and this at a time when 'England' as a political concept did not yet exist. It met under the leadership of Theodore, archbishop of Canterbury from 668 to 690. The influence of Theodore—a monk of Greek origin and already a sexagenarian

when appointed to the see—on the spirituality and culture of Anglo-Saxon England was as far-reaching as were the results of his administrative skills. Under Theodore, Canterbury gained a school of Christian scholarship and unrivalled intellectual brilliance—subjects studied included Greek, law, metrics, and astrology—while the English Church at large was given its diocesan system, a new sense of its identity shaped by the precepts of canon law, and a penitential that married insular with Mediterranean custom.

Theodore's achievements notwithstanding, the question still remains: how was Christianity in early Anglo-Saxon England spread beyond the circles of the élite? In current scholarship this is a debate centred on an understanding of the role of monasteries in pastoral care that starts with a re-examination of the very meaning of the word *monasterium*. Originally translated as 'monastery', it is now thought more appropriate to use 'minster' or 'mother church'. Such establishments might house communities of monks, or priests, or both; they might, but more usually did not, act as places of retreat from the demands of the outside world. The work of evangeliza-

THIS SLAB from Wirksworth, Derbyshire, may once have formed part of an early Anglo-Saxon funerary monument. The scenes depicted include the Crucifixion and Ascension as well as the less familiar Death of the Virgin. The singularity of the iconography is perhaps to be attributed to the influence of Eastern Christianity as introduced by Theodore, archbishop of Canterbury.

tion was too pressing to accommodate the specializations of active or contemplative vocations common to later ages. In seventh- and eighth-century England it was the business of monks and priests alike to spread Christianity both by example and by word. Faith was to be taught; it was not, ideally, to be inculcated through compulsion nor even by magical demonstrations of the power of the new God. Miracles might strengthen the convictions of waverers, but they could never take the place of the kind of education and pastoral care of which Bede, for one, was so passionate an advocate. To Bede, even those living in the wildest and most inaccessible hills of his native Northumbria should be sought out and offered the sacraments; even those who had no knowledge of Latin could and should be instructed in the rudiments of Christian doctrine through preaching and through vernacular translations of the Lord's Prayer and the Creed.

The Wrath of God and the Viking Scourge

Bede's was a utopian vision, as he himself well knew. What he could not have known was that within a hundred years of his death pagan Vikings would have sacked, among other holy places, both his own monastery of Jarrow and Columba's foundation of Iona, and that such depredations were to cause fear for the very future of Christianity in England. The story of the Viking raids and conquests is told elsewhere in this volume (Ch. 2); what needs to be traced here is the Christian response. Why, Christians needed to know, had God allowed the Vikings to come to England 'to ravage and burn, plunder and rob'? There could be but one answer: such events were, in the words of Wulfstan, archbishop of York (1002–23) 'the wrath of God, made clear and visible towards this nation.' How best to atone for such sins, how to court and merit God's future protection were not questions so easily answered. At the risk of simplification it is possible to see how three kings favoured different solutions, each one of which throws light on both the theory and the practice of Christianity in Anglo-Saxon England.

The first and in many ways most radical proposal was advocated by King Alfred (871–99). Early medieval kings, as has often been noted, culled their models of rulership from the books of the Old Testament. For Alfred, key texts came from the apocryphal Book of Solomon: 'If, therefore, you value your thrones and your sceptres, you rulers of the nations, you must honour wisdom so that you may reign for ever' (6: 21). For the time when these words had been heeded, Alfred looked back to the days of Archbishop Theodore and of Bede, to a supposed golden age when there were 'men of learning … throughout England', and when wisdom and success in warfare had gone hand in hand. If his kingship was to prosper, if further disaster to be averted, then it was the values of this past era that Alfred believed he had to emulate. The Vikings were God's warning. 'Remember', wrote Alfred, 'what punishments befell us in this world when we did not cherish learning nor transmit it to

other men. We were Christians in name alone and very few of us possessed Christian virtues' (Alfred's prose Preface to Gregory's *Pastoral Care*). All who could must be 'set on track' and schooled in the books which it was considered 'most necessary for all men to know'—Bede's *Ecclesiastical History* included, translated for the purpose into English.

Learning might be a sure way to God's heart; yet there is no evidence that Alfred's plans for the schooling of his people touched more than a select number. More broadly based were the appeals to penance and prayer following the second wave of Viking attacks in the reign of King Æthelred (978–1016), when attempts were made to call the entire nation to its knees. The wrath of God, provoked by the terrible sinfulness of his people, must be and could be assuaged by correct reparation. According to an edict of *c.*1009, 'decreed when the great army came to the country', the whole nation was to seek God's help to withstand the enemy. The Monday, Tuesday, and Wednesday before Michaelmas were national fast-days; only bread, herbs, and water were allowed. Everyone was to go barefoot to church for confession and join in the processions of relics.

Tenth-Century Monastic Reform

The edict of *c.*1009 reflects a state of national emergency. Wide-scale penitential fervour on quite this scale could hardly be sustained on a regular basis; nor indeed was it clear that such action on the part of the laity was necessarily the most efficacious form of supplication. In the preceding reign of King Edgar (957–75) the notion that some prayers were better than others had been forcefully promoted through a movement for monastic reform. In 964, in a spectacular demonstration of the new climate that this movement promised, the secular clergy of the New and Old Minsters of the king's capital of Winchester had been expelled, allowed back only on condition that, having taken vows of poverty and chastity, they join the communities of the newly intruded monks. In justification of this draconian action the king explained:

Fearing lest I should incur eternal misery if I failed to do the will of him who moves all things in heaven and earth, I have—acting as the vicar of Christ—driven out the crowds of vicious canons from various monasteries under my control, because their intercessions could avail me nothing ... and I have substituted communities of monks, pleasing to God, who shall intercede for us without ceasing.

The new monastic reform movement drew its inspiration from the leadership of a triumvirate: Dunstan, archbishop of Canterbury, Æthelwold, bishop of Winchester, and Oswald, archbishop of York and bishop of Worcester. Backed by the king, they revolutionized the spiritual geography of England. New hierarchies were introduced. A special relationship was now seen to link Christ and his saints with the King and his monks. As Christ ruled in heaven, so on earth did Edgar, the 'vicar of

THE CHURCH of Breedon-on-the-Hill, Leicestershire, where this (probably ninth-century) angel is to be found occupies the site of an Iron Age fort. A monastery dedicated to St Peter was built there in the seventh century to act as a missionary centre. It has been suggested that the model for this angel was an early Christian ivory.

Christ'. His monks meanwhile guarded the tombs of the saints and sought their spiritual support.

The monastic reformers of the tenth century justified their actions with reference to the age of Bede. In reality, their aims were significantly different from his. In the world of Bede, monasticism was eclectic; each monastery had felt free to experiment, to choose its own customs, to fashion quite particular lifestyles. Thus Bede's own monastery of Jarrow, founded by Benedict Biscop, was built to provide a fit setting for the treasures, precious books, and icons which he had brought to England from his Italian travels. No expense was spared to create an innovative and at the same time luxuriously 'antique' monastery: masons and glaziers were brought from Gaul to build a stone church 'in the Roman manner'. In these surroundings it comes as no surprise to find that the manuscripts that emanated from Jarrow followed their Mediterranean models so closely that only expert eyes can tell them apart. Very different were the manuscripts, the architecture, and the organization of Lindisfarne, home to the Ionan mission, home also to the bishop of Lindisfarne, who lived there, as Bede noted with some surprise, subject to the authority of the abbot. Different again were the arrangements at Whitby (Yorks.), where a community made up of monks and nuns, following perhaps a Gallic pattern, was led by an abbess. While Wilfrid, Northumbrian bishop and abbot, might boast that it was he who had first introduced the sixth-century Italian Rule of St Benedict into England, there was as yet no suggestion that this rule was considered normative, as it would become in the tenth century. Quite the contrary: monasticism in the eighth century flourished on diversity. To say that by

THIS CHALICE, of Anglo-Saxon design, is inscribed around the foot with the names of Tassilo, a duke of Bavaria in the late eighth century, and his wife Liutpirc. Bavaria owed its Christianization to the efforts of St Boniface and his helpers; in this way Anglo-Saxon artistic skills and taste could have been transmitted to the continent.

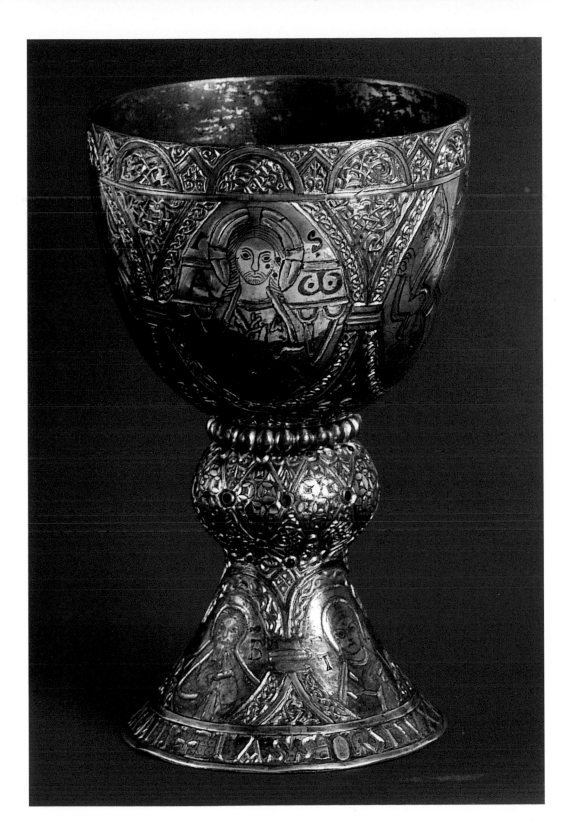

800 as many as 200 autonomous communities had been set up may well be to give a conservative estimate; any projected list would have to make room not only for the well-documented sites centred on the cults of saints and kings but also for countless tiny communities, such as Withington (Glos.), founded and jealously guarded as family inheritances to win influence in this world and merit in the next.

By the tenth century such monastic diversity was no longer in fashion. Already in the seventh century, as we have seen, the diocesan organization of England had been rationalized: Archbishop Theodore's initiative here had been followed by strenuous attempts in the eighth century, notably at the council of Clofesho of 747, to bring liturgical order to the Church, to see that church feasts were celebrated 'properly', and that God was worshipped 'unanimously'. Some two hundred years later, belatedly it could be thought, it thus became the turn of monasteries to be 'standardized' in the name of reform. Edgar's establishment of monks in Winchester in 964 was followed by similar foundations at Peterborough in 966, and at Ely in 970. The plan, according to one source, was for forty such monasteries to be established; and though we cannot now name all of them it is not impossible that the target was reached. The climax of the enterprise came with the issuing of the *Regularis Concordia* ('The Monastic Agreement') at the synod of Winchester of *c*.970. Summoning his bishops, abbots, and abbesses, Edgar 'urged all to be of one mind as regards monastic usage ... to avoid all dissension, lest differing ways of observing the customs of one rule should bring their holy conversation into disrepute'. All monks and nuns accordingly swore to live according to 'one uniform observance'. Rejecting the overlordship of any layman, they yet accepted royal protection and gave to the king the right to control the election of their superiors. Every day, indeed eight times every day, their liturgy prescribed prayers for the king and queen (and unless there was some special need the king got a ninth prayer too).

In its alliance with king and queen and with its establishment of monastic cathedrals—the precedent here was St Augustine's community at Canterbury—the English monastic reform movement marked itself out from the contemporaneous Continental movement by which in many other respects—notably in the development of its liturgy—it was much influenced. While on the Continent reformers were anxious to preserve immunity from secular power, in England this aim was shared, but not to the exclusion of the king. On the contrary, the king, as we have seen, was to be the monks' protector. While in the past there had been times when kings and monks had been at loggerheads, jealous of each other's power bases, partnership now seemed mutually advantageous. The monks gained endowments for

ALMSHOUSE at Ewelme, Oxfordshire. This institution was founded in 1437 by the earl and countess of Suffolk for thirteen paupers. This was a rather grand building, as the high quality of the brickwork in the doorway shows, but belongs to a time when many non-aristocratic people and organizations were founding hospitals and almshouses.

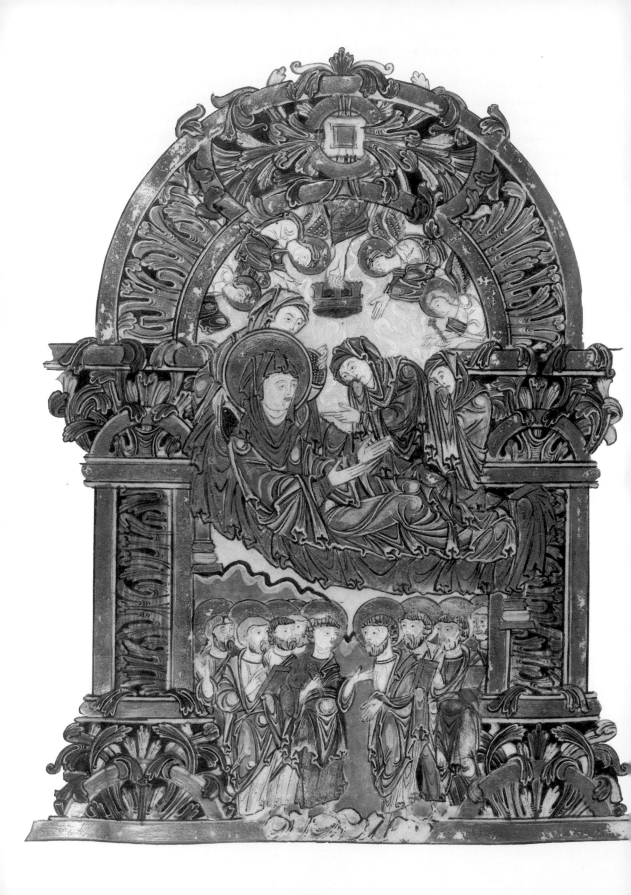

their foundations, and the king, crucial support. The kings of Wessex, it must be remembered, were only newly kings of England. In the unification of England—in the surmounting of factional and local loyalties and rivalries—the monks of the new foundations had a major role to play. The magnificent coronation ceremony at Bath in 973 was a reflection not only of the triumphs of Edgar's kingship, but also of the place within his rule of the many abbots assembled in the abbey. Their presence testified to a role that went beyond the ceremonial. Abbots attended the king not only at his coronation but also at his court. In 970 seventeen abbots witnessed royal charters.

A further way in which monks could bolster both their own and royal standing was through the appropriation of the cults of saints. Saints had been venerated in England already in Roman Britain; the cult of the British martyr Alban (d. *c.*210) was still alive in the days of Bede. The arrival of missionaries in the sixth and seventh centuries saw the establishment of further cults, both imported and indigenous. To own relics from Italy or Gaul was to possess treasured status symbols; better still, though, was to acquire a saint of one's own. Bede's *Ecclesiastical History* contains records of the cults of saints of the north, spiritual heroes such as the bishops of Lindisfarne Aidan, and, above all, Cuthbert. Such saints strengthened the faith of pilgrims who came to the saint's tomb as well as adding to the renown of the community who guarded it and to the stature of its patrons. In the tenth century the kings of Wessex must have found it galling in their bid for power as kings of England that so many cults should have been flourishing in the north! But a well-known remedy was at hand: relics were 'stolen', transferred from the original cult centre to a new home. If all went well, it was proof that the saint had given his or her blessing to the move and the theft legitimated. While the details of many of these translations are lost to us, it is to say the least striking both how many relics the new foundations of the tenth century acquired and how the remains of many northern saints, in the course of the century, travelled south.

Women and Reform

Since formal processes of canonization were not required until the later middle ages, the cults of saints could and did multiply with speed. In the age of the conversion women of royal blood had become saints with astonishing rapidity. The alleged holiness of such women reflected glory back on to their male kin and helped to strengthen the claims of their dynasty. In the tenth-century reform movement the

THIS DEPICTION in the Benedictional of Æthelwold of the death and coronation of the Virgin as queen of heaven testifies not only to the Marian piety of the monastic reformers of the tenth century but also to the important role played in the movement by the earthly queen, Ælfthryth.

role played by women was overshadowed by the dominance of the new monks, but still it should not be neglected. Many noblewomen patronized the new movement by giving it land and, although there was no revival of double monasteries, the *Regularis Concordia* was written with nuns as well as with monks in mind; both Wherwell and Romsey in Hampshire were among the new foundations for women, while the slightly older foundations of Shaftesbury and Wilton continued to house women with royal connections who might achieve sanctity—Edgar's daughter, Edith of Wilton is a notable example—or who might be entrusted with delicate political tasks; it was the nuns of Shaftesbury, in the turmoil following Edgar's death, to whom was given the responsibility of fostering and controlling the cult of Edgar's successor, Edward, murdered after only three years of kingship.

Edward's murder, allegedly at the instigation of his stepmother Ælfthryth, need not concern us here, but there is more to say of Ælfthryth that does have an important bearing on our subject. To tell the story of the tenth-century monastic movement in terms of the relationship between Edgar and his monks and to leave out the bonds forged between Ælfthryth and Bishop Æthelwold is to create a seriously one-sided picture. In Æthelwold's political theology there was a place for both king and queen, for the king as the Good Shepherd of his people, for the queen as the representative on earth of the Virgin, the queen of heaven. Thus it is in the *Benedictional of Æthelwold* that the earliest representation of the coronation of the Virgin is to be found and it is at Winchester, Æthelwold's see, that new liturgical texts and prayers for Marian feasts were composed.

If it remains true that Marian devotion was never widespread in the tenth century, this can serve as a reminder that the monastic reform movement, successful and powerful though it was, could not sweep all before it. Local aristocracies continued to favour local cults and to patronize those houses of secular clerks long associated with their families. But all the while, and yet more significantly up and down the country, a revolution was taking place: the birth of a parochial system that would survive beyond the Reformation, even into the twentieth century.

Parochial England

By 1050, England could be described as a country 'being filled everywhere with churches, which daily were being added to in new places'; so Bishop Herman of Ramsbury told Pope Leo IX. Modern estimates have confirmed the bishop's impressions. The key to this proliferation of churches lies in the changing patterns of land-holding in the tenth and eleventh centuries; old estates were fragmenting to be replaced by local manors, centres for the aspirations of a growing 'gentry' class. For the lords of these manors, as for their tenants, a church and priest of their own was much to be desired. Something of what this might mean, as well as the diplo-

macy required in laying the foundations of what would subsequently develop into the modern parochial system, can be glimpsed from the record in the early twelfth-century cartulary of Christchurch (Hants) of a church founded in the 1090s:

[Dean] Almetus testifies that he was present at the dedication of the church of Milford and that Alvric the Small asked Dean Godric and through him Bishop Wakelin, if he might build a church there, under condition that Christchurch should not lose any part of its ancient customs, that is, tithe and churchscot. Furthermore, Alvric gave half a virgate of land to the church when it was dedicated. At the same time, the bishop and Alvric handed over the church and the land to Dean Godric and the canons of Christchurch free of services by handing over the key. It was stipulated in the presence of the bishop that only Alvric's slaves and cottars should be buried there, and that they should pay 4d. as sepulture. Godric agreed that he would send a priest there, who should be fed at Alvric's table whenever he was resident there. The priest should wait for Alvric before beginning the service, he being the greater man, to a reasonable extent. The priest should accompany Alvric to the Hundred whenever he went there, but no further. Almetus also saw Godric send a certain priest of Christchurch there, by name Eilwi. Godric held the church in this way during his life, and after him his successors held it in the same way.

With Alvric's church we have crossed already the divide that separates Anglo-Saxon from Norman England. Alvric himself had suffered from the new regime that the events of 1066 had brought. The establishment of the New Forest in 1079 for the king's hunting had deprived him of much of his land with only meagre compensation, and it was on just this land that Alvric's new church was built. None the less, to suggest that the Norman Conquest as such significantly accelerated the establishment of local churches is likely to be misleading. Although it has been estimated that by 1100 some six to seven thousand such churches had been built—with only another thousand or so added during the later middle ages—there seems no reason to doubt that many of these foundations are of Saxon origin. Legislation dating from the reign of King Edgar makes it clear that local churches were already being set up both in rivalry to and to supplement the provisions of the older minsters. What the Norman Conquest did was to hasten the fashion for such churches to be built, or as the case might be, rebuilt, in stone rather than in wood; hence their durability and survival to this day in English villages up and down the country.

The Norman Conquest

In 1066 the Normans had fought at Hastings as a godly army, blessed with the provision of a papal banner. To justify their invasion it had been necessary for them to blacken the reputation of both secular and ecclesiastical rulers in England and to cast the king they hoped to oust, Harold, as a perjurer, and Stigand, archbishop of Canterbury since 1052, as pluralist and reprobate. It followed that in the consolidation of their victory ecclesiastical reform would be an important item on the agenda. Once Stigand had been removed and Lanfranc, abbot of the Norman monastery of

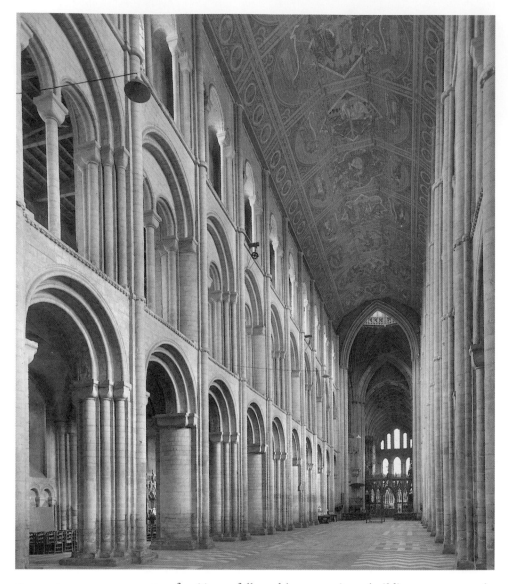

THE NORMAN CONQUEST of 1066 was followed by a massive rebuilding programme in the new Romanesque style. Characteristic of Romanesque is the three-storey elevation as seen here at Ely Cathedral. Noticeable, too, at Ely is the painted ceiling. Although this dates from the nineteenth century, it gives an idea of the colour and decoration which filled medieval cathedrals.

Bec, elected in his place, far-reaching changes were indeed introduced: new officials, new ecclesiastical courts, new episcopal sees, new precepts of canon law. In contrast to all this activity the Anglo-Saxon Church of the eleventh century has come to be seen, if not as decadent, then at least as somehow flagging and stagnant,

sorely in need of fresh inspiration and stimulus from across the Channel of the kind that only someone of the calibre of Lanfranc could provide. This view has little to commend it. Abroad, the Anglo-Saxon Church was long known for its missionary activity; missions, notably St Boniface's, had set off in the eighth century to convert the Old Saxons of the Continent; in the eleventh century this was a tradition maintained by missionary work in Scandinavia. At home, the late Anglo-Saxon Church could boast a rich devotional life. For all its limitations, the tenth-century monastic reform movement was still bearing fruit a century later, both in and outside the cloister. England, as nowhere else in Europe, had a tradition of vernacular religious literature, best exemplified in the late Anglo-Saxon period by those homilies of Ælfric, abbot of Eynsham, and former pupil of Æthelwold of Winchester, which he composed 'for the edification of the simple'. Winchester itself remained renowned as a centre of book production, of magnificently illuminated benedictionals, and recent work suggests that the monastic scriptoria of reformed houses such as Winchester were as concerned with the provision of texts for local priests and for the mission field as they were with the creation of de luxe codices.

Norman appreciation and appropriation of Anglo-Saxon skills and traditions took time. In the first flush of conquest churches were despoiled of treasure, taken off as booty to adorn the churches and monasteries in France: 'some received extremely large gold crucifixes, remarkably adorned with jewels. Many were given pounds of gold or vessels made of the same metal' (William of Poitiers). Bishoprics and abbacies were assigned to Normans who neither knew nor wished to respect English customs: at Glastonbury, the newly appointed Norman abbot brought in armed henchmen in his attempt to 'persuade' the monks to adopt a different chant; at Canterbury, Winchester, and Exeter, feasts peculiar to England at the time, such as the celebration of the Conception of the Virgin, were abolished; at Evesham relics of the saints were submitted to the ordeal of fire to test their authenticity. But by the end of the eleventh century the worst of such confrontations were over; the process of assimilation had begun. In the twelfth century monastic chroniclers such as William of Malmesbury, himself of mixed Norman and Saxon parentage, could now set to work to retell and rewrite the Anglo-Saxon past.

Conflicts of Church and State

The England of William of Malmesbury was, however, ecclesiastically very different from the England of 1066. The explanation lies as much with the papacy as with the Normans. In 1098–9 Archbishop Anselm, successor to Lanfranc at Canterbury, was present at councils in Italy where the then pope, Urban II, denounced both lay investiture—kings giving bishops and abbots the symbols of their office—and the practice of kings demanding homage from these appointees. Urban here was implementing the policies of his predecessor, Pope Gregory VII, policies which had

already caused pandemonium across Europe and which, once Anselm felt personally committed to them, seemed to threaten the position and status of the king of England. What was at stake was not simply the abandonment of customary protocol, but the very nature of the relationship between Church and State. In pre-Conquest England the king, as we have seen, could be depicted as a Christ-like figure, the Good Shepherd of his people. In the Gregorian world-view, there was no place for such theocratic notions; on the contrary kings were little better than robbers whose only hope of salvation lay in submission to the protection and demands of the Church. To fulfil this office the Church itself had to be purified—hence the determined efforts of reformers to put an end to simony and clerical marriage. Kings from time to time might back these moral aspects of the reform of the Church; what they would not as willingly do was to allow the diminution of their power implicit in the demand that they abandon lay investiture and homage or that they cede in any way to the growing claims of the papacy to hold the overlordship of Christendom.

In such conflicts between Church and State—and they erupted periodically throughout the middle ages—there was only one way forward: compromise. It was by a compromise that Anselm and the king came to settle in 1106 the question of lay investiture and homage; it was also compromise which brought peace again to the English Church after the bitter conflict—over matters such as the control of appeals to Rome and the treatment of criminous clergy—between Henry II and his chosen archbishop of Canterbury, Thomas Becket. Becket's murder in his cathedral in 1170 served as a constant reminder of the dangers of intransigence, for both parties. The conflict also showed how complex in any such situation were the loyalties of those involved. The bishop of London, and with him many of the bench, considered Becket to be 'a fool'; the pope himself, embroiled in a schism, needed the support of Henry II and found his role as Becket's champion a considerable embarrassment. Henry's allies, meanwhile, conscious that they had on their side 'might', were as yet uncertain as to the strength of their claims to 'right'. These tensions are worth stressing because it is such interplay which makes the triangular relationship between pope, king, and English hierarchy so dynamic a tale. A glance at the reign of King John underlines the point: John, refusing to admit Stephen Langton, the papal nominee for the see of Canterbury, incurred an interdict, severely restricting the church services which it was lawful to hold, and the threat of deposition. His deteriorating position as king led him to capitulate, and, faced with the rebellious barons of Magna Carta, to give England to Pope Innocent III as a papal fief. Langton meanwhile, having been accepted as archbishop by the king, now took the barons' part and in consequence found himself suspended from his office by the pope.

John's reign, with the sealing of Magna Carta in 1215, stands out as a landmark in English history. In the history of the Church 1215 has a different significance. It was in this year that Innocent III held the Fourth Lateran council, a council which gave

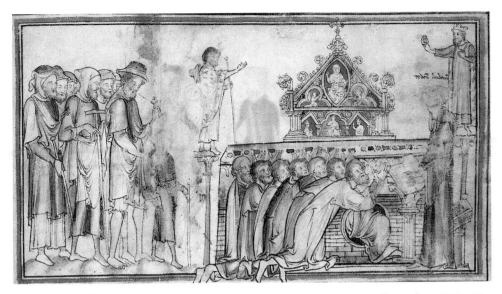

THE WESTMINSTER ABBEY PILGRIMS depicted here gather around a tomb which, like St Osmund's at Salisbury, has niches cut into the side for their use. Pilgrims needed to take care not to get stuck; the niches were not in fact designed to accommodate the whole pilgrim but only that part of him or her in need of healing.

unprecedented attention to the needs of the laity. According to this council, the most important of all the arts, to be ranked above both the study of theology and logic, was the care of souls. This being so, steps were to be taken to ensure that all priests were educated in pastoral care, trained not only to celebrate rituals correctly but also to preach to the people, to hear confessions, and to assign appropriate penances. Confession, as communion, was henceforth an annual obligation enjoined on all the faithful, both men and women. These provisions of the council, coming as they did after years of deliberation among the intellectuals of the nascent university of Paris, were to be far-reaching in their effects. As a test-case we may look at their implementation in an English diocese, the diocese of Salisbury. But before doing so we should consider the wider context for the development and functions of Salisbury as a cathedral city.

Salisbury: the Making of a Cathedral

In 1075 as a part of Archbishop Lanfranc's reforms a decision was taken at the council of London that episcopal sees should in future be based not in villages but in towns. Accordingly, the united sees of Sherborne and Ramsbury were moved to just outside Salisbury, to Old Sarum, where a fine Romanesque cathedral was built alongside the new Norman castle. The cathedral was completed and canons introduced to serve it under the direction of Osmund, bishop from 1078 to 1099. What rule these first canons observed is not clear but by the mid-twelfth century a secular

chapter had been formed, one of the nine to staff an English cathedral in contrast to those sees such as Canterbury, Winchester, and Worcester which had long been entrusted to monastic communities. These first canons of Salisbury were notable for the seriousness of their spiritual concerns and the scope of their scholarship. Here texts as yet unavailable in England were copied and a library built up that placed Salisbury on a par with the most up-to-date Continental schools of biblical exegesis. Salisbury was, however, no ivory tower. Three, maybe four, of the scribes copying these books have recently been identified as part of the workforce enlisted in the making of Domesday Book. Moreover, for thirty-six years, from 1103 to 1139, Salisbury's bishop was none other than Roger, financial wizard to King Henry I and his viceroy during his absences in Normandy.

Bishop Roger spared no expense in adding to the grandeur of his cathedral. However, despite his lavish patronage, in the course of the twelfth century dissatisfaction with the building grew apace; it was, it was alleged, windy, noisy, and short of water. More to the point, perhaps, was the desire for a new cathedral that could rival the architectural splendours of the recently rebuilt cathedrals of Winchester and Wells. By the second decade of the thirteenth century both the king and the pope had been persuaded to support plans for a new Salisbury cathedral; fund-raising was under way throughout the country, a site had been chosen two miles from Old Sarum, and in 1220 the foundation stones were laid. By 1266, the building was complete, looking from the outside—but for the fourteenth-century additions of tower and spire— much as it still does. The inside tells a different story. Unlike today, the thirteenth-century cathedral was ablaze with colour, a choir screen of painted and gilded kings and angels separating the nave from the choir. At each of the fifteen altars behind this screen Mass was sung daily, the addition of an eastern transept providing room for liturgical solemnity and adding emphasis to the focal point of the high altar where, as decreed by the Lateran council of 1215, following the definition of the doctrine of transubstantiation, the sacrament was kept in a pyx. The great nave—twice the length of the nave of Old Sarum—was in theory the space of the laity, but since the cathedral fulfilled none of the functions of a parish church, in practice it was the place, for clergy and laity alike, for special occasions, for grand processions on the solemn feast days of the year.

The cathedral might not minister on a daily basis to the laity of Salisbury but it still mattered to them, not least because it housed the man who would become their saint. In the move from Old Sarum the canons had brought with them the bodies of their former bishops. Of these the one who was most especially revered was their founder Osmund, and his body was placed, in all probability, under the central arch behind the high altar. It looks as if the hope and expectation was that Osmund would soon be canonized and then translated to a shrine in the Trinity Chapel; his tomb, still visible today, was covered by a stone box pierced with niches so pilgrims could stretch their hands through to touch it. In the event the canonization pro-

ceedings dragged on until 1457. (Osmund thus became the last saint to be canonized in England until the twentieth century.) But as far as the local population of Salisbury was concerned the name of Osmund could be efficaciously invoked long before his official laurels had been won. Together with the Virgin, the patron of the cathedral, he is reported as performing many a cure. In around 1410, for example, a child watching a game at Laverstock was hit on the head by an iron quoit; prayers to God, the Virgin, and Osmund restored her to consciousness. In 1421 the daughter of a Salisbury citizen was impaled on an iron spit; prayers and a subsequent pilgrimage to Osmund saved her life. The succour a reputed saint such as Osmund could give to local people did not of course preclude their also making pilgrimages to more famous shrines. The pilgrim badges such travellers brought back, only recently retrieved from the beds of the River Avon and the Millstream—into which they had perhaps been thrown as thank-offerings—testify to pilgrimages from Salisbury to renowned shrines both in England and abroad, to St Thomas Becket's shrine at Canterbury, for example, and St James the Apostle's at Compostela in Spain. Such pilgrimages had many needs to satisfy: penitential, devotional, thaumaturgic. Harrowing though they may have been for the sick and crippled in search of a cure, pilgrimages also engendered an atmosphere of carnival. Alongside the badges, the water-beds of Salisbury have also yielded up little bells and whistles of the kind that critics of pilgrimages so deplored: 'what with the noise of their singing, and with the sound of their piping and with the jangling of their Canterbury bells, and with the barking of their dogs after them, they [pilgrims] make more noise than if the king were there away, with all his clarions and other minstrels' (William Thorpe, 1407).

Richard Poore, Bishop of Salisbury 1217–1228, and Thomas Chobham

When the rebuilding of Salisbury was begun, its bishop was Richard Poore. Richard was a friend of Archbishop Langton's, perhaps even in his Paris days his pupil. Both were men fired by the desire to implement the reforms of the Fourth Lateran council, at which they had been present, and to give the English Church a new start after the bleak years of the papal interdict when so many services and ceremonies had been forbidden or curtailed. In this endeavour, Richard's contribution was of the utmost importance. His diocesan statutes, drawn up in 1220, set new standards for synodal legislation; he encouraged the free education of boys by endowing schoolmasters with benefices; he founded the city's first hospital; he invited Franciscan friars to come to Salisbury. His codification of his cathedral's liturgy led, in time, to the adoption of the Use of Sarum as the norm for services throughout England. Thomas Chobham meanwhile, his dean, produced a manual that covered everything that parish priests, faced with the sharpened obligation to hear confession and administer penance, could possibly need to know.

The aim of thirteenth-century reformers such as Poore and Chobham was not to

correct narrowly but rather to educate. A glance at either Poore's statutes or Chobham's manual suffices to confirm this. Both Poore and Chobham, for example, are much concerned with the welfare of pregnant women and the care of infants. According to Poore's statutes, women are to feed their babies with care; they are also to be told 'not to leave babies alone near water without someone on the watch'. According to Chobham, 'priests ought to charge women who are pregnant … not to press on with heavy work after conception, because doctors say that [even] with light work the foetus is cast out from the womb'. This is not to say that theology was neglected but it was practical and didactic rather than speculative. Thus Chobham discussing what a priest must know and how it relates to the care of souls can write: 'The priest must also know the four cardinal virtues—prudence, justice, fortitude, and temperance—so that he will know how to teach the penitent to distinguish good from evil through prudence, how to avoid evil and do the good through justice, how to uproot vices and plant virtues through courage, and, through temperance, how to avoid gluttony and lust.' Fixed tariffs for sins, of the kind advocated by older penitentials, were now a thing of the past, to be replaced by probing questions that yet gave the penitent the benefit of the doubt. Here, for example, is Chobham on drunkenness: 'the priest ought to enquire of the penitent if he was drunk how he got drunk, whether perchance because he did not know the power of the wine, or because of guests, or because of an exceeding thirst coming upon him.'

The Monastic Renaissance

The best-known agents of thirteenth-century reform are those newcomers, the mendicants or friars, whose success in winning hearts and minds proved so galling to many of their elders. We cannot, however, embark on the story of the friars without first considering the monastic renaissance of the twelfth century, which was as dramatic in its effects in England as it was in Europe.

When the Normans came to England in 1066, there were, according to Domesday Book, some forty-five monasteries—eight of them for women—worthy of record. In the first decades after the Conquest, there was no immediate rush to found more, the significant exception being the steps taken to revivify monasticism in the north of England, a region where the monastic reform movement of the tenth century had had no impacts and which was now a political trouble spot. It was after William's brutal harrying of the north in 1069 that one of his knights, Reinfrid, renounced earthly for spiritual warfare, became a monk at Evesham, and discovered Bede's *Ecclesiastical History*. Together with a like-minded group of monks, Reinfrid returned to the north, afire with the ambition of re-creating the way of life of the 'golden age' that he had found described in Bede. Welcomed by Walcher, bishop of Durham and later earl of Northumbria, Reinfrid and his band were allowed to settle on the site of Bede's monastery of Jarrow, long since disused after the Viking

raids of the ninth century; and there, 'for the sake of Christ, they took up their abode in the midst of cold, and hunger and the want of all things; they who might have had every abundance in the monasteries which they had deserted' (Symeon of Durham).

Useful, politically, as Reinfrid's initiative may have been to William I and to Walcher, what is interesting monastically is that the motivation that inspired Reinfrid and his friends is akin in spirit to those movements for monastic reform that were to transform the spiritual map of twelfth-century Europe. Throughout the eleventh century, groups of hermits, chiefly but not exclusively in northern Italy and France, had sought to find new ways to live the monastic life that would, in their estimation, accord more faithfully with what they perceived as the norms of simplicity and asceticism of the early Church. In making Bede his master Reinfrid was thus at one with those Continental reformers who for their part looked back to the Desert Fathers, and to St Benedict, and to St Augustine of Hippo.

Of all the eleventh-century eremitical experiments the most spectacular future was to lie with the band that gathered together in the 1090s in Burgundy, at Cîteaux, and which thus became the birthplace of the Cistercian order of white monks. Though much credit for the success of Cistercians will always be laid at the feet of the novice of 1113, Bernard, later abbot of Clairvaux and preacher *extraordinaire*, the contribution of the Englishman Stephen Harding, abbot of Cîteaux from 1109 to 1134, cannot be overlooked; the *Charter of Love*, an early and formative Cistercian manifesto, is almost certainly his work. None the less it was Bernard and not Stephen who played an influential role in promoting the development of the Cistercian order in England, not least by his sending a contingent of monks from Clair-

A POST-MILL from the Cistercian abbey of Rievaulx, possibly of the kind in common use on the abbey's estates. Self-sufficiency and an emphasis on manual labour were central to the ethos of early Cistercian monasticism.

vaux in 1131–2 to found the third Cistercian house in England and the first to be set up in the north, at Rievaulx in Yorkshire.

The Cistercian success story in the north of England, which followed on from Rievaulx, was startling. Within less than twenty years another eight houses had been founded. It has become usual both to attribute this rapid expansion of the order to the availability in the north, underpopulated and war damaged as it was, of just those isolated sites—in biblical terms places 'of horror and infinite solitude' (Deuteronomy 32: 10)—favoured by the early Cistercians and at the same time to underline the irony of a situation which gave to these monks the opportunity of becoming the most prosperous of sheep farmers in the Yorkshire wolds. Contemporary critics of the Cistercians were not slow to point to the irony, jeeringly claiming that greed rather than asceticism was the hallmark of their way of life and that if they could not find an underpopulated spot, they quickly made one, 'razing villages, overthrowing churches and turning out parishioners' (Walter Map). But, *pace* Map, entrepreneurial skills alone could never have accounted for the spread of the Cistercian order. To understand it, the nature of monastic expansion in England in the twelfth century as a whole needs to be taken into account.

The rise in the number of monasteries in twelfth-century England was certainly spectacular; more than 250 new houses were founded for men, and over 100 for women. Particular reasons lie behind many of these foundations. Among them were the neglect, hitherto, of monasticism in the north; the previous shortage of provision for women; the desires of second-generation Norman colonists to found houses in the country which they were now beginning to make their homeland. But over and above these considerations lies the concern of those who joined them with their salvation and how they could attain it. On the one hand, the God of the twelfth century was less terrifying than his earlier manifestations had suggested: his compassion and mercy were seen now to be as great as his power to punish and condemn. On the other hand, this 'humanized' God was in some sense more demanding, for, wanting to be worshipped not in fear but in friendship, he could expect from each Christian a personal response rather than the gathering in of a debt that could be vicariously paid. Monasticism in the tenth century had functioned on the gathering in of debts. Monks were recognized as belonging to that order of society responsible for the salvation of those for whom they prayed. In the twelfth century and later, this remained an important part of monastic life, but alongside it there developed a quite different ethos. The monastic call to which so many responded in the twelfth century was the call to become Christ-like, to know, to love and to imitate God-as-man. This was the vision which inspired Ailred, abbot of Rievaulx (1147–67), as he decided to renounce his life as a courtier and become a Cistercian. His later reflections on his vocation, his desires to 'share in the suffering of Christ' and the value that he placed on his monastic friendships 'as a stepping stone to the knowledge and love of God' encapsulate the new currents of twelfth-century spirituality.

The Coming of the Friars

One of the hallmarks of the Cistercian way of life was the order's forswearing of all parish work. While not every order shared their dogmatism on this point, it is generally true that as a speciality parish work belongs to the orders of friars of the thirteenth century. The founders of the two orders, St Francis (*c*.1181–1226) and St Dominic (*c*.1171–1221), were very different in personality and aim. But the orders which took their names assumed, even within their lifetimes, much of the responsibility for ensuring the success of the directives of the Lateran council of 1215. The Dominicans first arrived in England in 1221, when Archbishop Langton welcomed them with open arms. In 1224 it was the turn of the Franciscans to seek his approval. The Dominicans, at this point the more scholarly of the two orders, put all their early efforts into building up a fully operative priory at Oxford, Oxford by now being a recognized university town. The Franciscans, by contrast, scattered themselves and by 1230 had bases in as many as thirteen towns, Salisbury (see above) being one of them.

The fictional characters of Friar Tuck of Sherwood Forest fame and Chaucer's Friar John have between them given the friars a doubtful name, at best as faintly ridiculous gourmands, at worst as unscrupulous and avaricious manipulators of the pious. Whatever the individual failings of 'real' friars there can be no doubt that much of the well-attested enmity that developed between the friars and the secular clergy can be attributed to jealousy of the friars' popular appeal. Preachers by vocation, the friars needed to and did perfect the art of holding the attention of the large crowds of men and women who gathered to hear them. The telling of entertaining anecdotes lay at the heart of their success; given that the joke in such tales was often made at the expense of local priests, the resentment which they aroused occasions no surprise. Here is a late thirteenth-century example from a Dominican sermon collection. The scene is the death-bed of a rich peasant, barely able now to speak but harassed by his

AN EARLY DEPICTION of friars in England, made only about twenty years after their arrival. By the mid-thirteenth century or so, it has been estimated, the combined numbers of Franciscans and Dominicans were in excess of 2,000.

parish priest, who persuades the man's wife that in the ensuing conversation 'Ha' is to be taken as 'yes', silence as 'no'. The priest then starts his interrogation:

'Do you wish to bequeath your soul to God after your decease, and your body to Mother Church for burial?' The reply came, 'Ha!' Then the priest said to him: 'Do you wish to leave twenty shillings to the fabric of your church, where you have chosen to be buried?' But the other made no reply and kept a complete silence. Forthwith the priest pulled him violently by the ear, whereupon the man cried 'Ha!' Then said the priest: 'Write down twenty shillings for the church fabric: for see, he has granted it with his "ha!"' After that the priest pondered how he could get for himself the man's chest [previously described as being full of money and treasure]. So he said to the sick man: 'I have some books, but I have no chest to put them in. That coffer over there would be most useful to me. Would you like me therefore to have that coffer to put my books in?' But the other said nothing whatever to these remarks. Then the priest pinched his ear so hard that those who were present declared afterwards that the pinch drew blood from the man's ear. Then the enfeebled rustic, in a loud voice, said to the priest before them all: 'O you greedy priest, by God's death never shall you have from me as much as a farthing of the money which is in that chest!' Having thus spoken, he turned to his devotions and expired. Accordingly his wife and relatives divided the money between them.

The Emergence of Lollardy

Anticlericalism of the kind encouraged by the friars—but of which they themselves were as often the butt—is not to be confused with outbreaks of heresy, however often the two are found together. On the mainland of Europe ecclesiastical reforms had long been accompanied by outbreaks of heresy, not least since the expectations which the reformers aroused were never likely to be fulfilled to everyone's satisfaction. England's experience was altogether different. Barely a heretic surfaced in the country until the late fourteenth century when, to the consternation of those in authority unaccustomed to such a challenge, an English heresy, Lollardy, made its first appearance. By 1401 stock had been taken of the situation and the necessary legislation was passed; henceforth, following Continental practice, obstinate heretics, or those who having once recanted then relapsed, were to be sent to the stake. That same year, William Sawtry, a Norfolk priest convicted of Lollardy, was burnt at Smithfield in London.

Without John Wyclif (c.1330–84) there might perhaps have been Lollards in late medieval England: religious zealots who even if they criticized pilgrimages and the cult of saints no one would have particularly minded; but there might not have been Lollardy. It was the teaching of Wyclif that created a recognizable and recognizably dangerous movement. Wyclif was an Oxford scholar whose early years—he was

THIS ILLUSTRATION of the Ascension comes from a psalter made c.1170. The portrayal of the ascension of Christ from the point of view of the apostles watching his disappearance into the clouds and catching the moment when only his legs or feet were visible was taken over by Anglo-Norman artists from late Anglo-Saxon examples.

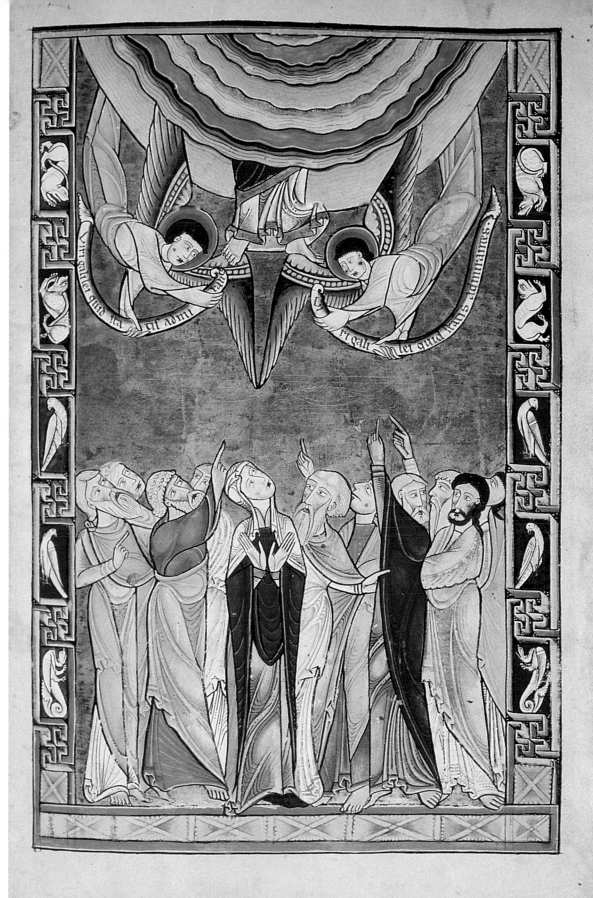

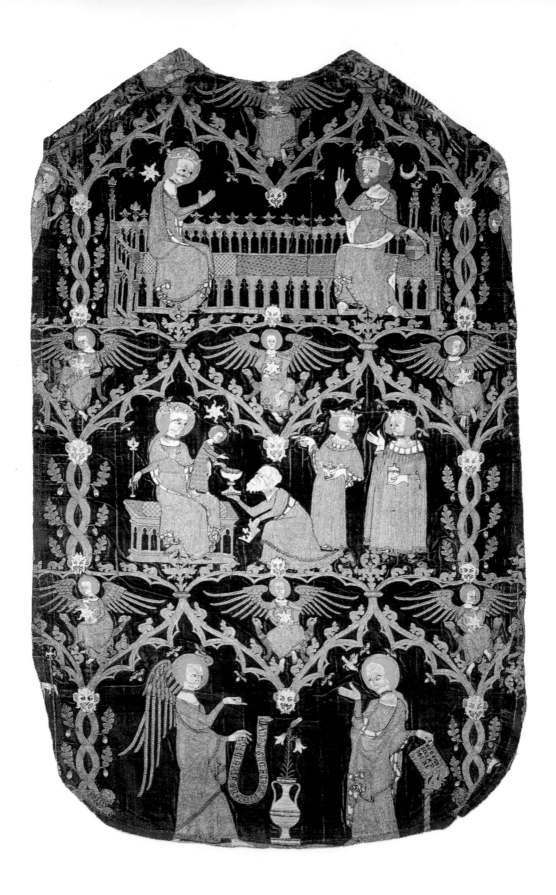

REPRESENTATIONS of the seven sacraments were seen in the later middle ages as a way of reinforcing the teaching of the church in the face of the threat of Lollardy. In this font from Badingham, Suffolk, extreme unction is depicted in the centre, with the baptism of Christ on one side and a scene of penance on the other.

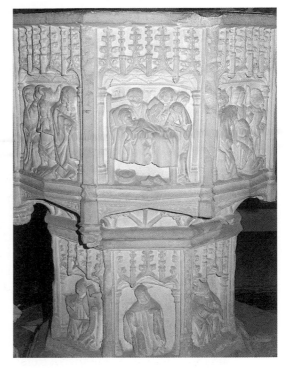

successively fellow of Merton, Master of Balliol, and Warden of Canterbury Hall— gave no inkling of his later notoriety. Sometime after 1371 his services were employed by the Black Prince and John of Gaunt and it was then that his new career in the public eye began. As a spokesman for government causes his controversial opinions at first were welcomed; it was only his rejection of transubstantiation as a philosophically untenable doctrine together with the suspicion—whether or not unfounded—that he was in some ways implicated in the Peasants' Revolt of 1381 that forced his retirement from the public arena to his rectory at Lutterworth. There, however, he continued to write with unabated enthusiasm in defence of ever more radical positions.

Wyclif's original brief in *c.*1371 had been to develop arguments to enable Edward III's government to direct clerical wealth from papal coffers to its own, so as to assist in the prosecution of the war against France. Wyclif would finally come to believe that church endowments should be pared down to the barest minimum. His reasoning here was set within the framework of a revised theory of the relationship between Church and State by which the pope represented the humanity of Christ, the king his divinity. It thus followed that it was the duty of the king to reform the Church and not vice versa. Not content with this reversal of traditional roles, Wyclif went further, claiming in his teaching on lordship or 'dominion' that power was nullified unless exercised by the virtuous; the true pope, in consequence, was not necessarily the man with the title, but simply whoever happened to be the most righteous man on earth. This was teaching which aroused suspicions of Donatism, a heresy

CHASUBLES provided, as here, an occasion for a fine display of English talent for embroidery. *Opus Anglicanum*, embroidery in gold, silver, and silk thread and often bejewelled, was valued throughout Europe. This particular chasuble dates from the mid-fourteenth century. The cloth is velvet.

long condemned by the Church, by which the validity of the sacraments depended on the moral standing of the celebrant. Wyclif himself denied the implication—it being from God rather than from any 'cursed man' that sacraments were received—but it is clear that his followers took his arguments a step further, claiming both that priests 'in deadly sin' had no sacramental powers and, conversely, that all truly good Christians, men and women, were in fact priests. According to Hawisia Mone, examined in the Norwich heresy trials of 1428–31, 'every man and every woman beyng in good lyf oute of synne is as good prest and hath as muche poar of God in al thynges as ony prest ordred [ordained] be he pope or bisshop.'

Hawisia Mone's views represented a gloss on Wyclif's teaching, but his own beliefs had already done much to undermine clerical status. By denying the doctrine of transubstantiation—claiming it to be an invention of the Lateran council of 1215—and the need, prescribed by the same council, for oral confession, he had at once diminished priestly power. Even more threatening to the church hierarchy was his advocacy of the doctrine of predestination. Since this was, to Wyclif, absolute, it followed that while the true Church was the body of the elect there was no guarantee and no sure way of knowing whether any particular priest, bishop, or pope was a member of this Church. They could just as well belong to the body of the damned.

Had Wyclif and the Lollards had their way, an English Church more radical than anything born of the Henrician Reformation would have been established. Just how strong, in the face of persecution, was the tradition of dissent that stretched from Wyclif to sixteenth-century Protestants is still a matter of some controversy, though there can be no doubt that the tradition was maintained. What is also clear, as heresy trials show, is the extent to which religious debate in late medieval England was not confined to any particular milieu; such matters touched men and women of all social classes and backgrounds. Wyclif's friends and supporters were made up, among others, of Oxford disciples who both sat at his feet and carried his ideas outside the university, of a court circle centred around John of Gaunt and Joan of Kent, widow of the Black Prince, by whose influence he was protected from ultimate disgrace (such as excommunication), and what may be called a 'country party' including figures such as the hermit William Swinderby of Leicester, and the mayor of Northampton, John Fox, whose activities helped the establishment of local groups.

Lollard theology was based on a belief in the supreme value of scripture—*sola scriptura*—and on the right of all Christians to be able to read and understand it. Huge efforts went into the provision of vernacular copies of the Gospels—occasionally of the whole Bible—to be disseminated among local groups up and down the country, alongside sermons and tracts. It was awareness of the crucial role played by the reading, memorizing, and discussion of such texts which led Thomas Arundel, archbishop of Canterbury, to pass stringent laws controlling the production of vernacular literature, in his *Constitutions* of 1409. Vital though Arundel may have conceived these measures to be, it was bound to put a damper on what had up to then

been the Church's own policy, those attempts spearheaded by the Lateran council of 1215 to educate the laity through the use of the vernacular. Ironically, the very ability to say the Our Father, the Creed, or Hail Mary in English now began to arouse suspicions of heresy. Extreme though this reaction may seem, something of the Church's dilemma can be seen by the appearance in the fifteenth century of an adaptation of the highly popular fourteenth-century Lay Folk's Catechism of John Thoresby, archbishop of York, turned into a heretical text through the interpolation of Lollard material.

The story of the fifteenth-century Church cannot, however, be read simply as a tale of forward-looking heretics battling against a reactionary hierarchy. The story that has to be told is more complex and interesting than that. Much of it can be illustrated by a look at the life of Margery Kempe, a woman herself suspected of Lollardy even though everything she valued most was precisely what the Lollards themselves rejected.

Margery Kempe

We know as much as we do about Margery because she herself chose to tell it to us; her autobiography, *The Book of Margery Kempe*, often hailed as the first of the genre to be written in English, was in fact ghost-written by priests; it none the less remains an astonishing piece of self-presentation, not least because the impression that it gives of Margery's flamboyant style is so alien to twentieth-century sensibilities that in the years following the discovery of the manuscript in 1934 Margery was dismissed as a hysterical neurotic. Only within the last ten years or so has Margery been 'rehabilitated' and situated within her rightful context.

Margery was born in around 1373 in Lynn (Norfolk) to a family of some importance—her father was five times elected to be Lynn's mayor. Her marriage in about 1393 to the burgess John Kempe brought her fourteen children along with recurrent intimations of her own wickedness and visions of heaven and hell. Her eventual desire to 'forsake the world and cleave to our Lord' and to take a vow of chastity and go on pilgrimage to Jerusalem met with some considerable opposition from her husband until the summer of 1413, when he managed to strike a bargain as revealing about pious practices as it is about marital relationships. John and Margery were at the time returning from a trip to York when the subject of Margery's wishes came up. Before they had reached home it had been agreed that John would expect Margery to share his bed, but that they would not have sex together; that she could go to Jerusalem but that she would first pay off John's debts for him and that henceforth Margery would give up her habit of fasting on Fridays to eat and drink with John.

For Margery, in her new life, there was no shortage of role models. On the Continent the experiences and revelations of women mystics and ascetics had long been

attracting attention and respect; reputations such as theirs both provided Margery with inspiration as well as helping to authenticate her claims and her ambitions, and she mentions them often in her *Book*. Bridget of Sweden (1303–73), for example, like Margery a married woman and furthermore a recognized saint, had made pilgrimages to Rome, to Santiago, and to Jerusalem; Mary of Oignies (d. 1213), a renowned Flemish holy woman, had, as Margery had, 'the gift of tears', so that neither of them could bear to contemplate Christ's Passion 'without dissolving into tears of pity and compassion'. At home, Margery herself met, and was encouraged in her vocation, by her contemporary, the great mystic Julian of Norwich. She also recalls how her priest read to her from the work of the English fourteenth-century mystics Richard Rolle and Walter Hilton.

For all the 'bookishness' implied by Margery's desire to have her own life recorded in a book and by the reading lists she gives in it, books do not as such provide the key to understanding her spiritual life. As she herself has God tell her:

I have often said to you that whether you pray with your mouth, or think with your heart, whether you read or have things read, I will be pleased with you. And yet, daughter, I tell you, if you would believe me, that thinking is best for you and will most increase your love towards me; and the more homely that you allow me to be in your soul on earth, it is worthy and right that I be the more homely with your soul in heaven.

Since the twelfth century Christians had indeed been constantly encouraged to 'think with their hearts', to re-create for themselves scenes from Christ's life, and to share imaginatively in the emotions of those present. The Cistercian Ailred of Rievaulx, for example, had told his anchoress sister to accompany Mary from the moment of the Annunciation until the Deposition, joining with her in her joys, her anxieties, and her sorrows. By the fifteenth century such advice, originally given only to professed religious such as Ailred's sister, had come to be recommended for all devout Christians. In 1410 Archbishop Arundel, as a part of his campaign against Lollardy, had authorized the publication of *The Mirror of the Blessed Lyfe of Jesu Crist*, a treatise for 'common persons and simple souls', expressly designed to help them to 'have sorrowful compassion through fervent inward imagination for the painful passion of Jesus' and to understand how, through his human nature, he could suffer, even from the

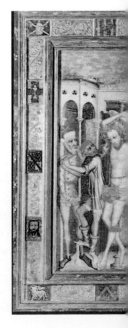

THE FOURTEENTH-CENTURY DESPENCER RETABLE in Norwich Cathedral is thought to have been painted by local artists and to have been the gift of those families whose shields of arms surround the frame. The image of Christ as he rises from his coffin stepping on one of the sleeping soldiers probably derives from medieval theatre.

time of his circumcision when his mother, 'seeing this little baby weep … kissing and speaking [had] comforted him as she might'. It is against this background that we have to understand what 'homeliness' and 'thinking with her heart' meant to Margery and how her religious life was shaped by the spirituality of her day.

Margery's *Book* opens with her description of a breakdown following the birth of her first child. Her recovery is signalled by the appearance of Christ 'in the likeness of a man … clad in a mantle of purple silk, sitting upon her bedside'. Following her later determination to lead a holier life, she has a vision in which she becomes maid to St Anne and is entrusted with the care of the infant Mary. Devotion to Anne was relatively new in late medieval England. Her feast day, officially introduced in 1382, was an occasion for the celebration of matronly virtues, given that Anne, according to legend, was married three times. (This made it possible for her to be the mother of all three Marys of the Gospels.) After her service to Anne, Margery's spiritual life develops further and she determines on her vow of chastity. As we have seen, she bargains with husband John about this on their return from York. The dating of this episode—Midsummer's Eve 1413—makes it clear that the couple had been to York for the Corpus Christi celebrations. The feast of Corpus Christi, introduced into England in 1318, celebrated at one and the same time the humanity of Christ and the mystery of his presence in the Eucharist. Aside from processions in which a consecrated host was borne aloft, there were plays, the York cycle being among the most famous, in which the drama of Christ's life was presented with an immediacy and vivacity which we know left their mark on Margery. In a vision that she had later of the crucifixion, she describes details that come straight from the

York cycle—the shrinking of Christ's sinews, for example, and the falling of the cross into a mortise. To these details she adds others, taken from her later experiences in Jerusalem. Thus she describes how Joseph of Arimathea took Christ's body from the cross and laid it on a marble stone, the stone that she herself had seen on her pilgrimage.

Margery, whenever she thought of Christ's passion and resurrection, wept so loudly that many who heard her considered her deranged. But however 'extraordinary' were her tears, it is clear that what provoked them was very 'ordinary': the sight of a crucifix or a *pieta* in a church, the Easter liturgy, or the Norwich retable showing Christ bound to a pillar. It is also clear how misguided were the attempts of those who wished to silence her by accusing her of Lollardy; Margery's imaginative reconstruction of extra-biblical scenes was precisely the kind of piety that the Lollards most abhorred; her orthodoxy was indeed acknowledged by Archbishop Arundel himself, who as a mark of his favour gave her a privilege that no Lollard would have wanted—the right to choose her own confessor. Margery, it should be remembered, though never lacking enemies, was equally never without her friends, not just in high places, but also among local men and women for whom she was a woman inspired by God, with whom they could share their innermost hopes and fears, someone it was good to have by a sick-bed and whose prayers God surely heard.

On the Eve of the Reformation

Between the death of Margery Kempe (*c.*1440) and the first salvoes of the English Reformation lie some ninety years. In the history of the Church, they were years full of new developments. One of the most vital and fascinating of these was a growing interest in meditation on the passion. This was a phenomenon that found expression in the adoption of a new cult, the cult of the Five Wounds of Jesus, a cult fervently propagated and cherished through the rich and ubiquitous imagery of the Image of Pity in which Christ was depicted raising himself up in his tomb, his wounds still fresh. With the advent of printing this scene was constantly reproduced in the many primers or Books of Hours now being made for laymen and women, but even before then it was widely available as a woodcut, on sale at pilgrimage centres or from travelling pardoners. Lavish indulgences, with promises of remission from the pains of purgatory, were granted to those saying the correct prayers before such an image, but astonishment at the calculations involved (32,755 years if the correct number of prayers were said) should not be allowed to obscure the layers of meaning that lay behind the cult. Meditation on the 'streams of blood' flowing from the wounds not only centred belief on the Real Presence of the Eucharist but also on its redemptive power and its social meaning. A fifteenth-century dramatist, the Wakefield Master, has Christ say to the souls assembled on the Day of Judgement:

Here may ye see my wounds wide
 that I suffered for your misdeeds
Through heart, head, foot, hand and side
 Not for my guilt but for your need
 Behold both back, body and side
How dearly I bought your brother-hood,
 These bitter pains I would endure
To buy you bliss thus would I bleed …
 All this I suffered for thy sake,
Say, man, what suffered thou for me?

Each wound offered protection against particular sins, the side wound, because of its closeness to Christ's heart, having especial salvatory power. This is the wound that Julian of Norwich sees in the tenth of her revelations, as a place 'fair and delightful, large enough for all saved mankind to rest in peace and love'. But the wounds of Christ could be seen also on the bodies of the poor, here and now. At the end of the time, Christ would appear before all the world, his wounds bleeding anew and the full import of Matthew 25 would be made evident. On that final Day of Judgement those who had shown no mercy to the poor were to expect none for themselves.

Trust, none the less, in Christ's mercy together with the ready availability of indulgences did much to alleviate the terrors presented by death, that awesome moment of first judgement when the sins of each soul were scrutinized and when all hope of heaven might yet be defeated by the wiles of the Devil as he lay in wait for a final chance to snatch a soul for himself. Except for the sainted few, immediate passage to heaven was out of the question; but, so long as hell could be avoided then, however dire were the penalties to be exacted in purgatory, they could be endured—not least because of the help that could be secured from neighbours and relatives still on earth.

EASTER-WEEK CEREMONIES in the middle ages culminated with the guarding, from Good Friday to Easter Sunday, of a representation of Christ's tomb. In some churches, such tombs were erected and dismantled each year, but in others, as here at Heckington in Lincolnshire, the Easter sepulchre was a part of the fabric of the church.

In the fifteenth century those who could afford it continued to endow chantry chapels, where one or two priests would daily say Mass for their souls and the souls of their departed kin; but such endowments were costly, and it can be counted as one of the achievements of the late medieval Church that indulgences to suit all pockets now became available. Unscrupulous dealers in indulgences, the medieval equivalent of ticket-touts, necessarily laid the system open to abuse, but the theory behind indulgences, that the living and the dead were united in a quest for heaven, was fundamental to medieval Christianity. The bedrock of this belief was to be found in the Mass.

The rich and the pious of the fifteenth century, great aristocratic figures like Margaret Beaufort (mother of Henry VII) or Cicely duchess of York (daughter of Edward IV), centred their devotions around their private chapels, where each day they might hear as many as four or five Masses, celebrated both for their own needs and the needs of the dead. For the population at large, Sunday Mass sufficed—unless there happened to be a midweek feast day—but through that one Mass and its setting the beliefs, values, and preoccupations of the later middle ages can be glimpsed, and may serve by way of conclusion to this chapter.

Let the church in which the Mass is to be sung be Wimborne Minster, Dorset, in the diocese of Salisbury, where the parents of Margaret Beaufort lay buried. This

church, an ancient foundation dating back to the period of the conversion, had long become the parish church of the market town of Wimborne. According to the figures of 1545, 1,700 communicants belonged to Wimborne. How many came to Mass on an average Sunday is not recorded; nor whether they took communion except at Easter—for the laity to do so was highly unusual, the practice and privilege of the select few. The Sunday Mass was richly beneficial. The service began with a procession

MADE OF ELEPHANT IVORY, this late fourteenth-century plaque once had a handle and was in regular liturgical use, passed among congregations who kissed it as a way of exchanging the kiss of peace that in the order of the Mass follows the *Agnus Dei*. The iconography of the Trinity, exampled here, was very popular in late medieval England.

around the church in which altars and congregation were sprinkled with freshly blessed water; some of this water was later distributed to homes, where it helped to keep devils at bay. After the prayer of confession and scriptural readings came the bidding of the bedes. This prayer, said in English, was in two parts: first, prayers were asked for the living, for all ecclesiastical and secular dignitaries, from pope and king to priest and mayor; for those with special needs such as prisoners, pilgrims, and pregnant women; and finally for the household which had provided the holy loaf for that week. The second part of the prayer was for the dead, the names of any parishioners or benefactors who had died recently being given special mention. The canon of the Mass followed and it was then that the chalice and host were elevated for solemn adoration by the kneeling congregation as the church bell tolled. Before the priest communicated he kissed a pax-board, an object frequently embellished with a sacred painting, which was then passed around for everyone present to kiss, symbol of the spirit of charity in which it was hoped all present were conjoined. The Mass ended with the sharing of the holy loaf. This bread, the first food to be eaten on a Sunday, was no ordinary food. At the moment of death, if no priest could be found to administer the viaticum, a morsel of holy bread made an acceptable substitute.

It goes without saying that the ideals of peace and devotional harmony which the Sunday Mass was meant to promote and reflect could be, and often were, shattered by the behaviour of those taking part. Priests might be drunk; parishioners might cause disturbances by 'talking and jangling', even by fighting over the pax-board; and those responsible for making the holy loaf might fail to do so. But nothing in all this was any kind of preparation for the revolution that Henry VIII was to introduce. A glance at the state of Wimborne in the fifteenth century shows it to have been a dynamic parish. It supported a local hospital, and regularly gave alms to the destitute. In part, the income for these activities was raised by renting out property, much of it only recently bequeathed, and from holding such fund-raising activities as church ales, cake-baking competitions, and fairs. Special projects necessarily demanded further forms of fund-raising. In 1448, for example, the parishioners of Wimborne decided upon a new church tower—church building, being regarded as a meritorious form of work that counted as penance, was much in vogue in the fifteenth century. To build their tower, the Wimborne parishioners made a number of successful appeals to the local gentry. From the lord of the manor of Hampreston they got 200 loads of stone. Just what the lord of the manor of Clenstone gave is not so clear, but the churchwardens' accounts show that two 'pasteys', a cake, and 7d. worth of malmsey wine helped to encourage his generosity. At the end of the century Wimborne's endowment promised to be further enriched through the munificence of Margaret Beaufort, whose aim was to found a chantry for the souls of her parents and to establish a school at Wimborne where grammar would be taught 'freely to all that will come while the world shall endure'. Negotiations, begun in

1497, were not formally concluded until 1511, by which time Margaret had died; but the provisions of her will make it clear that the project was dear to her and not one which her executors were to shelve. By the terms of the 1511 foundation charter a priest was appointed to take charge of the school. He was also to say Mass daily at the chantry altar for Margaret, her son, her parents, and all her relatives, and to take part in the daily Mass of the Minster sung in honour of God, the Blessed Virgin, and St Cuthburga, Wimborne's patron saint.

Cuthburga was a saint much honoured in her church. Each year on her feast day, 31 August, a fair was held in the church's cemetery; the church was swept clean and offerings made before the bejewelled and revered statue of the saint, either at her feet, or to her head, or in her apron. Churchwardens' accounts of 1488/9 record the buying of a piece of worsted for a new apron. In 1530, 137 rings were counted 'upon' this apron. In 1538, the very year in which the church was ordered to remove her statue, a new legend of the saint had just been acquired. The order was none the less obeyed, though the parishioners got permission to keep the silver from the statue's head. Nine years later, an Act of parliament dissolving all chantries put an end to Margaret Beaufort's newly founded Wimborne chantry.

Haphazardly but surely, the Reformation was engulfing the medieval Church of England.

7 The Visual Arts

❧❧ Nicola Coldstream ❧❧❧❧❧❧❧

Most shining of crosses encompassed with light.
Brightly that beacon was gilded with gold;
Jewels adorned it, fair at the foot,
Five on the shoulder-beam blazing in splendour.

I gazed on the Rood arrayed in glory,
Fairly shining and graced with gold,
The Cross of the Saviour beset with gems

These words, from the eighth-century dream-meditation *The Dream of the Rood*, offer a rare glimpse into medieval aesthetics. In that period there was no critical language of art, and written comments tend to be formulaic. Appearance was expected to represent the status of the patron, and objects were praised for their craftsmanship or value. But the poet's emphasis on brightness and shining light is not only an aesthetic formula: the bright gleam of gold and jewels led the viewer into God's presence, the radiance reflecting the light of truth, as on the early twelfth-century copper-gilt Gloucester candlestick (illustrated on p. 219). Owing to its qualities of brightness, as well

as its intrinsic value, metalwork was the highest of all medieval arts. Works on other media—stone, paint, ivory—were made to resemble it as closely as possible. The open-work effects of interlace and animal ornament in the Lindisfarne Gospels (see colour plate), for example, or the crisply angled mouldings in the nave of Lincoln cathedral (illustrated on p. 221), are intentionally based on the motifs and characteristics of contemporary metalwork.

Medieval art was not exclusively religious, and secular concerns found their way into church art. There is a great imbalance between the surviving quantities of religious and secular medieval artefacts; but wills and inventories, such as those of John duke of Bedford, brother of Henry V, indicate the volume of secular books, jewels, textiles, and plate that are now lost. The Dunstable swan jewel shows the quality and richness of non-religious art. Yet, owing to its function as the bringer of salvation, the Church was the primary recipient of art patronage, whether by churchmen or the laity. Architecture and the visual arts were intended to serve the needs of worship and reverence, and for display. They pleased the eye, while directing the mind towards suitable thoughts. In the later middle ages especially, imagery encouraged the viewer to experience through contemplation the horror and pain of Christ's Passion. The modern English church building gives little idea of its appearance before the Reformation. Henry VIII seized the precious metals; Puritans smashed the glass and figure-sculpture. It can be difficult to imagine the number of altars, with their painted or carved altarpieces; textile hangings, statues, candelabra; tombs, set out in profusion, screened off in chapels made in any corner that a benefactor could set aside or build. From the earliest years churches were alive with colour—wall paintings, hangings, floor mosaics and tiles, and, later, stained glass and contrasting stones. Plain stonework was whitewashed and painted, stone and wood carving coloured and gilded.

Medieval Christian art was centred not on Man, but on God. Its focus was the cross of the crucifixion. Words from *The Dream of the Rood* are carved on the eighth-century stone cross at Ruthwell in Galloway (illustrated on p. 37); the poem could be describing the contemporary gilded copper Rupertus Cross, which was made by an Anglo-Saxon craftsman. The Rood—the carved image of the crucified Christ between the Virgin Mary and St John—was suspended before the congregation in every church. Similar images appeared in large and small scale, in wall paintings, sculpture, stained glass, manuscript illuminations, portable images, ecclesiastical vestments, and liturgical furnishings. Artists strove to visualize the invisible. Although there were periods of naturalism, and from the fourteenth century artists in England showed some interest in representing believable space, this was a millennium of essentially non-naturalistic art. It was not wholly abstract, although pattern and ornament were popular. Animals, birds, fish, and plants remain recognizable even as they are converted to abstract designs. Much was expressed in signs, symbols, and gestures, and images held layers of meaning. Sophisticated

moralizing parallels appeared on the eighth-century Franks Casket, which compares sin and suffering in the lives of Jesus and Weland the Smith. The figures in combat on the Gloucester candlestick represent the fight between good and evil, darkness and light. Common to all the arts were schemes in which Old Testament events prefigured those in the New Testament. One of the justifications of art was to tell the Christian story; yet biblical teachings on graven images ran very deep, and the Byzantine iconoclastic movement had repercussions in the West—every so often, clergymen expressed unease about sacred images. But figured representation and narrative art were essential, and from late Anglo-Saxon times narrative art flourished in medieval England. English artists were good story-tellers, presenting the narrative with immediacy, pathos, or a strong humour that often tipped over into caricature.

Unlike modern artists, medieval artists worked largely to commission, and within accepted boundaries of both form and content. There is evidence that, before the Conquest, craftsmen were skilled in several crafts, and that churchmen were among the talented scribes and metalsmiths; but from the late eleventh century the vast majority of craftsmen were specialists and laymen. Much medieval art was collaborative. The work of the architect was effectively submerged beneath that of the carpenters, glaziers, and painters. Manuscript production required makers of parchment and ink, scribes and binders as well as illuminators. Motifs were collected in pattern-books for workshop use, or copied from existing works, and could be transmitted long distances on portable objects. Copyright did not exist, and originality was not prized for its own sake. For these reasons, although many artists are documented, and some works can be securely attributed, very few names will be mentioned here. To write the history of medieval art in terms of talented individuals obscures its true nature.

The greatest English talent and skill lay in metalwork, embroidery—known throughout Europe as *opus anglicanum*—manuscript illumination, and, probably, panel-painting. Very few panels survive; but such works as the thirteenth-century retable in Westminster Abbey, and the late fourteenth-century Wilton Diptych are of exceptional quality. English artists worked in the technical vanguard, using oil glazes by the mid-thirteenth century. Only after the Conquest did architecture and architectural ornament come into their own. The few surviving medieval wood sculptures suggest that there was much beautiful carving in that medium, but before the thirteenth century monumental stone sculpture was not particularly distinguished. Stylistically, English medieval art tends to be gentle and reticent. For all their vigour, figures are graceful and, except for some Anglo-Saxon and Romanesque work, fairly static. The main benefactors were the king, the nobility, and the higher clergy. They were the wealthiest, and had the greatest obligation to support both the Church and their own status by appropriate largesse and display. But from the thirteenth century onwards, other classes—merchants, knights and

gentry, parish priests—began, with the same mixture of altruism and self-interest, to ensure their personal salvation by endowing works of art. Those who could not afford to build a church or chapel could donate a stained-glass window or a painting; if a carved tomb was too expensive, a monumental brass was not. The medieval church building came to reflect very exactly the interests of the people who used it.

The contribution of patrons to stylistic development is difficult to assess. In 1174 the monks of Canterbury were guided in their choice of design by the master mason himself; but French elements in the design of York Minster in 1291 are attributed to the patron, who had lived in Paris. Patrons were almost certainly responsible for subject-matter; but craftsmen had a professional interest in the arts, and often travelled as widely as the patrons. The constant but haphazard trickle of Continental influence into English art, some comprehensive, some a matter of small detail, suggests that all concerned made contributions. The demands of liturgical development and changes in taste and patterns of devotion ensured that the church building of the mid-fifteenth century was very different from that of 600.

Early Anglo-Saxon Art to the Ninth Century

The book-based, Latin culture brought to the Anglo-Saxons by the Christian mission from 597 was imposed slowly. It never entirely supplanted the Germano-Celtic tradition: some characteristics of late sixth- and early seventh-century Anglo-Saxon art were to last for many years. Evidence of artistic styles exists in aristocratic jewellery and dress ornaments excavated from graves. The Germano-Celtic art known as Style I used animal and geometric motifs cast in gilded bronze, in a chip-carved technique that created an angular, faceted surface. The Late Antique, Mediterranean art brought by the Christians was a strong contrast, in both style and content. The St Augustine Gospels, a manuscript illuminated in Italy that almost certainly came with the missionaries, has human representations and narrative scenes: images of the Evangelists, dressed in sub-classical costume, and seated under Roman arches flanked by scenes from the Gospels. But the local aristocracy, through whom the missionaries worked, stayed with the Germano-Celtic tradition, now in Style II, which was the product of access to Byzantine gold. Gold could be drawn into fine strands of wire, to make filigree, plaits, and chains, from which were fashioned sinuous, elongated animals, threaded across surfaces in knots and interlace. Christian symbols—the cross, the fish—executed in Style II, appeared rapidly in metalwork designs. The centrepiece of the Crundale Buckle (see colour plate) is a large fish, decorated in beaded wire, and flanked by a series of filigree knots that form the body of a typical Style II snake. The buckle itself is worked with garnets in cloisonné cells, gold granules, and filigree. Similar styles and cell-work techniques appear on the jewellery from the early seventh-century, princely East Anglian ship-burial at Sutton Hoo. The grave-goods included objects from the eastern Mediterranean, such

as the Anastasius silver dish (illustrated on p. 9): the Anglo-Saxons evidently had no objection to classicizing southern work—they prized it—but their own craftsmen did not imitate the style, or incorporate it into their own designs.

Roman culture was imposed through church buildings and church books. At first, it can be seen most clearly in architecture. The Anglo-Saxons built in timber—simple, rectangular halls, probably descending from Romano-British traditions. Timber structure continued for domestic building throughout the medieval period and beyond: wood was also used for some Anglo-Saxon churches, but these were often associated with secular building complexes, as at Yeavering, Northumberland, and Bremilham in Wessex. Generally, however, the Christians preferred stone, owing to its 'Roman' connotations, recognized by Bede. In the south—Canterbury, Reculver, and Bradwell—they adapted surviving Roman buildings, to make modest rectangular churches, with an altar, an apse for the clergy, and the side chambers—*porticus*—used for burials. From the mid-seventh century, Bishop Wilfrid and Benedict Biscop introduced Roman building types in the north, as testified in the crypts at Hexham and Ripon. Northumbrian churches had sumptuous, colourful decoration, much of it in the Roman manner, with *opus signinum* floors at Monkwearmouth and Jarrow. The west porch (*c.*700) at Monkwearmouth is one of several northern buildings with lathe-turned balusters, which attempt to imitate Roman columns. The fragments of stained glass and painted wall plaster from these sites suggest that Frankish Gaul was the intermediary with Rome.

The Jarrow glass includes figured work that may be datable to the late seventh century. Figural art came to Northumbria, as it had to Kent, through church books brought from Italy. Such books were at Monkwearmouth/Jarrow by *c.*700, when a late antique model was used for the illustrations in the Codex Amiatinus, the great bible taken to Italy by Abbot Ceolfrid in 716. But the visual culture of Northumbria was that of the early Irish Church, expressed in the Insular style that was common to both Ireland and Northumbria in the late seventh century and the eighth. Insular art was the heir to the German-Celtic tradition: its interlace, fretwork, and sinuous, biting animals flourished in metalwork and manuscripts alike. Insular art was to define much Mercian and Southumbrian art, extending its influence into continental Europe, and underlying many of the decorative formulae of Romanesque art. The extent to which Northumbrian craftsmen were prepared to accept classicizing forms can be seen in the gospel books produced around 700. These books, bound in jewelled covers, expounded the Word of God in highly decorated pages, using fine display scripts and many colours. A manuscript codex is itself a Mediterranean form, and the gospel books contain much Mediterranean material: Italian liturgical uses and scripts; arched canon tables, giving the gospel concordances; Evangelist portraits. But the Evangelist portraits in the Lindisfarne Gospels are rendered in a flattened, schematic style unrelated to its southern exemplars. The book's decoration is purely Insular, with ornamental carpet pages and openings to the gospel texts

in which the decorative initial letter and the display script are composed both to integrate the text and to honour its sanctity.

Yet figural art was now becoming more common, if still rendered in a rigid, schematized style, as shown by the Evangelist portraits of the early eighth-century Gospels of Saint Chad. Such contemporary manuscripts as the Durham Gospels have narrative pages, and there is documentary evidence of narrative paintings in churches. By the eighth century the possibilities of visual narrative art were being explored, and the sophistication of the few surviving examples suggests that much high-quality work must be lost. The iconography of the ivory Franks Casket refers to the Roman, Jewish, Germanic, and Christian traditions (illustrated on p. 38). The Vespasian Psalter, a manuscript made in Canterbury about 725, has the earliest known historiated initials—opening letters to sections of text, which incorporate small figures or scenes, combining narrative with the Insular taste for integrating the text and the decoration.

The Vespasian Psalter also has full-page illustrations based on a Byzantine model, including David as Psalmist, with his musicians, presented in a classicizing style. Native and Mediterranean styles were now increasingly combined, if not fused: the arch under which David sits is decorated with Celtic trumpet spirals, and the Psalter shows its Insular connections in its elaborate display script. In Northumbria, Classical figures appear alongside the runes and interlace of the standing crosses at Ruthwell and Bewcastle. Vine scrolls adorned with animals or birds were carved, again alongside interlace, on decorative panels and door jambs in Yorkshire and the borders.

The Vespasian Psalter is one of several luxury manuscripts produced in eighth-century Canterbury. The arts flourished in the newly powerful Mercia and Southumbria. From main centres at Canterbury, Lichfield, and Worcester came a huge variety of church books—bibles, gospels, psalters, mass books, and small prayer books—as well as lives of the saints and copies of Bede's *Ecclesiastical History*. Links with the Carolingians took Anglo-Saxon craftsmen, as well as scholars, into continental Europe—the Tassilo chalice (see colour plate) is probably the work of such an artist. From the Continent came new exemplars, and with them a new sense of monumentality. Luxury Byzantine books inspired the gold and silver lettering in such Canterbury books as the Vespasian Psalter and the Stockholm Codex Aureus. By the late eighth century the taste for both Byzantine styles and monumental decoration was not confined to manuscripts. It appeared in architectural and free-standing sculpture, as on the cross-shaft at Codford St Peter, Wiltshire, which shows a man grasping a leafy bush. Interlaced plants and a vine scroll in shallow relief adorn an arch in Britford church, Wiltshire (about 800); and at Breedon-on-the-Hill in Leicestershire there are friezes of vine scrolls inhabited by elegant birds and figured panels, one showing an angel blessing (illustrated on p. 180).

From the mid-eighth century the formal layout and clearer spatial organization of

EARLY NINTH-CENTURY CARVED RELIEF in Breedon-on-the-Hill church, Leicester-shire. The vinescroll, inhabited by birds pecking grapes, shows Mediterranean influence.

buildings seem to depend on Carolingian models. The nave of Brixworth, North-amptonshire (illustrated on p. 41), was, like earlier buildings, flanked by *porticus*; but here they were reached through massive brick arches. East of the nave was a sepa-rate choir, and an apse surrounded by a passage that acted as a crypt. The early ninth-century church at Cirencester, Gloucestershire, was a nine-bay basilica, with proper aisles and no *porticus*; it had an eastern apse over a crypt, and a second crypt east of that. The four decorated columns in the crypt at Repton, Derbyshire, were probably inserted in the late eighth century. The four-column crypt is a Carolingian form, and at St Oswald, Gloucester, a similar crypt was combined with another Carolingian feature, a western apse. Both crypts and apses had specific liturgical functions: until the late twelfth century, a consistent theme in church architecture would be the clear differentiation of spaces.

Late Anglo-Saxon Art to the Mid-Eleventh Century

Owing to the connections of Alfred and his successors with Rome and the Frankish court, the most significant influences on English art from the late ninth century to the Conquest were Carolingian and, later, Ottonian. The impact of the Vikings was more political than artistic, even under Danish rule in the eleventh century. Anglo-Saxon interlace ornament did not disappear, but the embroidered vestments presented by Athelstan to the shrine of St Cuthbert at Durham in 934 have the fleshy acanthus leaf that was a Carolingian hallmark. The copy of Bede's *Life of St Cuthbert*, given at the same time, has the earliest English miniature of the patron presenting the book—which was to prevail to the end of the middle ages. In the cir-cle of Æthelwold and Dunstan developed the so-called Winchester school of illu-mination, in which the page had heavy borders, strongly coloured and gilded, with

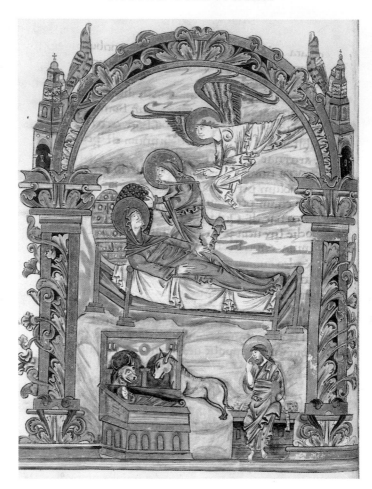

THE NATIVITY OF CHRIST from the Missal of Robert of Jumièges. Made in the early eleventh century, this is an example of the Anglo-Saxon 'Winchester' school of manuscript illumination. Borders are outlined in gold and filled in with exuberant patterns of acanthus leaf, and the figures are drawn in an agitated, sketchy style derived from Carolingian art.

acanthus leaf exploding into stylized patterns. The drawing is confident and crisp, figures schematized, in rapid movement, and with fluttery drapery derived from Carolingian prototypes.

From the late tenth century the Anglo-Saxons had developed drawing to a specialized art, in both coloured outlines and tinted contours (illustrated on p. 19). Figures were often placed unframed or in the text, as in the Sherborne Pontifical. The acme of this agitated, fluttery drawing style is the Harley Psalter, one of three copies of the early ninth-century Carolingian Utrecht Psalter, made in Canterbury between the early eleventh century and the late twelfth. These drawing techniques and acanthus patterns were to harden under Romanesque influence, but they under-

lie the development of much English medieval illumination. Other far-reaching innovations of these years include the Beatus initial—the dominant initial to Psalm 1—with acanthus foliage and a biting cat mask (for a late eleventh-century example, see illustration on p. 218); and the series of prefatory miniatures of the life of Christ in a psalter, as in the mid-eleventh-century Tiberius Psalter in the British Library.

Although manuscripts provide the best evidence of late Anglo-Saxon art, we know that churches were fully decorated with wall paintings, coloured glass, floor tiles, and textile hangings, and furnished with objects in metal and ivory. Monumental sculpture took the form of roods—surviving at Breamore and Romsey, Hampshire. The sculptured angels at Bradford-on-Avon, Wiltshire, the painted angels in Nether Wallop church, Hampshire, and the style of the Sherborne Pontifical show the close relation of all the arts at this time.

The concentration of monastic churches reflects church reform. Churches still had *porticus*, often with galleries; but under Carolingian influence buildings became larger and more articulated. A central tower often marked the position of the choir, as at St Mary-in-Castro, Dover, a position that survived in monastic liturgical layouts until the late middle ages. At Winchester, a great western block marked the shrine of St Swithun in the Old Minster. Yet articulation was somewhat imprecise: the strip decoration on such churches as Barton-on-Humber represents the Anglo-Saxon response to Carolingian interpretations of late Classical pilasters.

Danish rule made some visual impression. The Viking 'great beast', a single animal filling the decorated field, appears on a relief slab from St Paul's churchyard; decorative metal mounts show how the tendrils of the Ringerike style and the Urnes-style snakes were adapted to English tastes that already favoured sinuous interlace. English influence was stronger on Denmark, however, and after 1042 England turned towards Normandy. Edward the Confessor's Westminster Abbey, a pre-conquest building in pure Norman style, closely resembling Jumièges Abbey (illustrated on p. 66), showed what was to come.

Anglo-Norman Art

In the earlier middle ages, European art was essentially regional. Despite the penetration of Insular art into continental Europe, and Carolingian influence in Britain, pre-Conquest art was a stylistic phenomenon of these islands. But from the late eleventh century styles were Europe-wide: English Romanesque—or Anglo-Norman—and Gothic are regional expressions of styles recognizable throughout the Roman Catholic world. Existing styles did not disappear: the Urnes style lingered in sculpture well into the twelfth century, and the agitated Winchester figure style never quite vanished. But what did vanish was the air of the accidental and unconfined, the light, fleeting images that just touch the page. Romanesque art is settled and hierarchical. Its images and ornament are focused, integrated, and

schematized. The capitals made in the 1120s probably for the cloister of Hyde Abbey, Winchester, with griffins, heads, and foliage in beaded roundels, are fully Romanesque in their crisp carving, organized composition, and alert demeanour.

Our impression of greater focus comes also from the increased evidence. Far more Anglo-Norman art has survived, partly because there was more of it, and partly because the Normans demolished all the significant Anglo-Saxon buildings and their contents. Although documentary evidence is meagre and has to be treated carefully, it is consistent: from now on, we can be certain that, although much art production was centred on monasteries, most craftsmen were lay professionals. The laity emerge, too, as patrons and benefactors. Their endowments allowed the religious orders, both established and new, to build and decorate on a grand scale. If the Cistercians started modestly, the quiet splendour of their mid-twelfth-century buildings at, for instance, Rievaulx and Fountains, tells a different story. The senior clergy, however, continued to innovate and lead artistic taste, in both monastic and secular churches. It is probably to Henry of Blois, bishop of Winchester, that we owe the first use of Tournai and Purbeck stones for decorative contrast.

Enough Anglo-Norman art survives to give us a clearer picture of regional styles, and of how different media were used. Metals and ivory were made into liturgical objects—crucifixes, crosier heads, reliquary plaques—and put to domestic use as bowls, buckles, and combs. Iron was used for elaborate hinges, and door knockers to ward off evil. Most books were for monastic and liturgical use. Everyday church books had fairly simple decoration, but psalters continued the Anglo-Saxon innovation of a series of biblical scenes before the sequence of psalms; and during the twelfth century a number of illustrated giant bibles—for reading in the refectory—were made for Bury St Edmunds, Canterbury, and Winchester.

The stylistic influence of Normandy was strong only in architecture, and Lotharingian bishops ensured that there were also influences from Flanders and the Rhineland. The sheer size of the new buildings, both churches and castles, larger than any seen in Britain since Roman times, made an immense visual impact; but they were also much more elegant. The articulated, coherent forms of Norman architecture demanded

CAPITAL from Hyde Abbey, Winchester. Carved in the late 1120s, these capitals, with biting birds in beaded roundels, are fully Romanesque in style.

unprecedented skills in setting-out and stone-cutting, and for main walls rubble was replaced by ashlar (worked blocks). The spread of the new manner was helped by the fairly rapid demolition of many Anglo-Saxon churches. At some great ecclesiastical centres—Canterbury, Glastonbury—groups of linked buildings were replaced by single basilicas, with integrated plans and articulated elevations. At others—Wells, Winchester—the new church was built next to its Anglo-Saxon predecessor, which was then pulled down. The choir plan with parallel apses, built at, for example, Christ Church Canterbury, St Albans, and Ely, had appeared before the Conquest at Westminster Abbey; the alternative plan, with an apse, ambulatory, and projecting chapels, was built at St Augustine's Canterbury, in the west midlands (Gloucester), and at Winchester. The extreme length of the Anglo-Norman nave, which could have up to fourteen bays, gave these great churches a low, squat profile; but exteriors were emphasized by towers at the crossing, the west façade, and sometimes at the eastern arm. Inside, three-storey elevations were set out like Roman aqueducts. The massive, thick walls were penetrated by passages at clerestory level; there were galleries over the aisles; and wall shafts ran the full height of the elevation, marking it clearly into bays (illustrated on p.186). The strong division into bays, which characterizes architecture in the whole Anglo-Norman region, was an important early element in the evolution of Gothic vaulted designs, as were Anglo-Norman vaults. Both barrel and rib vaults were used: the sequence of Anglo-Norman rib vaults began at Durham, to be developed in Normandy at Lessay and Caen. Durham and possibly Lincoln were vaulted throughout, but naves were usually roofed in wood, vaulted only in later centuries (as at Gloucester).

The churches at Caen and Canterbury from which Anglo-Norman architecture developed were designed with elements clearly related through all parts of the elevation, and articulated arches with several orders, each with its appropriate capital and base. Capitals were cubic, either with corner volutes in the Norman manner, or the cushion type adopted from the Empire. But, although the clarity remained, Anglo-Saxon waywardness proved strong and durable. In East Anglia, at Norwich, Peterborough, and Ely, arches were not always supported by colonnettes; in the west midlands and elsewhere, huge columnar piers pushed the upper storeys high towards the roof. With this play on architectural elements came a taste for surface decoration, much of it architectural or geometric ornament. By the mid-twelfth century walls could be covered in blind arcading, often with intersecting arches, zig-zag chevron, chip-carving and billet-mouldings; and vaults, windows, and doors picked out with chevrons or the gripping beak-head motif.

In the years immediately after the Conquest, the Anglo-Saxon figural and decorative tradition remained strong in all the arts, partly because the Normans themselves had been heavily influenced by Anglo-Saxon art. The Beatus initial of a manuscript made in Canterbury shows the hybrid nature of much late eleventh-century work: the solid colour background, the figure types, and their placing within

the letter are Norman, but the form of the letter and its iconography are Anglo-Saxon. Yet by the mid-eleventh century both Anglo-Saxon and Norman styles had been subject to the stiffening and schematization of figures and drapery that characterizes Romanesque, as we can see in the Bayeux Tapestry (illustrated on p. 72). It was in manuscripts and metalwork rather than monumental sculpture that the style emerged. The Gloucester candlestick is densely composed of human figures and monsters in combat and entwined in foliate scrolls—the inhabited scroll that is a particular feature of English Romanesque art. The pattern of figures, tendrils, and banded inscriptions is the heir to Insular interlace and the Viking great beast; but some of the figures, while cleaving to the line of the candlestick, are fully in the round.

Heroic combat, fable, and epic were favoured themes in secular as well as religious art, and distinctions were not always clear-cut. The Bayeux Tapestry, depicting the battle of Hastings, may well have been made for a church setting, as may the so-called Sigmund relief in the Winchester City Museum, which probably shows an event from the Volsunga saga. Fables are carved on the capitals of William Rufus's Westminster Hall. Too little secular art has survived to give any idea of its range; but Anglo-Norman church art resembled in content that of Europe as a whole, encompassing biblical narrative, saints' lives, fable and myth, and theophanies, such as Christ in Majesty. Such themes appear in architectural sculpture and carved church furnishings—capitals, doorways, fonts, and screens—which developed strongly only from the twelfth century, reflecting work in other media in style as well as subject-matter.

The fusion of figures and structure in the Gloucester candlestick is typical of the visual arts in general, from monumental sculpture to manuscript miniatures. Architectural sculpture was shaped according to its position on the building, the relief never protruding beyond the wall plane. On a door jamb—as at Kilpeck (Hereford and

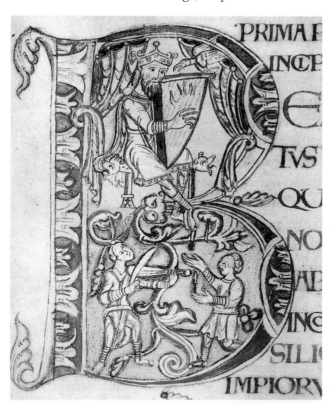

BEATUS INITIAL from St Augustine's Commentary on the Psalms. The emphatic opening letter to Psalm 1 became traditional from the early eleventh century. This late eleventh-century example is from a manuscript illuminated in a hybrid Anglo-Saxon and Norman manner.

Worcester)—the human figure could be elongated; on capitals, it would be short. On semicircular tympana above doors, the figures expansively fill the more generous space, as, for example, the St George and the dragon group at Moreton Valence, Gloucestershire. In such works as the ivory cross in the Cloisters in New York small figures cling and swoop round the frames of the narrative roundels; and in manuscripts they stand on the branches of plant scrolls, or lean an elbow on the frame of the miniature.

As the twelfth century proceeded, influences came in from France, Italy, Germany, and Byzantium. Some of these connections are specific—motifs from Saint-Denis Abbey near Paris appearing in the sculpture installed by Bishop Alexander on the west front of Lincoln cathedral—but others, for example the Byzantine influence detectable in manuscripts and metalwork, are more general. These include the dampfold drapery style, where drapery clings to arms and legs as if wet. This style dominated English figured art in the middle decades of the twelfth century. It is associated with Master Hugo, the lay artist who made bronze doors for Bury St Edmunds Abbey, and to whom is attributed the Bury Bible. In a series of magnificent books, the solid, schematized forms were developed into ever-greater abstractions: the flattened, cobweblike figures in the Lambeth Bible; the Winchester Psalter; the more sharply etched contours in the later York Psalter. They were accompanied by increasingly stylized foliage, the leaves stretched and curled, in variations on the trilobate 'Byzantine blossom'.

One of the most striking characteristics of English painting from the twelfth century onwards is its depth and range of colour. The miniatures in the St Albans Psalter and the Bury Bible, for instance, are painted in rich, subtle hues, not only of red, blue, and green, but grey,

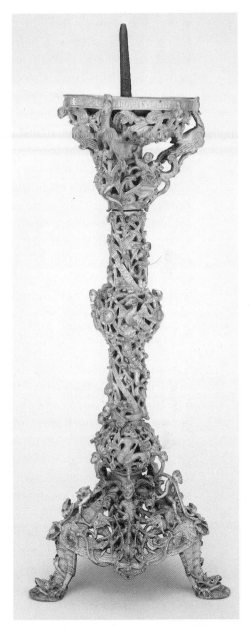

THE GLOUCESTER CANDLESTICK, commissioned between 1107 and 1113. The decoration consists of men and beasts caught in foliage, some in combat. Inhabited foliage is typically English. The inscription refers to Gloucester Abbey (now Cathedral), and to the struggle between darkness and light—the light of Christian doctrine.

violet, and orange, highlighted in white and outlined in black. The palette of the Lambeth Bible painter included pastel pinks and pale blues. Backgrounds could be gilded, as in the York Psalter, or panels of solid colour; the deep blue ultramarine derives from lapis lazuli. Colour radiated from ceilings, stained-glass windows, and walls. William of Malmesbury's famous comment on the colourful effects in the early twelfth-century Glorious Choir of Canterbury cathedral shows that love of colour extended to the marble floors.

Onyx marble has been found at Canterbury, but the commoner marbles are actually polished limestones. They were in use by the mid-twelfth century for furnishings and to offset the creamy limestone and sandstone ashlars of the bearing walls. Fonts and tomb-slabs came ready-made from Tournai in Belgium, but cheaper sources in England were rapidly exploited—at Purbeck in Dorset, near Wells, Somerset, and at other local sites. Purbeck stone is associated with decorative colonnettes and capitals. It was used to stunning effect in a series of later twelfth-century buildings, following a fashion already established in northern France, associated with the beginnings of Gothic architecture.

Early Gothic Art to the Mid-Thirteenth Century

'Gothic' is an unsatisfactory stylistic label. Coined by Italian Renaissance humanists to distinguish their own new fashion of architecture from what they saw as the barbarism of their northern forerunners, it has since encompassed all the visual arts between the late twelfth century and the sixteenth. Applied to architecture, it generally evokes buildings with a tall, light structure and huge windows, propped up by flying buttresses; moulded—usually pointed—arches; and rib vaults. But 'Gothic' covers a succession of stylistic variants, including buildings that bear little resemblance to that description. Most secular buildings, for example, did not need fliers, and were vaulted, if at all, with barrel or groin vaults. Yet, whatever the variations in Gothic, it can be distinguished from Italian Renaissance buildings, just as the reference to Classical ideals and the centrality of the human form distinguishes Renaissance figured art from that of the middle ages.

Gothic structure was devised in France, and it was from there that the first Gothic styles arrived in England—in the south at the cathedrals of Canterbury (from 1174) and Wells, in the north at Ripon Minster and the Cistercian abbey of Byland. For the English, the French style was a matter of form rather than substance. The English were accustomed to rib vaults and mural decoration of arches and shafts, having

THE NAVE of Lincoln Cathedral, c.1220–40. Surfaces are richly moulded and decorated, including the vault, which is composed of several ribs from each springer, rising to a longitudinal ridge rib. There is copious Purbeck marble, and the foliage capitals are in the bunched stiff-leaf.

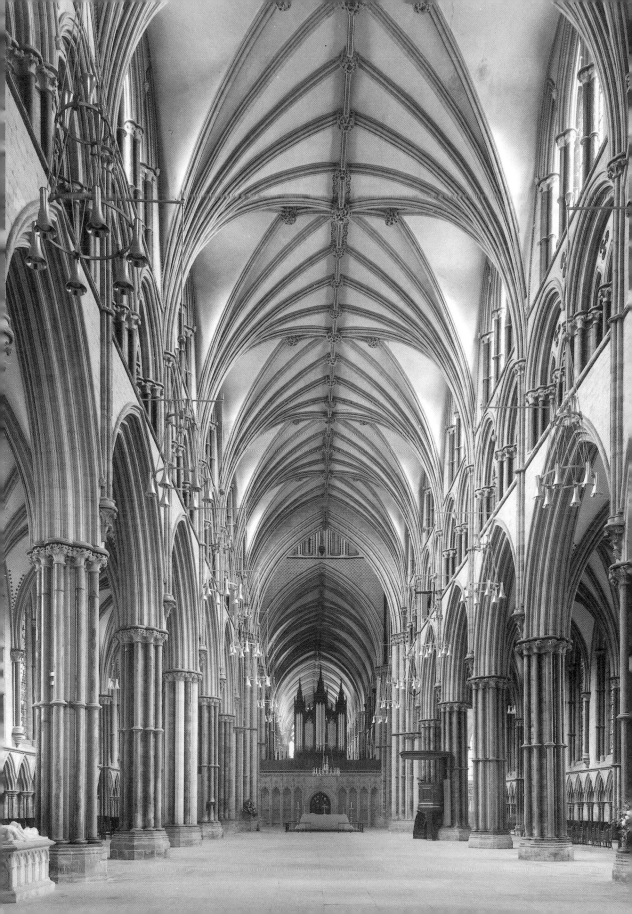

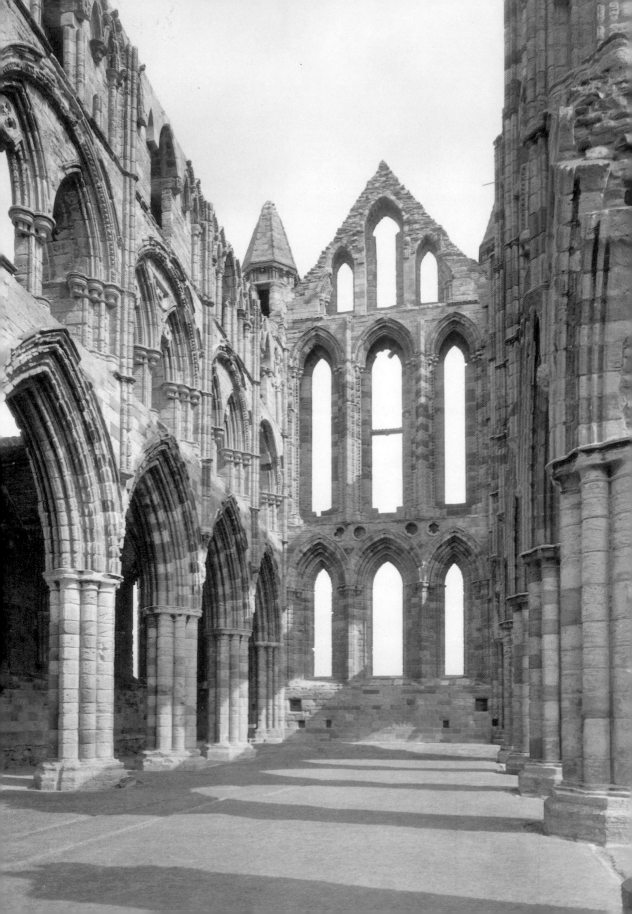

helped to invent both; but they never took to height, nor to French methods of constructing rib vaults and thin walls. We can only guess at the reasons. There was a native preference for low buildings; rib vaults sit easily on thick walls, and builders were not keen on flying buttresses, finding other ways to gain large windows. Medieval English building was often additive—a new choir or nave attached to an existing structure—and proportions adapted to fit. As the proportions were established in Anglo-Norman architecture, the English continued to build elevations with tall galleries and short clerestories, a strong contrast to the band triforium passages and long clerestories seen in metropolitan France.

The arrival of French forms in the 1170s disturbed English taste to the extent of producing a generation of structural compromises. Canterbury, Wells, and Byland have thinner walls, and versions of the band triforium. But within a generation English designers were asserting their independence of France not only in matters of height and structure, but also in plans and ornament. In St Hugh's choir at Lincoln, built in the 1190s, the vault, far from being a simple cross-rib, had a pattern of extra ribs, adding to the surface patterning of the walls. It started the taste for decorative vaulting that was developed in the 1220s in the nave at Lincoln and continued to the end of the middle ages, with increasingly dense patterns of ribs (as at Wells and Gloucester; illustrated on pp. 22 and 231). The nave of Lincoln shows the elaboration of mouldings, with sharp, metallic edges, and shafts clustered round the core of a pier. Foliage took on the bunched, stylized form known as stiff-leaf. Shafts and capitals were carved in contrasting Purbeck stone. Trefoils and quatrefoils were punched through plain surfaces. Both inside and out (as on the west façade of Wells), architectural decoration increasingly evoked metalwork.

The façade of Wells is composed of niches, which signify sacred space. The move to make the church building represent and embody the holy reliquaries it sheltered reflected the political and religious importance of relics in the thirteenth century. Around the turn of the twelfth and thirteenth centuries relics and shrines were factors in the rejection of eastern apses in favour of rectangular choir plans. Great churches now terminated either in a cliff-like gable wall (as at Whitby Abbey) or with single-storey chapels built out beyond the gable wall. The flat end walls emphasized arrangements of windows, as in the eastern lancets of Whitby; but the rectangular plan was less an aesthetic device than a practical solution to the conflicting claims of the clergy and laity to space in the eastern arm. Its success is testified by the number of great church choirs—Ely, Lincoln, Old St Paul's, Exeter—that were rebuilt or extended in rectangular form. The choir and presbytery remained permanently screened; the space beyond the high altar could be arranged as needed to

THE CHOIR of Whitby Abbey, North Yorkshire, looking east. Built c.1200, it is rectangular, with a flat east wall enlivened by narrow lancet windows. The pointed arches, multiple shafting, and moulded piers are typical of early Gothic architecture in the north.

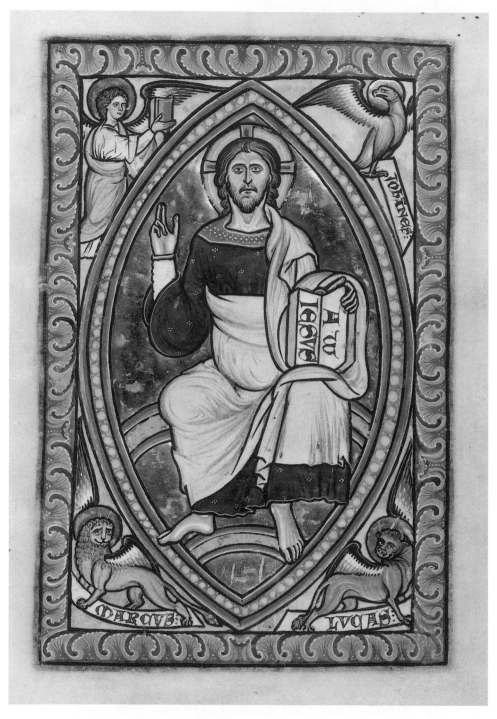

CHRIST IN MAJESTY from the Westminster Psalter. A monumental figure, showing Byzantine influence in the head and draperies, which gently follow the form of the body.

accommodate the main shrine, a Lady chapel, and subsidiary altars for lesser shrines and soul masses. At Lincoln in the later thirteenth century, pilgrims to the shrine of St Hugh entered the eastern arm by the great south or Judgement door, walked round the route of shrines and left by a smaller door on the north side, having caused minimum disturbance to the clergy in the choir. Many of the new buildings were associated with renewed attention to an established shrine, as at Ely or St Albans. The main shrine—visible to the officiating priest at the high altar—was raised on a tall base often made of the same materials and forms as its surrounding architecture. The shrine-like decoration of the building was a deliberate reflection of the shrine itself. The shrine areas could be emphasized by greater decoration. In the Trinity chapel at Canterbury, which housed the main reliquary of Becket, the decorative nature of the interior was further enhanced by green marble columns and a mosaic floor. Around the chapel, the stained glass depicted the life and miracles of the saint (see colour plate).

Stylistically, the Canterbury glass, made around 1200, is part of a movement away from the schematic patterns of Romanesque to a softer, apparently more naturalistic manner, inspired by Byzantine models. The head of 'Christ in Majesty' in the Westminster Psalter is in Byzantine style; his draperies follow his contours in soft folds. The naturalistic trend was a European phenomenon, led by metalworkers, but spreading rapidly into other art forms. This had begun a generation earlier: the initials and miniatures of the Winchester Bible display traditional Romanesque forms alongside the new, gentle style. The figures in scenes from the life of St Nicholas on an ivory crosier head anticipate this more rounded style, where dampfold abstractions have been softened into graceful curves.

Around 1200 the main stylistic connections were with France. In illumination they were so close that the style of some manuscripts is impossible to locate definitely on one side of the Channel or the other. The Canterbury glaziers were closely associated with north-east French glazing workshops, and were almost certainly hired through the French master mason of the building. The Canterbury glass glows with yellows, mauves, and greens against red and blue grounds. Manuscript painting emphasized bright red and blue, the figures standing out against gilded grounds; but, influenced by stained glass, illuminators arranged their pages with roundels and other shapes derived from the iron armatures of windows. From the early thirteenth century, book production was affected by new demands from the laity and the universities. Scribes, illuminators, and producers of raw materials settled near one another in towns. The laity bought romances, chronicles, and lives of the saints, and books for private devotional use, such as illustrated psalters, missals, and books of hours. A series of bestiaries, illustrating and describing the habits of animals, both actual and mythical, survives from these years. Artefacts were produced for the popular market, notably pilgrim badges and vessels for holy water, a trade much encouraged by the extreme popularity of the shrine of Becket.

THIS IVORY CROSIER HEAD was carved *c.*1150, with scenes from the life of St Nicholas. The figures are in the soft, naturalistic style that superseded Romanesque towards the end of the twelfth century.

Quantities of pilgrim badges (illustrated on p. 16) have been found in excavations; what we lack, largely owing to iconoclasm, are the statuettes and groups of holy figures, in wood, ivory, and metals, that were made for churches and lay patrons alike, and which we know only from exported examples that survive in Scandinavia. From around 1220, the soft style gave way to a sharper-edged manner, of flatter, elongated figures with angular gestures and drapery. The style is exemplified in attenuated form in the wooden St Michael and the Dragon group, made about 1250 and now in Trondheim. In the mid-thirteenth century, in the circle of the chroni-

cler Matthew Paris, the technique of coloured outline drawing was briefly revived, seen in the scenes from the life of Thomas Becket (illustrated on p. 104). Monumental sculptors sought stylistic inspiration in France, although architectural sculpture was arranged differently. The screen façade, wider than the building it fronted, was well established in English architecture—Rochester, Peterborough, and Lincoln—and doorways were not emphasized. At Wells and Salisbury, figures of saints, biblical narrative, and a theophany, in a vast theological *summa*, were disposed in tiers across the whole screen façade. Later, there would be carved doorways at Westminster and Lincoln, but the figures were spread beyond the confines of the portal. It was in architectural ornament that England was to make her unique contribution to European Gothic.

The Decorated Style: The Mid-Thirteenth Century to the Mid-Fourteenth

Between the mid-thirteenth century and the mid-fourteenth the English developed a church interior that was without precise parallel elsewhere. Intense, concentrated surface decoration provided a setting for a new kind of imagery. Beside small-scale images on vault bosses, window embrasures, altarpieces, and church furnishings were placed figures that were life-size or even larger, carved in relief or effectively free-standing, on pedestals or in niches. Prominent and three-dimensional, they were naturalistically painted, their costume carefully picked out with the patterns of real textiles.

Many of these figures were intercessionary saints and angels; or benefactors inviting prayers on their behalf. The great carved angels in the Angel choir at Lincoln, begun 1256, point to Paradise and judgement. But, as with the earlier Becket glass at Canterbury, much of the imagery was self-referential,

WOODEN FIGURE GROUP of St Michael spearing the dragon from Mosvik, Norway. The looped drapery and calm, classicizing face relate this sculpture to contemporary work at Westminster Abbey. The figure's wings are broken off; his mantle is coloured red and green, powdered with gold fleurs-de-lis.

alluding to the purpose of the specific building. At Westminster the figures of Edward the Confessor and St John on the south transept wall, enacting the famous legend of the Ring and the Pilgrim, reminded all who entered the church that this was the Confessor's shrine. The Lady chapels of Bury St Edmunds, St Albans, and Ely had elaborate programmes focused on the life and symbolism of the Virgin; and the imagery of the great octagonal crossing at Ely was devoted to the founder, St Ætheldreda, and other benefactors. At Tewkesbury, the lords of Tewkesbury were represented in stained glass, set in a paradise created with symbolic sculptures. The realism and assault on the senses was in perfect accord with contemporary changes in religious emphasis towards the more personal relation of the individual to God and the means of salvation; towards a more mystical union with Christ, expressed in the doctrine of Transubstantiation and the feast of Corpus Christi. More than ever did the church become the space where the everyday world met the eternal one offered by the Christian message.

The setting for these images was elaborate and ornamental. The metallic glitter of such mid-century buildings as Westminster and Lincoln were clearly intended to surpass the new choirs of Canterbury and Ely. The walls of Westminster Abbey are encrusted in a repeat pattern of rosette diaper, its windows embellished with circles of the recently invented stone tracery, its vault bosses, window embrasures, and dados filled with carved imagery and foliage. Later, architectural ornament took on new intensity with the introduction of two elements that were to govern its appearance for the rest of the middle ages: micro-architecture and the ogee. Goldsmiths had taken architectural forms—arches, gables, buttresses, tracery, pinnacles, and battlements—to decorate reliquaries, censers, and other such pieces; the miniature form, now with especially sacred connotations, was taken back by architects for use on buildings and sculptures. The ogee, or S-curve, was used in sinuous tracery patterns, and undulating mouldings and arches. Often combined with small gables in micro-architecture, ogee arches appeared on niches, and in other decorative contexts. In their mature form they bent forward through space to become 'nodding' ogees. Niches, signifying a sacred space, sheltered holy figures, either singly or in ranges on façades. Tiers of niches with nodding ogees in the Lady chapel at Ely, the north porch of St Mary Redcliffe in Bristol, and on the west façade of York Minster bring life and movement to the wall surface.

It was window tracery that had the greatest effect on designs of great churches, as

Facing, above: THE CRUNDALE BUCKLE from the mid-seventh century combines Christian imagery—the central fish—with a sinuous knotted snake in Celtic Style II.

Facing, below: MIRACLE OF ST THOMAS BECKET (stained glass roundel, Canterbury Cathedral). The glass round Becket's shrine in the Trinity Chapel, made *c*.1200, depicts his life and miracles. The scenes are painted in the soft style prevalent in those years.

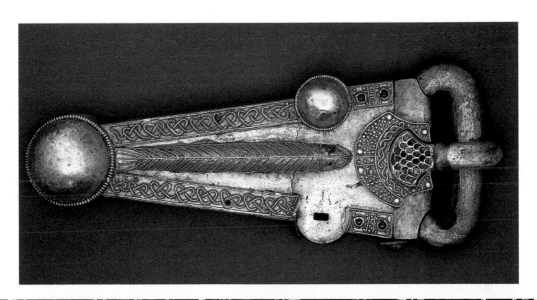

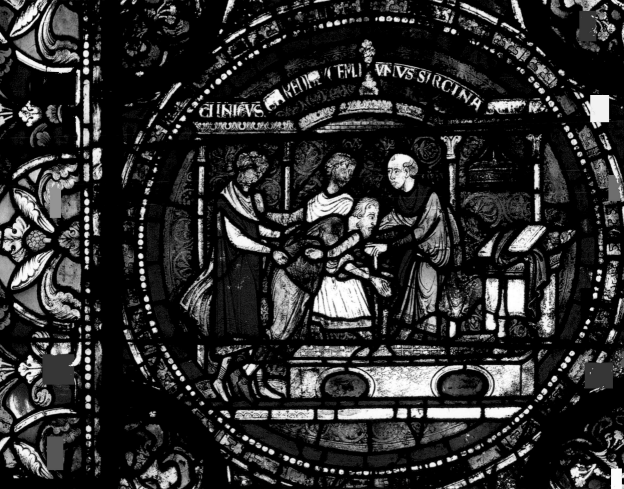

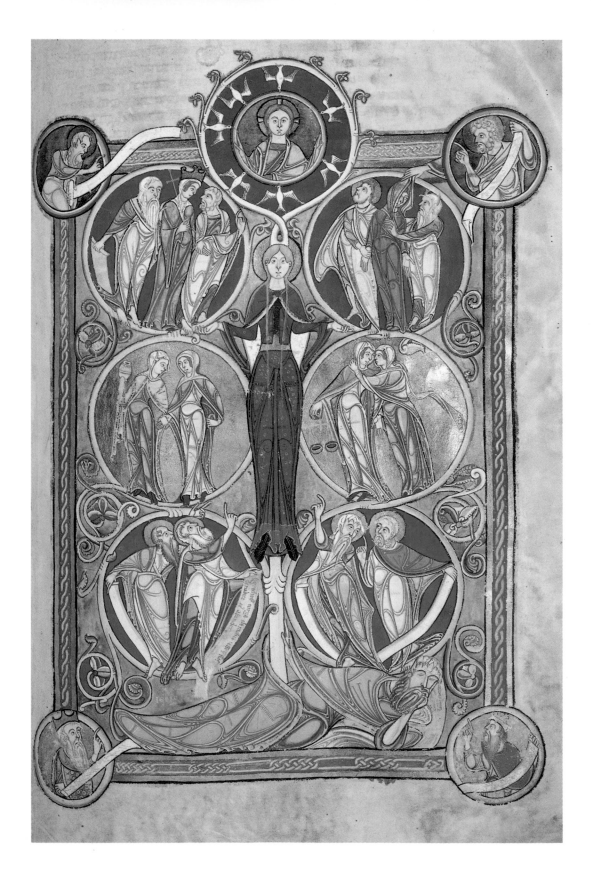

it could not be adequately displayed in the traditional three-storey, deep elevation. At Exeter cathedral, rebuilt from about 1270, the middle storey was reduced to a narrow triforium passage; the nave of York Minster, begun 1291, has a tall, flat elevation in French style, which made the tracery far more visible. In smaller buildings the middle storey was abolished. York Minster is the only great church built in these years to show any new thinking about structure; but its walls are still massive. Although the building or refurbishing of great churches continued, attention was switching away from monasteries to mendicant and secular churches—especially smaller chapels and collegiate churches for family soul masses. These buildings, particularly the new mendicant churches (e.g. Blackfriars, London), were simpler, with thin walls, slender piers, and wide spaces. The mendicant churches would become the model for the great town parish churches of the fourteenth and fifteenth centuries.

Architects were now concerned primarily with pattern, not only in tracery but in ground-plans and vaults. By the 1320s vaults had become intricate nets of ribs, produced by the careful application of time-honoured methods based on geometrical figures. Geometrical figures now became overt, in polygonal bases and monumental ground-plans. Polygonal towers appeared at the castles of Caernarfon and Denbigh; church architecture boasts two spectacular polygons—the Lady chapel at Wells and the crossing of Ely cathedral. Both irregular octagons, these buildings merge with their surrounding spaces in a series of oblique angles. At Ely, where the stone octagon supports a wooden lantern on a vault set (inevitably) at 45 degrees to it, the effect is of movement, arrested and held. At Bristol and Gloucester, vaulting ribs fly through space, unencumbered by webs. There, stone was imitating the qualities of carpentry, but architecture in general was given the properties of decoration.

The Decorated style, as it is aptly known, was not confined to architecture: all the arts echoed and reflected each other. The sinuosity of ogees affected foliage sculpture, which adopted undulating forms of seaweed. Micro-architecture appeared on tombs, liturgical furnishings (illustrated on p. 203), shrine bases, and other small but monumental structures, such as the Eleanor crosses, set up in the 1290s to commemorate Edward I's first wife. Niches and mouldings on walls were continued across windows, in stained glass (e.g. York Minster, Wells cathedral). Micro-architecture was ubiquitous in manuscripts, wall and panel paintings, ivories, textiles, floor tiles, metalwork, and wood. One of the finest ensembles of church fittings, the choir furnishings made for Exeter cathedral from 1316, comprised the bishop's wooden throne, and the stone altar screen, sedilia, and pulpitum screen, all with tiers of ogee arches, gables, pinnacles, and foliage cresting.

TREE OF JESSE from the Lambeth Bible. This miniature is typical of mid-twelfth-century English painting, with schematic figures, damp-fold drapery patterns, and clear, bright colours.

Above: VIEW from the retrochoir into the Lady chapel, Wells cathedral, 1320s. The Lady chapel is an irregular octagon that merges with the space of the retrochoir. Note the seaweed foliage, the decorative vault, and the regular, repetitive pattern of the window tracery.

Facing: END WALL of the south transept, Westminster Abbey, *c*.1245–55. Against a background decoration of carved rosette diaper, foliage, and window tracery are large figures in high relief of censing angels, SS Edward the Confessor, and John the Evangelist, referring to Henry III's favourite story of the Confessor. Large-scale interior sculpture was an innovation that transformed English churches.

TOMB OF ARCHBISHOP PECHAM (d. 1292) in Canterbury Cathedral. The arch-and-gable, with ogees, micro-architecture, and small carved figures of weepers on the base, exemplify decorative motifs for structures of all kinds.

In evoking the presence of the heavenly kingdom, Decorated is both realistic and illusionistic, although, as in all art, the realism is relative. Figures were idealized, or often grotesque—this was the period of monsters and 'babewyns' that inhabited manuscript pages, gargoyles, and corbels. Sculptured figures were, however, painted in naturalistic colours. Paint traces on the west front of Exeter cathedral show pink flesh tones, and draperies in red and green. From the thirteenth century we find random but minutely accurate observation of the natural world: the identifiable foliage in the chapter house of Southwell and elsewhere, birds and animals in manuscripts and wall paintings. Some corbel heads at Salisbury and Ely could well be carved from the life. Yet there were strict limits to realism, dictated by both artistic and religious considerations. In the mid-fourteenth century there are hints of three-dimensionality in the painted canopies of the Wells stained glass; and hints of spatial recession in depictions of tiled floors in manuscripts and the wall paintings (1350s) of St Stephen's chapel in the Palace of Westminster. Yet the background is abruptly blocked in, to preserve the integrity of the surface. Despite facial likenesses, there was as yet no portraiture in the modern sense. Effigies like that of Edward II (illustrated on p. 114) reflect not the deceased's personality, but the condition of his soul. Too much realism in art upset the clergy, who worried that people would confuse representation with actuality. In practice, idealization of figures continued as before, the graceful, looped draperies at Westminster and Lincoln, changing by 1300 to swayed poses with broad drapery folds, as in the Heckington Easter Sepulchre (illustrated on p. 203).

The theatrical, sculptured interiors were illusionistic by definition. The decoration of St Stephen's played elaborate visual games, with fictive architecture and

THE GORLESTON PSALTER, made perhaps for Thetford Priory. It is typical of early fourteenth-century English illumination, with interlace, spikey foliage, and borders decorated with naturalistic birds, heraldry, and monsters or 'babewyns'.

sculpture painted beside genuine mouldings and carved figures. At the more material level, illusionism was used to create costly effects. Sculpture and painting were expensive in both labour and materials. Carved and plain surfaces were coloured, gilded, or whitewashed; figures had metal trimmings. The choir of Exeter cathedral, the most richly decorated area, was painted in blue, with silver leaf on a scarlet ground. New luxury techniques and materials were introduced: translucent enamelling; and, where Purbeck marble had sufficed for effigies such as that of William Marshal in the Temple church (illustrated on p. 6), gilt bronze and alabaster became fashionable. Contrary to the belief of such Gothic Revival architects as A. W. Pugin, medieval craftsmen were not true to their materials, often using cheap substitutes even in works for their wealthiest patrons. The late thirteenth-century panel painting thought to be the high altar retable of Westminster Abbey has fake cameos and glass painted to resemble enamel. Base metals were gilded; plaster painted to look like marble. In the Lady chapel at Ely the mouldings appear to interweave, where they are cut off to save stone. Paramount was the need for the flamboyance, colour, and sparkle necessary to appropriate display.

A general increase in splendour is discernible everywhere. The close ties of blood, household, and obligation ensured the rapid cross-fertilization of artistic ideas whether works were made for ecclesiastical or lay patrons, for the aristocracy or for the newly emerging patronage of the gentry and their clergy equivalents. The differences lie in what was made rather than in its quality: the early fourteenth-century

{ 233 }

psalters and books of hours made for gentry families and monastic clergy in East Anglia are as beautifully designed and put together as those made for their social superiors. The gentry commemorated themselves in stained-glass windows and memorial brasses, and bought books and other portable works; the lay aristocracy and bishops could also afford to build. Art production was now based in towns—Norwich, Oxford, York, and, above all, London—and monumental brasses, books, and objects in ivory, wood, or metal were made both to commission and for the open market. If some artists, such as the painter Walter of Durham, were kept busy in royal service, no craftsman was reserved exclusively by any one patron. Masons ran stone-contracting and tomb-making businesses; Purbeck marblers had set up workshops in London, but alabaster carvers were still based near the quarries in the midlands. Painters made ephemera for festivals as well as panel and wall paintings and manuscripts—and it is this mingling of arts and skills that maintained the homogeneity of late medieval art.

The intricacy of these artistic relationships and the absence of written evidence obscure the different roles played by craftsmen, advisers, and patrons in devising programmes of decoration. They probably varied, as they do today, according to the knowledge and skill of the individuals concerned. Random documentary survivals tell us that Henry III and Bishop Grandisson of Exeter were active and involved; Edward II is even said to have supplied designs for one project. The evidence suggests that the homogeneity of the Decorated style was not achieved systematically. The arrival and subjugation of foreign stylistic influences, for example, were positively random. Henry III seems have been interested in reproducing aspects of French royal display; but tracery patterns were brought by his masons or advisers. The Italians who made the Cosmati floors and shrine base were brought by the abbot of Westminster; we have no idea who introduced

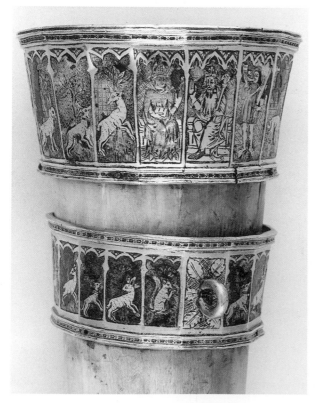

SILVER AND ENAMEL BANDS on the elephant-ivory Savernake horn, made in the second quarter of the fourteenth century in the technique of translucent enamel. In silver micro-architectural settings are naturalistic birds, hunting dogs, and forest animals, flanking figures of a king, a bishop, and a forester.

Italian iconography and styles into early fourteenth-century manuscripts and the wall paintings at Ely; we associate the Italian elements in Bishop Grandisson's ivory diptychs with his own connoisseurship, but we have no proof.

We can be certain only that all these elements were put to use to create a style that reflected contemporary aspirations. Episcopal patronage was especially lavish and creative: bishops not only sponsored building campaigns in cathedrals, collegiate churches, and their own palaces, but they were the first to have canopied tombs with little figures of weepers and cast metal effigies. The aristocracy attended to both spiritual comfort and chivalric display. Gilbert de Clare's tomb, set with gems and silver, or those of Edward I's brother Edmund and his cousin, the earl of Pembroke, in Westminster Abbey, were in leading taste. Tintern Abbey was rebuilt by the earl of Norfolk with the latest tracery designs; and at Tewkesbury the Despensers evoked Paradise with innovative vault patterns. The design of Earl Gilbert's Caerfili castle, with concentric plan and strengthened gatehouse, anticipated those of Edward I's castles in North Wales. Laymen liked their effigies to be arrayed in full armour; micro-architecture includes miniature battlements, often with arrow-loops. These secular intrusions can be interpreted allegorically as representing the fight against sin; but heraldry and heraldic colours and patterns were now every-where, as signs of ownership or allegiance, but also as decoration. The two panel paintings (Paris, Musée Cluny; a Suffolk church) that make up a Dominican altar furnishing from East Anglia have backgrounds chequered in heraldic colours, an effect often also seen in manuscripts. Manuscript illuminations regularly include marginal scenes of legends, daily life, or animals impersonating human activities.

Royal patronage was essentially aristocratic, but with one difference: the deliber-ate promotion of kingship. Lavish royal patronage was not new. The Norman and early Plantagenet kings had built splendidly: monastic foundations, including their burial churches—Henry I's Reading, Stephen's Faversham—have left hints of mag-nificence. Royal castles—Orford, Dover—were handsome as well as strategically planned. But from the reign of Henry III the imagery of the kings' houses and churches, especially in the abbey and palace of Westminster, dwelt on the sanctity of kingship through their sainted ancestor and their biblical antecedents. The first three Edwards indulged royal splendour and display in such imposing buildings as St Stephen's chapel (begun 1292), the castles in North Wales, and Windsor, which, as the headquarters of the Order of the Garter, refurbished by Edward III, became the grandest royal residence in contemporary Europe.

The redecoration of the choir of Gloucester (illustrated on p. 22) after the burial of Edward II could be seen in this context of royal self-promotion. The trellis of flat, rectilinear tracery, repeated on all surfaces, is ultimately derived from late thir-teenth-century buildings in France (notably St-Thibault-en-Auxois; illustrated on p. 21) through the intermediary of St Stephen's. It heralds the latest style of English architecture, the Perpendicular. Yet, although the flatness and simplicity are a

contrast to the bulbous three-dimensionality of contemporary Decorated works, presentation was the only thing that changed. Gloucester is encased in surface ornament, sculpture, and glass. The trellis is unstructural, standing by courtesy of the Anglo-Norman masonry that supports it. The building is a theatrical interior in the established tradition.

The Late Middle Ages

Imagery and micro-architecture survived to the Reformation. The prevailing rectilinearity, refinement, and thinness did not preclude concentrated, busy decoration, encrusting all surfaces, including the vaults. Coverage, whether of a stone surface or a manuscript page, was, if anything, more densely textured. Ornament was harder and stiffer, mouldings faceted, canopies and pinnacles emphasized and extended. In windows, rows of figures under dominant canopies continued the pattern of the walls. The trends noticeable from the late thirteenth century seem to be intensified, although the impression may be slightly false, as after the mid-fourteenth century patronage is better documented. This late phase brought no startling artistic change: tombs retained the form of sarcophagus, effigy, and tester; the layout of the manuscript page, with frame, initial, and text, remained faithful to schemes established centuries earlier. Monumental sculpture was still conceived not in the round but in architectural settings. Yet the visual arts were beset by exaggeration and dichotomy—display and humility, realism and artifice—carried to extremes. All classes became more ostentatious. Monarchy was strongly promoted, particularly under Richard II and, later, in Edward IV's new mausoleum at St George's, Windsor; and more people than ever could afford works that had hitherto been confined to the few. Chivalric display became more closely identified with provision for death and salvation.

One obvious visual dichotomy is that of enclosure and greater spaciousness. Walls were thinner, supported by more refined piers. Windows were more plentiful; and from about 1400 the flatter arch struck from four centres increased the glazed area. Multi-ribbed lierne vaults were more rectilinear, with higher, flatter profiles. Fan vaults—cones decorated with tracery—existed first only over small spans, such as tomb canopies, or the cloister at Gloucester (1360s). Fans, sometimes incorporating pendants, flourished in porches, aisles, and chantry chapels. Except at Sherborne Abbey they were not built over main spans until very late in the fifteenth century. Pendant vaults, of which fine large-scale examples survive in the Divinity Schools, Oxford, about 1480, may have been derived from timber roofs. These, like

BURWELL CHURCH, Cambridgeshire, was built by the parishioners in the 1450s. It is covered in Perpendicular panelling, and had the large windows and generous aisles that allowed for individual benefactions of stained glass and altars.

the spaces beneath, were also being opened out, with devices including the cantilevered hammer beams, of which the largest were built for Westminster Hall in the 1390s (illustrated on p. 76).

Work in the new manner appeared in several great churches from the 1360s onwards—York, Canterbury, and Winchester—but, despite continued renewal and additions, most patronage went to chantry chapels, parish and collegiate churches. Urban parish churches in particular were modelled on the earlier mendicant type: a light structure, comparatively long and low, often with a square, crenellated tower. Burwell church shows how generous aisles and large windows allowed benefactors to establish chantry altars, to give panel paintings (illustrated on p. 200), statues, and liturgical vessels, and to commemorate themselves in memorial brasses and stained-glass windows. Building in the Decorated style continued down to the 1380s—the change was not sudden, nor was it occasioned by the economic consequences of the Black Death. Perpendicular may look simple and reduced, but embellishment was just as expensive as before.

Although late fourteenth- and fifteenth-century stained glass is relatively translucent, churches were darker than they are now. The feeling of enclosure and privacy was enhanced by the increased number and permanence of screens, in both stone and wood. Choir screens had tracery, coving to support the Rood, and often painted panels at the base, displaying saints or heavenly hierarchies. Less elaborate screens marked off private burial chapels. The screen could become a miniature building, as in the series of bishops' chantry chapels (see colour plate) placed

THE SWANSEA ALTAR-PIECE made of alabaster in the later fifteenth century, depicts the Joys of the Virgin. This was a popular devotional subject in the late middle ages. The oak frame, with its inscriptions and decorative tracery, is original. The scenes, partly gilded and painted, are flanked by figures of SS John the Baptist and John the Evangelist.

between the main piers of Winchester cathedral from about 1400—each an exquisitely moulded setting just large enough for the tomb and altar. In great churches, choir screens became monumental stone structures, often complemented by equally imposing screens behind the high altar, as at Durham and Winchester, which concealed the main shrine and focused attention on the altar itself, to emphasize the presence of Christ in the sacrament.

Screens and glazing were adorned with biblical figures, saints, and kings, the last on the choir screens of York and Canterbury. The impact of these rows of large, broadly executed figures is different from narrative work, although that survived in sculpture and wall painting and to a lesser extent in glass. The great east window of York Minster, made about 1400, had an Apocalypse cycle, and the windows of Great Malvern Priory, made from the 1420s, have New Testament scenes; but the translucence of stained glass at this period did not suit narrative. Moreover, reflecting the tendency towards private devotion, iconographical emphasis in stained glass, wall painting, and altarpieces moved away from narrative instruction towards moralizing, liturgical, and devotional themes—the Magnificat, the Works of Mercy, the Seven Sacraments. Altarpieces presented such devotional themes as the Joys of the Virgin and the Passion of Christ. Fonts, which had mostly lacked figurative decoration for the past two centuries, were now often carved with suitable subjects, including the Seven Sacraments, as at Badingham, Suffolk (illustrated on p. 197). Alabaster became extremely popular for tomb effigies and panels. Alabaster altarpieces, exported as

far as Spain and Scandinavia, were partly gilded and painted, highly polished, and set in ornamental frames.

Single alabaster panels, depicting the Virgin, Passion scenes, and patron saints, were sold for personal devotion. Just as private spaces were being established in churches, more privacy was required at home, from ranges of state rooms at Warwick Castle, sets of apartments at Bodiam Castle, Sussex (1380s), to the suites of rooms on each floor of Lord Cromwell's tower at Tattershall, Lincolnshire (illustrated on p. 172), built in the 1440s. Fortification did not disappear—Cromwell's house at South Wingfield, Derbyshire, built around 1450, has a strengthened tower, and commands miles of country. Dominant, crenellated thresholds were built at least partly for show. The fortified gatehouse of Thornton Abbey, Lincolnshire, built in the 1380s, contains the abbot's rooms. Military purposes were also concealed by suave designs that flaunted late medieval ideas of chivalry. Wardour Castle, Wiltshire, built in the late fourteenth century by Lord Lovel, is an elegant hexagon. Tattershall, relying for defence on the castle within which it stands, is built of brick, a material popular in East Anglia from the thirteenth century. Its moulded brick vaults are decorated with shields of arms. Local lords placed their arms prominently above gatehouses, as at the Percy castle of Warkworth, Northumberland. The stringcourse of Westminster Hall is carved with badges and devices of Richard II; and coats of arms routinely embellished portable objects, such as manuscripts or plate.

Chivalric imagery also pervaded the church. The east window of Gloucester (1350s) depicts the derivation of authority from Heaven to Earth, the lords including Edward III's associates on the French campaigns. At Canterbury, the Black Prince's armour was hung above his tomb. The angels in the Wilton Diptych, probably made for Richard II in 1396/7, wear Richard's livery collar and white hart badge. The demeanour and hierarchies of Heaven naturally took on earthly guise. The jewellery worn by the angels in the Wilton Diptych resembles white opaque enamel *en ronde bosse*, the technique used for the luxurious little Dunstable swan livery badge (illustrated on p. 130). Splendour was not, however, confined to the aristocracy. One of the most beautiful surviving jewels (Oxford, New College)—a silver-gilt letter M containing gold figures of the Virgin and Archangel—belonged to a gentry family. The Cokaynes of Ashbourne, Derbyshire, chose alabaster effigies, in immaculate contemporary costume, rivalling those of royalty (Henry IV and Joan of Navarre at Canterbury) or bishops (Wykeham at Winchester).

The Wilton Diptych epitomizes the opposition of realism and artifice within a single work. The likeness of the king, meticulously recorded flowers and textures of costume, skin, and hair contrast with the punched gold ground and detailing, and the graceful swaying figures in the right-hand panel. Similar graceful figures and settings appear in such manuscripts as the 'Troilus and Criseyde' and the Psalter and Hours made for John duke of Bedford. The manner that these works represent

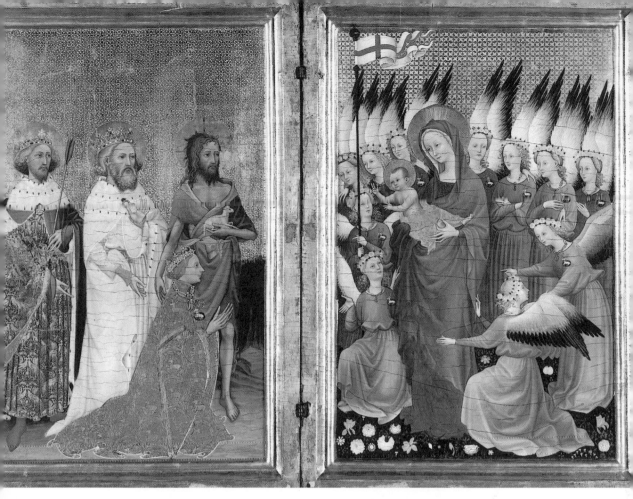

THE WILTON DIPTYCH, made ?1396/7, probably for Richard II. Richard, accompanied by his patron saints on the left, kneels in adoration of Christ and the Virgin, set in Paradise among a choir of angels wearing Richard's livery badges, on the right. The background is gilded and punched, and stippling defines Christ's drapery and the symbols of the Passion in his halo.

contrasts vividly with the harsher, flatter styles of such books as the Litlington Missal (see colour plate), the Norwich panels, or the later Badingham font. The former have traditionally been ascribed to a court style prevalent across Europe, known as the International Gothic; but this style is no more or less international than any other in the middle ages, nor is it exclusive to court cultures. In England in these years there were many different styles, reflecting the large number of artists from different backgrounds and countries. Flourishing workshops in cities such as Norwich and York produced paintings and stained glass; London was full of artists from the Holy Roman Empire and the Netherlands, fulfilling the enormous demand for books and painting. These artists introduced the soft style of gentle figures and bright, fleshy leaves seen in the Bedford Hours (see colour plate), which was also popular in stained glass. The general European tendency to enhance the reality of

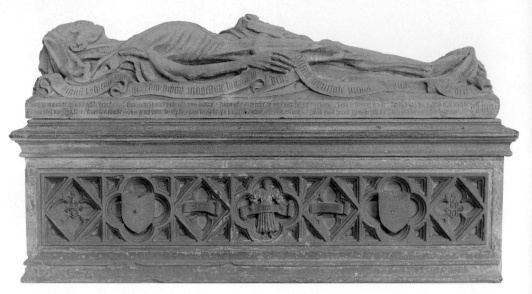

TOMB OF JOHN BARET, d. 1467, St Mary's, Bury St Edmunds. The effigy is a *transi*, the worm-eaten cadaver that proclaims the humility of the dead man and warns against vainglory.

religious experience by showing holy figures in contemporary costume was strengthened by Netherlandish interest in finely realistic detail and facial types (illustrated on p. 278). Sculptured figures, such as the kings (1380s) in Westminster Hall and the figures on the Great Screen at Winchester (1470s), were given naturalistic expressions. Depictions of Richard II in the Wilton Diptych and his bronze effigy (illustrated on p. 121) show that likeness was now acceptable. Yet the smaller, decorative figures on the Winchester screen show that realism was chosen only where appropriate: there was not yet a general move towards it.

Realism, of the ghoulish and morbid sort, reached its apogee in the bloodier alabaster representations of the Passion and of John the Baptist's severed head; and in the *transi*, the repellent, worm-eaten cadavers on tombs, such as that of John Baret of Bury St Edmunds. The *transi* developed the admonition against vainglory seen also in representations of the 'Three Living and the Three Dead' (see colour plate). Yet late medieval piety could also have an air of comfort and security, as at the Cobham family's college and church in Kent, with its array of memorial brasses. The wealthier the patron, the more ostentatious the pious humility. Aristocratic collegiate churches were often attached to castles, as at Tattershall or the Yorkist

THE BEAUCHAMP CHAPEL, St Mary's, Warwick. The glass and sculpture in the burial chapel of Richard, earl of Warwick, give an idea of mid-fifteenth-century piety. The effigy prays to an image of the Virgin. In the windows angels praise her; the earl and his family kneel to Christ and the Nine Orders of the Angels.

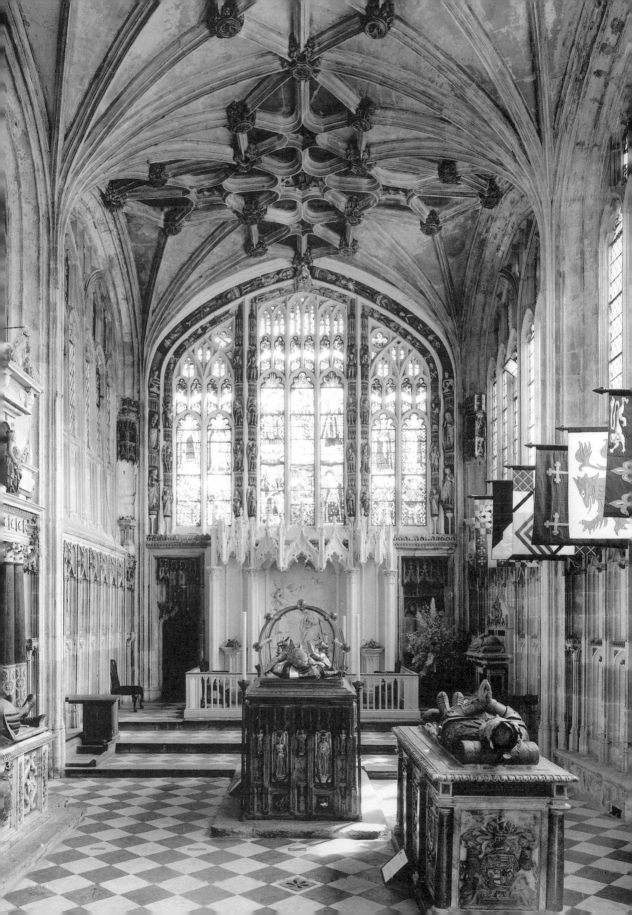

college at Fotheringhay, emphasizing that magnificence continued in death as in life. The lavish, cathedral-like St George's chapel at Windsor, founded by Edward IV in 1475, was a deliberate challenge to Henry VI's foundations at Eton and Cambridge, only to be challenged in its turn by Henry VII's chapel at Westminster.

Such displays were, however, neither hypocritical nor cynical. We are singularly fortunate that one mid-fifteenth-century burial chapel has survived relatively unscathed. In St Mary's, Warwick, the funerary chapel of Richard Beauchamp earl of Warwick is dedicated to the Virgin Annunciate, a traditional symbol of humility. Angels in the stained glass sing in honour of the Virgin; in the east window representations of the earl and his family kneel to Christ and the Nine Orders of the angels, which are carved in the window jambs. Warwick's enamelled Purbeck marble tomb stands in the centre of the chapel. Influenced by contemporary Flemish art, the brass effigy is intensely naturalistic. Dressed in armour, his emblems at his feet, the figure of the earl gazes up at an image of the Virgin, his beautifully veined hands in an attitude of prayer. It is an image of soldierly piety, a soldier of Christ, humbly seeking the Virgin's intercession. The Beauchamp chapel is one of the few buildings in England that can still give us an impression of medieval religious feeling, and show the importance of all the arts in giving it expression.

8 Language and Literature

Derek Pearsall

'English' begins as the language of the Germanic tribes who settled what is now called England in the fifth and sixth centuries. It was a conquest and settlement quite different from that of Gaul, where the Frankish invaders took over the estates of the Latin-speaking Gauls and adopted their language. In England the Jutes, Saxons, and Angles, from the lowlands of western Jutland and north-west Germany, did not absorb the culture of the people they conquered, and they kept their own language. The newly settled land was called 'Anglia' in Latin as early as the sixth century and its people 'Angli' or 'Angli-Saxones' (Saxons of Anglia, to distinguish them from the Continental Saxons); Pope Gregory called King Æthelbert of Kent 'rex Anglorum' in 601; and Bede's great history, from which much of our knowledge of the conquest comes, is called the *Historia Ecclesiastica Gentis Anglorum*. In the vernacular the language was called 'Englisc' from the time of the earliest records, the people occasionally also the 'Angel-Seaxan', in imitation of Latin, and the land first 'Angelcynn' and

then 'Englalande' from about the year 1000. 'Anglo-Saxon', as a term to describe the people, the language, and the period of history from the settlement to the Norman Conquest of 1066, came in with the revival of early English studies around 1600, while 'Old English' is the more usual modern term for the language of the period, distinguishing it from 'Middle English' (*c*.1100–1500).

The Old English Language

The 'English' language began with the separation and gradually increasing differentiation of the language of the newly settled peoples of England from the matrix of the Continental West Germanic tribes. Some of the differences introduced can still be seen in the systematic variations between modern English and modern German, for instance *leap/laufen*, *open/offen*, *water/wasser*, *ten/zehn*. Old English, as we shall now call it, was a fully inflected language, with inflected noun, adjective, and verb, fully inflected definite article, weak and strong declensions of the adjective (used in different syntactical situations), and strong and weak verbs, for instance *drifan–draf–drifen*, giving modern 'drive–drove–driven' (strong), and *lufian–lufode–gelufod*, giving modern 'love–loved–loved' (weak). There was also grammatical gender (*wif* and *cild* were both neuter, and *wifmann*, 'woman', was masculine) and a dual form of the personal pronoun, not much used. The earliest writing (for instance on the Ruthwell Cross, around 700) is in runes, a Germanic development of the Latin alphabet used for inscriptions, but the orthodox Latin alphabet was soon adopted, with the addition of some letters derived from runes, such as þ (*thorn*, 'th'), ð (*eth*, 'th') and ƿ (*wynn*, 'w'). Some of the differences between Old English and modern English can be seen in the following brief extract from the translation of Bede's *Historia* carried out under the direction of King Alfred, describing how Hengest and Horsa grew impatient with the British king Vortigern:

And þa wæron Seaxan secende intingan and towyrde heora gedales wið Brittas. Cyðdon him openlice and sædon, buton hi him maran andlyfne sealdon, þæt hi woldan him sylfe niman and hergian þær hi hit findan mihton. And sona ða beotunge dædum gefyldon; bærndon and hergedon and slogan fram eastsæ oð westsæ, and him nænig wiðstod.

And then were the Saxons seeking cause and occasion of their separation from the British. They made known openly to them and said that unless they gave them more to live on they would seize and plunder for themselves where they might find it. And soon they fulfilled the threat with deeds; they burned and plundered and slew from the east sea to the west sea, and none withstood them.

The language here is the West Saxon of Alfred's Wessex. The dialects of the Germanic settlers persisted in the parts of the country they settled, as Kentish (the dialect of the Jutes), West Saxon (which soon dominated the other Saxon dialects), and Northumbrian and Mercian (the languages of the two Anglian kingdoms). The little that survives of any but West Saxon survives mostly in charters, runic inscrip-

tions, fragments of verse, and interlinear glosses in Latin gospel books. West Saxon established its dominance during the reign of Alfred as the language of written record throughout the country and maintained it until and beyond the Conquest.

Old English accepted very few borrowings from the indigenous Celtic language, apart from some river-names (Avon, Esk, Usk, Wye), and not a great many from Latin, whether from the Roman inheritance (*weall*, 'wall', *stræt*, 'street') or from later ecclesiastical importation (*biscop*, from Latin *episcopus*). Like modern German, Old English expanded its vocabulary by compounding rather than borrowing, for instance, *tungol-cræftiga*, 'star-crafty one', for 'astronomer'. It was more receptive to borrowings from the more closely related Scandinavian language of those who settled in the north and east of the country from the late ninth century onwards, and many modern words can be recognized as being of Scandinavian derivation, for instance words with *sk-* such as 'sky', 'skin', 'skirt' (cf. 'shirt', from Old English), and some very common words such as 'they', 'them', 'their', and 'are'.

The Beginnings of Old English Poetry: 'Beowulf'

'English poetry' has its roots in the common Germanic inheritance of alliterative poetry: in habits of oral verse-making, hymnic, encomiastic, mnemonic, that lie obscure yet potent behind the extant written remains; and in the alliterative four-stress line which is the common verse-form of early Germanic poetry in Old Saxon, Old High German, and Old Icelandic as well as Old English. The subject-matter of this Germanic inheritance is principally in the legends of the great tribal migrations of the fourth to the sixth centuries, and the heroes of this *Völkerwanderung*—Sigemund, Heremod, Eormenric, Ingeld—as they appear in allusions in the poems of *Beowulf*, *Deor*, and *Widsith* (a poem about a far-travelling *scop*, or poet-singer, which may have embedded in it some ancient fragments of oral verse). These allusions are so cryptic and casual that they argue for the presence of well-known heroic 'lays' behind the extant remains. These lays were short recitations, celebrating the exploits of a hero or some conflict in which heroic values were crucially tested, and they were sung by the *scop* in the mead-hall before the the king and his warriors. The classic allusion is in *Beowulf*, in the lay of Finnesburh sung at the feast in Heorot after Beowulf's victory over Grendel. Such lays represent an idealized version of the practice of a violent warrior society such as existed among the Germanic tribes up to the seventh century. Being oral, they do not survive except in the modified and Christianized form imposed upon them by the written culture—apart perhaps from the *Battle of Finnesburh*, a heroic lay so 'pure' and so detached in its accidentally surviving form from its context that it is impossible to tell what is going except by reference to the Finnesburh episode in *Beowulf*.

Though the existence of a pre-settlement Christian-Latin literacy in Britain is not to be questioned, and is evidenced in the surviving Irish-Latin and Welsh-Latin

traditions (for instance the diatribe of the Welsh monk Gildas in 547 against the British), English literacy, that is, writing in English, must trace its origins to the Augustinian conversion of 597. It is thus essentially a Christian literacy. Other cultures such as Old Irish and Old Icelandic have substantial survivals of pre-Christian vernacular stories and other material, but English does not. English poetry must be said to begin with Caedmon's 'Hymn of Creation': Bede tells us that Caedmon, one of the brothers at Whitby Abbey during the abbacy of Hild (657–80), was so ashamed of his lack of skill in singing to the harp that when it came round to his turn he left the hall and went to see to the cattle, where, at the cattle-byre, he was commanded by an angel to sing of the Creation. His 'Hymn', which Bede translates into Latin, is copied in the Northumbrian dialect into the earliest surviving Latin manuscript (737) of the *Ecclesiastical History*. Whether Bede's story is 'true' or not, it is a wonderfully powerful narrative of origins.

We owe what we know of Old English poetry almost entirely to four codices, compilations made in the late tenth century as a by-product of the revival of learning in the monasteries: they are now in Oxford (Bodleian Library MS Junius XI), London (British Library MS Cotton Vitellius A.xv), Vercelli cathedral library in

BEOWULF, preparing for his last battle, remembers his youth at the court of King Hygelac and the tragic slaying of the king's eldest son by his younger brother. In this late tenth-century manuscript, verse is written as prose to save space. The edges of the page were charred by fire in 1731.

northern Italy, and Exeter cathedral library. The poems that they contain range in date from the eighth to the tenth centuries, and the most famous of them is *Beowulf*. This is the story of the monster- and dragon-slaying exploits of a non-English hero with no traditional Germanic history who is 'invented' in order to represent a Christianized version of heroic values. Beowulf fights to cleanse society of monsters (Grendel is *Godes andsaca*, 'God's enemy'), and is generous, loyal, enduring, and mild-mannered rather than heroically cunning and ruthless, like Achilles, or Grettir, or Cuchulainn. The world of the poem is consciously recognized to be a pagan world, but in its values it is inevitably assimilated to the Christian dispensation (*Godes leoht geceas*, 'he chose God's light', is how the death of a pagan is recounted). Beowulf's heroism in the service of his country and others is contrasted with the family feuding and revenge-seeking of the old Germanic heroes who inhabit the thickly allusive margins of the story. The style is heavily ornamented, and full use is made of the metaphorical compounds or kennings (such as *hron-rad*, 'whale-road', for 'sea', and *woruld-candel* for 'sun') and the syntactical variation that are so characteristic of this highly mannered poetry.

Beowulf was written in the eighth century and is closely associated with the Christian-Latin tradition of learning which grew strong in England after the Augustinian conversion and especially after the educational innovations of Archbishop Theodore of Tarsus and Abbot Hadrian, sent over in 669 to consolidate the Augustinian mission. Aldhelm (d. 709), the greatest scholar of seventh-century England, was educated by Hadrian at Canterbury (not by Welsh scholars, as used to be assumed); he wrote a treatise on virginity for the nuns of Barking, verse sermons, an epistle on metrics for King Aldfrith of Northumbria, and *Ænigmata* (Riddles) on the model of the Irish-Latin tradition. The Irish-Latin tradition had a strong influence also in Northumbria, which saw a great flowering of learning in the early eighth century after the foundation of the monasteries of Wearmouth (674) and Jarrow (685). The most famous surviving product of the Northumbrian renaissance is the Lindisfarne Gospels, with their glosses in the Northumbrian dialect, but the towering presence is Bede, a scholar with a European reputation who wrote verse and prose lives of St Cuthbert, a treatise *De Natura Rerum* (extant in over 100 manuscripts), treatises on grammar and metre, and collections of homilies and books of biblical exegesis as well as the *Ecclesiastical History of the English People*, his masterpiece. Later in the century, Alcuin began his scholarly career at York before being persuaded by Charlemagne to go to France to initiate there a programme of educational reform.

It is within this broad tradition of learning that *Beowulf* is to be placed. There is no sharp distinction in this period between Latin and vernacular Christian culture: Aldhelm is said to have recited vernacular lays, Bede wrote a five-line 'Death-Song' in English alliterative verse, and King Alfred thought his love of 'Saxon poetry' not incompatible with his Christian-Latin learning. The monasteries of the period were

generously receptive to such poetry: less austere than the tenth-century foundations and re-foundations, they admitted laymen, including retired kings, and many monks were not in orders or had no Latin. No doubt there was some compromising of standards: Bede's last work is a letter to Archbishop Egbert of York complaining of the way monasteries have become extensions of the households of the magnates, and Alcuin's letter to the bishop of Lindisfarne in 797 is famous. 'Quid Hinieldus cum Christo?' he asks, complaining of the way monks prefer refectory readings about the heroes of Germanic legend to Gospel stories—and in doing so tells us pretty exactly where *Beowulf* was written and had its first audience.

Religious Poetry

Most of the poetry, however, that satisfied this need for monastic lectionary material was of a more unexceptionably religious character. The bulkiest items are the scriptural poems (versions of parts of Genesis, Exodus and Daniel survive) for the origins of which in secular verse-making Bede provides such a memorable narrative. There are also saints' lives, such as as those of *Guthlac* and *Andreas*; devotional poems, such as the rhapsody on Advent known as *Christ I* and the magnificent *Dream of the Rood*, a fragment of which is inscribed on the Ruthwell Cross in Dumfriesshire as 'spoken by' the Cross; and more generally religious and didactic material, including homilectic and reflective poems, gnomic poems, and riddles, all assiduously collected in the tenth-century codices. Cynewulf is the only poet known by name: he names himself in runes in his four poems, *The Fates of the Apostles*, *Elene*, *Juliana*, and *Christ II*, a poem on the Ascension. He is a kind of monastic journeyman-poet, probably of the early ninth century. His poem on the finding of the Cross by St Helena (*Elene*) was clearly written as lectionary material for the Feast of the Invention of the Holy Cross on 3 May.

The religious poems use the traditional style and vocabulary and the traditional heroic apparatus: Abraham and Moses figure as Germanic chieftains, and the Apostles as a kind of *comitatus* or body of armed retainers. The effect is sometimes a little incongruous, as when Andreas the 'battle-hardened warrior', bristling with heroic epithets, approaches the gates of the city where St Matthew is imprisoned—all to no purpose, since he is invisible anyway and the guards fall dead through the power of the holy spirit without word or blow. But we should not see this as a sign of incompetence or unease: the poets are fulfilling the potential of the heroic style by diverting it from useless fictions to profitable truths, in the tradition of Christian-Latin poets such as Juvencus, Sedulius, and Prudentius. These are not scriptural paraphrases for the unlettered, but learned poetic structures, the authors of which assume a respect for the vernacular which is lost within two centuries and which Milton labours to recover. Sometimes, though, the adaptation of the heroic style is more than a shrewd move: the portrayal of Christ, in *The Dream of the Rood*, as the

geong hæleþ ('young hero') who 'mounted' (*gestah*) the Cross and 'embraced' (*ymbe-clypte*) it willingly is daringly conceived, while the images of exile, loss of lordship, and the empty windswept mead-hall give particular moving power to the reflections on the transience of life in 'elegiac' poems such as *The Wanderer, The Seafarer,* and *The Ruin.*

King Alfred and the Monastic Revival

After about 850 the Danish invasions and the consequent destruction of monasteries and books led to a decline of learning (except perhaps in West Mercia) in which both Latin and vernacular suffered. King Alfred describes in his Preface to the translation of Gregory's *Pastoral Care* the sad state of learning when he came to the throne, and it was he who effectively brought Old English prose into being (only scraps of laws, charters, and glosses survive from the time before) to supply the gap caused by the Viking destruction of Latin culture. Alfred's campaign of recuperation was remarkably well thought out, and he translated or caused to be translated some of the basic works of the Christian-Latin tradition: Bede's *Ecclesiastical History;* the universal history of Orosius, the *Historia adversus Paganos* (431), into which he himself inserted the first-hand report of the voyages of Ohthere and Wulfstan to the White Sea and the Baltic; the *Pastoral Care,* a handbook of instruction for priests; Gregory's *Dialogues,* Augustine's *Soliloquies,* and Boethius's *Consolation of Philosophy,* all of them noble works, to which Alfred made his own thoughtful additions, of faith enduring in time of tribulation. Alfred also perhaps did the prose translation of the Psalms in the *Paris Psalter* and the metrical translation of the Boethius *Metra.* But his greatest work, and the foundation of the greatest achievement of Anglo-Saxon England, was the beginning of the *Anglo-Saxon Chronicle.* Written up from the earliest times to the present as a compilation from Bede, universal histories, brief chronicles in Easter tables, and West Saxon genealogies, and incorporating on one occasion a remarkable early prose survival, the account of *Cynewulf and Cyneheard* (755), the *Chronicle* begins in earnest with accounts of Alfred's own battles against the Danes, and the grand epic narrative, probably written by himself, of the battle of Edington and the peace of Wedmore (878). Copies were distributed to major surviving centres of learning, and the *Chronicle* was kept up to date in a number of them until and beyond the Conquest. There is nothing comparable in any vernacular for at least two centuries after Alfred.

Alfred's defeat of the Danes and stabilizing of the kingdom also brought about the conditions for the monastic revival of the tenth century under Dunstan, Oswald, and Æthelwold. With such strong leaders and with royal support, the newly founded and restored monasteries were able to resist renewed Danish incursions beginning in 980. It was a different monastic culture from that of the eighth century, more concentrated on education and government than on spirituality and learning;

rules abound, such as the codification of monastic practice in the *Regularis Concordia* of 975. The revival gave little encouragement to vernacular poetry: the four codices were copied, but they are a mere offshoot of the revival and were little read or attended to. However, a few poems were composed in the old tradition, and they are amongst the finest: the poem of *The Phoenix*, translated from the Latin of Lactantius, a rapturous celebration of the phoenix as a symbol of resurrection; *Judith*, a version of the Bible story very apt to a time of heathen invasion, with vivid evocation of the contrast between Judith's radiant purity and the drunken orgies and lustful desires of Holofernes and his followers; and the highly dramatic account of the Fall translated from an Old Saxon original and inserted into the old *Genesis* in the Junius manuscript, with its subtle and psychologically charged portrayals of Satan and the temptation of Adam and Eve. There is also *The Battle of Brunanburh*, a paean of triumph inserted into the *Chronicle* to celebrate Athelstan's great victory of 937, and *The Battle of Maldon*, the most famous heroic poem in the English language, recording the minor incident that began the final Danish conquest of England, the annihilation of the Essex levies under Earl Byrhtnoth by a Danish raiding party in 980. It is the classic story of the battle to the death in the narrow place against hopeless odds. The resolute words of the aged retainer Byrhtwold, as he prepares for battle and certain death, are the best known in Old English:

> Hige sceal þe heardra, heorte þe cenre,
> Mod sceal þe mare, þe ure mægen lytlað.

> The mind must be more resolute, courage keener, spirit greater, as our strength grows less.

Late Old English Prose

But the greatest energies of the revival went into prose, much of it in the vernacular, where Ælfric and Wulfstan forged a powerful instrument of instruction, persuasion, and exhortation. While the poetic codices mouldered unread, Ælfric was copied, recopied, glossed, and annotated until the early thirteenth century. Ælfric, who became abbot of Eynsham, near Oxford, in 1005, wrote two large cycles of sermons, a series of lives of the saints, and translations of much of the Old Testament. He writes a plain, fluent prose that can rise to a more rhythmical semi-alliterative prose at climaxes in a narrative or in the exposition of high points of doctrine. He also wrote a *Colloquy*, designed for use in teaching Latin to the boys in monastic schools. Wulfstan (d. 1023), archbishop of York, writes a more emphatic, rhetorical prose, with heavy two-stress phrasing, particularly in the famous *Sermo Lupi ad Anglos* (1014), denouncing the weakness and corruption of the English as they succumbed to the Danes. He wrote other homilies, and also the remarkable *Institutes of Polity*, a statement of the rights and responsibilities of the different classes of the national community.

There are other prose writings too that can be seen as the product of the monas-

OPENING OF ÆLFRIC'S COLLOQUY, a dialogue (early eleventh century, probably from Canterbury) for teaching Latin to the boys of a monastic school. It begins: Þe cildra biddaþ þe, eala lareop, þæt þu tæce us sprecan / We children ask thee, O master, that thou teach us to speak.

tic revival, such as the astronomical manual of Byrhtferth of Ramsey, as well as unexpected survivals such as the prose 'romance' of *Apollonius of Tyre*. The character of the prose of the revival tradition needs to be clearly understood. Where the eighth-century scholars and religious poets wrote from within a rich mixed Christian-Latin and Germanic tradition, Ælfric works with Latin biblical exegesis, commentary, and homily in order to 'reach down' to his vernacular audience. He writes for laymen and unlearned clerics, providing a systematic course of instruction in the teachings of the Church. He is not writing for equals, for other monks, but for an audience in need of instruction. This late vernacular prose inaugurates a long period of over three centuries in which English prose, and verse as well, is principally used for didactic purposes. Where Bede's Latin scientific treatises are part of the intellectual history of Europe, Aelfric's *De Temporibus Anni* is a simplified digest for students, and Byrhtferth's *Manual* is an astronomical primer for 'uplendiscum preostum and iunge mynstermen'.

The Effects of the Norman Conquest: Latin and Anglo-Norman to 1200

Though it never replaced Latin as the language of higher learning, Old English came to be used, in the West Saxon written language or *Schriftsprache*, for a wide range of purposes in the late Anglo-Saxon period, in law, church, education and

administration as well as in historical and literary texts. With the Norman Conquest, and the imposition upon England of a transplanted Norman governing class, speaking a Norman-French dialect, English was relegated to a lower status as the language of a conquered people, and Latin resumed its customary European role as the language of learning and education and of all the functions that had been so exceptionally usurped by late Old English prose. English was never systematically suppressed, and it retained, particularly in the west, where Norman influence was less pervasive, the capacities of a prestige vernacular, but it becomes marginal. Writing in English during the next two centuries was a series of fragmented responses to European influences in a language thrown open to the winds of change. England was now, in the Anglo-Norman kingdom, politically part of Europe in a way that it had not been since Roman times; it was culturally also part of Europe—and not a very important part—and remained so even after the loss of Normandy in 1204.

The change-over to Latin can be clearly seen in three areas where Old English had established dominance: in the writing of history, in the framing of laws, and in the discourse of political institutions. The *Anglo-Saxon Chronicle* was kept up for a few years in a few monastic centres, and at Peterborough until 1154, but all the important work was in Latin, and the twelfth century was the golden age of Anglo-Latin historiography. The histories that were written by these mainly monastic compilers were histories of England, its kings, and its Church, done from a national standpoint under royal and aristocratic patronage. Early twelfth-century compilers such as Simeon of Durham and 'Florence' of Worcester gave way to historians such as Eadmer of Canterbury and Ordericus Vitalis (an English monk living in Normandy), who wrote with particular freshness of their own times, the former down to 1122, the latter to 1141. The great history of the kings of England by William of Malmesbury goes down to 1142, and the *History of the English* by Henry of Huntingdon to 1154; William of Newburgh carries on until 1198. William's reputation as an

CHARTER WITH GREAT SEAL, *c.*1070. Supposed Latin charter of William the Conquerer, forged in the twelfth century, when beneficiaries of earlier grants made verbally found it necessary to have written evidence. After the Conquest, Old English was supplanted by Latin as the language of formal documentation.

objective historian was much enhanced in his own view by his scathing denunciation of Geoffrey of Monmouth, whose *Historia Regum Britanniae* was completed in 1138. Largely the product of his own fertile invention, Geoffrey's *Historia* traces the kings of Britain in their descent from the Trojan Brutus and develops Arthur, from hints and traces in earlier history and legend, into the great national hero of the British resistance to the Saxons. He launched the Arthurian legend on its irresistible career, and his *Historia*, for all that it is not history, is one of the key documents of the middle ages.

In law and politics, as in history, Latin took over from Old English, most dramatically in the use of Latin for the exhaustive survey of English landholdings made for the new kings in 1086 in Domesday Book ('the book of the day of assessments'). In the stricter world of law, Ranulph de Glanville's late twelfth-century treatise on the laws and customs of England was followed up by the definitive codification of Henry of Bracton in the middle of the following century. In the field of political writing, John of Salisbury might be taken as the representative of twelfth-century Anglo-Latin institutional culture to set against Wulfstan in the eleventh. A scholar of Paris and Chartres, a member of the household of Thomas Becket, whose murder in 1170 he witnessed and whose life he afterwards wrote, and later bishop of Chartres (1176–80), he is the model of the 'Europeanness' of the new breed of English-born scholar. His work on Aristotelian logic, the *Metalogicon*, and his compilation of political wisdom, the *Policraticus*, are touched by the humanism and intellectual urbanity of the schools of the twelfth-century 'Renaissance'.

Latin is also one of the languages of the court culture of Henry II and his queen, Eleanor of Aquitaine, in the brilliant flourishing of the Angevin empire after the disturbances of the reign of Stephen (d. 1154). Walter Map (fl. 1181–92) is the court writer *par excellence*, purveyor of scandalous stories, satirical poems, sophisticated trifles; his best-known work is an anecdotal compilation, *De Nugis Curialium* ('Courtiers' Trifles'). Nigel Wireker's main work is a witty Latin verse satire on monks, the *Speculum Stultorum* (*c.*1190), recounting the adventures of the ass Burnellus ('Brownie'). Giraldus Cambrensis, like the others a clerical official, had more earnest moments of ambition as a churchman, and a stormy life, but his best-remembered works are compilations of reminiscences, with a strong personal touch, of his official journeys to Ireland (*Topographia Hibernica*) and Wales (*Itinerarium Cambriae*). Peter of Blois (d. 1212) was also in the service of Henry II, and left a carefully edited series of *Letters* as his bid for literary fame. Less closely connected with the court, but equally evidence of the flourishing of Latin literature, are writers like Joseph of Exeter, author of a Latin epic of Troy (*c.*1210), Alexander Neckam, author of a not too serious book on natural history (*De Naturis Rerum*), and two writers on the art of writing poetry, Geoffrey of Vinsauf and John of Garland. All of them had close connections with France or were educated there or settled there in later life.

But Anglo-Norman vied with Latin as the language of court culture, especially in

those aspects of court culture such as love-poetry and romance where women had an influence as patrons and audience, and soon established its pre-eminence. As a language, it was the cradle-tongue of the governing class, and in the twelfth and thirteenth centuries it was the prestige vernacular in England. It penetrated deep into the middle and even lower layers of English society, and no one with any pretensions to education or literary esteem would be without it. There would be much English spoken, of course, much bilingualism and peaceful coexistence, and variations of linguistic practice within the everyday life of one person and in different rooms of the same household. But it is an irony that Anglo-Norman entered on its flowering, in the thirteenth century, just as its roots were severed, with the loss of Normandy in 1204. Signs of the decay of Anglo-Norman as a genuine vernacular begin in the late thirteenth century, with the appearance of grammars and glossaries, indicating that it is now a polite acquisition rather than a natural possession, while the shift in the relative status of English and Anglo-Norman is marked by protests at the unnatural state of a land which does not acknowledge its own language. As the author of *Arthour and Merlin* (*c*.1290) says, announcing his determination to write in English:

> Riȝt is þatt Inglische understond,
> þat was born in Inglond;
> Freynsche use þis gentilman
> Ac everich Inglische Inglische can.

The tenacity of Anglo-Norman should not be underestimated, but its days were numbered.

But in the Angevin courts of the twelfth century Anglo-Norman enjoyed a spectacular pre-eminence in poetry. The Jerseyman Wace dedicated his translation of Geoffrey's *Historia*, the *Roman de Brut*, to Eleanor of Aquitaine in 1155, while Geoffrei Gaimar did a more serious *Estoire des Engleis* (*c*.1150) and Jordan Fantosme a vivid history (*c*.1175) of Henry II's wars against the Scots. Also associated with the court of Henry II and Eleanor are the highly sophisticated romances of *Tristan* by Thomas (fragmentary) and Beroul, the romance of *Horn* by another Thomas, the exotic romances of Hue de Rotelande (*Ipomedon*, *Protheselaus*), and the *lais* of Marie de France, whose life, as her name suggests, was mostly spent in England. Anglo-Norman was also the language of the *Jeu d'Adam* or *Mystere d'Adam* (*c*.1140), a dramatization of the story of the Fall full of psychological insight; and the oldest and only authentic text of the best-known of all Old French poems, the *Chanson de Roland*, was copied in England in the twelfth century by an Anglo-Norman scribe.

The Effects of the Norman Conquest on the English Language

The natural processes of change in the spoken language were concealed during the last two centuries of the Anglo-Saxon period by the existence of a standard written

language. When English lost its status, after the Conquest, as a major language of writing and record, the spoken language resumed its more traditional role as the determinant of what was written, and the changes that had been taking place over two centuries, as well as the changes currently taking place, were released fully into the written forms of English. This is why Middle English, though it does not come into existence suddenly, is so markedly different in appearance from Old English, why Middle English seems so 'English' and Old English so 'foreign'.

Many of the most obvious changes have to do with spelling and the written appearance of the language. Sound-differences long concealed in standard West Saxon spelling, such as the different pronunciations conventionally represented by the letter *c*, are now distinguished by scribes less or not at all conversant with traditional spelling practice: before certain front vowels, *c* is replaced by *k*, a new letter from Anglo-Norman (*cene* becomes *kene*), while the palatalized form of *c* [ch] before other front vowels is now spelt *ch* (*cyrice* becomes *chirche*), just as *sc* [sh] in similar positions becomes *sh* (*sceal* becomes *shal*). Certain voicings of consonants in medial positions, long unrepresented in standard West Saxon, are now recorded in spelling (*lufian* becomes *luvien*), and there are significant changes also in the representation of vowels. The letter *æ* (*aesc*) disappears completely and is replaced by *a*, for the short vowel, or *e/ea*, for the long vowel. The sound represented by Old English *y* (something like the *u* in modern French *tu*) had long developed in different directions in different dialects, and was now distributed among these different sounds as *e*, *u* or *i* (*synn* becomes *senne* in Kentish, *sunne* in the west and south, and *sinne* in the north and east). The letter *y*, thus released, is used as an alternative for *i*, especially in ambiguous minim sequences. Other changes are more purely graphic, though they affect the appearance of the language considerably. The letter-form ᵖ (*wynn*) is soon lost and replaced by the Anglo-Norman double *u*; the letter-form ȝ (*yogh*) survives in fossilized spellings like ȝe, but the variety of sounds it represented in Old English are more and more spelt as *h*, *gh*, *w* or *y*; the letter-form ð (*eth*) is soon replaced by *th*, the spelling also used for þ (*thorn*), which, however, survives pretty strongly, and in fossilized forms and abbreviations such as þe and þt well into the fifteenth century.

Of more fundamental importance are the changes in grammar and syntax that make the structure of Middle English so different from that of Old English (a 'synthetic' language) and so much more like that of modern English (an 'analytic' language). The significant change is the reduction in the number of inflections, already well advanced even in written late Old English, and the levelling of the few that are left to *-e*, *-es*, and *-en*. Adjectives gradually cease to be declined at all, as does the definite article (with consequent loss of grammatical gender); nearly all nouns fall into one simple declension; and more and more Old English strong verbs are conjugated weak (e.g. *burn*, *walk*, *weep*). As a result of the erosion of inflexional endings, the forms of words alone can no longer be relied upon to convey the

relationship of the parts of a sentence, as they could in Old English (or Latin); word-order becomes overwhelmingly important as the way of indicating the relationship of subject, verb, and object or the concord of adjectives and nouns; and other syntactical relationships are increasingly conveyed by noun-phrases, with a corresponding increase in the number of 'little words' such as prepositions and articles. Meaning is 'shaken out' into the characteristic loose-limbed but dynamic structures that make English such a powerfully adaptive language.

Loan-words now start to flow into the newly receptive structures of the old language, with the 'slotting-in' of the new words additionally facilitated by the simpler inflectional system to which they have to adapt. There is a drastic reduction in the Old English word-stock (though words of Old English derivation continue, and continue still, to account for a majority of the total *volume* of words used), and a massive influx of thousands of words from French. Some are the kinds of words that one would expect to be borrowed by a subject race (*baron, noble, servant, royal, reign*); others are so basic that they seem always to have been part of the language (*cry, fool, ruin, calm, cruel, safe*) and argue for the close intermingling of the two linguistic communities. Often the new loan-word lies side by side with a native synonym, creating those richly connotative pairings (*hearty, cordial*) so widely admired as a special property of English. Sometimes a word will be borrowed from Norman-French and then reborrowed at a later date, in a different form, from Parisian French, so creating other interesting pairings (*catell/chattel, warden/guardian*). Meanwhile, borrowings from Latin are at first quite small in number but increase to a torrent in the fourteenth and fifteenth centuries as English takes over more and more of the functions, in science and learning, traditionally reserved for Latin.

The Norman Conquest also had an impact on dialect. The fossilized West Saxon *Schriftsprache* had concealed much dialectal divergence, but now, with no written standard to act as a preservative of received forms, the dialects flew apart. Between the five principal dialects of Middle English—Kentish, Southern, East Midland, West Midland, and Northern—there are many differences in pronunciation, in grammatical inflexion, and in vocabulary, and even in the late fourteenth century Chaucer complains feelingly of the 'gret diversite | In Englissh, and in writyng of oure tonge' (*Troilus and Criseyde*, v. 1793–4). The long supremacy of Anglo-Norman had much to do with the fact that it was a *lingua franca* and was understood, by those who understood it, throughout the realm.

The Post-Conquest Legacy of Old English Verse and Prose

The breakdown of the 'classical' form of Old English poetry—whether it is truly a 'breakdown' or simply a reassertion of the simpler popular two-stress structure upon which the classical style had been hung like a brocade—is evidenced in poems

inserted, usually on the death of kings, in the *Chronicle* during the eleventh century. After the Conquest, there are remnants and transitional forms which show a loosening of the patterns of stress, more irregular alliteration, occasional rhyme or assonance, and a total change in the shape of the line, which now appears regularly end-stopped, where the classical form used the alliterating half-line in free enjambement. The line, like the language, is 'shaken out' into looser, strongly end-stopped structures. Two fragments of verse, copied into a Worcester manuscript of Ælfric's *Grammar* (the *Worcester Fragments*), one a lament on the decline of Anglo-Saxon learning with the advent of foreign teachers, show the nature of the changes that are taking place. We should think from now on of alliterative verse as a kind of rhythmical bank on which poets can draw in different ways, as in *The Proverbs of Alfred* (c.1180), a compilation of moralistic sayings suggesting the interests of a monastic or clerical schoolmaster, or the *Bestiary*, where native, Latin, and French metrical forms are all used. In the thirteenth century, as we shall see, alliterative verse, in both regular and loosened forms, offered itself to Laȝamon as one of a number of metrical alternatives for his great poem of the *Brut*, and regular alliterative verse has a grand reflourishing after 1350.

Old English prose continued to be kept up in a few monasteries until the early twelfth century, and the Peterborough copy of the *Chronicle* has a very late entry dated 1154, though the language is now much changed. Ælfric's sermons continued to be copied and imitated well into the twelfth century, and Old English prose was still being read and glossed in the Benedictine abbey at Worcester in the early thirteenth century. The rhythmical semi-alliterative prose of Ælfric (not always sharply distinct from verse) had a particular influence in the area to the south and west of Worcester, an area which was traditionally resistant to the incursion of new traditions. A group of lives of virgin-martyrs (*St Juliana*, *St Katherine*, *St Margaret*), a treatise on virginity (*Hali Meidenhad*), and an allegory of the guarding of the soul (*Sawles Warde*) were written for women religious in the area in the second quarter of the thirteenth century. With the *Ancrene Wisse* ('Guide for Anchoresses'), as accomplished and sophisticated a piece of prose, in a plainer style, as any from the English middle ages, they form a group called the 'Katherine Group' and are written in a highly developed literary language which has its ancestry in the West Mercian dialect of Old English but no progeny. The saints' lives are written in an elaborately wrought form of rhythmical alliterative prose, and are loosely connected with another group of rhapsodic prose lyrics on the Passion, written for women and exploiting some of the erotic intensity of the new language of affective devotion. This kind of rhythmical prose, which was more capable of accommodating linguistic change than the stricter structures of verse, had its development in the fourteenth century in prose works of mystical devotion like *A Talking of the Love of God*, while the more restrained prose of the *Ancrene Wisse*, through repeated copying, became part of the central tradition of English religious prose.

The Thirteenth Century: A Trilingual Culture?

Poems such as the late twelfth-century *Proverbs of Alfred* and *Bestiary* have their Anglo-Norman equivalents in works by Sanson de Nanteuil and Philippe de Thaon (it is significant that we know the names of the Anglo-Norman but not the English poets), as does the harshly didactic *Poema Morale*, in the *Romaunz de Temtacioun de Secle* of Guischard de Beaulieu. All are or are likely to be the work of monks or other religious in small houses. Even in the predominantly Latin and Anglo-Norman households of the twelfth-century bishops, English had a foothold, and the witty poem of *The Owl and the Nightingale*, in which the relative merits of taking life seriously and enjoying it are debated with a charming lack of intensity, concedes nothing in sophistication to the closely parallel Anglo-Norman poem of *Le Petit Plet* of Chardri nor to the clever debates of the Latin schools and Walter Map. There was perhaps a time in the late twelfth century when the two languages were in precarious equilibrium, before Anglo-Norman began a century in which its dominance was periodically reinforced by events such as the arrival in 1236 of Eleanor of Provence as Henry III's queen, with a large French train.

There are of course regional factors that help to maintain English in an equal or challenging position as a literary language. In the west, particularly the south-west midlands, English always retained a high prestige, and the writings of the 'Katherine Group' are superior to anything in Anglo-Norman and fully conversant with doctrinal and devotional writing in Latin. The English version of Wace's French redaction of Geoffrey of Monmouth's *Historia*, written in the second quarter of the thirteenth century by a Worcestershire priest called Laȝamon, is one of the great English poems and perhaps the only one, in its celebration of the battles and conquests of Arthur, with a claim to be a true national epic. Laȝamon is more heroic and martial than Wace, less courtly, but this is a conscious choice, not a mark of a less sophisticated culture; Laȝamon is familiar with the techniques of both French and Latin poetry. The realities of his position, as an English poet, are perhaps best conveyed in the fact that there are nearly 200 manuscripts of Geoffrey, twenty-six of Wace, but only two of Laȝamon's *Brut*. Later in the century, the *Chronicle* of Robert of Gloucester (*c*.1280) is another example of the vigour of English in the western abbeys as distinct from those in the rest of the country, where Latin or Anglo-Norman would be the normal language for serious historical writing.

The coming of the friars to England (the Dominicans arrived in 1221, the Franciscans in 1224) led to a kind of pragmatic trilingualism. The friars were particularly

THE ANNUNCIATION to the Virgin Mary from the Bedford Psalter and Hours. Made after 1414, it is associated with a German illuminator working in London: characteristic are the soft figure style, the fleshy leaves, and the recession of the *prie-dieu*. The Catesby arms at the foot of the page are a later addition.

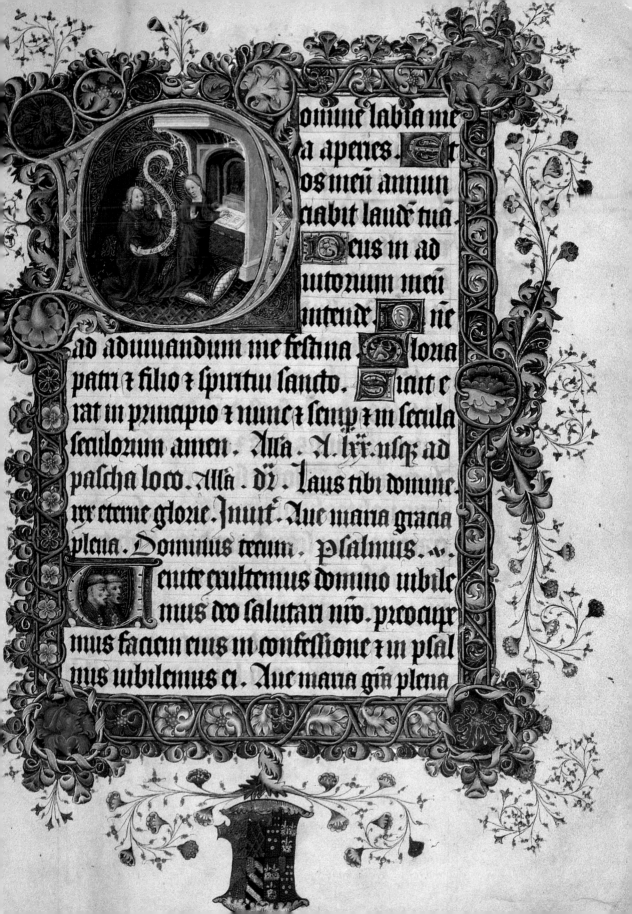

omine labia me
a aperies. Et
os meū annun
ciabit laudē tuā.
Deus in ad
iutorium meū
intende. Dīe
ad adiuuandum me festina. Gloria
patri ⁊ filio ⁊ spiritu sancto. Sicut e
rat in principio ⁊ nunc ⁊ semp ⁊ in secula
seculorum amen. Alła. A. lxx. usq̃ ad
pascha loco. Alła. dr. laus tibi dnīne.
rex eterne glorie. Inuit. Aue maria gracia
plena. Dominus tecum. Psalmus. v.
Venite exultemus domino iubile
mus deo salutari nīo. preocupe
mus faciem eius in confessione ⁊ in psal
mis iubilemus ei. Aue maria gīa plena

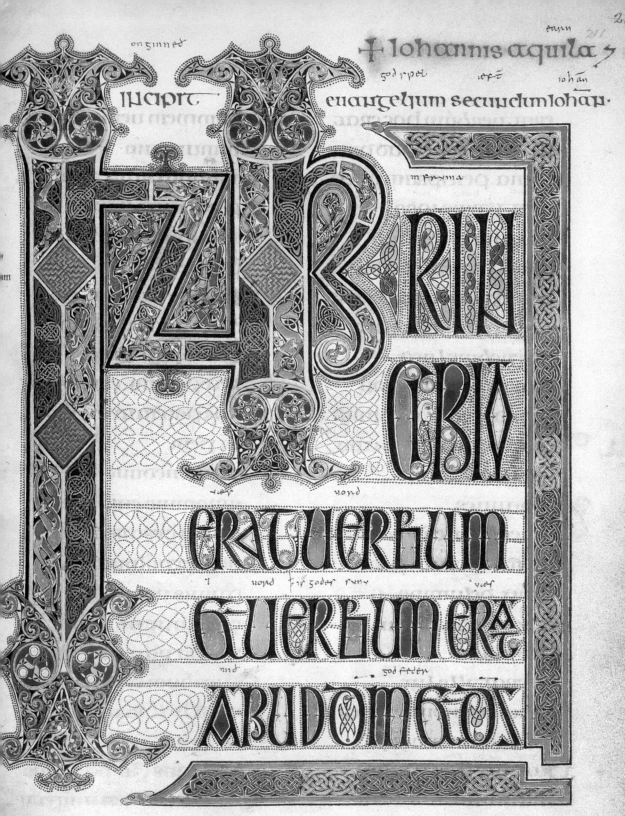

active as preachers and popularizers and they gathered material for these purposes—poems, songs, stories, as well as homiletic pieces—in all three languages, Latin, Anglo-Norman, and English, according to their prospective audience. Some of their compilations survive (for instance, Cambridge, Trinity College MS B.14.39; London, British Library MS Cotton Caligula A.ix; Oxford, Jesus College MS 29) and they are rich repositories of verse sermons, exempla, and treatises in verse and prose, and songs and hymns to Christ and the Virgin. The *Luve-Ron* of Thomas of Hales (who wrote also in Latin and Anglo-Norman) is a characteristic Franciscan production, a 'love-song' written for an aristocratic lady which concludes, after a meditation on the transience of life, that Christ is the only *soth leofmon* ('true lover'). In equipping themselves for the popular pulpit and other less formal roles as spiritual guides, the friars also swept up other material of a less specifically edifying nature, and their miscellanies provide the only evidence of thirteenth-century writing in English in a number of secular fields—beast-fable (*The Fox and the Wolf*), farce (*Dame Sirith*), 'ballad' (*Judas*), and satirical burlesque (*The Land of Cokaygne*). The accidents of survival have evidently deprived us of much quite sophisticated writing in English; Latin and Anglo-Norman, with their social and cultural advantages, had access to more secure channels of transmission.

In other areas, too, one can see the workings of this pragmatic trilingualism and bilingualism. The *Speculum Religiosorum* of St Edmund of Abingdon is adapted for non-monastic and non-clerical audiences in both vernaculars. The Anglo-Norman verse sermons in the *Miroir* of Robert of Greetham are adapted into English without much change, and the allegorical poem of the *Chasteau d'Amour* by Robert Grosseteste, bishop of Lincoln, is similarly adapted, though with some loss of polish. The easy intercourse between the three languages is nicely illustrated in the circumstances of survival of the famous little song of 'Sumer is i-cumen in', which appears uniquely in a collection of musical pieces, with texts in Latin and Anglo-Norman, deriving from Reading Abbey.

The relationship between the three languages is more formally demonstrated in the issue of the *Proclamation* of Henry III in 1258, a written confirmation of the agreement reached at Oxford between the king and his barons which was sent out to the sheriffs of all counties in England in both English and French, as well as being enrolled in Latin. The strange spelling of the English version shows the unfamiliarity of the government scribes with any written form of the language, which they were evidently instructed to employ for political reasons (there were many com-

THE LINDISFARNE GOSPELS, an illuminated manuscript of the early eighth century, with a ninth-century Anglo-Saxon translation (some of the earliest surviving written English) written word by word between the lines of the Latin. Depicted is the opening to St John's gospel: In principio erat verbum & verbum erat apud de*um*/in fruma wes word & word *et* is godes sunu wers mid god feder (note the helpful gloss).

plaints about the 'Frenchification' of Henry's court). The significance attached to
the written record is also worth stressing here. There had been a time when agree-
ments were reached between men and held to on the basis of the given word of the
participants; now, in the twelfth and thirteenth centuries, with the increase in the
number of university-trained clerks and non-monastic professional scribes, there
was an enormously greater emphasis on written documents. *Magna Carta* (1215) is a
famous example, in its demonstration of the determination of the barons to have a
written record of the charter of rights they had extracted from King John; at the
other end of the social scale, the rebels of Essex and Kent, at the time of the Peas-
ants' Revolt (1381), circulated the subversive *Letters of John Ball* in the form of letters
patent as if to mark their mastery of the written culture of their oppressors.

A history of England is bound to give prominence to writing in English, but the
real weight of the culture in the thirteenth century lies elsewhere, and it would be
wrong to ignore the hegemony of Latin and Anglo-Norman in certain areas of dis-
course. Latin dominated the writing of history, where Matthew Paris, monk of St
Albans (d. 1259), surpassed his great twelfth-century monastic predecessors, main-
tained a network of European correspondents, and was invited as an honoured guest
to court in 1247, even though he was a severe critic of Henry III's policies. Latin also
dominated the world of learning, where England and the Continent formed a
single scholarly community. Many English scholars, from Alexander of Hales
(d. 1254) to John Duns Scotus (d. 1308), spent much of their career in Paris, but
Robert Grosseteste (d. 1253) taught at the Franciscan school in Oxford and helped
to make it a European centre of excellence. He wrote commentaries on Aristotle,
treatises on science, and promoted the study of Greek, while his famous pupil Roger
Bacon (d. 1294) was the foremost non-theological scholar of his day. Even at court,
Latin retained some of its twelfth-century esteem as the language of satirical and

occasional poetry, as in the writing of Henry of Avranches and Michael of Cornwall at the court of Henry III.

Anglo-Norman, however, was inevitably bound to prevail over Latin in the thoroughly Frenchified royal court and in aristocratic households throughout the country. Matthew Paris did an Anglo-Norman translation of the Latin life of *Seint Aedward le Rei* by the Cistercian monk Ailred of Rievaulx for Henry III's queen, Eleanor of Provence, and for the same patroness the Latin poet John of Hoveden wrote an Anglo-Norman devotional poem of the nightingale, *Rossignos*. The lives of contemporary heroes such as William Marshal (d. 1219) and William Longespee (d. 1226) were celebrated in almost-contemporary romanticized epics, and up and down the country the Anglo-Norman aristocracy set poets to work fabricating romances of their ancestry, such as *Gui de Warewic* and *Fouke Fitzwarine*. The great stories of antiquity are rendered into Anglo-Norman verse, as in the *Roman de Toute Chevalerie* of Thomas of Kent, recounting the adventures of Alexander. Anglo-Norman literature, didactic, devotional, educational, and recreational, dominates the century.

Literature in English lags behind, excluded completely from most of these areas of royal and aristocratic patronage, though sharing with Anglo-Norman the simpler practical purposes of instruction to the laity and uneducated clergy, especially after the Lateran council decree of 1216 that made annual confession obligatory and stimulated the production of works telling people how and what to confess. The poem called *Handlyng Synne*, translated by the Lincolnshire canon Robert Mannyng (1303) from the Anglo-Norman *Manuel des Pechiez* (c.1260), is an example of such a manual of confession, much enlivened with exemplary stories. Mannyng was later (1338) the author of an English version of the Anglo-Norman *Chronicle* of Peter of Langtoft. The turn of the century saw the first growth of the vast *South English*

THE WESTMINSTER PROCLAMATION of Henry III, 1258, in Latin, French, and English begins: Henri purȝ godes fultume [help] king on Engleneloande. A copy of the proclamation was sent to each county. The use of English, in addition to Latin and French, is unusual for an official document of the period, and was a sop to the 'nationalist' reaction to the Frenchification of Henry's court.

THE AUCHINLECK MANUSCRIPT *c.*1330–40, is a major early anthology of Middle English secular and religious verse. This folio shows a change of script (but not of scribe) at line 7307, as the romance of *Guy of Warwick* switches from couplet to tail-rhyme stanza.

Legendary, a proliferating collection of verse saints' lives for vernacular pulpit use, and the extensive verse compendium of biblical narrative and doctrinal instruction known as the *Cursor Mundi*, the first major work in English to come from the north since the Conquest. The last years of the century also saw the beginnings of the writing of romance in English on a level of sophistication not noticeably lower than that of some of the Anglo-Norman romances and for an audience of provincial gentry or urban burgesses probably not much different in character or rank. *King Horn* and *Havelok* are particularly fine examples of adaptation from Anglo-Norman; *Guy of Warwick* is a respectable version of a famous Anglo-Norman 'ancestral romance'.

The Triumph of English

After this century during which it was overshadowed by Anglo-Norman, English gradually assumed, during the course of the fourteenth century, its perhaps inevitable role as the principal and then the sole literary language of the English people. Latin of course long retained its monopoly as the language of monastic history, as in the vast *Polychronicon* of Ranulph Higden, monk of Chester (d. 1364), and as the language of learning and theology. The writings of the most famous of the 'modern' theologians, William of Ockham (d. 1349), are in Latin, as are those of his most resolute opponent, Thomas Bradwardine, archbishop of Canterbury (d. 1349). The work of the classicizing friars, such as Nicholas Trivet (d. 1334?) and Robert Holcot (d. 1349), with their keen and mildly 'humanist' interest in classical writings and mythology, is all in Latin, and the *Philobiblon* (1345) of Richard of Bury, bishop of Durham, is concerned only with his love of books in Latin. Anglo-Norman, meanwhile, was rapidly losing its character as a spoken vernacular and more slowly losing its hold on the centres of royal and aristocratic patronage. It continued to be used in official and legal documents well into the fifteenth century, but Gower's *Mirour de l'Omme* (*c*.1375) represents the last gasp of literary Anglo-Norman. It is noteworthy that Gower tried to write a version of Continental French rather than the Anglo-Norman which was increasingly sneered at (as in the description of Chaucer's Prioress) for its provincialism.

The shift in status of English in relation to Anglo-Norman is well illustrated in two important literary manuscripts, both of about 1330–40. British Library MS Harley 2253 is a compilation of English and Anglo-Norman poems, amatory, religious, and satirical/political, made for a Shropshire landed family. It is probably the most important single manuscript of English poetry: most of the religious poems occur elsewhere, but none of the secular poems, and the manuscript thus provides most of our knowledge of secular and love-lyric before Chaucer. The tone is often witty, sophisticated, and ironic and many poems are written in elaborate and difficult stanzas with heavy ornamental alliteration. The manuscript is a witness to the tenacity of an élite English literary culture, equal or superior to Anglo-Norman, in

he was so rauisschit · of þat siȝt
Almost for ioye · he swownede riȝht ·
he fel doun flat · bifore hire feet ·
þe teres of his eȝen · he doun leet ·
he gretteu hire · Wiþ þat mylde steuene
And seyde ladi · O Queen of heuene
Moodir of Ihū · my lady marie ·
for my moodir · weyl I crie ·
O Wey heo seide · I nam not heo ·
Weltou þou wenest · þat I beo

Bote coy ly þe · as you seest me her
I am þe moodir · þat þe beey
Biforen I seyde · you wistest wel
Faylyng · as a fend of hel
I am non such · as you seest her
Ihū help · and weytu · of þi preyer
Ffrom derkenesse · I dresset · to blisse cleer
þe tyme beo blesset · þat I þe beer
And for þe kuyndenesse · of þi deede
Souereyn ioye · schal beo þy meede

And alle þat leiȝey · þeos masses ys do ·
schul saue hem self · and soules also
þer fore Bone · þis storie you preche
an day some · god ȝ · ȝe be teche
Whon heo hedde endet · þis wordes swete
Angeles token hire · hom to heuene
þe same hom to god · vs sende
Do wone wiþ him · wiþ outen ende · Am̄

vij Peticões			vij Dona sps scī			vij Cirtutes	contra	vij Uicia
Pater noster qui es in celis sctificetr · n̄ · f ·			Timor dm̄			Humilite		Superbia
þis pet·	fadur þou ne þi nom̄ be halut	leduy a man to	Drede of god	leduy a man to		Mekenes se and lou nesse ·	Is a ȝeˀt	Pride & stolunesse
Adueniat regnū nm̄ ·			Pietas			Caritas		Inuidia
þis pet·	let þi kyngdū vn te come vn to mo us	leduy a man to	Pite of his riȝt uoze ·	leduy a man to		Ioue & charite ·	Is a ȝeˀt	Enuie
Fiat uolūtas tua sicut in celo · & in terra ·			Sciencia			Pax		Ira
þis pet·	let wille be do i erþe as it is in heuene	leduy a man to	Knowliȝ & witt þat he be nouȝt a fool	leduy a man to		Pees & reste I herte ·	Is a ȝeˀt	Wretthe & angur
Panem nm̄ cotidianū da nobis hodie ·			Fortitudo			Letitia spual		Accidia ·
þis pet·	leid on re riche þynges bred heue us to day	leduy a man to	Strengþe a ȝenst his goostli enemies	leduy a man to		Murthe & lykinge I godus seruise ·	Is a ȝeˀt	Slouthe & heuinesse i godus seruise
& dimitte nobis debita nr̄a sicut nos · d · d ·			Consiliū			Paupertas sps		Auaricia
þis pet·	leid for ȝeue us our re dette of siñ ne al we for ȝeue oñs · amē	leduy a man to	Counseil a ȝenst giles of þe world	leduy a man to		Pouerte of soule þ it re dispise þat wichedric of þis	Is a ȝeˀt	Couetise
& ne nos in ducas in temptacionē ·			Intellectus			Mensura & sobert ·		Gula
þis pet·	leid suf fre us nouȝt to falle i to chaūge te in mañ	leduy a man to	Vndur stondiȝ þat is good & nouȝt is euyl	leduy a man to		Mesure i mete and soburnelle I drinke	Is a ȝeˀt	Glotonie
Set libera nos a malo Amen ·			Sapiencia			Castitas		Luxuria
þis pet·	lord þ deliuere us from vnkyndnelte	leduy a man to	Sauour & likiȝ i his god	leduy a man to		Chastite & clannel se ·	Is a ȝeˀt	Lecherie

Et quoniā uirtutes ab dona piona ad uirtutes & uirtutes sunt contra uicia

Annota god · in trinite
In þre only · as þ persones þre
Fadir · and sone · and holy gost ·
þat as þo god · as þe sone most ·
spede us non · at þis bigynnyng ·
And graunt vs alle · good endyng ·
And ȝif my grace · such Wordus to sey
þat may beo most · god to pay ·
And to him louyng · and Worschipe ·
And to þi fad · schome and chenschupe
And to ȝou · þat me heres also
hele of soule · to alle ȝo ·

þat is neode · of good counsayl
And meede to me · for my trauayl
Preyer alle non pay charite ·
specialich · þat hit so be
And ȝou to riche mon · Wiþ good Wille ·
Bidde a pater noster · stille ·
Gode men and Wimmen · I ou pray
take ȝe good kepe · to þat I say ·
take no ȝelþaȝ · to my dedes ·
Al ȝif I beo sinful · þat ȝat bes
No to my persone · ne to my bodi
þauȝ I beo feble · and vnworþi

For þauȝ I beo · of vuel maneres
þe Wordus I ȝede · aȝe neuer þe Wers
ffor alle goode Wordus · men schulde preise
And nouȝt lakke · ne saue · þat hem seis
þer fore · take no ȝelþaȝ to me
Wheþer I am good · or vuel to se
Bote to my Wordus · only take kepe
And While I speke · kepe you from slepe
And on alle · þat here me riȝt
þe Benisun of god · mote a liȝt
Warne ȝou furst at þe bigynnyng
I Wol make · no veyn carpyng ·

the west country. The other key manuscript is the Auchinleck MS (Edinburgh, National Library of Scotland, Advocates' MS 19.2.1), made in London for a non-aristocratic but not uneducated customer and demonstrating the firm hold that English had taken on the middle ground of literary culture in the very heart of the metropolis. Virtually all the contents are poems in English: many of them are pious and didactic, but the significant bulk of the manuscript is devoted to romances, English versions of French and Anglo-Norman romances of love and chivalry, many of them translated *ad hoc* for the purposes of the manuscript and its new rising class of bourgeois readers. Nearly all are written in the short four-stress couplet or the newly fashionable 'tail-rhyme' stanza, and they mark a clear advance in the process by which the commanding heights of courtly and chivalric literature were subsequently annexed to English in over a hundred romances in verse and prose.

English continued to be used, of course, as the language of religious instruction, and the fourteenth century saw a proliferation of such works. *The Prick of Conscience*, a work of remorseless penitential exhortation and terror, survives in some 127 manuscripts, far more than any other Middle English poem (there are fewer than ninety, whole or part, of *The Canterbury Tales*). There are many such penitential and catechetical works, and also lives of Christ, cycles of homilies in verse and prose, versifications of the Passion story, all typically represented in the massive compilation of religious writing known as the Vernon MS (Oxford, Bodleian Library MS Eng.poet.a.1), done for a midland religious house around 1380 as a complete 'sowle-hele' or programme of health for the soul. The thirteenth-century tradition of composition in English of poems and hymns and poetic expositions of Christian doctrine by religious continued in the work of minor writers like the Austin canon William of Shoreham (*c.*1320) and the Franciscan William Herebert (d. 1333).

Verse is the more commonplace medium of didactic instruction in Middle English; prose is generally reserved for an élite of more specialized readers; but English now advances everywhere into the territories of prose previously reserved to Latin. Richard Rolle, hermit of Hampole (d. 1349), wrote Latin treatises, commentaries, and poems, but also, principally for women recluses, treatises and poems in English, the latter charged with rhapsodic fervour and heavy with alliteration. He did more than any other to open English to élite forms of devotional and mystical writing. He was followed in the later part of the century by the three great English writers of the prose of mystical devotion, the Austin canon Walter Hilton (d. 1396), author of *The Scale of Perfection*, the anchoress Julian of Norwich (*The Revelations of Divine Love*), and the unknown author of *The Cloud of Unknowing*, an advanced treatise on the

THE PATERNOSTER PAGE, a very elaborately diagrammatic teaching page, in the 'Vernon' MS, a *c.*1390–1400 encyclopedia of *sowle hele* [soul's health]. An early flow-chart, it shows, in Latin and English, how meditation on the seven petitions of the Our Father leads to virtue and avoids sin.

A CARTHUSIAN DEVOTIONAL MISCELLANY, *c.*1400, from northern England. An example of the presentation of a didactic religious text with simple explanatory picture: the Tree of Life. Man perches in a tree gnawed at by 'day' and 'nyght', while hell-mouth yawns below.

practice of meditation. At about the same time, in the 1380s, the Wyclifite translation of the Bible was being made, a bold demonstration of the growing power of the vernacular that was branded as Lollard heresy but which foreshadowed events of 150 years later. English prose also began to be used in other strikingly new if less controversial ways, in the English version of the immensely popular *Mandeville's Travels*, perhaps the first properly 'recreational' prose since the Old English *Apollonius of Tyre*, and in the vast translations by John Trevisa of Higden's *Polychronicon* and of the encyclopaedia of Bartholomaeus Anglicus, *Of the Properties of Things*.

Alliterative Poetry

In the west, from Gloucestershire to Lancashire (though not entirely confined to the west), there was a resurgence of alliterative writing after 1350, nourished from old roots in the area, sustained by traditions of western monastic learning and historiography, and newly stimulated by the aristocratic and gentry patronage that had

switched from Anglo-Norman. This alliterative poetry had its links with the past, in its use of the unrhymed alliterative line and in the survival of certain 'poetic' words, but it was new made, and was on the whole writing of extraordinary sophistication. There is a self-conscious and expert debate on the economic condition of England in the 1350s, *Winner and Waster*, a flamboyant retelling of the story of the *Morte Arthure*, lavish in poetic and heroic and pathetic effects; learned versions of the stories of Troy, Alexander, and the siege of Jerusalem that match their Latin originals in verbal intricacy. There is one love-romance, *William of Palerne* (c.1350), directly inspired by aristocratic patronage, but the poetry of the reflourishing is characterized most often by a strong historical and moral consciousness; it is sophisticated and learned, but rather clerical than of the court, at least to the extent that love is not a principal theme and women not apparently a significant element in the audience. Such generalizations are apt to the greatest poems of the 'revival', the four contained in British Library MS Cotton Nero A.x and generally ascribed to the same poet. *Patience* and *Cleanness* are powerfully dramatic reworkings of biblical

THE FIGURE OF PRIDE, from *Piers Plowman*. The only extensively illustrated manuscript (Bodleian Library, Oxford, MS Douce 104: 1427, Ireland) of Langland's poem, with informal marginal pictures throughout which engage vividly in interpretation of the poem's meaning.

stories; *Pearl*, one of the miracles of English poetry, gives a human urgency, in its story of the loss of a loved one and the pain of coming to a spiritual consolation, to the stern theology of anti-Pelagianism; while *Sir Gawain and the Green Knight*, the wittiest and most fully dramatically realized of all medieval romances, unfolds the beauties and splendours and almost comic inadequacies of chivalric idealism with a cool and measured tolerance. Without these four poems, the alliterative 'revival' would be a baroque episode in the history of English poetry; with them, it is one of the key events.

Piers Plowman is in alliterative verse, but otherwise shares few of the preoccupations of the 'classical' poems of the reflourishing. Written by William Langland, who spent most of his life in London as an unbeneficed cleric and of whom virtually nothing is known for certain, it consists of a series of reworkings, conventionally distinguished as A, B, and C, of a strangely compelling series of dreams. Successive visions tell of a world corrupted by greed; of the attempt at a reform of that world and the establishment of a true Christian community through the agency of the honest Ploughman; of the turning inward when that quest fails, and the searching within the self for the roots of truth and justice and 'doing well'. It is a poem of quirky learning and idiosyncratic structure that yet drives forward to an intensely personal vision of the intellectual and spiritual pilgrimage of the Christian.

Piers Plowman inspired a number of fifteenth-century poems of satire and complaint on the abuses within the Church and State (*Richard the Redeless*, *Mum and Sothsegger*, *Pierce the Ploughmans Crede*), some of them of a distinctly Lollard cast. The stricter kind of alliterative verse also survived into the fifteenth century, drifting further northward (*The Awntyrs off Arthure*, *Golagros and Gawain*) into Scotland as 'Chaucerian' poetry spread outwards from the metropolis.

Court Poetry

The last barriers to literary English were those erected around the royal court, which remained predominantly French-speaking

EQUESTRIAN PORTRAIT of Chaucer as a Canterbury pilgrim in the Ellesmere MS (*c.*1410), set beside the beginning of his tale of *Melibee*. The disproportion of rider and horse suggests that an existing three-quarter-length portrait of the poet was adapted to the needs of the manuscript.

THE *Vox Clamantis* is a Latin poem in which Gower castigates the vices of the age. The poet is pictured here as the cosmic archer, shooting the arrows of his moral rebuke at the globe, which is shown in the traditional 'T-O' form (inverted) of the world-map, but with the compartments representing the three elements of earth, sky, and sea instead of the three continents.

until the reign of Richard II; the French poet Jean Froissart was the important literary figure in the household of Queen Philippa in the 1360s, and Gower still thought French an appropriate language for his first major poem in the mid-1370s. The annexation of the court to English would have taken place anyway, but the process by which it did so coincides with the career of Geoffrey Chaucer (*c*.1343–1400), who has an air therefore of being responsible. He probably wrote poems in French during his early life as an esquire of the royal household, but he made a decisive choice to write in English in 1369, with his poem on the death of John of Gaunt's wife, *The Book of the Duchess*, and English poetry never looked back. Little of his poetry is associated directly with court patronage, and the most supremely 'courtly' of his poems, *Troilus and Criseyde* (1381–6), is dedicated to his London friends Gower and Strode. But Chaucer, as a court and civil servant for much of his life, was to that extent a recipient of royal patronage and a member of the court 'circle': the Prologue to *The Legend of Good Women* (1386–7) is addressed to Anne, Richard II's queen, and the love-vision poems of *The House of Fame* and *The Parliament of Fowls* may have been written for court occasions. Later in his life, his court connections were looser, and the work of his last years, *The Canterbury Tales*, with its exploration of every kind of human society and European narrative form, is a world away from the fashionable love-romance of *Troilus*.

Talk of Chaucer as a 'court-poet', necessary as it is to mark the new status of English poetry, may distract attention from his greater achievement, which was to bring English fully into the stream of contemporary French and Italian poetry, to 'Europeanize' English poetry by making it part of the whole medieval Latin and vernacular tradition, and to invent the metrical form that has dominated English verse since his time—the pentameter, which he used in both couplet and stanza. Chaucer's translations of the key works of the European tradition, the *Roman de la Rose* of Guillaume de Lorris (*c*.1230) and Jean de Meun (*c*.1275) and *The Consolation*

of Philosophy of Boethius (d. 525), are as important a part of his cultural achievement as any, though it was his visits to Italy in 1372–3 and 1378, and his ripening knowledge of the work of Dante, Petrarch, and Boccaccio, that opened his eyes to a role for poetry in which it should be more than the servant of princes or the Church. He had a sense of the importance of poetry, and of his own importance as a poet, to which no other English poet comes before Spenser.

Chaucer had an important influence on fifteenth-century courtly poetry, but few contemporaries as a court-poet. Among his circle of admirers and imitators there are one or two minor poets such as Sir John Clanvowe (*The Book of Cupid*) and Henry Scogan, and also Thomas Usk, executed in 1388, author of the prose *Testament of Love*. His most distinguished fellow poet is John Gower (d. 1408), author of estates-satire in French (*Mirour de l'Omme*) and Latin (*Vox Clamantis*) and, after Chaucer had blazed the trail, of a major poem in English, the *Confessio Amantis*. First addressed to Richard II and subsequently, when Gower grew disillusioned with Richard, to Henry of Lancaster (the future Henry IV), the *Confessio* is a very large collection of stories arranged under the headings of the Seven Deadly Sins in the manner of a lover's confession and exemplifying virtue in love and in the community at large. It is a work belonging to the older not the modern European tradition, written in the older short couplet not the pentameter, but it is a superb poem by any but Chaucerian standards.

The Fifteenth Century

Court-poetry continues in the fifteenth century, in the sense that Chaucerian love-vision has a vigorous life among his followers, such as John Lydgate (*The Complaint of the Black Knight*, *The Temple of Glass*), Sir Richard Roos (*La Belle Dame sans Merci*, a translation from the French of Alain Chartier), and King James I of Scotland (*The Kingis Quair*), and in many anonymous courtly love allegories, such as *The Flower and the Leaf* and *The Assembly of Ladies*. But the Lancastrian and Yorkist courts were not great centres of courtly culture; preoccupied with maintaining their precarious hold on power, kings extended their patronage more to the poetry of political propaganda and national identity. *The Regement of Princes* (1411–12) of Thomas Hoccleve (*c.*1369–1426), a Privy Seal clerk remarkable elsewhere for his development in a series of poems such as *La Male Regle* of a highly individual version of Chaucer's 'autobiographical' voice, is part of the Prince of Wales's bid to establish himself as a wise and reliable future king, while the *Troy-Book* of John Lydgate, monk of Bury (1371–1449), was written at Henry V's request to mark the new status of English as a literary language to rival Latin and French. Lydgate, whose output of occasional verse for every kind of patron and occasion was prodigious, and who as Chaucer's disciple quite consciously tried to out-achieve his master, was also taken up by Henry VI's advisers to write poems on the king's title to the French throne and on

his coronation in 1429, almost as a kind of poet laureate, and later by Humphrey duke of Gloucester, to translate *The Fall of Princes* from Laurent de Premierfait's French version of Boccaccio's Latin prose *De casibus illustrium virorum*, as an assertion of the duke's claim to be a great patron of letters on the Italian humanist model. As a poet, Lydgate is best represented by his religious poetry, where, in his Marian hymns and resplendent *Life of Our Lady*, he is more than the Cynewulfian monastic journeyman he often seems to resemble.

Court and aristocratic patronage remains important throughout the century, but there is a very significant shifting of literary culture to a broader base. The early years of the century see the beginning of a rapid expansion in the commercial production of literary manuscripts, partly to cater for the demand for the poems of such as Chaucer and Gower, but more to fill the gap in the reading material of the vastly increased number of readers of English, of all classes. It is the great age of translation, as English not only expands its role in established areas of devotional and didactic writing (such as the prose translation by the Carthusian Nicholas Love of the seminal text of Latin affective devotion, the *Meditationes Vitae Christi*, about 1408, or the several translations of the allegorical *Pelerinages* of Guillaume de Deguileville) but also takes over from French in high romance and books of courtesy and from Latin in history, government, learning, science, medicine, philosophy, horticulture (Palladius on husbandry), military theory (Vegetius on war), and economic policy (*The Libel of English Policy*). Sir John Fortescue, chief justice to Henry VI, wrote on constitutional law and polity in both Latin and English (the *Monarchia* of *c*.1471 is perhaps the first such work in English since Wulfstan), and Bishop Reginald Pecock even attempted, rather unluckily, to write a kind of academic theology in English (*The Repressor of Overmuch Blaming of Clergy*, 1455). Strikingly symptomatic of the changes that have taken place are the decision of Charles

THIS AUTOGRAPH DRAFT of a letter, possibly by Henry V, is the earliest example of English in a royal autograph.

STAGING-PLAN (c.1440) for the morality play of *The Castle of Perseverance*. Unique and much-discussed diagram of a 'theatre-in-the-round', with 'scaffolds' surrounding the playing-space and the 'castle' at the centre.

of Orleans, while he was in prison in England (1415–40) after being captured at Agincourt, to learn how to write poetry in English, and the extraordinary circumstance by which the Carthusian monk James Greenhalgh, towards the end of the century, found himself translating *The Cloud of Unknowing* into Latin.

The flood of writing in English means that far more survives from the fifteenth century than from the whole of the previous millennium. Some of it is fourteenth-century composition, but most is new production. There are many more authors whose names are known, a few of them civil servants like Chaucer, such as Hoccleve and George Ashby, most of them members of religious orders, such as Lydgate, John Walton, author of a verse translation of Boethius (1410); John Awdelay (fl. 1426); Benedict Burgh (fl. 1450); Osbern Bokenham, author of a series of *Legends of Holy Women* (1443–7); and John Capgrave (1393–1464), Austin friar of Lynn and author of a large *Chronicle* in English as well as other English and Latin works. There are also the first appearances of dramatic texts in English, written records of the play-cycles of the guilds of York and Wakefield and of the mystery and morality plays of the itinerant professional companies (the 'N-Town' cycle, *The Castle of Perseverance*, *Mankind*); the first written copies of kinds of popular verse that had previously had only a mouth-to-mouth existence—lewd and gnomic verses, calendar calculations, prognostics, charms; and the first survivals of ephemeral documents such as letters (the Paston letters) and of oral narration (*The Book of Margery Kempe*).

The most important event of the fifteenth century for the English language and for English literary culture is the introduction of printing into England by William Caxton in 1476. The English language was already on its way to being standardized on the model of the east midland dialect of London in the early fifteenth century: the systematization of grammar and spelling in the professionally produced London copies of Chaucer, Gower, and Hoccleve was one important influence; Henry V's determination to have English as the language of Chancery and other official documents was another. There was still much variation in spelling, and some confusion in the representation of the grammatical final -*e* that Chaucer had preserved for metrical reasons; and there were still some significant differences between dialects, such as the variation in the form of the third person singular of the present tense of verbs, which was -*th* in the south and -*s* in the north. Caxton recognized clearly how important standardization was for the printing press and he tells as a cautionary tale his famous story of the Yorkshire traveller in Kent who asked for 'eggys' and was told by his hostess that she knew no French: 'And the marchaunt was angry, for he also coude speke no frenshe, but wolde have had egges, and she understode hym not.' The Kentish hostess would have understood 'eyren', but she was about to be bypassed by history.

The influence of Caxton and his followers upon English literary culture is the beginning of a new history. There were no immediate changes: the principal products of Caxton's press and of his own translating activities were the histories, poems,

romances, and didactic and religious works that had been the staple fare of English readers throughout the middle years of the century. Only Sir Thomas Malory's *Morte D'Arthur*, however it came into Caxton's hands, would stand out as unprecedented in such a history of literary production, as the supreme example of the kind of large-scale prose romance cycle that had become popular in Burgundy. But the scale of production, the role and significance of the author, the nature and function of the audience were all, with the spread of printing, to change in ways that made for a different kind of literary culture.

CHAUCER reciting (not reading) his poem, *Troilus and Criseyde*, to a splendid court audience, in a manuscript of *c*.1420. Not necessarily historically authentic, but the best example of an author portrait from the English middle ages.

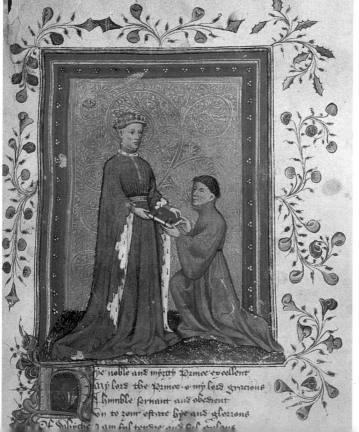

THE MONK LYDGATE
represents himself in the
Prologue to his poem, *Siege
of Thebes*, meeting Chaucer's
pilgrims as they prepare to
depart from Canterbury.
The illustrator of this *c.*1460
manuscript shows Lydgate
(*third from left*) in black cope
and hood, with the towers of
Canterbury Cathedral in the
background. The vociferous
person is the Host.

THOMAS HOCCLEVE
presenting his poem, *The
Regiment of Princes*, to Prince
Henry, *c.*1411–12. A superb
presentation-picture; the
kneeling figure may possibly
be the person who commis-
sioned the copy (Lord
Mowbray) and not the poet.

Editor's Postscript

In August 1485 an unlikely pretender, the Lancastrian claimant, Henry Tudor earl of Richmond, triumphed over Richard III at Bosworth. The battle, although closely fought, was not a large one. Neither of the two armies is thought to have exceeded 8,000 men, and the full potential of Richard's force was not realized. But the outcome of the battle was highly significant. For the first time since 1066 an English king had been killed in his own kingdom. A political revolution had been effected. The throne of England was taken by a new dynasty.

Initially Henry VII's position was insecure. His power base was dangerously narrow, and there was no assurance that he would survive for any longer than his predecessor. But, within a few years, Henry had established an ascendancy. In 1487, at Stoke, he won a decisive victory over the earl of Lincoln and the pretender Lambert Simnel, and a decade later he saw off a popular rebellion in Cornwall. Unlike Edward IV, Henry did not have to face a threat from an 'over-mighty' subject. Earlier struggles had put paid to most of his rivals, and because of the circumstances of his accession he was not beholden to any one over-ambitious supporter. The result was that he was able to rule firmly and without favour. The rapid improvement in the state of his finances greatly assisted him. The royal demesne was replenished and he was careful to control his spending. But simultaneously he projected a powerful and highly exalted royal image: the chapel bearing his name in Westminster Abbey bears ample witness to that. By the time of his death in 1509 he had won the grudging respect (if not the affection) of his subjects.

In political terms, there can be little doubt that 1485 constituted a major turning-point. The verdict of Bosworth, confirmed at Stoke, brought to an end the long period of internal strife which had begun at the battle of St Albans in 1455 and which ultimately had its origins in Henry of Lancaster's usurpation in 1399. But it is possible that an excessive concentration on the political side distorts our understanding of the importance of the period as a whole. In a broader context, the significance of 1485 appears less obvious than it does in the strictly political. It is not easy to think of many far-reaching developments that had their origins around then. Economically, the key transformation had occurred well over a century earlier—in the thirty-or-so years after the Black Death. It was in those years—years of recurrent plague visitations—that the sharpest rise in wages had occurred, that the labour legislation had been introduced, and that the manorial demesnes had been put out to lease. Few if any economic changes of comparable significance occurred at the end of the fifteenth century. Equally there is little sign of developments of importance in the nature of piety or the organization of the Church. Traditional, 'catholic', religion continued to flourish. Parish churches—even a few monastic churches—were

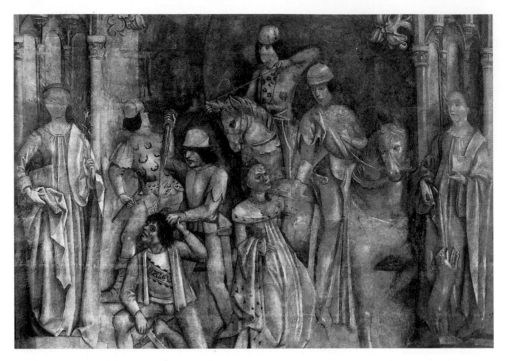

THE WALL PAINTINGS in the chapel of Eton College (*c*.1477–87) are among the finest of their date outside Italy. Their strongly sculptural quality is evident in this episode from the series on the south wall—the empress being rescued by a knight, from the *Miracles of the Virgin*. The paintings are strongly Flemish-influenced. Although executed under royal patronage, they had little direct impact in England.

embellished and rebuilt. Gifts and benefactions were still going the way of the friars; relics were still being collected and offerings being made to images. It is true that changes of habit or fashion were to be observed in the practice of popular devotion: while some saints' cults rose in popularity, for example, others declined. It is also true that among the gentry the old communal habits of devotion were breaking down. But evolutionary change had always been a feature of medieval religious life, and it is doubtful if anyone in the 1480s could have foreseen upheavals on the scale that were to occur some fifty years later.

 In the cultural life of the realm, similarly, no shifts of particular importance occurred around the time of Bosworth. In architecture the Gothic idiom was still dominant. Buildings were characterized, as they had been for well over a century, by grid-like window tracery, extensive use of panelling, and standardized mouldings. There was little or no sign of interest in the classical vocabulary used in Italy. In painting, too, work continued on firmly traditional lines. Decoration remained heavy or stiff, and surfaces were densely textured; the quality of drawing was often poor. There was no evidence that the paintings in the chapel of Eton College fore-

shadowed a change of style or approach. Not until Holbein's arrival at the court of Henry VIII did a major revolution take place in painting in England.

It is considerations of this nature that have led a number of historians to doubt whether the 1480s constituted a turning-point at all in English history. Even the importance of 1485 in political terms has been questioned: it is argued that Henry VII wrought few if any changes in the structure of government, that he ruled much as the Yorkist kings had, and that the real 'revolution' in government was to come in the 1530s or later. Whether or not these arguments carry conviction—and the political history of early sixteenth-century England is highly controversial—it is none the less possible to identify at least a couple of areas in which significant change may be said to have occurred. The first of these relates to demography, and the second to the introduction of printing.

The demographic history of the late middle ages has yet to be established satisfactorily; but at least there is broad agreement on the main trends. At the beginning of the fourteenth century the country's population stood at roughly 6–7 million. The coming of, first, the famines and, then, the plague reduced it within half a century by about a half. It may have fallen further still in the 1360s as a result of successor plagues; and then in the fifteenth century it remained static. In earlier periods when population had fallen—in the fifth and sixth centuries, for example—it had quickly climbed up again. But in the century to 1460 the pattern was very different. Whether because of the rate of mortality or because of changes in people's life cycles, it remained stubbornly low. Only in the final decades of the century does it appear to have picked up again. At first the increase was small—so small as to be barely noticeable—but later it quickened; and in the sixteenth century it became rapid. By the time of the Civil War the population had risen to some five and a quarter million. The consequences of the rise have often been commented on. Pressure on the land increased; wages began to fall in real terms; and laws were passed to control vagrancy. England in 1650 was a very different country from England in 1450. The demographic trends that had made it so were ones that were long drawn out; but the significant point is that they had their origins in the final decades of the middle ages.

The other development that was to reshape the character of England after the 1480s was the introduction of printing. In the middle ages books, pamphlets, and manifestos had all been produced by hand. This constraint had not prevented the growth of a book trade. In towns like London, Oxford, and Cambridge, where there was a heavy demand for the written word, scriveners established ateliers and turned out multiple copies of popular works. But the slowness of the rate of production naturally limited supply. The introduction of printing at the end of the middle ages transformed this situation. Mass production of a sort could be contemplated. The first printer to set up a workshop was William Caxton, in the sanctuary at Westminster in 1476. Others quickly followed his example, among them Wynken de Worde and Richard Pynson. The works which these men published were varied in

character. In the year of Bosworth Caxton himself published Malory's celebrated *Morte D'Arthur*. But nearly a half of the works produced were manuals of piety and devotion. Initially, it seems, the effect of the introduction of printing was simply to satisfy an existing market. But in the longer term it resulted in a reshaping and an expansion of that market. Approaches to learning, religion, and political communication were all in due course to be transformed. It is hardly an exaggeration to say that the Reformation and the rise of a popular Protestantism would be unimaginable without printing. A by-product of a simple technological advance in the fifteenth century was thus a far-reaching political and religious revolution in the sixteenth.

In the middle and later decades of the fifteenth century major changes were under way in many other parts of Europe. The process of change is particularly noticeable in the political field. In the Iberian peninsula a union of the states of Aragon and Castile was effected by the marriage of the two kingdoms' rulers, Ferdinand and Isabella, respectively. North of the Pyrenees, the ending of the Hundred Years War between England and France and their allies precipitated a major reorientation of French foreign policy, allowing a diversion of military effort to Italy: and the campaigns eventually unleashed there were to inaugurate a major revolution in warfare. These were events of the highest importance in the political and economic development of the Mediterranean world. But the event with the largest consequences for the future—and much the most striking in symbolic terms—was one which was to lead the people of Europe to look outwards. This was Christopher Columbus's voyage to America. Columbus undertook the voyage with the backing of Ferdinand and Isabella of Spain, who were looking to increase their income from trade. In Columbus's wake, a number of other fleets undertook voyages to the Americas—many of them Spanish, but some Portuguese. No Englishmen were involved in these earliest stages of exploration. Henry VII, however, did not want to be left out of the search for new markets and trading routes. Accordingly in 1497, when a Genoese merchant, John Cabot, approached him for letters patent to undertake a voyage with five ships 'to lands unknown to Christians', he agreed to the request. Cabot sailed from Bristol on 2 May. Six weeks later, and after a voyage of nearly 3,000 miles, he landed in Newfoundland. No colony was established on the island, but an English crew had set foot in the New World for the first time. More than anything else, it is the discovery of the Americas that marks the transition from the medieval period to the early modern. England was to play its most active role in the process of discovery and colonization a century later. But Henry's backing for Cabot was a sign of the growing interest that was to come. In the 1490s, the age when men and women lived in a Europe-bound world was drawing to a close; in the new era now opening, people were to find themselves acting out their lives in much broader and less familiar arenas.

Further Reading

1. MEDIEVAL ENGLAND: IDENTITY, POLITICS, AND SOCIETY

Broad questions of identity are tackled by M. T. Clanchy, *England and its Rulers 1066–1272* (London, 1983). For the pre-Conquest period, see especially P. Wormald, 'The Making of England', *History Today*, 45 (Feb. 1995), 26–32; and King Alfred's own writings, collected in *Alfred the Great. Asser's Life of King Alfred and Other Contemporary Sources*, ed. S. Keynes (Harmondsworth, 1983). England's external relations are surveyed in the essays in N. E. Saul (ed.), *England in Europe 1066–1453* (London, 1994) and M. Jones and M. Vale (eds.), *England and her Neighbours 1066–1453* (London, 1989). See also the essays by R. W. Southern in his *Medieval Humanism and Other Studies* (Oxford, 1970). For the formation of a national Church, see P. Heath, *Church and Realm, 1272–1461* (London, 1988). For further reading on the visual arts, see Chapter 7, 'The Visual Arts', in this book.

2. ANGLO-SAXON ENGLAND, *c.*500–1066

Many of the written sources for the Anglo-Saxon period are translated in D. Whitelock (ed.), *English Historical Documents*. vol. i, 2nd rev. edn. (London, 1979). Bede's *Ecclesiastical History* is available in a well-annotated paperback translation by J. McClure and R. Collins (Oxford, 1994). The best general book on the period is J. Campbell (ed.), *The Anglo Saxons* (London, 1982, repr. in paperback Harmondsworth, 1990), with contributions by P. Wormald and E. John. F. M. Stenton, *Anglo-Saxon England*, 3rd edn. (Oxford, 1971) is a classic. P. Sawyer, *From Roman Britain to Anglo-Saxon England* (London, 1978) is very stimulating, as is the same author's *The Age of the Vikings*, 2nd edn. (London, 1971). Key aspects of the whole period are admirably treated by J. Campbell, *Essays in Anglo-Saxon History* (London, 1986), N. Brooks, *The Early History of the Church of Canterbury* (Leicester, 1984), P. Stafford, *The East Midlands in the Early Middle Ages* (Leicester, 1985), and H. Leyser, *Medieval Women: A Social History of Women in England 450–1500* (London, 1995), and of the earlier centuries by C. J. Arnold, *The Archaeology of the Early Anglo-Saxon Kingdoms* (London, 1988), D. Kirby, *The Earliest English Kings* (London, 1991), H. Mayr-Harting, *The Coming of Christianity to Anglo-Saxon England*, 2nd rev. edn. (London, 1990), the contributors to S. Bassett (ed.), *The Origins of Anglo-Saxon Kingdoms* (Leicester, 1989), and, more controversially, N. Higham, *An English Empire: Bede and the Early Anglo-Saxon Kings* (Manchester, 1995). The Sutton Hoo finds are presented in R. Bruce-Mitford, *The Sutton Hoo Ship-Burial* (3 vols. London, 1974–83), and the recent re-excavations are taken into account in M. Carver (ed.), *The Age of Sutton Hoo* (Woodbridge, 1992), and C. B. Kendall and P. S. Wells (eds.), *Voyage to the Other World: The Legacy of Sutton Hoo* (Minneapolis, 1992). On the later Anglo-Saxon period, P. Stafford, *Unification and Conquest* (London, 1989) is excellent. Visual evidence is discussed by C. R. Dodwell, *Anglo-Saxon Art: A New Perspective* (Manchester, 1982), and in two fine British Museum/British Library exhibition catalogues: J. Backhouse, D. H. Turner, and L. Webster (eds.), *The Golden Age of Anglo-Saxon Art* (London, 1984), and L. Webster and J. Backhouse (eds.), *The Making of England: Anglo-Saxon Art and Culture AD 600–900* (London, 1991).

3. CONQUERED ENGLAND, 1066–1215

The standard works by F. Barlow, *Edward the Confessor* (London, 1970), and D. C. Douglas, *William the Conqueror* (London, 1964), accept most, if not all, of the Normans' justification of

their claim. By contrast, see the closing pages of V. H. Galbraith, *Domesday Book: Its Place in Administrative History* (Oxford, 1974). For an evocation of what late Anglo-Saxon England might have been like, F. W. Maitland, *Domesday Book and Beyond: Three Essays in the Early History of England* (Cambridge, 1897; reissued with an introductory essay by J. C. Holt, 1987), remains unsurpassed. An incisive recent survey of the Conquest is B. Golding, *Conquest and Colonisation: The Normans in Britain, 1066–1100* (London, 1994). A. Williams, *The English and the Norman Conquest* (Woodbridge, 1995), takes the viewpoint of the conquered, and is professedly inspired by E. A. Freeman, *The Norman Conquest* (6 vols. Oxford, 1867–79), a largely unread classic. R. Fleming, *Kings and Lords in Conquest England* (Cambridge, 1991), emphasizes the dramatic rupture in aristocratic landholding consequent on the Conquest. For the new world of the Norman barons, see F. M. Stenton, *The First Century of English Feudalism*, 2nd edn. (Oxford, 1961); J. Hudson, *Land, Law and Lordship in Anglo-Norman England* (Oxford, 1993); and, most importantly, the essays of J. C. Holt, collected in his *Colonial England* (London, 1996). Holt's 'Politics and Property in Early Medieval England', reprinted here, is one of the two most important essays on the subject published in the last fifty years. It is concerned (amongst many other things) with the effects of divisions between England and Normandy, and it undermines the central thesis of J. Le Patourel's magisterial *The Norman Empire* (Oxford, 1976).

On Domesday Book, see V. H. Galbraith *The Making of Domesday Book* (Oxford, 1961); R. Welldon Finn, *The Domesday Inquest and the Making of Domesday Book* (London, 1961); and J. C. Holt (ed.), *Domesday Studies* (Woodbridge, 1987).

The collected essays of C. W. Hollister, *Monarchy, Magnates and Institutions* (London, 1986), are the best introduction to the baronage under Henry I; on Henry's government, see J. Green, *The Government of England under Henry I* (Cambridge, 1986). Contrast H. A. Cronne, *The Reign of Stephen* (London, 1970) with R. H. C. Davis, *King Stephen*, 3rd edn. (London, 1990); but it is still well worth reading J. H. Round, *Geoffrey de Mandeville: A Study in the Anarchy* (London, 1892), as was demonstrated in the spat between Davis and J. O. Prestwich in the *English Historical Review* (1988–90). A recent collection of essays is E. King (ed.), *The Anarchy of King Stephen's Reign* (Oxford, 1994).

A challenging book on the period from Henry's accession to Magna Carta is J. E. A. Joliffe, *Angevin Kingship*, 2nd edn. (London, 1963); better still, and more wide-ranging, is J. C. Holt, *Magna Carta*, 2nd edn. (Cambridge, 1992). The most original approach to the implications of the legal reforms is S. F. C. Milsom, *The Legal Framework of English Feudalism* (Cambridge, 1976). Much of Milsom's inspiration came from the other most important essay of the last fifty years: S. E. Thorne, 'English Feudalism and Estates in Land', *Cambridge Law Journal*, 6 (1959). On Magna Carta itself see, in addition to Holt's book of that title, his *The Northerners*, 2nd edn. (Oxford, 1992), on baronial disaffection in John's reign, and the remarkable essay 'Magna Carta 1215–1217: The Legal and Social Context', reprinted in *Colonial England*. For the vast expansion in the records of government towards the end of this period, see M. T. Clanchy, *From Memory to Written Record*, 2nd edn. (Oxford, 1993).

4. LATE MEDIEVAL ENGLAND, 1215–1485

Good general surveys of late medieval English political history are M. H. Keen, *England in the Later Middle Ages* (London, 1973), and A. Tuck, *Crown and Nobility 1272–1461* (London, 1985); royal government is described in detail in A. L. Brown, *The Governance of Late Medieval England 1272–1461* (London, 1989), while the development of royal finance is covered by G. L. Harriss, *King, Parliament and Public Finance in Medieval England to 1369* (Oxford, 1975), and that of parliament in R. G. Davies and J. H. Denton (eds.), *The English Parliament in the Middle Ages* (Manchester, 1982). Among the best studies of individual reigns are M. Prestwich, *Edward I* (London,

1988), W. M. Ormrod, *The Reign of Edward III* (London, 1991), C. Allmand, *Henry V* (London, 1992), G. L. Harriss (ed.), *Henry V: The Practice of Kingship* (Oxford, 1985), R. A. Griffiths, *The Reign of King Henry VI* (London, 1981), C. Ross, *Edward IV* (London, 1974), and R. Horrox, *Richard III: A Study of Service* (Cambridge, 1989). For England's relations with France and the countries of the British Isles, see M. Vale, *The Angevin Legacy and the Hundred Years War 1250–1340* (Oxford, 1989), C. Allmand, *The Hundred Years War* (London, 1988), A. Curry, *The Hundred Years War* (London, 1993), and R. Frame, *The Political Development of the British Isles 1100–1400* (Oxford, 1990). For Crown–noble relationships see K. B. McFarlane, *The Nobility of Later Medieval England* (Oxford, 1973), and C. Given-Wilson, *The English Nobility in the Late Middle Ages* (London, 1987). Important studies of specific aspects of late medieval English political history include S. Walker, *The Lancastrian Affinity 1361–1399* (Oxford, 1990), E. Powell, *Kingship, Law and Society: Criminal Justice in the Reign of Henry V* (Oxford, 1989), and A. J. Pollard, *The Wars of the Roses* (London, 1988).

5. THE ECONOMY AND SOCIETY

The only book to survey the whole period is D. Hinton, *Archaeology, Economy, and Society: England from the Fifth to the Fifteenth Century* (London, 1990), and it is especially useful on the pre-Conquest period. For the period after 1066, the textbook that provides the most comprehensive coverage is J. L. Bolton, *The Medieval English Economy* (London, 1980). R. H. Britnell, *The Commercialisation of English Society* (Cambridge, 1993) gives an important interpretation of the period, which offers an alternative to M. M. Postan, *The Medieval Economy and Society* (London, 1972). Two surveys of archaeological evidence are C. Platt, *Medieval England: A Social History and Archaeology from the Conquest to 1600* (London, 1978) and J. M. Steane, *The Archaeology of Medieval England and Wales* (London, 1985). A book which digs deeper and which combines archaeological and documentary evidence is G. Astill and A. Grant (eds.), *The Countryside of Medieval England* (Oxford, 1988). The period of growth is surveyed in E. Miller and J. Hatcher, *Medieval England: Rural Society and Economic Change, 1086–1348* (London, 1978) and *Medieval England: Towns, Commerce and Crafts, 1086–1348* (London, 1995). On the later middle ages, a social survey is provided by M. Keen, *English Society in the Later Middle Ages 1348–1500* (Harmondsworth, 1990) and for a more detailed and economic approach, C. Dyer, *Standards of Living in the Later Middle Ages: Social Change in England c.1200–1520* (Cambridge, 1989). On more specialized aspects, see R. Holt and G. Rosser (eds.), *The Medieval Town: A Reader in English Urban History 1200–1540* (London, 1990); R. H. Hilton, *Bondmen Made Free: Medieval Peasant Movement and the English Rising of 1381* (London, 1973); B. M. S. Campbell, *Before the Black Death: Studies in the 'Crisis' of the Early Fourteenth Century* (Manchester, 1991).

6. PIETY, RELIGION, AND THE CHURCH

For the Anglo-Saxon period a number of primary sources are readily available in translation, notably Bede, *The Ecclesiastical History of the English People*, ed. J. McClure and R. Collins (London, 1994) and Adomnan of Iona, *Life of St. Columba*, ed. and trans. R. Sharpe (Harmondsworth, 1995). For the post-Conquest period, P. Matarasso, *The Cistercian World: Monastic Writings of the Twelfth Century* (Harmondsworth, 1993) contains an interesting selection of texts, many of them of relevance to England. For the fourteenth and fifteenth centuries, see the collection of documents in R. N. Swanson (ed. and trans.), *Catholic England: Faith, Religion and Observance before the Reformation* (Manchester, 1993). Useful insights into piety are afforded by M. Kempe, *The Book of Margery Kempe*, ed. and trans. B. Windeatt (Harmondsworth, 1985), and Julian of Norwich, *Revelations of Divine Love*, ed. and trans. C. Wolters (Harmondsworth, 1966). Amongst the secondary literature for the Anglo-Saxon period there is much of relevance in J. Campbell

(ed.), *The Anglo-Saxons*, 2nd edn. (London, 1991). Essential for the conversion is H. Mayr-Harting, *The Coming of Christianity to Anglo-Saxon England*, 3rd edn. (London, 1991), and for the making of parishes, J. Blair (ed.), *Minsters and Parish Churches: The Local Church in Transition 950–1200* (Oxford, 1988). The eleventh and twelfth centuries have been covered by F. Barlow, *The English Church 1000–1066* (London, 1963) and his *The English Church 1066–1154* (London, 1979). D. Knowles, *The Monastic Order in England*, 2nd edn. (Cambridge, 1963) is still a classic but should be supplemented now by J. Burton, *Monastic and Religious Orders in Britain 1000–1300* (Cambridge, 1994). For religion and the laity, see R. Finucane, *Miracles and Pilgrims: Popular Beliefs in Medieval England* (London, 1995) and P. Biller, 'Marriage Patterns and Women's Lives: A Sketch of Pastoral Geography', in P. J. P. Goldberg (ed.), *Woman is a Worthy Wight* (Stroud, 1992). For Salisbury, see T. Webber, *Scribes and Scholars at Salisbury Cathedral, c.1075–c.1125* (Oxford, 1992); T. Cocke and P. Kidson, *Salisbury Cathedral: Perspectives on the Architectural History* (London, 1993); and A. Brown, *Popular Piety in Late Medieval England: The Diocese of Salisbury 1250–1550* (Oxford, 1995). For the fourteenth century, W. A. Pantin, *The English Church in the Fourteenth Century* (Cambridge, 1955) is still indispensable, but for Wyclif and his influence, A. Hudson, *The Premature Reformation: Wycliffite Texts and Lollard History* (Oxford, 1988) is now essential. For a stimulating and very different perspective on the fifteenth century, see E. Duffy, *The Stripping of the Altars* (New Haven and London, 1992). For the wider context of the subject-matter of this chapter, see R. W. Southern, *Western Society and the Church in the Middle Ages* (Harmondsworth, 1970).

7. THE VISUAL ARTS

For general surveys of the period, see C. Platt, *The Architecture of Medieval Britain: A Social History* (New Haven and London, 1990); M. Rickert, *Painting in Britain: The Middle Ages* (Harmondsworth, 1965); L. Stone, *Sculpture in Britain: The Middle Ages* (Harmondsworth, 1972); G. Webb, *Architecture in Britain: The Middle Ages* (Harmondsworth, 1965). R. Marks, *Stained Glass in England during the Middle Ages* (London, 1993), discusses not only style, but iconography, patronage, and glass-making techniques.

Anglo-Saxon

More detailed discussion of Anglo-Saxon art can be found in C. R. Dodwell, *Anglo-Saxon Art* (Manchester, 1982); and E. Fernie, *The Architecture of the Anglo-Saxons* (London, 1983). Two exhibition catalogues provide thorough, up-to-date, well-illustrated surveys: for the earlier period, L. Webster and J. Backhouse (eds.), *The Making of England: Anglo-Saxon Art and Culture AD 600–900* (British Museum, London, 1991); and for the later period, J. Backhouse, D. H. Turner, and L. Webster (eds.) *The Golden Age of Anglo-Saxon Art 966–1066* (British Museum, London, 1984).

Romanesque (Anglo-Norman)

For a comprehensive survey, see G. Zarnecki, J. Holt and T. Holland (eds.), *English Romanesque Art* (Hayward Gallery, London, 1984). T. S. R. Boase, *English Art, 1107–1216* (Oxford, 1953), is still useful. S. Macready and F. H. Thompson (eds.), *Art and Patronage in the English Romanesque* (Soc. of Antiquaries Occasional Paper, 8; London, 1986) contains specialist, but wide-ranging, studies.

Gothic

The richly illustrated exhibition catalogue, J. Alexander and P. Binski (eds.), *Age of Chivalry* (Royal Academy, London, 1987), is the fullest survey of the arts and architecture to the late four-

teenth century. P. Brieger, *English Art, 1216–1307* (Oxford, 1957), is the best survey of thirteenth-century art available; for the later period, J. Evans, *English Art, 1307–1461* (Oxford, 1949), although outdated in some respects, is full of insights lacking elsewhere. For architecture in its European context, see C. Wilson, *The Gothic Cathedral: The Architecture of the Great Church 1130–1530* (London, 1990). J. Bony, *The English Decorated Style: Gothic Architecture Transformed, 1250–1350* (Oxford, 1979), does the same for a particular period. N. Coldstream, *The Decorated Style: Architecture and Ornament 1240–1360* (London, 1994) offers a different perspective. J. Harvey, *The Perpendicular Style 1330–1485* (London, 1978) concentrates on the characteristic details of a wide range of buildings. R. Marks and N. Morgan, *The Golden Age of English Manuscript Painting 1200–1500* (London, 1981), is a concise introduction, copiously illustrated in colour. Much less is written on secular art, but J. Stratford, *The Bedford Inventories: The Worldly Goods of John, Duke of Bedford, Regent of France (1389–1435)* (London, 1993), gives valuable information and illustrations of comparative material, even though the works themselves are mostly lost. For practical aspects of medieval art, see J. Blair and N. Ramsay (eds.), *English Medieval Industries: Craftsmen, Techniques, Products* (London, 1991), which concentrates not on history of style, but on production techniques and organization. The British Museum Medieval Craftsmen series takes a similar approach, providing concise and very well-illustrated introductions to the craftsmen, their organization, and their working methods: P. Binski, *Painters* (London, 1991); S. Brown and D. O'Connor, *Glass-Painters* (London, 1991); J. Cherry, *Goldsmiths* (London, 1992); N. Coldstream, *Masons and Sculptors* (London, 1991); C. De Hamel, *Scribes and Illuminators* (London, 1992); E. Eames, *English Tilers* (London, 1992); K. Staniland, *Embroiderers* (London, 1991).

8. LANGUAGE AND LITERATURE

A standard introduction to Old English is Bruce Mitchell and F. C. Robinson, *Guide to Old English*, 4th edn. (Oxford, 1986). For Middle English, see N. F. Blake (ed.), *The Cambridge History of the English Language 1066–1476* (Cambridge, 1992). David Burnley has an introduction to the language of the later Middle English period in his *Guide to Chaucer's Language* (London, 1983). There are modern English translations of most of the corpus of Old English poetry in S. A. J. Bradley, *Anglo-Saxon Poetry* (London, 1982), and an introduction to the literature of the period in Michael Alexander, *Old English Literature* (London, 1983). The whole of the period 500–1500 is covered in the essays in W. F. Bolton (ed.), *Sphere History of Literature: The Middle Ages*, rev. edn. (London, 1986), and the poetry in Derek Pearsall, *Old English and Middle English Poetry* (London, 1977). There are useful samplings of Middle English texts, with helpful apparatus, in J. A. W. Bennett and G. V. Smithers (eds.), *Early Middle English Verse and Prose* (Oxford, 1966); K. Sisam (ed.), *Fourteenth-Century Verse and Prose* (Oxford, 1921); D. Gray (ed.), *The Oxford Book of Late Medieval Verse and Prose* (Oxford, 1985), E. P. Hammond (ed.), *English Verse between Chaucer and Surrey* (Durham, NC, 1927) and Alexandra Barratt (ed.), *Women's Writing in Middle English* (London, 1994). Introductions and surveys are provided by J. A. W. Bennett (with Douglas Gray), *Middle English Literature* (Oxford, 1986); J. A. Burrow, *Medieval Writers and their Work* (Oxford, 1982). Boris Ford (ed.), *The New Pelican Guide to English Literature*, i, pt. 1, *Chaucer and the Alliterative Tradition* (Harmondsworth, 1982), has essays and samples of representative texts. Elizabeth Salter, in *English and International: Studies in the Literature, Art and Patronage of Medieval England* (Cambridge, 1988), gives the best account of literary culture in the twelfth and thirteenth centuries. Prose is covered in the essays in A. S. G. Edwards (ed.), *Middle English Prose* (New Brunswick, NJ, 1984), and drama in R. Beadle (ed.), *The Cambridge Companion to Medieval English Theatre* (Cambridge, 1994). For later medieval poetry, see A. C. Spearing, *Medieval to Renaissance in English Poetry* (Cambridge, 1985). For some modern developments in the historical interpretation of Chaucer and the later literature, see David Aers, *Community, Gen-*

der and Individual Identity (London, 1988); Lee Patterson, *Negotiating the Past: The Historical Understanding of Medieval Literature* (Madison, Wis., 1989); and the essays collected by Patterson in *Literary Practice and Social Change in Britain 1380–1530* (Berkeley and Los Angeles, 1990). Michael Clanchy provides an invaluable account of developments in and attitudes to writing up to 1307 in *From Memory to Written Record* (London, 1979), and there are essays towards a survey of late medieval book-production in Jeremy Griffiths and Derek Pearsall (eds.), *Book Production and Publishing in Britain 1375–1475* (Cambridge, 1989).

Chronology

1189 Death of Henry II. Accession of Richard I
1194 Richard's return to England after crusade and imprisonment
1199 Death of Richard I. Accession of John
1204 Loss of Normandy to France
1214 Battle of Bouvines
1215 Pope Innocent III holds Fourth Lateran council at Rome
 Signing of Magna Carta
1216 Death of King John. Accession of Henry III
1221 Arrival of the Dominicans in England
1224 Arrival of the Franciscans in England
1227 Henry III's personal rule begins
1244 'Paper Constitution' presented to Henry III
1245 Rebuilding of Westminster Abbey begins
1258 Making of the Provisions of Oxford
1264 Simon de Montfort defeats the royalists at Lewes
1265 Death of Simon de Montfort at Evesham
1272 Death of Henry III. Accession of Edward I
1284 Statute of Wales
1292 John Balliol chosen as king of Scots
1294 Outbreak of war with France (to 1303)
1296 Outbreak of war with Scotland
1306 Robert Bruce claims throne of Scotland
1307 Death of Edward I. Accession of Edward II
1312 Murder of Piers Gaveston
1314 Battle of Bannockburn
1318 Introduction into England of the feast of Corpus Christi
1322 Execution of Thomas of Lancaster
1326 Invasion of Isabella and Mortimer
1327 Deposition of Edward II. Accession of Edward III
1329 Death of Robert Bruce
1333 English victory over the Scots at Halidon Hill
1337 Outbreak of the Hundred Years War
1340 English naval victory at Sluys
1346 English victories at Crecy and Neville's Cross
1348 Black Death in England
1356 English victory at Poitiers
1360 Treaty of Brétigny
1369 Renewal of war with France
1376 The 'Good Parliament'. Death of the Black Prince
1377 Death of Edward III. Accession of Richard II
1381 The Peasants' Revolt
1384 Death of John Wyclif
1387 Battle of Radcot Bridge
1388 The 'Merciless Parliament'
1396 Twenty-eight year truce with France
1399 Deposition of Richard II. Accession of Henry IV
1400 Outbreak of Owen Glendower's revolt in Wales
1401 Death penalty introduced for heresy

1408	Death of Henry Percy, earl of Northumberland
1413	Death of Henry IV. Accession of Henry V
1414	Lollard Rising
1415	English victory at Agincourt
1419	Assassination of Duke John of Burgundy at Montereau
1420	Treaty of Troyes
1422	Death of Henry V. Accession of Henry VI.
1429	Joan of Arc raises siege of Orleans
1435	Treaty of Arras ends the French civil war
1437	Henry VI's personal rule begins
1449	Charles VII invades Normandy
1450	Duke of Suffolk assassinated. Jack Cade's Revolt
1453	Loss of Gascony. Henry VI's first bout of madness
1455	First battle of St Albans
1460	Richard duke of York claims the throne
1461	Deposition of Henry VI. Accession of Edward IV
1470	Flight of Edward IV. Readeption (reaccession) of Henry VI
1471	Restoration of Edward IV. Death of Henry VI
1483	Death of Edward IV and V. Accession of Richard III
1485	Death of Richard III. Accession of Henry VII

Family Trees

The Kings of Wessex and England to 1066

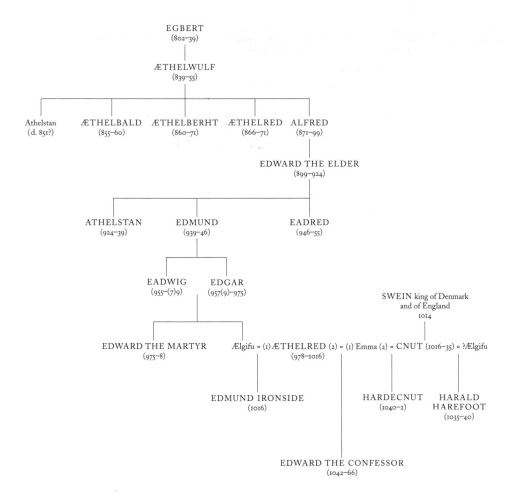

EGBERT
(802–39)

ÆTHELWULF
(839–55)

Athelstan (d. 851?) — ÆTHELBALD (855–60) — ÆTHELBERHT (860–71) — ÆTHELRED (866–71) — ALFRED (871–99)

EDWARD THE ELDER
(899–924)

ATHELSTAN (924–39) — EDMUND (939–46) — EADRED (946–55)

EADWIG (955–(7)9) — EDGAR (957(9)–975)

SWEIN king of Denmark
and of England
1014

EDWARD THE MARTYR (975–8)

Ælgifu = (1) ÆTHELRED (2) = (1) Emma (2) = CNUT (1016–35) = ?Ælgifu
(978–1016)

EDMUND IRONSIDE (1016)

HARDECNUT (1040–2)

HARALD HAREFOOT (1035–40)

EDWARD THE CONFESSOR (1042–66)

The Norman and Angevin Kings

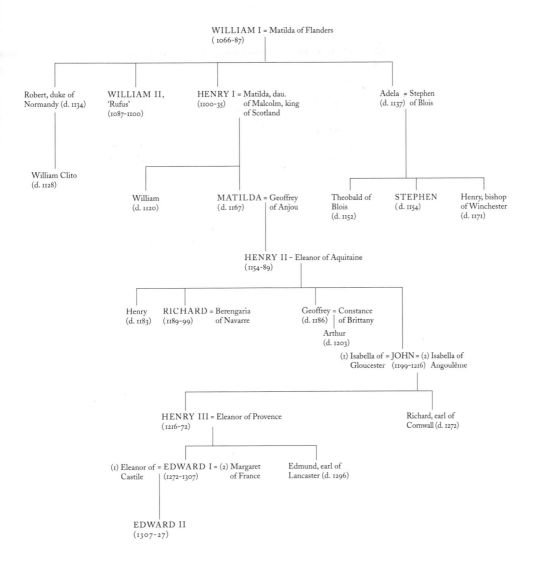

WILLIAM I = Matilda of Flanders
(1066-87)

Robert, duke of
Normandy (d. 1134)

WILLIAM II,
'Rufus'
(1087-1100)

HENRY I = Matilda, dau.
(1100-35) of Malcolm, king
 of Scotland

Adela = Stephen
(d. 1137) of Blois

William Clito
(d. 1128)

William
(d. 1120)

MATILDA = Geoffrey
(d. 1167) of Anjou

Theobald of
Blois
(d. 1152)

STEPHEN
(d. 1154)

Henry, bishop
of Winchester
(d. 1171)

HENRY II – Eleanor of Aquitaine
(1154-89)

Henry
(d. 1183)

RICHARD = Berengaria
(1189-99) of Navarre

Geoffrey = Constance
(d. 1186) of Brittany

Arthur
(d. 1203)

(1) Isabella of = JOHN = (2) Isabella of
Gloucester (1199-1216) Angoulême

HENRY III = Eleanor of Provence
(1216-72)

Richard, earl of
Cornwall (d. 1272)

(1) Eleanor of = EDWARD I = (2) Margaret
Castile (1272-1307) of France

Edmund, earl of
Lancaster (d. 1296)

EDWARD II
(1307-27)

The Descendants of Edward III

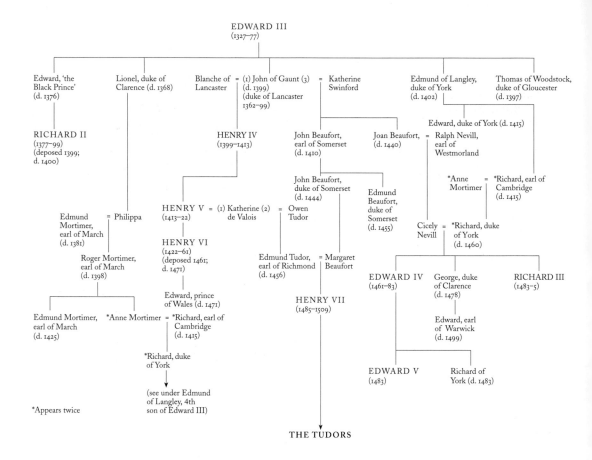

THE TUDORS

Illustration Sources

The editor and publishers wish to thank the following for their kind permission to reproduce the illustrations on the following pages:

Key: BL = British Library

Title-page: BL (MS Royal 18 D ii fo. 148ʳ); border to chapter openings: Master and Fellows of Corpus Christi College, Cambridge (MS 61 fo. 1ʳ)

154 Cambridge University Collection of Air Photographs: copyright reserved
158 BL (MS Royal 17 G v fo. 36)
159 Southampton City Council
162 Museum of London Archaeology Service
167 Cambridge University Collection of Air Photographs: copyright reserved
168 © British Crown Copyright/MOD. Reproduced with the Permission of the Controller of Her Britannic Majesty's Stationery Office
170 R. Floud, *Essays in Quantitative Economic History*, 1974, OUP
171 Hereford and Worcester County Council
172 A. F. Kersting
176 BL
177, 180 Conway Library, Courtauld Institute of Art
182 BL (MS Add 49598 fo. 102ᵛ)
186 A. F. Kersting
189 Syndics of Cambridge University Library (MS Ee.3.59 fo. 30ʳ)
193 English Heritage
195 Syndics of Cambridge University Library (MS Gg 6 42 fo. 3ʳ)
197 Prof. Ann Eljenholm Nichols
200–1 © Woodmansterne
203 Conway Library, Courtauld Institute of Art
204 Trustees of the Victoria & Albert Museum
213 Conway Library, Courtauld Institute of Art
214 Bibliothèque Municipale, Rouen (MS Y.6 fo. 132ᵛ)
216 Conway Library, Courtauld Institute of Art
218 Master and Fellows of Trinity College, Cambridge (Trinity MS B.5.26. fo. 1)
219 Trustees of the Victoria & Albert Museum
221, 222 A. F. Kersting

224 BL (MS Royal 2 A xxii fo. 14)
226 Trustees of the Victoria & Albert Museum
227 Vitenskapsmuseet Trondheim, photo by Per E. Fredriksen
230 © RCHME Crown Copyright
231 Conway Library, Courtauld Institute of Art
232 University of Warwick, History of Art Photo Collection
233 BL (Add MS 49622 fo. 68ᵛ)
234 © British Museum
237 A. F. Kersting
238–9 Trustees of the Victoria & Albert Museum
241 Trustees of the National Gallery, London
242 Conway Library, Courtauld Institute of Art
243 University of Warwick, History of Art Photo Collection
248 BL (MS Cotton Vit A xv fo. 187)
253 BL (MS Cotton Tiberius A iii fo. 60ᵛ)
254 BL (Add MS Ch 11205)
262–3 Public Record Office (Westminster Proclamation of Henry III)
264 Trustees of the National Library of Scotland (MS Adv. 19.2.1 fo. 146ᵛ)
266 Bodleian Library Oxford (MS Eng Poet a 1 fo. 231ᵛ)
268 BL (Add MS 37049 fo. 19ᵛ)
269 Bodleian Library Oxford (MS Douce 104 fo. 24ʳ)
270 Henry E. Huntington Library and Art Gallery, San Marino (EL 26 C 9 fo. 153ᵛ)
271 BL (MS Cotton Tiberius A iv fo. 9ᵛ)
273 BL (MS Cotton Vespasian F iii fo. 8)
274 Folger Shakespeare Library (V.a 354 fo. 191ᵛ)
278 © RCHME Crown Copyright

Picture research by Sandra Assersohn

Index

Note: Numbers in *italics* refer to black and white illustrations and their captions. Colour plates (which are unpaginated) are located by reference to the nearest page of text, printed in **bold**.